British Studio Ceramics

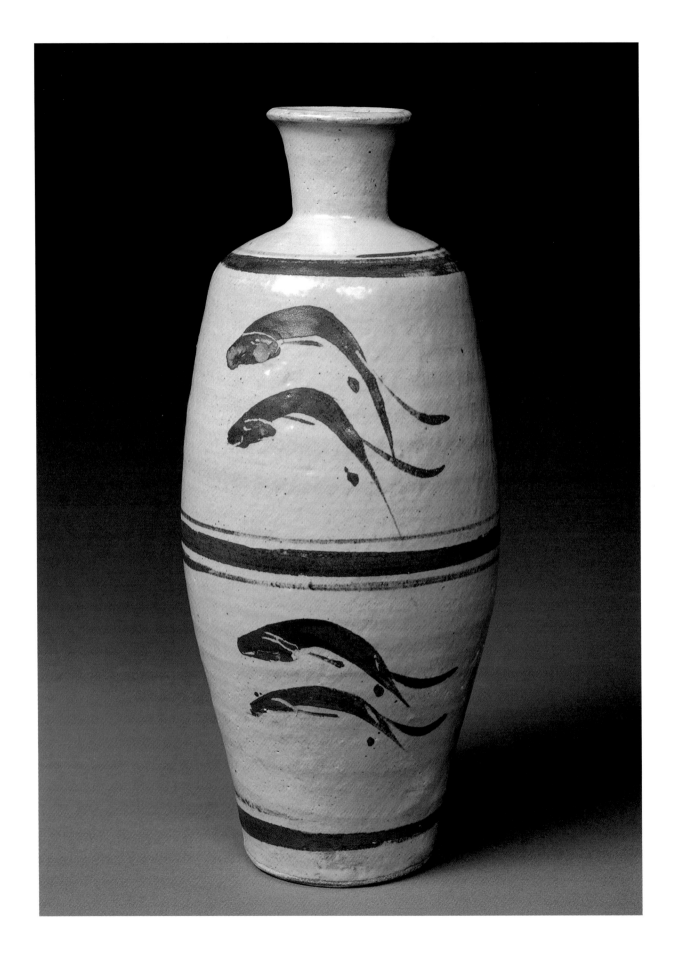

British Studio Ceramics

Paul Rice

The Crowood Press

First published in 2002 by
The Crowood Press Ltd
Ramsbury, Marlborough
Wiltshire SN8 2HR

British Library Cataloguing-in-Publication Data
A catalogue record for this book is available from the
British Library.

ISBN 1 86126 529 8

Photograph previous page: Bernard Leach, 'leaping salmon'
bottle, stoneware, cream glaze painted with iron, 1960s,
ht: 34cm.

Photographs page 6: *top left*, Michael Cardew, slipware,
*c.*1931, ht: 36cm; *top right*, Elizabeth Fritsch, 'Counterpoint',
stoneware, painted with slips, 1989, ht: 32cm; *bottom left*,
Edmund de Waal, porcelain, celadon-glaze, *c.*1999, ht: 40cm;
bottom right, Kate Malone, 'Millennium Jug', stoneware, crys-
talline glaze, 2000, ht: 27cm.

Acknowledgements
My thanks to the many potters, collectors, and gallery and
museum staff who provided invaluable information and,
especially, to Christopher Gowing for his contribution to
the appendices. Also thanks to all those who supplied
transparencies: Ben Williams, Adrian Sassoon, Anita Besson,
Conrad Bodmin, Magnus Dennis, Gareth Williams, Simon
Cottle and many others. Collectors who generously allowed
pots from their collections to be photographed include: Sir
David Attenborough, John Christian, Isobel Czarska, Simon
Fox, Sadao Matumura, Ed Wolf – my thanks to them and to
others who preferred to remain anonymous.

Photographs
All photographs by John Coles except:
plates 4, 6, 27, 46, 58, 59, 61, 64, 67, 71, 72, 73, 79, 127, 178:
 Magnus Dennis
plates 133, 179, 195, 197, 213, 242: courtesy of Adrian Sassoon
plates 97, 124, 159, 166, 239: courtesy of Galerie Besson.
plates 44, 132, page 6 (top right): courtesy of Sotheby's.
plates 20, 28, 34, 39, 50, 74, 81, 80, 92, 129, 131, 134, 135, 146,
 147, 151, 152, 154, 169, 190, 193, 223, 229, frontispiece:
 courtesy of Phillips Auctioneers
plate 55: copyright and from collection of Buckinghamshire
 County Museum
plates 89, 83, 86, 98: Steve Reece; copyright Barbican
 Art Galleries
plates 1, 18, 84, 88, 93, 95, 99, 138: courtesy of Bonhams
plates 204, 238: Philip Sayer; courtesy of Barrett Marsden Gallery
plates 168, 141: David Cripps; courtesy of Barrett
 Marsden Gallery
plate 3: courtesy of Garth Clark Gallery
plate 167: courtesy of Austin/Desmond Fine Art
plate 208: courtesy of Laurent Delaye Gallery
plates 16, 62, 122, 171: courtesy of private collectors
plates 128, 144, 150, 156, 160, 188, 191, 192, 198, 201, 209,
 210, 216, 217, 225, 232, 246, page 6 (bottom left): courtesy
 of the artists

Typefaces used: text and headings, ITC Giovanni; chapter
headings, ITC Tiepolo.

Typeset and designed by
D & N Publishing
Baydon, Marlborough, Wiltshire.

Printed and bound in Singapore by Craft Print International.

Contents

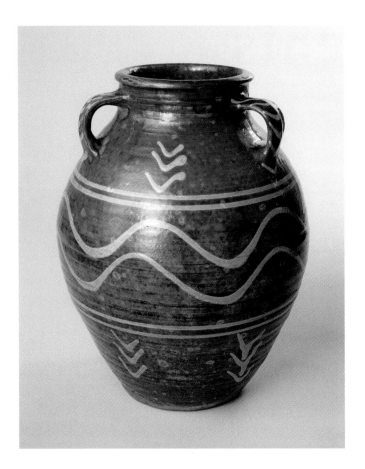

Introduction

I first became aware of British studio ceramics in the early 1970s when I visited the painter, Patrick Heron, at his cliff-top home on the Cornish coast. He had helped to keep the Leach Pottery running during the war years and had a few fine examples of pots by Bernard Leach and Shoji Hamada.

I was immediately drawn to these pots and found in them some of the same qualities that I liked in post-war abstract painting together with a sense of volume that I often found missing from modern sculpture. I was amazed to discover how few people in the art world had any knowledge of this work and that quality pieces by major potters could be purchased for less than small works by almost unknown British sculptors.

Collecting studio ceramics in the 1970s was not an easy task. There were few good craft outlets and most were more like giftshops than art galleries. There were almost no books or information available on the subject and the leading auction houses, until about 1976, did not consider even the work of major modern potters to be worth selling. Although a number of museums owned fine collections, the pots only rarely emerged from storage – often miscatalogued.

Despite these difficulties there seemed to be several good reasons, apart from love of the pots, to persevere. One of these reasons was largely a practical one. Most pots were relatively inexpensive, useful, and did not need the sort of care that most collectable objects require. They are impervious to light, changes in temperature or humidity, dirt, stains, smoke, sharp objects and insects. My fear of breakages (every new collector's fear) has proved to be almost entirely without foundation. High-fired pots, particularly if thrown, tend to bounce rather than break. After nearly thirty years of living with a houseful of pots – despite the attempts of three children and a number of cats and cleaning ladies – I have had only two breakages and a small number of minor chips. I know collectors who still put their Lucie Rie coffee service in the dishwasher or the Michael Cardew casserole in the oven (but I wouldn't recommend it).

For me, one of the many interesting aspects of British studio ceramics is that this country led the world for much of the twentieth century. France had a brief period of producing highly important work at the beginning of the century; Japan has produced much superb tableware and fine traditional pottery; and America had a period of enormous vitality in the postwar years and is unequalled in the field of ceramic sculpture. With these exceptions, the majority of interesting and influential work has been made in Britain.

In no other area of the visual arts has Britain had so much impact. London has never been the centre of modern art in the same way as Paris in the pre-war years or New York afterwards. While there have been many highly important British artists, few would cite this country as the world leader in modern art. Even British sculptors have not had nearly as great an impact as British potters.

Devotees of the 'fine arts' argue that ceramics is a minor art form that lacks the profundity of painting or sculpture. I would refute that. Great works of art in almost any medium are infinitely profound and any lack is in our ability to see and feel what is there. No such problem exists in the East where ceramics are considered to be at least as important as any other art form. To the Japanese, a sixteenth-century tea-bowl is as important as the *Mona Lisa* is to us.

Why have British studio ceramics been so dominant? I think there are two primary reasons for this. The first is Britain's fine and unique ceramic tradition, starting in medieval times.

English medieval pottery was little affected by outside influences and is particularly interesting. By the fifteenth century its production was widespread and this diversity continued when tin-glazed wares were introduced to Britain in the mid-sixteenth century. London, Bristol and Liverpool were just a few of the centres of production.

The seventeenth century saw the introduction of slipware, stoneware and salt-glaze. Slipware, which started in the first half of the century in Wrotham, Kent, is a form of ceramics that, in Europe, was entirely British. The slip-trailed decorative chargers made by Thomas Toft and others in Staffordshire are one of the finest achievements in clay.

Other lead-glazed earthenwares were introduced in the eighteenth century when creamware, agateware and jasper-ware all became popular. The eighteenth century also brought the rise of the Staffordshire potteries and, especially, that of Josiah Wedgwood. Creamware, which virtually eliminated tin-glaze, was also produced at Leeds, Liverpool and elsewhere. Porcelain was also introduced in the eighteenth century and, although the factories at Chelsea, Derby and Worcester are the most widely known, there were many other sites of production.

The industrial revolution brought about a great increase in the importance of the Staffordshire factories. The firms of Wedgwood, Spode, Minton and others produced an enormous variety of wares, which were exported in huge numbers. The nineteenth century also brought the influence of

William Morris and a movement away from factory production. William De Morgan, a student of Morris, was just one of those who started making 'art pottery'. The firms of Royal Doulton and, later, Moorcroft, are even better known.

Throughout its ceramic history, Britain has produced a wide variety of types of pottery – many with a style unique to Britain. With this background it is not surprising that so many talented artists – most of whom were trained as painters or sculptors – should turn to clay rather than working in some other medium. In other countries most of these artists would have remained in the 'fine arts'.

The second, and more direct, reason for the importance of British studio ceramics is Bernard Leach. His influence on modern ceramics parallels and even exceeds that of Pablo Picasso on modern painting. Leach's pots, ideas, books and students have left their mark on every corner of the ceramic world.

Without Leach, it is doubtful whether Hamada would have ever come to Britain or whether his important early students, Cardew, Pleydell-Bouverie and Braden would ever have achieved such prominence. Even William Staite Murray greatly benefited from the status Leach brought to pottery and from the technical knowledge he brought to Britain.

The starting point for modern postwar ceramics in Britain was, primarily, Lucie Rie. Rie was strongly influenced by Leach, and it was his fame as a potter that attracted her to England. Most refugee artists went to America. Without Rie, it is unlikely that Hans Coper would have worked in clay. Rie and Coper, through their ceramics and teaching were the major influence on British studio ceramics in the second half of the century. Elizabeth Fritsch, Ewen Henderson, Alison Britton, Jacqui Poncelet, John Ward and Geoffrey Swindell are just a few of their students whom they greatly affected.

Alternatively, one could easily write the history of modern British studio ceramics as a series of reactions against the style and ideas of Leach. The debate over the quality of his work and the validity of his ideas rages more fiercely now than ever, but it is not difficult to imagine how much of a ceramic backwater Britain might have been had he stayed in the East.

Leach's death in 1979 coincided with, and partly caused, the beginning of a renaissance in interest in British studio ceramics. New galleries opened and began to promote the exciting potters who emerged in the 1970s. New collectors appeared creating a demand for young potters and soaring prices for masters such as Leach, Rie and Coper. Major auction houses began to take a keen interest and museums began to unveil their collections and some started purchasing in quantity for the first time in many years. This enthusiasm has continued to grow year by year and, today, the British ceramic scene is unrecognizable from that of twenty-five years ago.

This interest in British pots seems to be even greater abroad. The best pots of Leach often go to Japan; the best of Rie and Coper often go to America. Most of our best contemporary ceramicists have had enormous success in foreign exhibitions – often much more than they would have in Britain. Despite all this interest, studio ceramics has remained extremely poorly served by publications. In this book I am hoping to provide both an overall introduction to those who have little knowledge in this area and some useful information for those that do. I have written largely from the point of view of how a potter's work fits in with, and is influenced by, other potters' work. This device, while extremely useful, is necessarily a simplification. Behind this is a highly complex blend of social, economic and political factors that has driven many of the developments in ceramics. I am painfully aware of how much information and how many fine potters have been left out, due to shortage of space. The range and depth of talent in Britain is so great that to begin to include everything would take several volumes. Most potters in this book have primarily made vessel-based ceramics and I have only briefly touched on ceramic sculpture or designs for factory production. This, sadly, has meant largely ignoring such important artists as Mo Jupp, Glenys Barton, Jill Crowley, Philip Eglin, Kenneth Clark and Anita Hoy.

The pots I have chosen for this book are, almost without exception, from private collections. This was partly a practical consideration but, more importantly, I wanted to include work that was typical rather than just being the most famous examples. Photography is poor at capturing the qualities of ceramics and I would recommend a visit to the many fine museum collections around the country that house many of these 'most famous examples'. At the end of this book I have included an extensive list of British public collections, cross-referenced with a list of information on 200 British, twentieth-century potters. I hope that this, together with the bibliography, will help those who wish to look further.

Many ceramics have been made to be held and used rather than just looked at. The pleasure of drinking from a teabowl made by Hamada – or by Jim Malone – is a totally different experience from seeing the same bowl in a museum's glass case. For those who wish to see or acquire the latest work, listings of exhibitions can be found in *Crafts Magazine*, *Ceramic Review*, *Ceramics in Society* or even on some internet sites.

The ceramics I have owned and seen have given me a tremendous amount of pleasure. I hope that this book may inspire others to appreciate what many consider to be Britain's most outstanding contribution to modern art.

Paul Rice
London, 2001

Chapter 1

The Early Years

The first twenty years of the twentieth century marked a major turning point in British art pottery. The usual portrayal of this time as being a barren period in studio ceramics is, to a certain extent, true. In France, excellent work was being done by Ernest Chaplet, Emile Decoeur, Emile Lenoble and others. Compared with this, or with British ceramics of the l920s and 1930s, the quality of work produced before 1920 was low.

This was a period of transition and experimentation; a movement from the decorative, low-fired pots of the Victorian factories to the modernist, high-fired work of the individual artist. It is difficult today to get a sense of just how hard this transition must have been. The technical hurdle alone was enormous. Very little was known at this time about early Chinese ceramics or any of the aspects of firing at high temperatures. Which clays to use, kiln construction, firing methods, and glaze recipes, all had to be learnt mostly by trial and error. The psychological hurdle must have been even greater. Art pottery was made in factories; designed, thrown, turned, decorated, glazed, fired and marketed by many different specialists. The idea of the studio potter controlling all of these tasks did not exist.

It is the work of the four extraordinary Martin Brothers that best illustrates this transition. Robert Wallace Martin began his working life as a stone carver on the Houses of Parliament. He worked in a number of potteries in the 1870s and together with his brothers set up their own pottery at Southall in Middlesex in about 1877. There they built a large kiln with the intention of salt-glazing, a process requiring firing at a high temperature. Salt-glazing had been done for some time at the Doulton pottery, but even though both Walter and Edwin Martin had worked there for a time, they had learned only the rudiments of this technique, which was kept a closely guarded secret. Many of the Martin Brothers' early firings thus ended in disaster, but eventually they produced a wide range of salt-glaze of surprisingly high quality.

Charles Martin devoted himself to the business side of the pottery, Walter Martin became skilled as a thrower and Robert Wallace Martin, the moving spirit of the brothers, indulged in his taste for the Gothic and produced a series of, now famous, grotesque birds, jugs with faces and other

highly fanciful work. Much of this, together with the decorative Doulton-style vases, clock cases, candlesticks and so on produced by the firm, is an obvious product of the nineteenth century.

The pots of the youngest brother, Edwin Martin, are rather more relevant to modern work. Edwin was a skilled decorator

Plate 1: Martin Brothers, stoneware, salt-glaze, 1893, ht: 25cm.

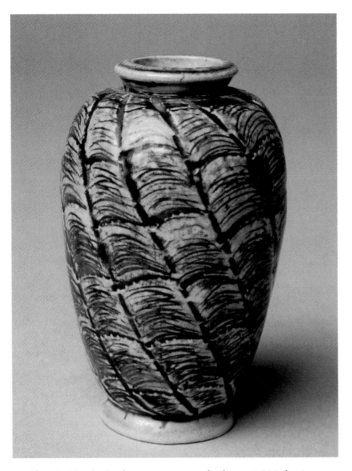

Plate 2: Martin Brothers, stoneware, salt-glaze, c.1900, ht: 8cm. This is a typical 'gourd' pot.

The work of William Howson Taylor, who set up the Ruskin Pottery near Birmingham in 1898, is more interesting. Taylor was a brilliant glaze chemist and, eventually, he also moved to high-firing. His main preoccupation was in learning the secrets of flambé glazes. These metallic oxide reduction glazes were extensively used by the Chinese, but the techniques were little known in the West. Taylor's success in this medium was quite staggering and, on a purely technical level, must rank as one of the greatest achievements in modern ceramics. Even today, most potters would find it difficult to match the range of effects and control of glazes that Taylor achieved. However, Taylor had more of the scientist than the artist about him and his pots convey this impression. The glorious glazes are often let down by poor shapes.

On the day Taylor closed the Ruskin Pottery he burnt all the records of his glaze experiments – the very thing he had dedicated his life to. This bizarre decision, together with Bernard Leach's intense dislike of these glazes, ensured that it was many years before flambé glazes were used in Britain again. Even in the 1970s and 1980s, when colourful glazes became fashionable, few potters explored this area.

If the Chinese flambé glazes were to prove to be a cul-de-sac, the opposite could be said of the monochrome glazes of the pre-Ming dynasties. In 1910, the Burlington Fine Arts Club in London's Savile Row held a highly influential exhibition of Chinese ceramics. A large number of these pieces were Tang, Sung and Yuan wares and this may have been for many potters their first exposure to this sort of work.

The effect on studio pottery was almost immediate. The same year, Reginald Wells moved to Chelsea and changed his style. In 1911, George Cox opened the Mortlake Pottery, also in London, and in 1913, the Upchurch Pottery was reopened in Kent by Wells's friend, Seymour Wakeley. All three began producing similar low-fired versions of pre-Ming wares. All three hired Edward Baker to throw the forms, which explains much of the similarity.

The Upchurch Pottery continued with little change until 1963. The Mortlake Pottery existed for only three years and very little has been written about the life or work of George Cox. Most of his pots appear to be based on Tang pots; and, like Upchurch, most are a bit dull. He did, however, produce some quite excellent pots. In 1914, Cox went to America where he published his book, *Pottery*. This book was virtually the only technical manual for potters in English for more than twenty years and was extremely influential on both sides of the Atlantic.

Reginald Wells was, almost certainly, the most interesting potter of the early years. Wells, initially trained as a sculptor, became one of the earliest pottery students at the Camberwell School of Art and Crafts. He first began to make slipware at Wrotham in Kent. This work was surprisingly good, though it lacked the originality or elegance of the slipware that would be made in the 1920s by Michael Cardew. However, Wells soon moved to Chelsea to design earthenware inspired by Tang and Sung pots. Some of these 'Coldrum' pots are quite

and he produced a number of wonderful decorative images of fish and underwater scenes. Between about 1897 and 1912 he worked on his 'gourd' pots. These are mostly small vases with heavily patterned surfaces that resemble gourds, shells and other natural textures. These pots have been enormously influential and are considered by many to be the first important studio pots produced in Britain.

The great influence of the Martin Brothers lay as much in their attitude as it did in the pots themselves. Here were potters who were willing to sacrifice commercial success in order to make the work they wanted to make. Their pots were the product of artists, not factory craftsmen. The Martins controlled every aspect of their work from start to finish. It was this idea that rapidly became the dominant theme of twentieth-century ceramics.

Bernard Moore and William Howson Taylor both made significant contributions to the development of high-fired pots. Bernard Moore at his pottery in Staffordshire began to produce high-fired imitations of some of the Chinese glazes of the later dynasties. He was particularly successful with sang-de-boeuf glazes. While Moore's pots are technically highly accomplished, they are severely lacking in any feeling and differ little in spirit from the similar low-fired factory work at Doulton's or Pilkington's.

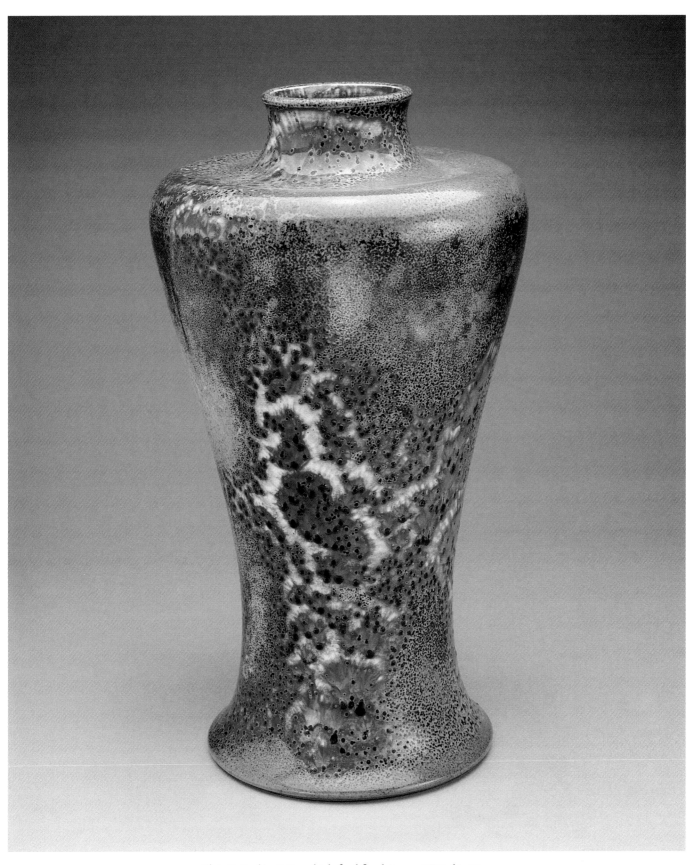

Plate 3: Ruskin Pottery, high-fired flambé ware, 1919, ht: 36cm.
Taylor's glaze effects have never been bettered.

beautiful and the glaze effects are varied and appealing, but many of the forms are weak and lifeless. This is not surprising as Wells had little to do with their actual production.

Wells led an extraordinary and varied life, designing houses, boats and aircraft as well as making both pottery and sculpture. After the war, and the collapse of his aircraft business, he began producing quirky stoneware imitations of Sung pots and, in 1925, when he moved from London to Storrington in Sussex he began to throw these pots himself. These 'Soon' pots often have a very pleasing dark reddish-brown body and are somewhat clumsy in shape – a trait that seems to give them a great deal of charm. Almost all the glazes are monochrome – a rich blue and a creamy white being the most commonly used. He was one of the first modern potters to develop the use of crackle glaze. There was little knowledge of Chinese glazes at this time and Wells

was not a technical master, so most of his Sung imitations are fairly far from the originals. The blue glaze he developed, for example, was supposed to be imitative of a chun glaze, but he was using the wrong metal oxide.

Wells was unjustly ignored until very recently when there have been signs that his importance is beginning to be recognized.

Another interesting early potter is Frances Richards. Her pots are quite amateurish and not always totally successful, but she is probably the first true studio potter. She made and fired pots in her garden in Highgate, London. I have seen both earthenware and stoneware pieces in a variety of styles, but her work in the 1920s was primarily Chinese influenced. Very little is known of her except that she lived in considerable poverty and was selling pottery long before the First World War.

Plate 4: George Cox, earthenware, copper-glaze, 1912, ht: 11cm. This pot was thrown by Edward Baker.

Plate 5: Reginald Wells, earthenware, 1910–20, ht: 17cm.
Wells intentionally tried for 'happy accidents' in his glaze effects.

Not all potters were obsessed with Chinese pots. Denise Wren, an Australian by birth, studied design at the Kingston College of Art from 1907 to 1912, where she was taught by Archibald Knox, the great Art Nouveau designer. She turned at once to pottery and had a special interest in early English ceramics and Celtic designs. Her early work is experimental and highly varied, but apart from a few Knox-inspired pots, is mostly fairly poor. In 1920, she moved to Oxshott in Surrey where she remained for the rest of her life. She is especially known for the simple and pleasing salt-glaze pots that she made in the 1950s and 1960s.

The painter Roger Fry, though deeply impressed by Tang and Sung wares, was another who avoided imitating Chinese pots. He studied ceramics about 1912–13 at the Camberwell School and soon began selling his pots at his Omega Workshops in Bloomsbury. Fry's work is tin-glazed earthenware and he was primarily interested in incorporating ideas from modern painting and design into his ceramics. He was also

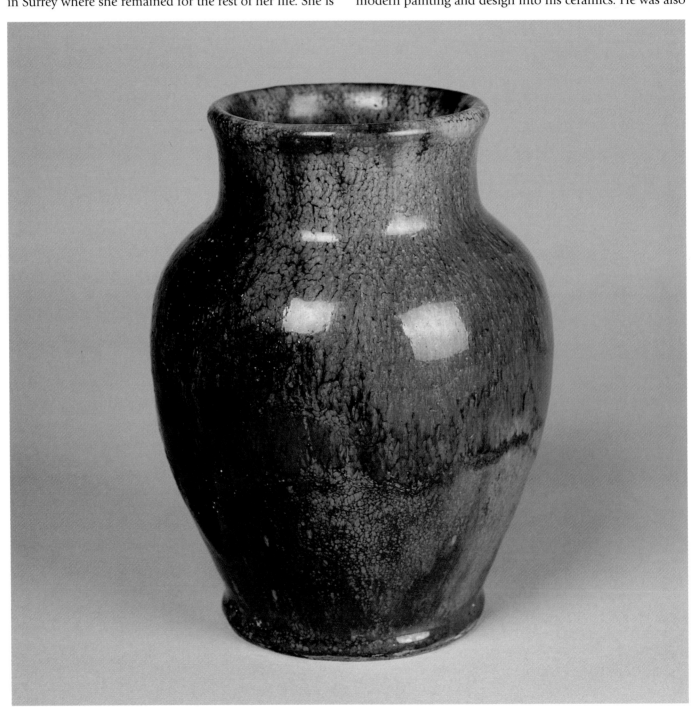

Plate 6: Reginald Wells, stoneware, c.1928, ht: 17cm.
Wells never achieved a chun-glaze as he probably did not know it was an iron-glaze.

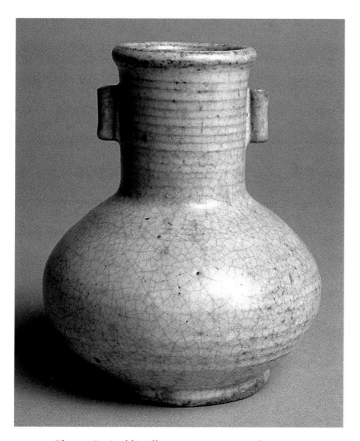

Plate 7: Reginald Wells, stoneware, c.1928, ht: 12cm.

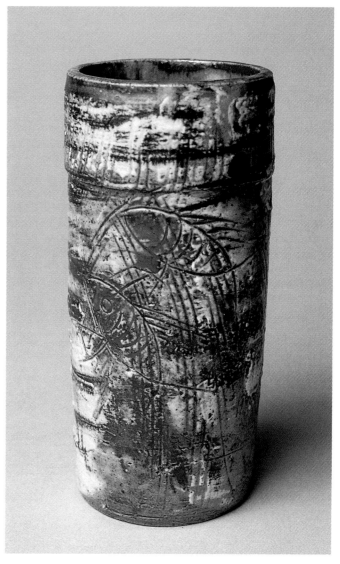

Plate 9: Denise Wren, stoneware, salt-glaze, c.1958, ht: 18cm.
Wren's pots are often more sought after by collectors than better
salt-glaze pots by other potters.

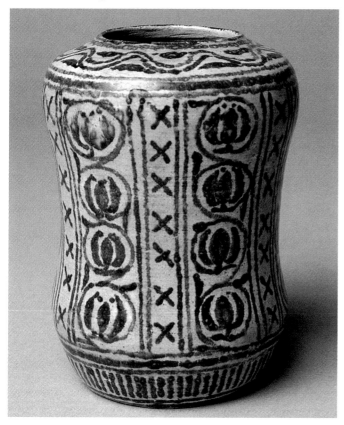

Plate 8: Frances Richards, earthenware, probably pre-1910, ht: 11cm.

influential in getting other notable painters, including Duncan Grant and Vanessa Bell, to decorate ceramics for Omega. Fry later went to work at the Poole Pottery factory in Dorset to try further experiments, but the outbreak of war interrupted his work and he did not return to ceramics when the war ended. The Victoria & Albert Museum has a number of examples of both early Denise Wren and Omega pots.

The influence of the London art colleges began to be of increasing importance at this time. Previously, to learn pottery would have meant a job at somewhere like Doulton's followed by years of experimentation. Now one could be taught at the Royal College of Art, the Camberwell School of Art and Crafts or the Central School of Art and Design.

Dora Billington was one of the most influential of the early teachers. She was trained herself first by Bernard

Moore and then at the Royal College. She went on to teach at the Royal College and, for many years, headed the Ceramics Department at the Central School. Her own ceramic work was somewhat indifferent, but she will be remembered for her teaching and for her book, *The Art of the Potter*, which became one of the most widely read books on ceramics after its publication in 1937.

By far the most influential figure of this period was W.B. Dalton. In 1899 Dalton was appointed principal of the newly opened Camberwell School of Art and Crafts in South London. Over the next twenty years, Dalton established Camberwell as the main training ground for fine potters. During this period Reginald Wells, Roger Fry, and two of the major potters of the 1920s and 1930s, William Staite Murray and Charles Vyse, were all taught at Camberwell.

Little has been written about Dalton's life and it is very unclear how much, if any, direct teaching of pottery he did while he was at Camberwell. The main teachers of pottery he employed were George Dunn, a professional thrower at the Derby factory, and Alfred G. Hopkins.

Hopkins was an extremely interesting figure. His own work, that is often highly eccentric, is forgotten today. Some would say deservedly so and, I must say, I have not seen many pots of Hopkins that greatly impressed me, but I have met collectors who claim he is the most neglected potter of the century. Hopkins's career as a potter was extremely successful in the 1920s and 1930s and he was shown at many leading London galleries including the Fine Arts Society. He potted in Lambeth and much of his work is in salt-glazed stoneware. He also claimed to have 'invented' salt-glazed porcelain. It was Hopkins and Dalton who strongly promoted the idea of the potter as a fine artist to be shown next to painters and sculptors. This viewpoint and the very high prices charged by Hopkins (reputedly the first potter to sell a pot for £100) were later to become strong features in the attitudes of William Staite Murray.

I do not know when Dalton started to make pots himself or how much work he did during his Camberwell years. In 1919, he resigned his post and began potting full-time at Gravesend where he stayed until his home was damaged in the Second World War. The Dalton pots that I

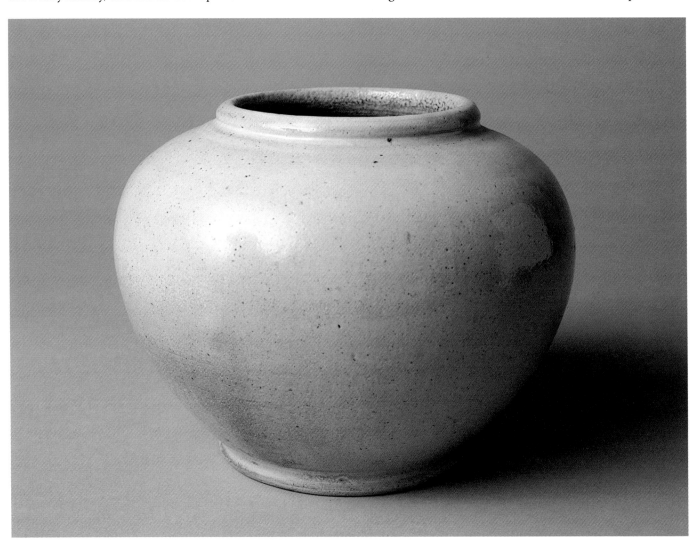

Plate 10: Alfred G. Hopkins, salt-glazed stoneware, 1920s, ht: 16cm.

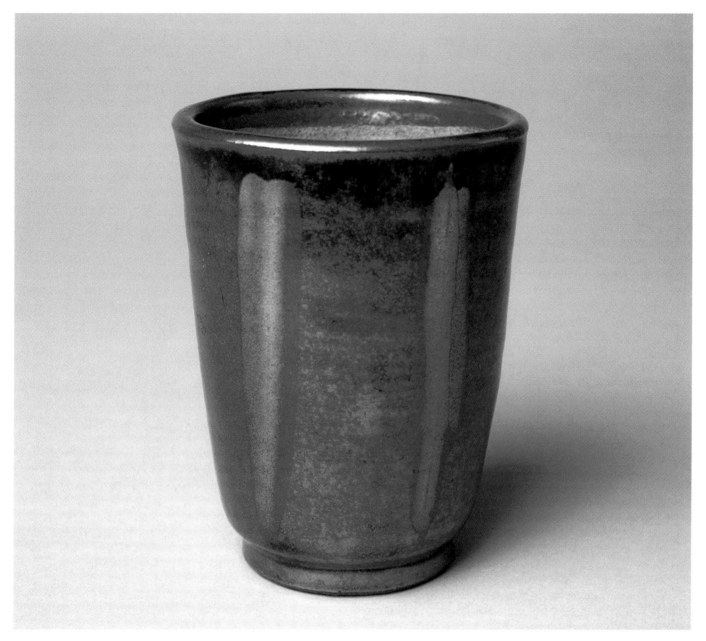

Plate 11: W.B. Dalton, stoneware, tenmoku-glaze, 1920–40, ht: 13cm.
It is a measure of how forgotten Dalton is that this pot has appeared wrongly described twice in major auctions, once as a Charles Vyse and once as a Matsubayashi.

have seen are extremely fine. Almost all are stoneware with monochrome glazes in Sung style. They are well-potted, surprisingly lively for that time and have a great simplicity of style. He worked in a variety of glazes and seems to have had a remarkable degree of control. Dalton did not date his work and without knowing which pots were made early on it is difficult to know just how much of a true innovator he was. Much of the stoneware of Reginald Wells, Charles Vyse, Constance Dunn and, particularly, William Staite Murray's early Sung-inspired pots all bear a marked resemblance to Dalton's pots.

In 1941, Dalton left for America where he established a pottery in Stamford, Connecticut and wrote a number of textbooks on ceramics. Several of his pots of this period can be seen in the Cooper-Hewitt Museum in New York. It seems likely that Dalton was one of the many Europeans who so strongly influenced the blossoming of ceramics in America in the post-war years.

By 1920, there were quite a number of established potters working in a way very similar to that of today and the transition from factory 'art pottery' to studio pottery was complete.

Chapter 2

Bernard Leach and Shoji Hamada

The arrival in England of Bernard Leach and Shoji Hamada in 1920 is regarded by many as the starting point of modern ceramics. Certainly, it is the most important single event in the history of twentieth-century studio pottery and it is clear that British ceramics would not have enjoyed such dominance had Leach settled elsewhere. Few people would argue with the view that Leach is by far the most influential potter of the century.

Bernard Howell Leach was born in Hong Kong in 1887. His mother died shortly after his birth and he lived, first, with his grandparents in Japan and, later, with his father in Singapore. At the age of ten he was brought to England with his uncle to attend a Jesuit school near Windsor. This was a profoundly unhappy time for Leach and, no doubt, greatly contributed to his later embrace of first Buddhism and later the Baha'i Faith.

Leach showed an early interest in drawing and at sixteen became the youngest student at the Slade School of Art under the somewhat notorious Henry Tonks. Leach's father had hoped for a 'normal' job for his son and Leach began working in a bank. However, this proved to be a brief diversion and Leach entered the London School of Art to study etching under Frank Brangwyn.

Born and raised in the East, educated in the West, it was more than anything else this straddling of two cultures that fuelled the work of Bernard Leach.

During this time, Leach's interest in Japan, inspired by the stories of Lafcadio Hearn, grew and in 1909 he set off for Tokyo. Etching was unknown in Japan and Leach went armed with a small etching press intending to teach this printmaking technique. By doing this he soon became friends with a wide range of Japanese artists.

It was at a party that Leach had his first experience of potting. All the guests were invited to decorate a piece of raku that was glazed, fired, and returned to them, still hot, almost at once. This seemingly innocuous event had a profound effect on Leach and he dedicated himself to finding a master and learning this craft. Together with his friend, architect Kenkichi Tomimoto, Leach managed to become a student of Ogata Kenzan, sixth in line of a 250-year-old tradition of master-potters stemming from the great Kenzan I, one of the most famous potters in Japan's history. Eventually, Leach and Tomimoto were given jointly the title of Kenzan VII. For a Westerner to be given such an honour is rare, if not unique.

During his years in Japan, Leach married his cousin, Muriel Hoyle, fathered five children, built a house and a kiln, designed furniture, acquired an extensive knowledge of Oriental art, and established a tremendous reputation as an etcher and as a potter working both in raku and stoneware. This is enough, perhaps, for an entire lifetime, but for Bernard Leach at the age of thirty-three, this was only the first chapter.

The relationship between Leach and Japanese culture is a subject about which there has been a great deal of discussion and about which there are several popular misconceptions.

The first notion is that Leach was greatly influenced by the craft movement in Japan. If anything, the reverse is true. When Leach arrived in Japan he was already aware of the ideas of William Morris and crafts in Japan were in a decline

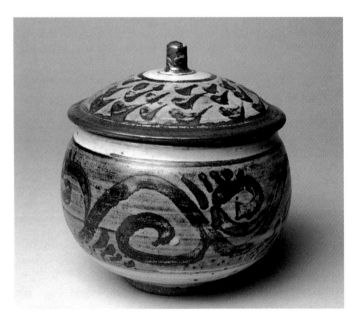

Plate 12: Bernard Leach, stoneware, painted with iron and cobalt, 1950s, ht: 20cm.
The design was based on a Swankalok jar in Leach's collection and was more commonly used for smaller jam jars.

similar to that in England. Leach's description of Ogata Kenzan as 'old, kindly and poor, pushed on one side by the new commercialism' is evidence of the attitude at that time to a ceramics master. It was Leach who largely inspired Tomimoto, one of Japan's greatest potters, to turn to ceramics. It was Leach who greatly influenced the younger Shoji Hamada. It was Leach who helped inspire the interest in ceramics of Dr Soetsu Yanagi and, eventually, rebuilt Kenzan's kiln on Yanagi's property. Yanagi, philosopher, poet and lifelong friend of both Leach and Hamada, became the mentor and prime moving force of the Mingei folk craft revival. The leading potters in this revival were Tomimoto, Hamada, Kanjiro Kawai and Leach. This is one of the many reasons that Bernard Leach is held in such high regard in Japan.

A second misconception is that Leach was a copyist of Japanese pots. This is wholly untrue. Firstly, I find it difficult to regard Leach as a copyist at all. Leach shares with many great artists the ability to take material from other sources and reshape it. This, incidentally, is one of the greatest achievements of Japanese culture. Throughout their history, they have plundered other cultures and transformed what they found into something uniquely Japanese. This applies to most of their transformations of Chinese and Korean art forms, to Zen Buddhism, and to their dominance in the world of modern technology.

Most of Leach's pots do not look much like those they are based on and even the ones that do are made in an entirely different context. A Sung bowl is created anonymously as a utilitarian object – a Leach bowl is created as an art object; an expression of an individual ideal. This change of context is a recurring theme in modern art from Marcel Duchamp's painting of the Mona Lisa to Andy Warhol's Campbells soup cartons and cans or Carl André's bricks.

Leach's attitude to this is described by the story of the woman who wrote to him complaining that a teapot he had made dribbled everywhere. Leach responded with a mild sense of horror that she should be serving tea in it – a St Ives standard-ware teapot (which is a copy), yes, but not one of his. He went on to explain the spiritual content of his pots and suggested that the piece be used as a sort of icon, to contemplate for inner peace. While this may be more than somewhat hypocritical in view of the great importance he placed on function in ceramics, it is not the attitude of a copyist. The only works of Leach that I consider to be real copies are some of the small functional slipware pieces that he made.

There are probably many who do not agree with this viewpoint, but, whether you regard Leach as a copyist or not, he did not copy Japanese ceramics. Leach was inspired by Korean Yi, Chinese Sung, English slipware, English medieval, Swankalok, Chinese early Ming, Persian, Pre-Columbian, Delft, but only occasionally by Japanese pots. To my knowledge, he never made a single pot in the Kenzan style and, ironically, his awareness of many types of Japanese ceramics was comparatively poor until his extensive stay in Japan in 1934.

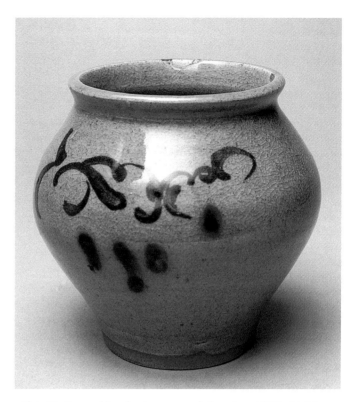

Plate 13: Bernard Leach, stoneware, celadon-glaze, 1920s, ht: 14cm. Leach sometimes made his own gold lacquer repairs to his favoured pots.

What Leach did take from Japan was the Japanese way of looking at pots. Most European pots, whether from great factories (Meissen, Sèvres, Wedgwood, and so on), the Victorian art potteries or even from the hand of Picasso, were primarily concerned with surface decoration. Leach believed that pottery started from the clay up and not from the decoration down. The difference is quite profound and leads to many changes in the way a pot is conceived and made. Materials become more important and making your own bodies and glazes becomes part of the process of making a pot. Leach left part of the pot unglazed to use the clay for its own decorative effect. The space enclosed by a pot became an important idea, as did space in the decoration itself. The emphasis on the pot being a functional as well as a decorative object meant that the feel of the pot to the hand (or the lips) was important. The weight must be related to the function – a vase should be heavy so it cannot tip; a teapot should be light so it is easy to lift. The nature of the foot-ring, the elegance of the seal-mark became important topics of conversation. All this was revolutionary to potters like W.B. Dalton or Reginald Wells.

Thus, when Leach arrived in St Ives in 1920, he came with a superb training, an extensive knowledge of Oriental art, a highly refined attitude to ceramics, a fair technical knowledge and years of experience as a potter. All this was a great advantage over the inadequate training in ceramics offered by the art colleges.

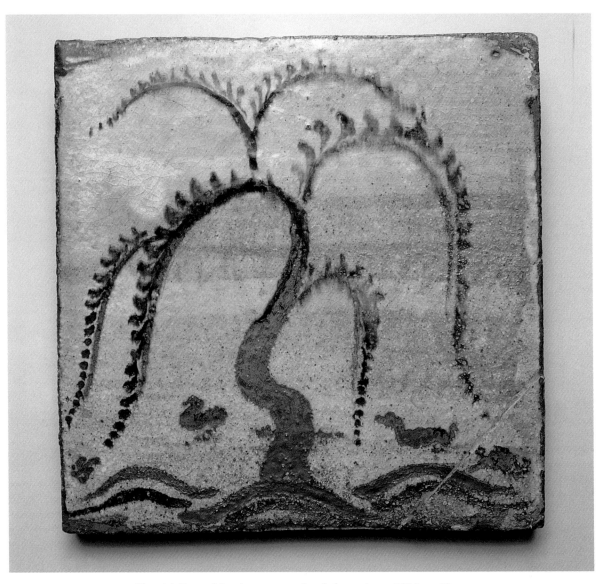

Plate 14: Bernard Leach, stoneware, brush decoration, c.1930, w: 23cm.
Tiles usually carry the impressed St Ives seal on the back and the St Ives and 'LB' personal mark painted in the design – most are only 10cm.

On the face of it, St Ives was a poor choice as a pottery site. It is far from London in an area with not particularly good clays, and the nineteenth-century tin mines had denuded the landscape of trees – not an advantage when you are using a large wood-fired kiln. However, Leach had been given a financial incentive by a wealthy patron and St Ives has long had a way of attracting artists that cannot just be explained by the rugged beauty of the Cornish coast or the fine light. In any case, Leach could be described as enthusiastic and inspirational and not as being particularly practical or disciplined.

Leach and Hamada built a traditional Japanese three-chambered climbing kiln – the first in Europe – and a smaller kiln for biscuit and raku firings. The first months were spent almost solely in finding materials. That good clays and sources of vegetable and wood ashes (necessary

for the glazes) were found was, I suspect, more due to hard work and good luck than to any prior thought about the suitability of Cornwall. But for Leach, building his own kiln, digging his own clay, making his own wood ash were all very important – part of his conception of pottery as 'a completely unified human expression'. Wood was obtained, initially, by a gentle conning of the Great Western Railway and Leach's account of this episode in his book on Hamada is characteristic of his flair for storytelling.

To say that there were serious teething troubles in the first years at St Ives would be an understatement. Kiln losses were excessively high and the kiln itself began to fall apart. Raku was soon abandoned because, while suitable for a Japanese tea-ceremony, it was too porous and fragile for English domestic use. Despite these and many other problems, enough good work was made for a London exhibition in 1921.

Plate 15: Bernard Leach, slipware, late 1920s, dia: 42cm.
This large charger is loosely in the style of Thomas Toft.

In 1922, Tsuronosuke Matsubayashi ('Matsu', as he became known) was brought to England to redesign and rebuild the kiln which, by now, was in a terrible state. 'Matsu' was the thirty-ninth generation of a Japanese family of potters, though he became better known in this country for his hilarious rendering of English than he did for his pots. Besides being a kiln specialist, 'Matsu' possessed an extensive knowledge of glaze chemistry, that far surpassed that of Leach or Hamada. His presence was invaluable to all the early potters at St Ives. On Hamada's return to Japan in 1923, Leach was joined first by Michael Cardew, then, when

he left, by Katharine Pleydell-Bouverie and, later, by Sylvia Fox-Strangeways, Norah Braden, and Charlotte Epton.

The 1920s was a supremely testing time for the Leach Pottery. Apart from the kiln losses, the difficulties in obtaining wood, and countless technical problems, there was also the major hurdle of getting the work accepted. In a country that was embracing the marvels of Wedgwood, this was no easy task, and the Pottery was always on the brink of financial collapse. Michael Cardew described Leach at this time as 'a voice crying in the wilderness' – a beautiful and accurate description. For the survival of the Leach Pottery we have to thank the

Plate 16: Bernard Leach, stoneware, celadon-glaze, c.1955, dia: 32cm.

Japanese. It has often been the case that Britain's finest artists have been accepted abroad long before they receive recognition in their own country and this was very much the case with Leach. Much of his best work at this time was sent to Japan and after Hamada's return he had regular exhibitions there in which, invariably, everything sold. This was a major and much-needed source of income. Even today, most of the finest Leach pots that are sold go to Japan. Leach also had regular exhibitions in London at galleries like Beaux Arts, Three Shields, and Paterson's in Bond Street, a gallery that regularly exhibited fine ceramics. Even though Leach's reputation was growing quickly it was not accompanied by much financial success.

During the 1920s, Leach's pots become increasingly assured. He produced a wide range of stoneware, some porcelain and raku, and a great deal of slipware. One of the most interesting aspects of his early stoneware work was the decorated tiles. The Pottery produced tiles for fireplace surrounds and many of these were painted by Leach. Leach was a very good draughtsman and exceptionally fine at the difficult art of brush decoration. In my opinion, this aspect of his work has not been equalled by any modern potter in the West. These small tiles were the ideal medium for the expression of this and, fortunately, a surprisingly large number of them seem to have survived.

Perhaps the most interesting aspect of the work at St Ives at this time was the development of slipware. To work with slipware was one of the main artistic reasons Leach returned to England. The claim by Leach and many of his supporters

that he rediscovered slipware is, of course, untrue. There was a great deal of slipware being made at that time and the work of some nineteenth-century potters in the Barnstaple area such as that of Charles Brannam was of a very high standard. But Leach was an admirer of Thomas Toft and was only interested in seventeenth- or eighteenth-century slipware, not in the 'decadent' work of the nineteenth century. The slipware of Leach did revive interest in this early work and much of the knowledge of early techniques was regained. For example, the method of making 'combed' decoration had been, apparently, lost. One morning at breakfast, Hamada sliced through a piece of bread with thick coatings of jam and Cornish cream. The observation of the effect this had instantly led to the rediscovery of one slipware technique.

The large decorated chargers that Leach produced somewhat in the Toft style are amongst his finest pots, but much of his more functional domestic work is, I think, amongst his most disappointing. Many are little more than good pastiche and far inferior to those made by Michael Cardew. Hamada, who did some slipware at St Ives, took the technique back with him to Japan where it was taken up with enthusiasm by several potters.

In 1930, Leach's eldest son, David, came to work in and, later, to take over the running of, the pottery. This gave Leach much greater freedom and he was away from St Ives for much of the 1930s. In 1932, Leach began teaching at Dartington Hall in South Devon, a small pottery he built with the help of Leonard and Dorothy Elmhirst. The

Elmhirsts became important patrons of Leach. They financed Leach's nearly two-year stay in Japan and Korea in 1934–5 (and also paid for the American painter, Mark Tobey, to accompany him). At one stage plans were made to transfer the entire Leach Pottery to Dartington Hall, but this idea was, eventually, dropped. Leach returned to Dartington Hall in 1936 to teach and to begin writing *A Potter's Book*, which, when it was published in 1940, became the 'bible' of the ceramics world.

With his interests so very divided, it is not surprising that Leach's pots from this period are somewhat uneven in quality. Some of his best work was made in this period, but also some of his worst.

During this time, David Leach made great improvements in the running of the pottery at St Ives. Bernard Leach was not as anti-technology as he has often been portrayed, but he was suspicious of it and slow to put it into use. Not so David Leach; he left the Pottery in the hands of Harry Davis and Bernard Leach's future second wife, Laurie Cookes, while he took a two-year course at the technical college in Stoke-on-Trent. On his return, he changed from wood-firing to oil-firing, replaced slipware with a semi-porcelaneous stoneware and introduced a number of technical improvements. This provided the basis that led to the success of the Leach Pottery in the years after the war; a subject I will come back to in a later chapter.

Bernard Leach, after the war, resumed his exhausting schedule of potting, teaching, lecturing and travelling. *A Potter's Book* was extremely successful in America and Leach was much in demand. In 1950, he toured the USA with an

Plate 17: Bernard Leach, stoneware, incised decoration, c.1955, ht. 29cm.
Leach's diverse source material shows here. The shape of the lid is copied from the Temple of the Moon in Beijing and the decoration is inspired by an early Mexican motif symbolizing the Sun.

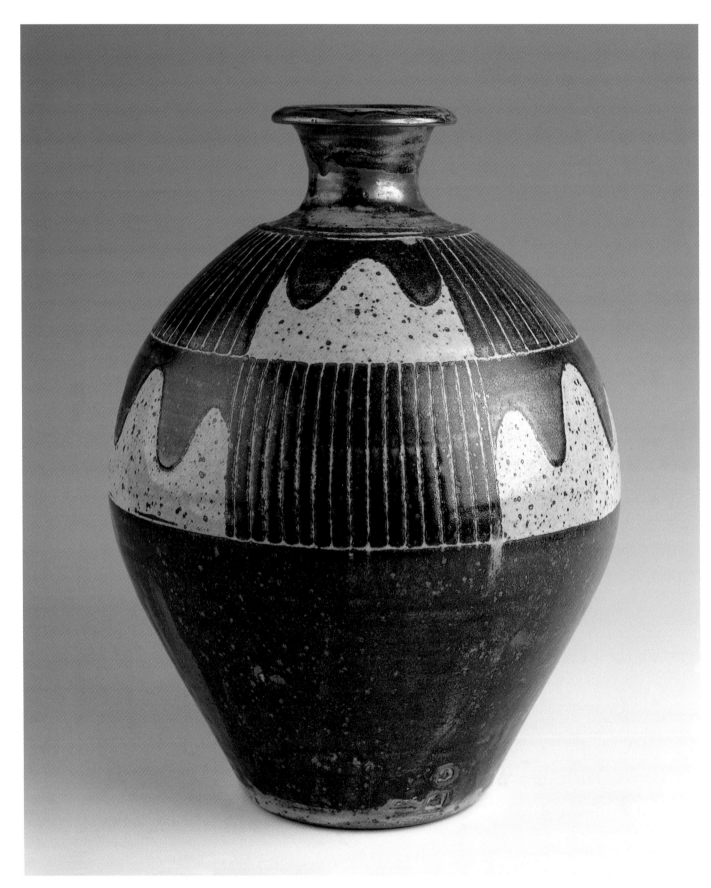

Plate 18: Bernard Leach, stoneware, iron decoration, c.1960, ht: 37cm.

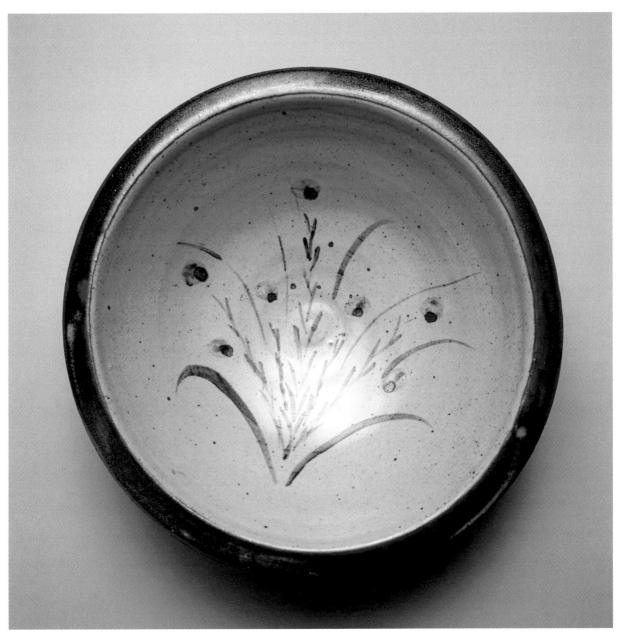

Plate 19: Bernard Leach, stoneware, painted with iron and cobalt, 1950s, dia: 31cm.
This standard bowl would have been thrown by another potter for Leach to decorate.

exhibition for four months and again in 1952, this time with Hamada and Soetsu Yanagi. There was another large travelling exhibition in 1958 and a 10,000-mile lecture tour in 1960. This was a crucial time in the development of American ceramics and Leach's influence must have been enormous. Warren MacKenzie, a talented American potter who worked at St Ives from 1950 to 1952, set up in Minnesota and became very successful potting in the Leach style, which added to this influence.

Leach again travelled extensively in Japan in 1954 working in collaboration with many leading Japanese potters. That trip also produced the raw material for another wonderful book, *A Potter in Japan*, and deepened his relationship with

the American potter, Janet Darnell, who in 1956 became his third wife. Bringing such a talented potter as Janet Leach to England was a significant contribution to British ceramics in itself. Both of Leach's sons, David and Michael, left in 1955 to start their own potteries, but this change was not as traumatic to the Pottery as it might have been. By now, the Leach Pottery was a success and, in any case, was largely being run by its foreman, William Marshall, who had worked there since 1938.

Leach's pots during the 1950s and 1960s are much more even in quality than his pre-war work. He did much less in the way of experimental work but, nevertheless, the range of work he produced is vast. Many more pots from this period

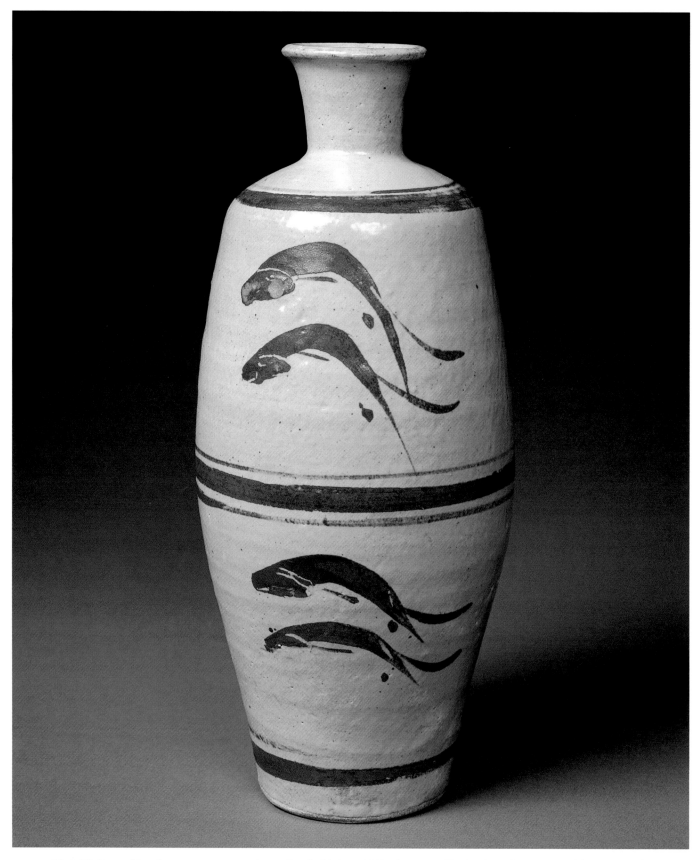

Plate 20: Bernard Leach, stoneware, cream glaze painted with iron, 1960s, ht: 34cm. The leaping salmon is one of the most sought after of Leach's designs.

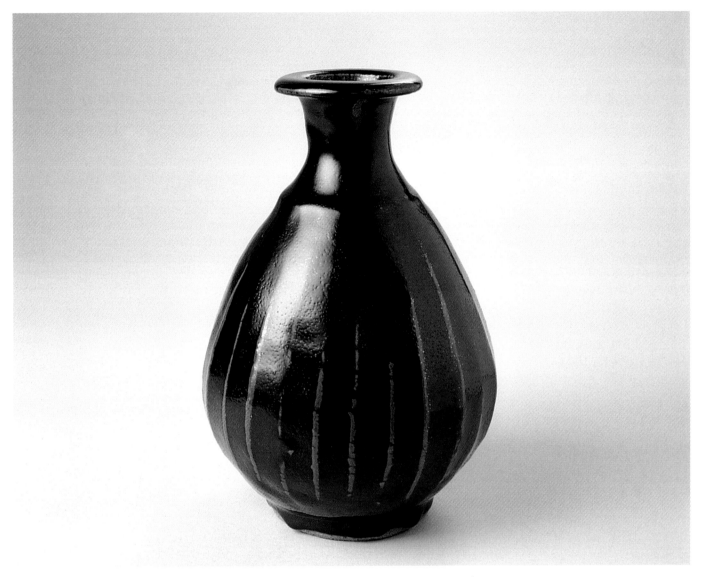

Plate 21: Bernard Leach, stoneware, tenmoku-glaze, c.1960, ht: 24cm.
Tenmoku is the classic and much copied glaze from which the abusive phrase 'brown pot' largely comes.

have remained in England and many people are only aware of pots from this time. In 1972, failing eyesight forced him to stop potting, ending a remarkable sixty-one years of making pots. By now, he was the most celebrated potter of the century with every sort of honour heaped upon him.

Leach's lifetime output of pottery was vast – he estimated over 100,000 pieces. He had over a hundred one-man shows in his life in at least a dozen countries. The best 10 or 20 per cent of his work is of remarkable quality. He worked in almost every medium of clay – raku, slipware, stoneware, porcelain – and added to this were salt-glaze pieces and even over-glaze enamels. He used an incredibly wide range of glazes – though he did have a horror of certain colours. He was often at odds with potters like Kanjiro Kawai who used colours he did not like. Leach mostly avoided using even the chun glaze, so beloved of Sung potters. He was comparatively poor at throwing, but a master

of every conceivable technique of decoration – brushwork, wax-resist, inlay, sgraffito, stencils, trailing, combing, fluting, even modelled animals, which he sometimes used for lid handles. He is one of the most successful modern British potters in the use of figurative decoration on pots. The willow tree, the leaping salmon, the wandering pilgrim, the flying bird, the running hare are all recurring themes in his work. Leach had an instinct for the right decoration and the Oriental gift for economy. He also had an outstanding ability to judge the relationship between body and glaze. Perhaps Leach's greatest gift of all was his innocence of vision. His belief in constantly repeating the same decorative motifs would result in staleness in many other potters, but Leach's enthusiasm and freshness for the hundredth 'pilgrim' dish was as great as for the first.

Leach once said, 'the pot is the man.' A profound truth, perhaps, but Leach's contribution to ceramics lay not just in

his pots, and not just in his role as husband of Janet Leach, father of David and Michael, grandfather of John, and mentor of hundreds of potters throughout the world. Leach's philosophy, particularly as expressed through his writing, is of tremendous importance. *A Potter's Book*, on the face of it little more than a 'how-to' manual for potters, has now been reprinted nearly twenty times with about 150,000 copies sold. This is quite remarkable for a book on pottery. The first chapter, 'Towards a Standard', is a marvellous piece of writing and a manifesto for ceramics.

Beyond East and West, published just before his death, is a further attempt at the unification of the two cultures. This attempt to bring together in one philosophy the best of East and West was expressed by Leach in clay. The power of his expression was so great that there is no modern potter who has not been influenced by it – even if that influence is only manifested in a desire to make pots that look nothing like those of Bernard Leach.

Leach has been the subject since his death of much hot debate amongst art critics, potters and collectors. The pro-Leach group tends to see his ideas as sacred and nothing is allowed to depart from this model. Thus, all other work is branded as unsuitable. While Leach also had this narrow-minded and somewhat patronizing side to his nature, it is not something to be perpetuated. It is sad to come across a potter who must have a kiln just like Leach's when there are as many different kinds of kilns as there are kinds of pots. How many still cling to their Leach kick-wheel when Leach himself wrote that he would prefer to find a reliable powered one.

The anti-Leach group is even more fervent and it has become quite fashionable to denounce his work. They tend to regard Leach as anachronistic, conservative and limited in vision. In my opinion, none of this applies at all to Leach, but often applies to 'the Leach tradition'. While most of the early St Ives potters and a few of the post-war ones managed

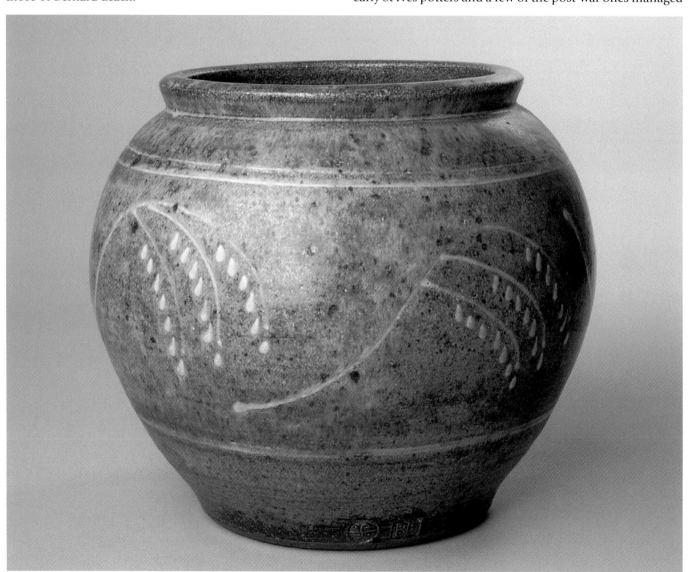

Plate 22: Bernard Leach, stoneware, c.1960, ht: 26cm.

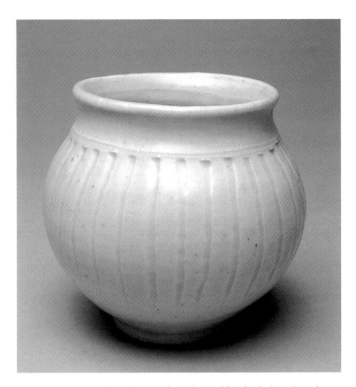

Plate 23: Bernard Leach, porcelain, 'ying ch'ing' celadon glaze, late 1960s, ht: 11cm.

almost sixty years. Leach was already a famous potter and Hamada greatly admired both his pots and his attitude to the spiritual quality of ceramics. Thus, when Leach decided to return to England it was not too surprising that Hamada should join him.

Hamada arrived with a good technical background but with relatively little experience as a potter. Despite this and all the early problems with starting a pottery at St Ives, Hamada made enough good work for two London exhibitions in 1923 at Paterson's Gallery. The range of work for these shows was enormous; almost every type of English functional wares, including whole tea-sets, and a number of Japanese wares such as tea-bowls, sake bottles and koga (small rounded boxes). A wide variety of decorative techniques were tried. Hamada signed his pots with the character, 'Sho'. Fortunately, quite a number of these pieces have survived. This is not only because of the great success of the exhibitions, but also because admirers retrieved his discarded pots from the river at St Ives. The pots produced for these exhibitions are, almost certainly, the best pots produced in England in the early 1920s – even surpassing Leach's work at that time – and they greatly influenced English potters. Despite their great strength, these pots are extremely stiff and tight compared to Hamada's work of even a few years later.

Hamada's likeable personality and desire to learn more of British art led him to meet many leading figures at that time. Eric Gill, the weaver Ethel Mairet and William Staite

to extend aspects of Leach's (or Hamada's) work into a personal style of their own, there are many who have slavishly copied the Leach style and added nothing. A visit to most craft shops would confirm this.

Ultimately, I hope this debate will disappear. The only thing the two sides have in common is that they both see Leach's work as a kind of tyranny rather than as one man's creative expression. The wonderful pots that he made are the base on which the rest of modern British ceramics is built.

When the 25-year-old Shoji Hamada arrived in England with Leach in 1920, few would have guessed that he was to become the master-potter of this century. On the face of it, it may seem strange to devote attention in a book on British ceramics to a Japanese potter who, in all, spent only four years in England. However, the effect of Hamada on British ceramics and the effect of British ceramics on Hamada were both so large that it is impossible to disregard it.

Hamada had an early interest in ceramics and, in 1913, began studies at the Tokyo Technical College. By coincidence, Kanjiro Kawai, that other great Japanese Mingei potter, was a fellow student and Hamada was later to work with him in Kyoto. The emphasis on this course was on the technical – endless glaze experiments, and so on – and Hamada longed for something else. When he saw early exhibitions of the pots of Tomimoto and Leach he knew the direction that he wanted to go in.

In 1918 he first met Leach and, a year later, joined him at the pottery Leach had built on the property of Soetsu Yanagi in Abiko. This was the start of a close friendship that lasted

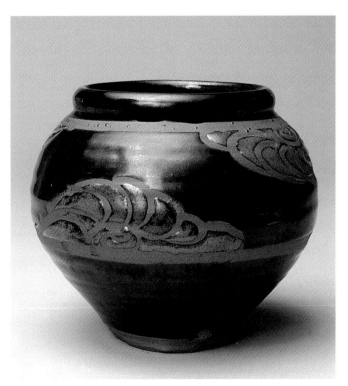

Plate 24: Shoji Hamada, stoneware, tenmoku-glaze, wax-resist decoration, c.1922, ht: 16cm.
This pot has the 'Sho' seal like all Hamada's made 1921–3.

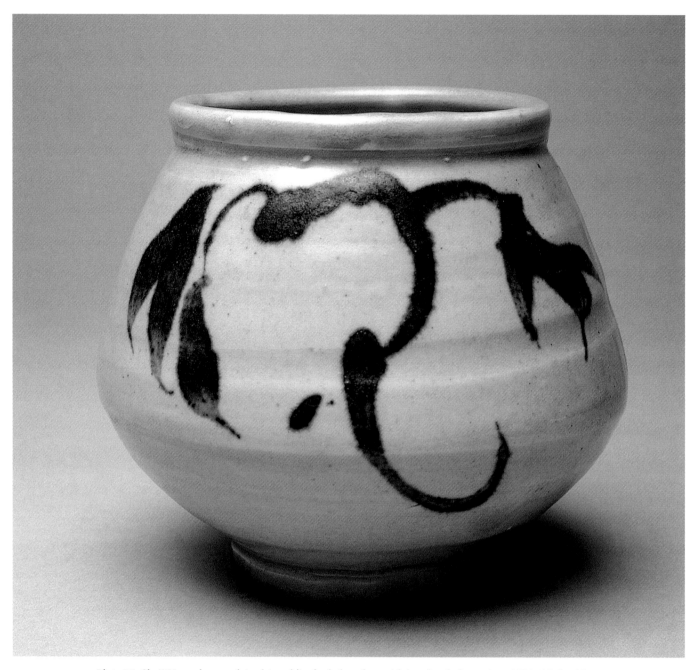

Plate 25: Shoji Hamada, porcelain, 'ying ch'ing' celadon-glaze with iron brush decoration, 1929–30, ht: 13cm.
Made at St Ives. Porcelain by Hamada is comparatively rare.

Murray all became friends. It was Hamada who won over 'old Mr Paterson', and Paterson's Gallery became the main showplace for ceramics in the 1920s. Hamada had four exhibitions there and the gallery also showed both Leach and Murray.

Hamada returned to Japan in 1924 after a long European tour. He turned down a number of prestigious official positions to join a community in Okinawa where he made pots for about six months, producing work for the first of his more than a hundred one-man shows in Japan. Hamada married and began his long association with Mashiko, a village of traditional potters who produced domestic wares for Tokyo, a hundred miles to the south. There, he continued to pot using the communal kiln.

In 1929, Hamada returned to England and stayed for some months, mostly potting at St Ives. He also travelled and made some pots at Dartington and even a few in William Staite Murray's studio in Bray. The pots made in England and similar work made in Japan were shown in two exhibitions at Paterson's in 1929 and 1931. The development of Hamada's work during his absence was extraordinary. These pots, stoneware and porcelain mostly with

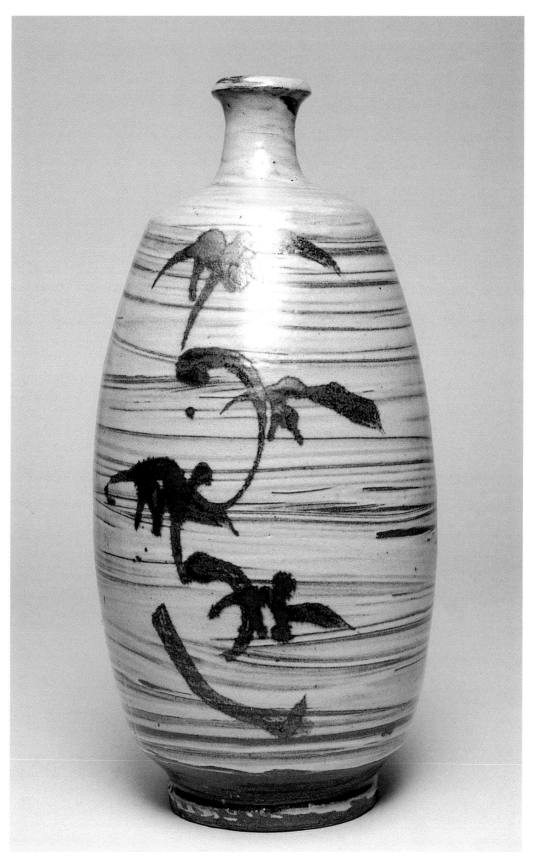

Plate 26: Shoji Hamada, stoneware, hakeme and iron brushwork, c.1930, ht: 37cm.
This was the most expensive pot (15 guineas) in the 1931 exhibition of Hamada's pots at Paterson's Gallery.

Plate 27: Shoji Hamada, stoneware, c.1953, ht: 20cm.
This bottle is moulded and one of his most frequently used forms. This bamboo decoration appears on countless Hamada pots.

brushed iron decoration, are certainly among the finest work Hamada ever produced. They show the flowing and spontaneous freedom both with clay and brush that is now so strongly associated with Hamada's work. Hamada is a potter's potter – every potter who has worked with or even seen Hamada work has been amazed by the relaxed and spontaneous ease with which he potted. Despite his great technical skill he seemed more like a child playing with clay.

His early pots are almost all thrown and tend to be more quiet and subdued, particularly in colour. Later, Hamada's work more often included moulded bottles and dishes, and he used a wider range of colours including a comparatively vivid blue salt-glaze and red and green enamels. His pots are surprisingly rough and asymmetrical – an obvious Japanese characteristic.

Hamada returned to Mashiko in 1930 to build his own kiln and did not return to England until 1952. In 1955, Hamada received the title of Holder of an Important Intangible Cultural Property (more popularly called a 'Living National Treasure'). This is the highest honour an artist can receive in Japan. He stayed in Mashiko until his death in 1978, by then a potter whose fame was only equalled by Bernard Leach.

In the 1950s and 1960s, Hamada travelled and lectured extensively in the USA. Despite the little time spent in England, Hamada's influence continued through the regular sale of his pots at St Ives and at the Little Gallery in London.

More than anything else, Hamada became the symbol of a 'Zen' potter. Zen is a Japanese form of Buddhism based on Chinese Ch'an Buddhism that, itself, is a mixture of Buddhist and Taoist philosophies. Ch'an was at the heart of the creations of the Tang and Sung Dynasties just

as Zen was at the heart of the creations of Leach and Hamada. The Zen attitude is that creation is one manifestation of the universal spirit. This is reflected on a more practical level by such ideas as anonymity, humility, usefulness, honesty and repetition.

Hamada represented all of these ideas. After 1923, Hamada never again signed his pots and his humble nature was known to everyone. Hamada's decision to turn down important positions in order to work in a poor pottery community was reflected in his quoting the Zen saying, 'The frog in the well does not know the great ocean, but he does know Heaven.' Usefulness was represented in his belief that pottery was at its fullest expression when joined to utility and all of Hamada's pots are functional. Honesty was represented in his belief that the beauty of pottery lay in good natural materials. This, for Hamada, meant the right use of what was at hand. He mastered the somewhat difficult local clay and his famous rust-orange, khaki glaze was made from stone from the Mashiko road. Janet Leach described how, while most potters were concerned with obtaining fine quality brushes, Hamada's were made from the scruff of a local dog.

By repetition, Hamada gained the freedom from conscious design. Many of his decorative methods, such as trailing and pouring, reduce the conscious process to an absolute minimum. His design of the bamboo spray, which became almost his trademark, was repeated countless thousands of times. By doing this, it became totally unconscious and representative of his inner state. I have heard it said that Hamada's decoration is one of the most perfect representations of the ideals of Abstract Expressionist painting – a surprise, perhaps, to those who cannot accept that the greatest potters like Hamada and Leach are as much great artists as any painter.

Chapter 3

Michael Cardew

Plate 28: Michael Cardew, slipware, c.1930, l: 24cm.

When Bernard Leach described Michael Cardew as his best student he was making quite an understatement, for Cardew soon became one of the finest potters of the century and one of the greatest slipware potters of all time.

Michael Cardew developed an interest in pottery as a child. His parents had purchased quite a number of pots from a country pottery at Fremington near Barnstaple, which was then in the hands of Edwin Beer Fishley, one of the last of the distinguished traditional country potters. Cardew visited the pottery which made a very strong impression on him. In 1921, while still an undergraduate at Oxford, he was giving most of his attention to pottery instead of his studies. E.B. Fishley had died in 1912, but Cardew visited his grandson, W. Fishley Holland, in North Devon and learnt to throw from him.

In 1923, Cardew left Oxford and went to visit Lake's traditional pottery at Truro and then to nearby St Ives to meet Bernard Leach and Shoji Hamada. Leach had never intended to take students, but Hamada was soon to leave and he was impressed by Cardew's 'young Apollo' looks and forceful personality. Later that year Cardew became the first of a long list of often distinguished potters who became students at St Ives.

Cardew arrived in St Ives with two 'gifts' from North Devon. The first was the technique of pulled handles. This was then unknown in Japan and, thus, to Leach and Hamada. The second was a Devon kick-wheel. At that time, Leach was only using a Japanese stick-propelled wheel that took some skill to control. The kick-wheel was a great improvement and was later modified into the ubiquitous Leach kick-wheel.

Plate 29: Michael Cardew, slipware, c.1929, ht: 25cm.
Few potters have made jugs as well as Cardew.

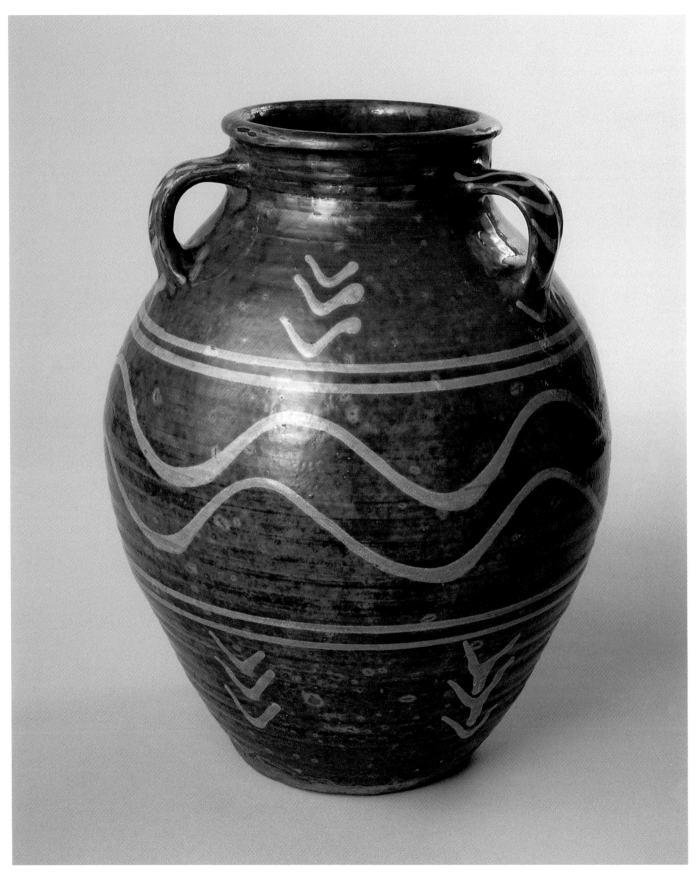

Plate 30: Michael Cardew, slipware, c.1931, ht: 36cm.

Cardew always said that Leach had taught him much, particularly about the importance of form. This is, undoubtedly, true, but Cardew's strong individuality asserted itself in his work very early on. He was almost the only major potter between the wars to be minimally influenced by Oriental pots. He had little interest in stoneware and concentrated all his attention on slipware. While Leach was inspired by seventeenth- and eighteenth-century work, primarily from the Midlands, Cardew was more interested in the Devon style of slipware.

In 1926, Cardew left St Ives and rented an abandoned pottery near Winchcombe in Gloucestershire. This was previously used for making flower-pots and washing pans, but had been closed for over ten years. Fortunately, the chief thrower, Elijah Comfort, was still in the area and Cardew convinced him to rejoin the pottery. A year later, Sidney Tustin, then fourteen, joined, and together they rebuilt the pottery. The kiln held up to 3,000 pieces and was usually fired about five times a year. In 1927, they had eight firings, although almost 90 per cent of the pots were Comfort's flower-pots and washing pans. There were many difficulties in the first few years and Cardew produced very few good pots.

The greatest difficulty lay with the glazes. Whereas much pottery is biscuit-fired and then glazed, all of Cardew's English pots are glazed raw and once-fired. While this system has several major advantages, the glaze has to be applied at just the right time. If the pot is too wet or too dry, the result is disastrous. Another problem was with the glaze itself. The lead sulphide (galena) glaze, apart from being poisonous, was highly erratic. The Leach Pottery had switched to a more reliable lead oxide glaze, but the quality was not as good. Cardew chose to persevere with the galena glaze and to accept the high kiln losses involved. In retrospect, this was a good decision. The Winchcombe pots have the most wonderful colour – a rich chestnut where the glaze covers the red body and a golden honey-yellow where it covers the white slip.

By 1928, Cardew was getting much better results. The next two or three years were the most prolific of his long career. Many people, including Cardew himself, have felt that this was also the finest period of his work. He produced almost every kind of domestic ware imaginable – vases, jugs, cider bottles, bowls, plates, teapots, and even oil-lamps. The decoration is usually either trailed slip or a scratched pattern through the slip. The decorative style is remarkably free and highly original. His pots have an incredible energy and a powerful and generous sense of form, particularly when thrown on a large scale. Cardew always said that he was a poor thrower, but a quick comparison between a large Cardew bowl and one thrown by Comfort would show that this was not true. Cardew had a number of London exhibitions at this time and some of his best work was bought by the collector Sydney Greenslade on behalf of the University College of Wales at Aberystwyth.

The only remaining technical problem was that of porosity. Unlike stoneware or porcelain, earthenware is porous, and the only thing that stops it from leaking is the glaze. If the glaze is slightly crazed (as it often was at Winchcombe) water passes through it. While this is not a serious problem for a flower-pot, it is for a milk jug, and the Pottery was getting many complaints. Cardew tried to solve the problem by firing at a higher temperature and introducing a black slip, which he hoped would vitrify. The problem was never entirely solved and was one of the major reasons that Cardew later turned to stoneware. The black slip did, however, add a whole range of decorative possibilities, and much of the work of the late 1930s was done in this fashion. A copper-green glaze was also introduced at this time. The pots Cardew made were often wonderful and reached their peak with his famous 'fountain' bowls, which were exhibited at the Brygos Gallery in Bond Street in 1938. The finest of these was purchased by Henry Bergan and is now in the Hanley Museum in Stoke-on-Trent.

Despite the quality of the work and the critical success, Cardew was not entirely happy at Winchcombe. For a start, he had by now married and had three children and the living conditions, first the loft of the pottery and, later, a shack built for £24, were hopelessly inadequate. Cardew had also developed a fascination with Cornwall. He was of Cornish origin and had now learnt the language and studied Cornish traditions.

In 1939, he left Winchcombe in the hands of Ray Finch and set off to try and find a suitable site in Cornwall. Eventually, he bought an inn at Wenford Bridge near Bodmin where he built a smaller version of the Winchcombe kiln. It was nearly ten years, though, before he managed to do any serious work at Wenford Bridge. Both Tustin brothers (Charles joined the pottery in the 1930s) were called up in 1941 and Cardew had to return to Winchcombe.

While still at Winchcombe, Cardew was offered the post held by Harry Davis at the pottery school at Achimota College on the Gold Coast of West Africa, now Ghana. Throughout much of Africa the local low-fired pottery was being made redundant by cheap metal and the Achimota project was an ambitious plan to get local crafts modernized. Cardew had no yearning for Africa and no wish to be part of such a grandiose scheme, but he was desperate for the money and the plight of African pottery was strongly reminiscent of the plight of English slipware, so he decided to go.

When its mentor H.V. Meyerowitz suddenly died, the pottery school was closed, and Cardew chose to stay in Africa and use the money intended for his passage home to found his own pottery. In 1945, he set up a workshop at Vumé-Dugamé on the Volta River about a hundred miles from Achimota. Vumé was a well-known pottery village making large red earthenware pots, but potters' wheels, kilns, and stoneware were unknown, so Cardew had to start from scratch.

Plate 31: Michael Cardew, slipware, c.1937, ht: 37cm.
Cardew made cider jars, one of the best of his forms, in a number of sizes.

The stoneware glazes he produced in Africa are amongst the most beautiful I have seen. One is a rich dark green glaze in which the iron flushes a vibrant red. Another commonly used glaze was a blue-grey ash glaze somewhat similar to a dark chun. The 'Vumé lily' became his favourite decorative motif and he used it repeatedly for the rest of his life. Pots from the Volta Pottery are extremely rare, partly because so few were made and partly because the only exhibition in Europe was a small one held in his brother's house in London.

Cardew was living on £120 a year and almost starving so it was no surprise when he decided to return in 1948, ill and exhausted. He spent six miserable months working at the Kingwood Pottery in Surrey. Kingwood produced earthenware (in which Cardew had now lost interest) from industrial materials. If ever proof was needed of the value of the Leach–Hamada philosophy of using good materials, one need look no further than Cardew's Kingwood pots. The form and decoration are fine, but the quality of the body and glaze is horrible.

Cardew returned to Wenford Bridge early in 1949 and added a downdraught chamber to the kiln in order to produce stoneware. He worked for nearly a year and a half there and an exhibition was held at the Berkeley Galleries in London. Then an advertisement appeared for Pottery Officer to the Commerce and Industry Department of the Nigerian Government and Cardew was off to Africa again – this time for nearly sixteen years. Cardew said, 'I was fifty. And that was when my life began.' He set up the Pottery Training Centre at Abuja in Northern Nigeria and was producing stoneware by 1952. Abuja was a village with a number of fine potters producing low-temperature wares, and many of these potters worked with him in stoneware.

These were exciting years for Cardew. Most of the year he was in Abuja; potting, teaching, checking on former students. For two or three months he would return to England, making pots at Wenford Bridge, lecturing, visiting friends. For the first time, he developed a real interest in the technical side of pottery and also acquired a fascination for geology. Later, he even gave some geology 'courses' at Wenford Bridge. Cardew's enthusiasm showed itself in his work. The pots brought back from Nigeria are remarkably good. The clay body is dark and dense, though quite brittle (a problem Cardew confessed, with no apparent regret, that he could

Plate 32: Michael Cardew, stoneware, ash-glaze, c.1959, w: 14cm.
This was made at Abuja and probably exhibited at the Berkeley Galleries. The blue-grey ash-glaze is similar to chun.

Plate 33: Michael Cardew, stoneware, ash 'tenmoku'-glaze, c.1970, ht: 23cm.
'Gwari' casseroles are Cardew's version of a traditional African form. Most were made at Wenford Bridge.

never solve). The glazes were similar to the ones used in Vumé and he also made greater use of the glazes resembling tenmoku and celadon. All Cardew's strength of form was in evidence, and the influence of Africa began to produce a whole range of new shapes: large stools based on Nigerian wooden kingship stools, 'Gwari' casseroles and teapots with collars around their lids, oil jars and small soy pots with screw lids, bowls with incised or raised patterns based on decorated calabash. The Berkeley Galleries held three large exhibitions of Cardew's pots and those of some of his

African students in 1958, 1959, and 1962. Many people feel that the Abuja pots are the very best of Cardew's stoneware.

On Cardew's 'retirement' in 1965, he returned to Wenford Bridge, but his interests were too divided for him to make very many pots. He travelled extensively – trips to Africa, four months in America in 1967 (the first of a number of visits), almost all of 1968 in Australia and New Zealand. He wrote, lectured, demonstrated, and dispensed his enthusiasm almost everywhere. His energy was enormous. I remember once he was delivering to me some pots

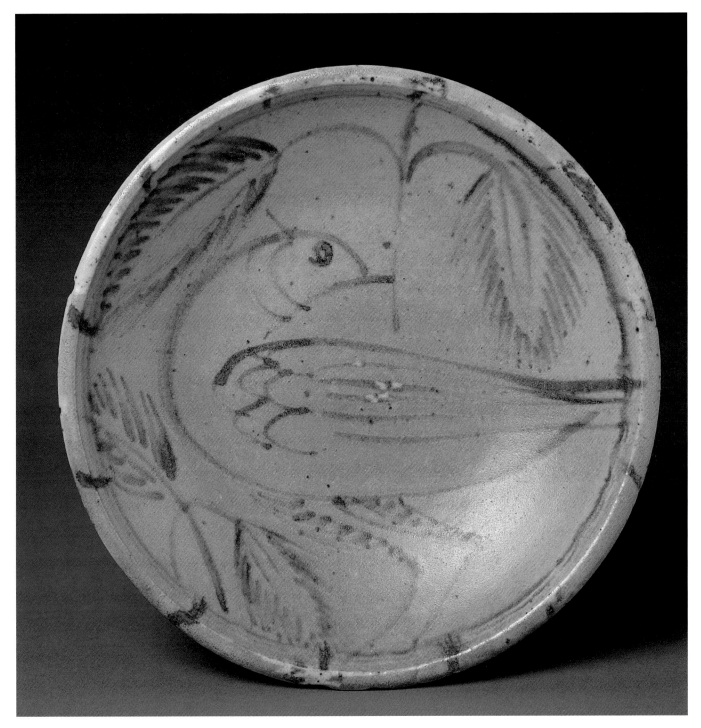

Plate 34: Michael Cardew, stoneware, c.1950, dia: 26cm.
Cardew first did bird decoration at Winchcombe, but his bird plates in stoneware are better known and much copied.

that he had made for a small retrospective exhibition that I organized in celebration of his eightieth birthday. He came bounding up my steep front steps carrying a very large and very heavy box of pots he had brought by train from Cornwall. I was somewhat concerned for his health, but his only concern was in retrieving a cherished piece of Nigerian rope that held the box together.

The pots produced at Wenford Bridge, while perhaps not quite up to earlier work, are still very good. The forms are mostly either ones developed in Africa or earlier at Winchcombe. Cardew began to make his famous 'rose' bowls, an extension of his earlier slipware 'fountain' bowls. His decoration at Wenford Bridge was, basically, of two types. He developed an opaque white zircon glaze on which he

painted in both an iron brown and a cobalt blue. Cardew's free decoration was always very expressive and it shows well in these pots. Birds, fish, lilies, and all manner of abstract patterns were used.

The other decorative effect used was much closer to Cardew's heart. His main love was still Devon slipware and at Wenford Bridge he finally achieved his ambition of reproducing its warm colours and decorative effects in stoneware. The standard glaze he developed was an ash glaze similar to a very transparent tenmoku. This gave a nut-brown over the dark body and a rich yellow when used over a white slip – an effect similar to that of the galena-glazed slipware of forty years earlier. I find some of these pots rather heavy and dead compared to their slipware ancestors, but Cardew's main concern was still with producing functional pots, and these 'slipware' pots are hard to break and cannot leak. Many are extremely powerful, though they can't compare to the best pieces made at Winchcombe or Abuja.

In over fifty years of running potteries, Michael Cardew had a great many students, but, sadly, few developed into major potters with their own style. Nearly all the slipware made at Winchcombe was in Cardew's style. Ray Finch is a fine potter, but his early work is so close in style to Cardew's that it is sometimes difficult to tell them apart. Finch, who joined Winchcombe in 1936 as an apprentice, eventually purchased the pottery from Cardew in 1946. During the 1950s and 1960s, he gradually replaced slipware with stoneware and continued the policy of functional ceramics at modest prices. The Winchcombe Pottery has succeeded in this and few doubt Finch's great technical skill and control as a potter, but, ultimately, his pots seem to lack some vitality. In recent years he has begun to develop more of a personal style.

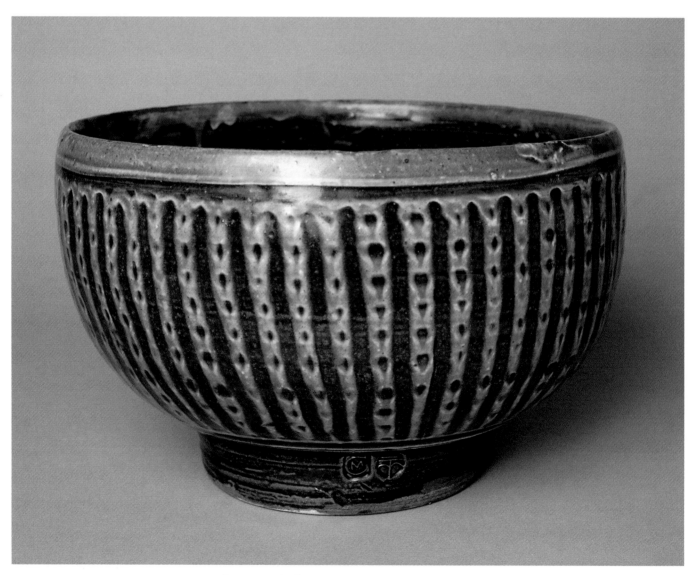

Plate 35: Michael Cardew, stoneware, c.1970, dia: 30cm.
This is one of his 'rose bowls' with the line and dot pattern. The colouring is intended to be similar to slipware.

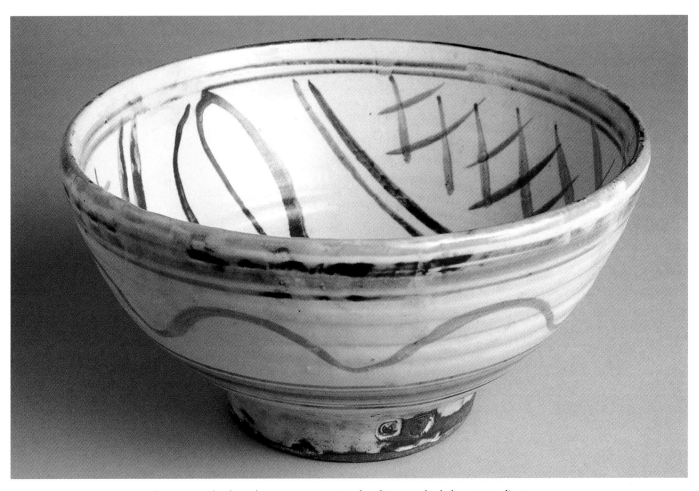

Plate 36: Michael Cardew, stoneware, painted with iron and cobalt, c.1979, dia: 24cm.
This 'tin'-glaze started a cream colour and became whiter in Cardew's later years.

Plate 37: Sidney Tustin, slipware, c.1950, ht: 14cm.
Tustin was rarely given the opportunity to make large pieces.

Sidney Tustin, possibly the most prolific potter of the century, is admired by many collectors and potters. All his work is small in scale and highly accomplished, if a little twee. His brother, Charles, produced similar work but of poorer quality.

Cardew's Wenford Bridge 'students' have fared little better. Seth Cardew, Michael's first son born in 1934, today runs the Wenford Bridge Pottery. He is a competent potter, but produces mostly copies of his father's work. Seth's son, Ara, shows more promise, but has yet to prove himself.

Svend Bayer, a Danish potter raised in Africa, has, probably, been the best of the potters to work at Wenford Bridge. Many of his large pots are very powerful. Only Rupert Spira, one of the last of Cardew's 'students', has really established himself with an individual style.

Some of the best of Cardew's students have been his Nigerian ones who were taught to make stoneware in his style. In Cardew's only departure from functionalism, he persuaded fine local potters like Halima Auda, Ashibi Ido and Ladi Kwali to make their large water jars in stoneware. While too heavy to be carried, these pots, particularly Ladi Kwali's, are absolutely magnificent and they owe little, stylistically, to Michael Cardew.

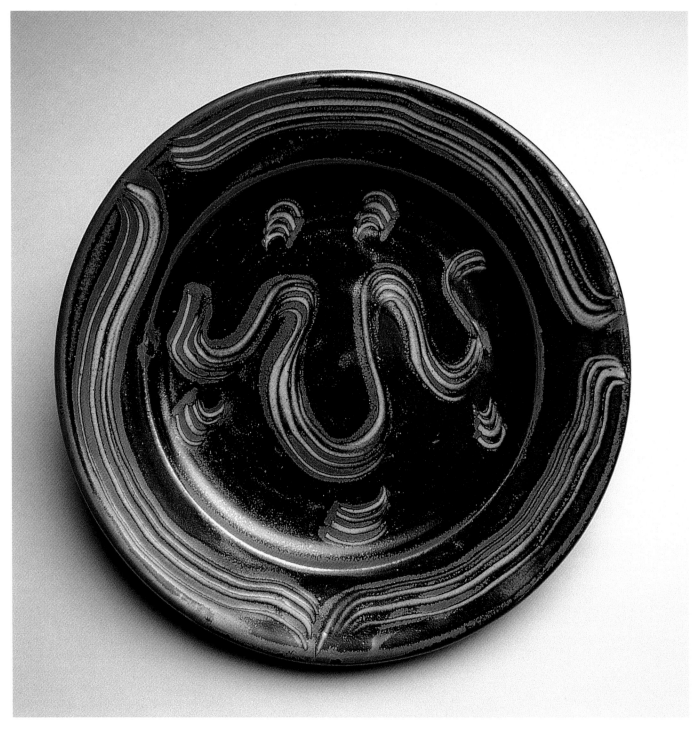

Plate 38: Ray Finch, stoneware, tenmoku-glaze, c.1980, dia: 30cm.
This wiped design is one of the most frequently used at Winchcombe.

Chapter 4

The Sung Revival

Some years ago, a famous modern art historian was asked to choose a single work of art that most typified the twentieth-century idea of beauty. The expectation was that he would choose some well-known painting – perhaps a Picasso or a Mondrian. He chose instead a Sung celadon bowl. It is not as strange a choice as it at first appears. Purity and simplicity of both colour and form, reduction to the bare essentials, the importance of the unconscious – all are major themes in modern art.

When Sung pots began to appear in England towards the beginning of the century, they transformed the face of British ceramics. In the 1920s, almost every major potter in the country was working in a Sung style. Two of these important potters, Katharine Pleydell-Bouverie and Norah Braden, were amongst the earliest students of Bernard Leach.

Katharine Pleydell-Bouverie ('Beano', as almost everyone called her) was born into one of Britain's aristocratic families (the Radnor earldom) and into the environment of Coleshill House in Berkshire, a beautiful seventeenth-century stately home in the Inigo Jones style. At Coleshill, there was a collection of Chinese blue and white and famille verte porcelain, so she had early exposure to fine ceramics. But it was not until her mid-twenties when she saw pots of Roger Fry at his Omega Workshops that her interest in pottery awoke. She began taking courses at the Central School where Dora Billington was teaching. Pleydell-Bouverie first met Bernard Leach at his exhibition at Paterson's Gallery in 1923 and asked to join him immediately at St Ives. Leach initially refused, but relented the following year when she finished her course at the Central.

Pleydell-Bouverie spent only a year assisting at St Ives and did not really make any pots, but coming into contact with Leach, Hamada and Cardew had a strong effect on her outlook. I say 'outlook' because, although her work is rooted in the Leach tradition, it has, otherwise, little similarity. Leach drew his inspiration from many sources – Sung being only one – but Pleydell-Bouverie dedicated the next sixty years to making ash-glaze pots in the Sung style. Though the similarity of her work to Sung pots is often striking, she was not interested in making copies. She once wrote to Leach, 'I want my pots to make people think, not

of the Chinese, but of things like pebbles and shells and birds' eggs and the stones over which moss grows.'

Probably the biggest influence on her work was Tsuronosuke Matsubayashi. 'Matsu' gave many talks at St Ives on clay, kilns and glaze chemistry. Pleydell-Bouverie took meticulous notes at all of these lectures and developed a particular interest in ash-glazes.

In 1925, she returned to Coleshill with 'Matsu' and Ada 'Peter' Mason, a sculpture student who had shared a flat with her in London and, later, joined her at St Ives. Together they turned the mill cottage on the Coleshill Estate into a pottery and built a wood-fired, two-chambered kiln. The first chamber was for glazed pots and the second, fired by waste heat, was for biscuit. Firing the kiln was a major procedure – thirty-six hours of continuous stoking and another thirty-six hours of cooling. It consumed about two tons of wood and, not surprisingly, was fired only four or five times a year.

Coleshill had many advantages as a pottery site. There were good clays on the estate, waterpower was available from the river and, most importantly, there was plenty of wood. Like many stately homes, Coleshill had grounds that were almost a tree museum. Nearly every kind of tree and shrub imaginable could be found on the property. Armed with her notes from 'Matsu's' talks and a book called *Manures for Fruit and Other Trees*, which gave a breakdown of the ash constituent of many trees, Pleydell-Bouverie began fourteen years of the most important glaze experiments done in the century. The ash was combined with feldspar and Dorset ball-clay and the results were carefully recorded in notebooks. Many pots have an incised number, corresponding to the body recipe and a painted code for the glaze recipe. These notebooks, containing many hundreds of recipes, together with much of Pleydell-Bouverie's fine collection of pots, are now in the Crafts Study Centre in Farnham.

Many of these glazes are of outstanding beauty. Laurustinus ash produced a quiet blue; scotch pine was almost a natural tenmoku; box ash produced dark grey-blue or green; whites and greys, often crackled, came from grass or reed ashes. When Bernard Leach wrote *A Potter's Book*, he

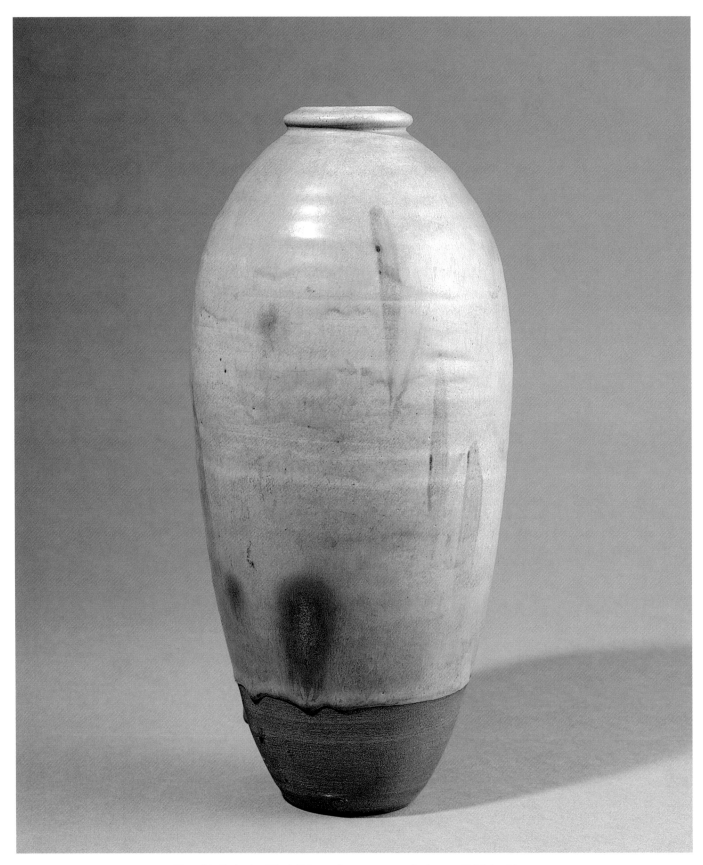

Plate 39: Katharine Pleydell-Bouverie, stoneware, ash-glaze, c.1926, ht: 31cm.
This pot probably has a box ash-glaze and has the 'Cole' sealmark that was dropped c.1928.

included a detailed account of Pleydell-Bouverie's experiments and they therefore reached a wider audience.

Had these glazes been on unlovely pots they would, perhaps, not have attracted much attention, but the work of Pleydell-Bouverie was far from being unlovely. Her pots, quiet in the extreme, have a warmth and charm rarely, if ever, equalled. I am typical in that, if asked to name my favourite potter, there would be quite a few names before Pleydell-Bouverie's – and, yet, I find I have more pots in my collection by her than by anyone else. Her pots have a rare quality. You may not notice them at first, but they creep into your heart and stay. When collectors 'weed' their collections, it is seldom her pots that go. Bernard Leach said, 'The pot is the man' and, possibly, the key to the appeal of Pleydell-Bouverie's pots lay in her own nature that was warm, humble, generous, humorous, gentle and full of spirit.

In fact, as a potter she had several deficiencies. She was not a particularly good thrower and, on the rare occasions that she made utilitarian pots, her handles and lids were very poor. Her brush decoration was indifferent and she almost totally abandoned it early on. Instead, for decoration, she relied on gentle ribbing or lobed panels combining with the

soft, luminous quality of the glazes. Her work is often at its best on a small scale – even her miniature glaze tests are wonderful though it is often the larger pots that collectors most want and that fetch high prices. She had enormous hands – 'murderer's hands', she called them – and it is amazing to think of her throwing these tiny masterpieces. Pleydell-Bouverie also made a wide range of flowerpots and vases in unglazed stoneware with combed decoration as an alternative to the red earthenware more commonly used.

The Coleshill Pottery had to be closed at the beginning of the war as blackout restrictions made it impossible to fire the kiln. After the war, Coleshill was sold and, sadly, destroyed by fire in 1952. In 1946, Pleydell-Bouverie moved to Kilmington Manor near Warminster in Wiltshire, where she stayed until her death almost four decades later.

At right angles to the Kilmington Manor House there is a huge, dark barn once used as a maltings. This became the pottery where Pleydell-Bouverie, with the help of Norah Braden, built an oil-fired kiln. Eventually, the lengthy firings became too much for an ageing potter and it was replaced by an electric kiln in 1960. By clever control of glazes, Pleydell-Bouverie managed to achieve the looks of reduction in

Plate 40: Katharine Pleydell-Bouverie, stoneware, crackled ash-glaze, c.1935, dia: 10cm.
This small bowl was originally in the collection of Sidney Greenslade.

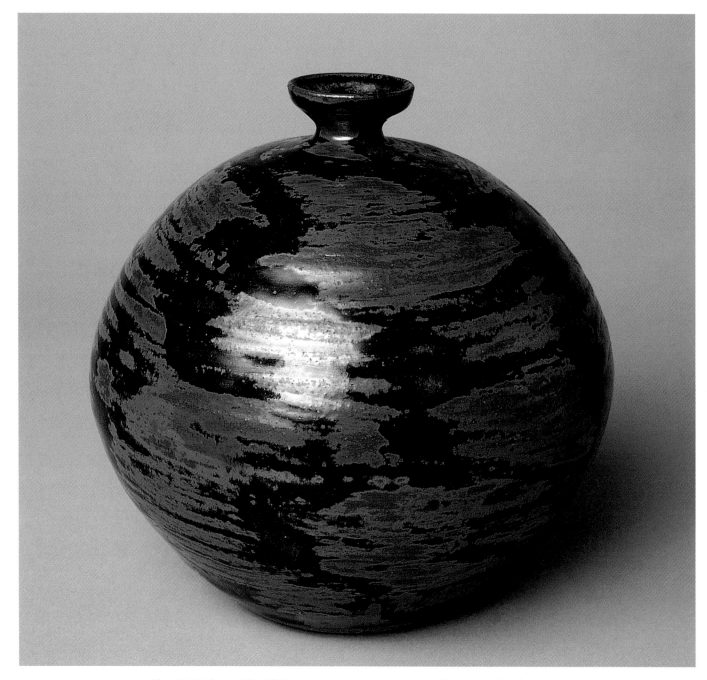

Plate 41: Katharine Pleydell-Bouverie, stoneware, scotch pine ash-glaze, c.1928, ht: 20cm.
This was one of her few early pots that she kept all her life.

an oxidizing atmosphere firing at about 1200°C, but the results were nowhere near as good as at Coleshill. She described her electric kiln as a 'good servant', but her wood-fired kiln as 'an inspired partner'.

Even the best of her work at Kilmington is quite inferior to her pre-war work. The loss of quality in the glazes is not the only reason. Advancing age and increased crippling of her hands due to arthritis meant that the throwing, turning and carving also deteriorated. Towards the end of her life some of the pots were embarrassingly dreadful. On the

credit side, she developed a distinctive style of carving and fluting and her pots never lost the warmth and charm that is so much a feature of their merit.

Pleydell-Bouverie was financially independent of her work and, throughout her life, sold her pots extremely cheaply. This was, of course, very much part of the Leach philosophy and her reasons for doing so were admirable. However, these low prices were one of the factors that contributed to the decline of Oriental-inspired pots in the 1970s. While some contemporary potters compared their

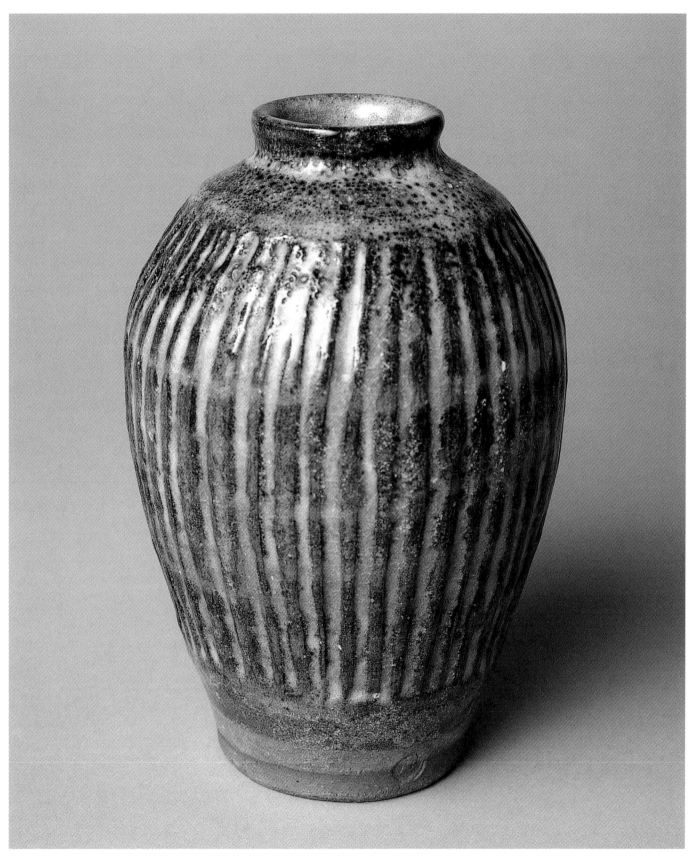

Plate 42: Katharine Pleydell-Bouverie, stoneware, ash-glaze, c.1960, ht: 20cm.
This vertical fluting was often used by Pleydell-Bouverie at Kilmington.

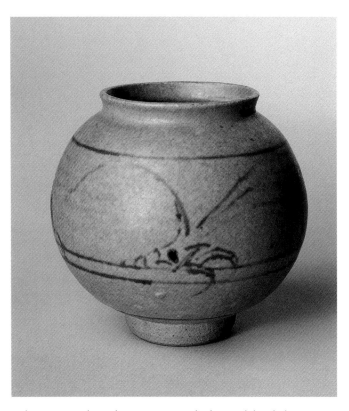

Plate 43: Norah Braden, stoneware, ash-glaze with brush decoration, c.1930, ht: 10cm.
There are also three other different drawings of marine life on this pot.

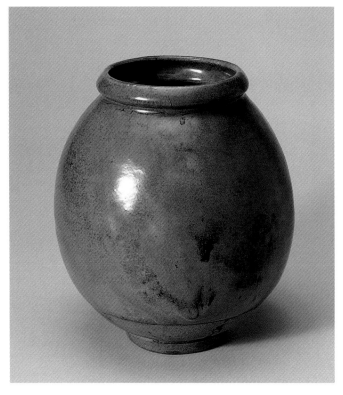

Plate 44: Norah Braden, stoneware, painted with iron, c.1930, ht: 21cm.

pots and, therefore, their prices to sculpture, those making 'Oriental' pots were pricing them in comparison to the uneconomic level of those by Pleydell-Bouverie.

In 1927, 'Peter' Mason emigrated to the United States and, the following year, Pleydell-Bouverie was joined at Coleshill by Norah Braden. This began a close and brilliant partnership that lasted for eight years.

Norah Braden studied at the Central School from 1919 to 1921 and then went for a further three years of study at the Royal College of Art. She began working at the Leach Pottery in 1925, just as Pleydell-Bouverie was leaving and stayed for three years, as Michael Cardew had done previously.

Braden arrived in St Ives already a fine draughtsman and a talented musician and she quickly became a first-rate potter. Bernard Leach, who often said that she was the most naturally gifted of all his pupils, described her as 'the most sensitive and critical of potters'. She, too, developed an early interest in ash-glazes and many of the few signed pieces made at St Ives are small ash-glaze bowls, one example being in the Victoria & Albert Museum.

The pots she produced at Coleshill in the next eight years are amongst the most beautiful of British studio ceramics. The wonderful ash-glazes are combined with Braden's skill and delicacy as a thrower and with her powerful sense of form. Sometimes, her pots are difficult to distinguish from those of Pleydell-Bouverie. I know one collector who has one large bowl of each potter, almost identical. Both have the same heavily crackled turquoise glaze; both, almost certainly, come from the same firing. But there are always subtle differences in shape. While Pleydell-Bouverie's shapes can be somewhat awkward, Braden's are strong, elegant and more austere.

Braden also had a greater range than Pleydell-Bouverie. She was skilled with brush design which she used in an extremely free and spare manner. She also made a number of powerful pots with dry matt surfaces and heavy potting rings that appear to be influenced by the work of William Staite Murray. Pleydell-Bouverie told me that Murray was the potter she most admired and who, surprisingly, was the greatest influence on her work. It is likely that Braden shared her admiration for Murray's pots.

Braden and Pleydell-Bouverie exhibited together in 1929 at the Little Gallery, but more often shared exhibitions with Leach, Cardew, Murray and Charles Vyse. The 1930s was a period when many fine galleries in London's West End showed ceramics. Paterson's, Colnaghi's, Lefevre's and the Brygos Gallery all showed their work.

Braden left Coleshill in 1936 and set up her own pottery in Sussex where she continued to make a few pots. Though she taught at Brighton School of Art and at Camberwell after the war, she made almost no pottery and largely abandoned the ceramics world. This is a great pity because she, undoubtedly, was a potter of exceptional quality. She became increasingly reclusive as the years went by and always refused interviews. Highly apocryphal stories of her

eccentricity began to circulate in the craft world. She was extremely self-critical and destroyed much of her already comparatively small output. Braden's pots are now very rare, particularly those with brush decoration.

Not all of the interwar 'Sung' potters were of the Leach school. Wells, Dalton and Richards were all actively making 'Chinese' pots – as was, the now almost totally forgotten, Constance Dunn. Dunn trained with W.S. Murray in the 1920s and produced some very lovely, sensitive pots. Almost nothing is known about Dunn, but she seems to be one of the very few of Murray's students who didn't work in his style.

Of all the potters who made 'Sung' pots, Charles Vyse was, perhaps, the most dedicated. Vyse came from a Staffordshire family of potters and as a 14-year-old became

a modeller's apprentice at the Doulton factory. He studied sculpture at the Royal College of Art from 1905 to 1910 and also studied in Italy and at the Camberwell School where he came into contact with W.B. Dalton.

Vyse began his career as a sculptor but, after his marriage, he began making moulded figures in painted earthenware, the first being produced in 1919. These romantic portraits of flower sellers and gypsies were modelled by Charles and painted by Nell Vyse. Sales were rapid and soon editions of the pieces were being made and the Vyses became relatively famous. These figures have little relevance to the development of studio ceramics except for the success they brought to Vyse.

Vyse's studio was on the Chelsea Embankment and one of his neighbours and close friends was George

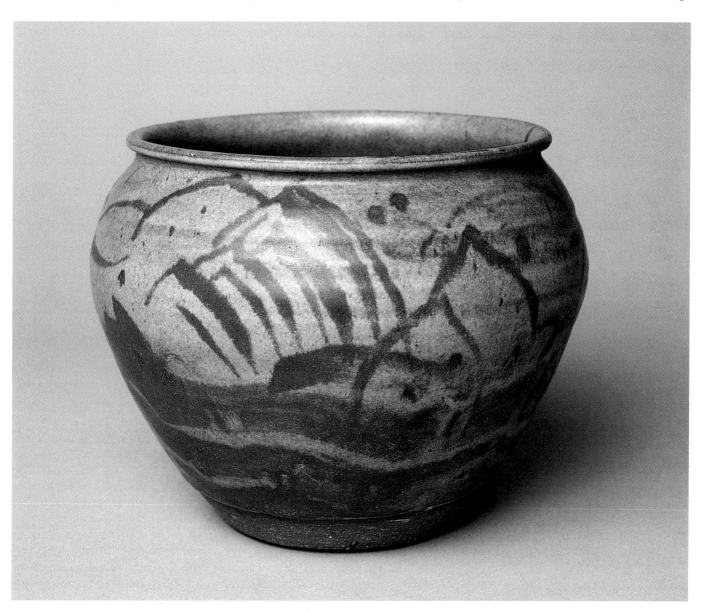

Plate 45: Norah Braden, stoneware, wood ash-glaze, c.1930, ht: 17cm.
The landscape painting here is a fine example of Braden's skill with brushwork.

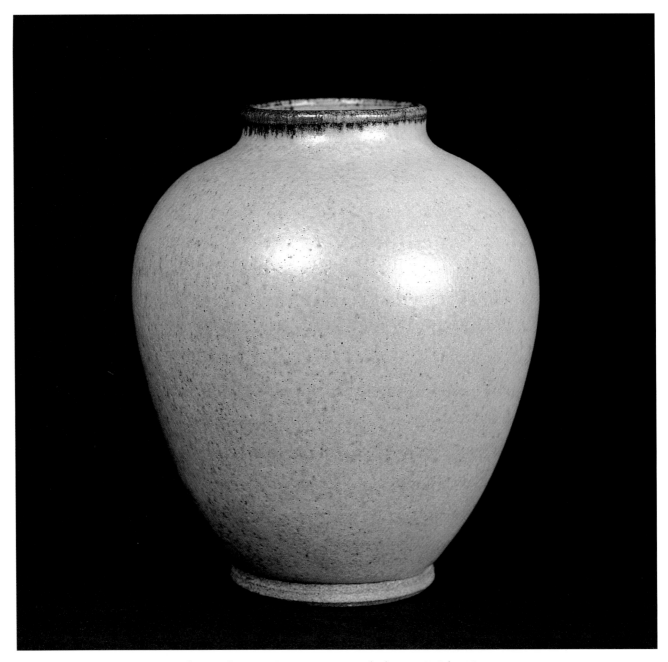

Plate 46: Constance Dunn, stoneware, ash-glaze, c.1935, ht: 15cm.

Eumorfopoulos. Eumorfopoulos had one of the greatest collections of early Chinese ceramics housed in a two-storey 'museum' at the back of his house. About 1927, Vyse began an extensive scientific attempt to master the techniques of Sung ceramics with the Eumorfopoulos collection as his source. Many of his pots are nearly exact duplicates. With his skill as an artist and his wife's exceptional knowledge of glaze chemistry, the Vyses soon achieved a remarkable control of the stoneware medium.

They produced pots in a wide variety of techniques for their annual show at Walker's Gallery in Bond Street. Brush-decorated pots, often with fish; celadons with modelled or incised decoration; carved pots with the crackled grey-white glaze sometimes called 't'zu chou'; all were wonderfully executed. But it is the tenmoku and chun glazes for which the work of Vyse is most remembered.

The tenmoku pots of Vyse show a control unimaginable in the pre-war years. They are often intricately decorated by painting in wax-resist and covering the tenmoku with a lighter glaze to produce elaborate patterns or animals. Vyse's most popular pieces are his modelled stoneware cats in which he has realistically rendered the tabby markings in the glaze.

Vyse is also credited with rediscovering the art of making the chun-glaze. It was widely believed that this was a copper-glaze and many potters in the 1920s were unsuccessfully trying to discover its secret. Vyse found a celadon bowl in the

Eumorfopoulos collection in which some chun had pooled in the bottom and he concluded correctly that it must be an iron-glaze. Like many great stories it is only partly true; Murray had been exhibiting chun pots as early as 1925.

Vyse soon mastered this difficult glaze and produced many fine pots. Most of his chun pots are bowls and many are based on a lotus bud in various stages of opening. He often splashed copper on the glaze to produce purple flashes on the blue.

These pots are the antithesis of the Leach philosophy. There is no potting from the heart here; no kiln accidents; nothing left to chance. Consequently, Vyse's work has been repeatedly vilified by Leach supporters as slick, commercial and lifeless. Compared to the work of Leach, Hamada, Pleydell-Bouverie, or Braden this is true, but Vyse's pots are still wonderful and most early admirers of Chinese ceramics were keen to buy them. Eumorfopoulos, Dean Eric Milner-White, Ernest Marsh and James Kiddell (who didn't care for the work of Leach or Hamada) were all eager collectors.

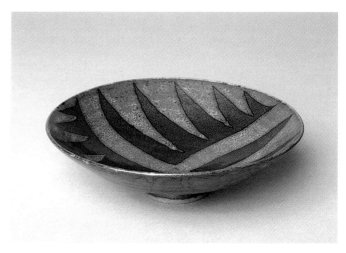

Plate 47: Charles Vyse, stoneware, tenmoku with wax-resist decoration, 1930, dia: 16cm.
The undersides of these bowls usually have a mottled/spotted patterning – often as interesting as the inside.

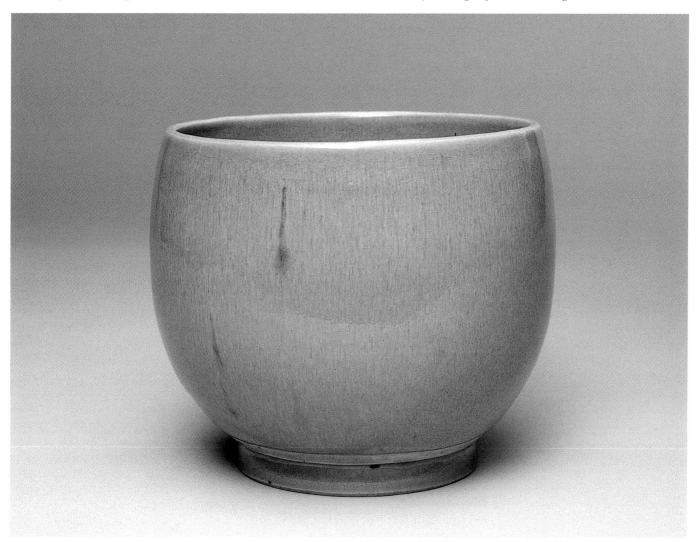

Plate 48: Charles Vyse, stoneware, chun-glaze, c.1935, ht: 13cm.
This glaze has a texture more typical of 'hare's-fur' glaze. The foot of this pot has a celadon-glaze.

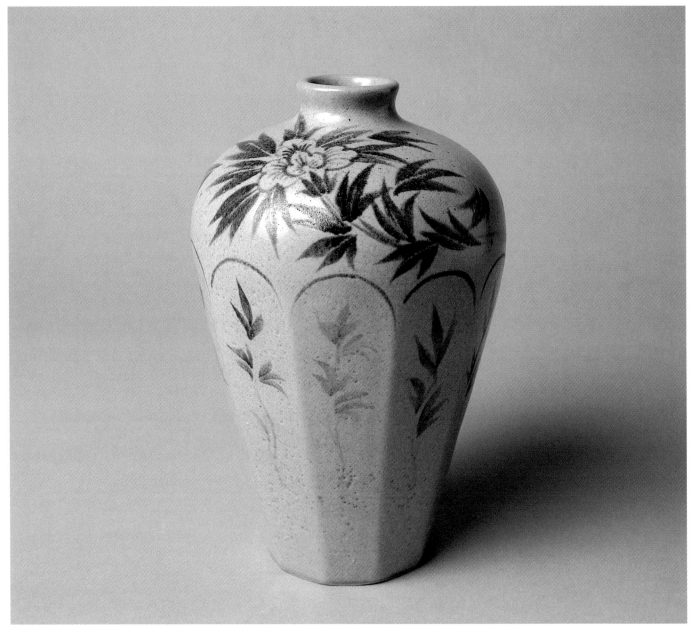

Plate 49: Charles Vyse, stoneware, iron decoration, 1928, ht: 23cm.

Vyse occasionally departed from Sung pots in some of his painted pieces. Some are painted in a two-dimensional imitation of his figurines and these, I think, are the least successful of all his pots. Others have Vorticist-inspired decoration similar to some done by William Staite Murray in the 1930s. There is, actually, no evidence that he copied Murray, rather than the other way around, but it is always assumed that he did. The few pots Vyse did in this style are exceptionally good.

The Vyses' Chelsea studio was badly damaged in an air raid in 1940 and they decided to leave London. Charles Vyse became an instructor at the Farnham School of Art in Surrey. Vyse continued to make painted earthenware figures after the war, but produced less stoneware. Some of this was his production of the tenmoku cats and other animals, but

he also made some interesting pots. He carried out considerable experiments using, of all things, cigar ash as a glaze ingredient. This, characteristically, produced a lovely matt lavender colour. Today, Vyse is a comparatively forgotten figure, but undeservedly so. Those who can see 'Oriental' pots only through the lens of the Leach philosophy will find little merit in his work but, for others, Vyse's pots are some of the most accomplished work of the interwar years.

The importance of Pleydell-Bouverie, Braden and Vyse as experimenters is enormous. Largely through their efforts, knowledge of early Chinese stoneware glazes went from almost nothing in 1920 to a fairly complete knowledge of Sung techniques by the time Bernard Leach published *A Potter's Book* in 1940.

Chapter 5

William Staite Murray

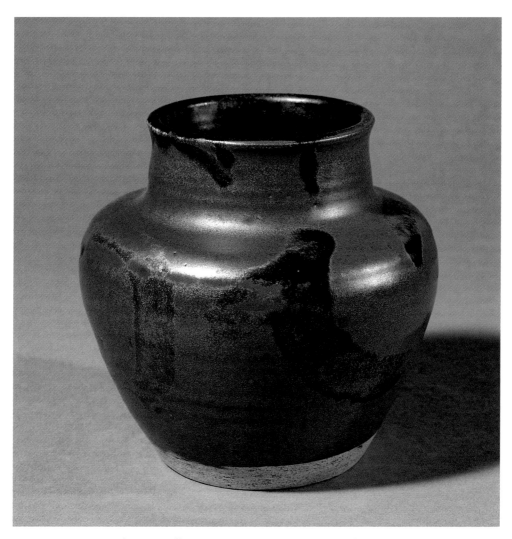

Plate 50: William Staite Murray, stoneware, 1923, ht: 15cm.
Murray's early pots are often very similar to the Chinese originals.

The story of British studio ceramics in the inter-war years is largely the story of two major potters. One was Bernard Leach. The other, of equal importance, was William Staite Murray.

Murray was born in London in 1881. His father was a Scot and had a business in Deptford as a corn merchant. Murray was withdrawn from school at the age of twelve and for two years was taught drawing and painting by two cousins who were professional artists. While initially supporting his son, Murray's father did not consider that being an artist was a suitable employment and William was sent to Holland to work for a firm of bulb and seed merchants. Murray spent much of his time travelling and had a lengthy stay in France

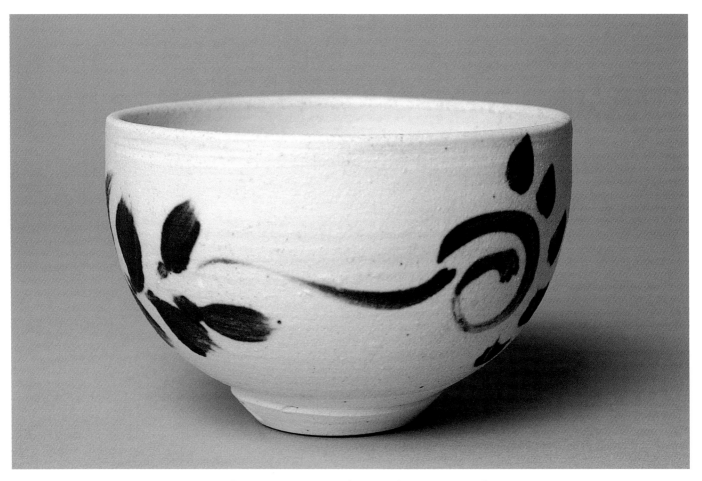

Plate 51: William Staite Murray, porcelain, iron decoration, 1926, dia: 13cm.
Murray never overcame his technical difficulties with porcelain – this is one of only two pieces to survive the first firing.

where he studied painting. Both Murray's interest in art and his interest in Oriental mysticism were developing rapidly. All this was not very much to his father's liking and Murray was first sent to North America for two years and, then, brought back to London to run one of his father's businesses.

In 1905 Murray married. He helped his wife set up an antique business but spent little time on his father's business which, consequently, failed. Around 1910, he enrolled at the recently started pottery course at the Camberwell School of Arts where W.B. Dalton was the school's head. It would seem, judging from Murray's development as a potter, that Dalton's influence was strong.

Murray came into contact with Cuthbert Fraser Hamilton, a Vorticist painter who had briefly worked with Roger Fry at the Omega Workshops and who had a strong interest in pottery. Between 1915 and 1918, Murray shared Hamilton's studio in Yeoman's Row, but few pots were made as Murray and Hamilton both did service in the war. The Yeoman Pottery wares, mainly shallow bowls, are white earthenware with white slip and painted in a variety of colours. It is not clear whether they each made pieces or whether Murray potted and Hamilton decorated. In any case, the Vorticist decoration had little to do with Murray's interests

at the time. He had already become a Buddhist and formed a small collection of Oriental pots and it was obvious that this was where his heart lay.

In 1919, Murray set up his own pottery at his brother's engineering works at Rotherhithe. He began making pots that were almost totally of Sung inspiration. Many were simple vases with monochrome glazes (often tenmoku), sometimes with splashed decoration. Murray also made a large number of brush-decorated pots using iron on a buff-coloured ground. The pots from this period are mostly small and exhibit none of the flamboyance that is so evident in Murray's later work. Nevertheless, many early reviewers saw more promise in these pots of Murray's than they did in the pots of Bernard Leach made about the same time.

Murray met Leach for the first time at an exhibition in 1921. They almost immediately became somewhat uneasy friends. There was a great deal of collaboration between them early on. They exchanged glaze recipes and Leach often had Murray do test firings for him. Murray formed a much closer alliance, though, with Shoji Hamada. Murray visited St Ives and learnt much from Hamada, who was always eager to share his knowledge. Hamada taught him how to make foot-rings and the Oriental technique of

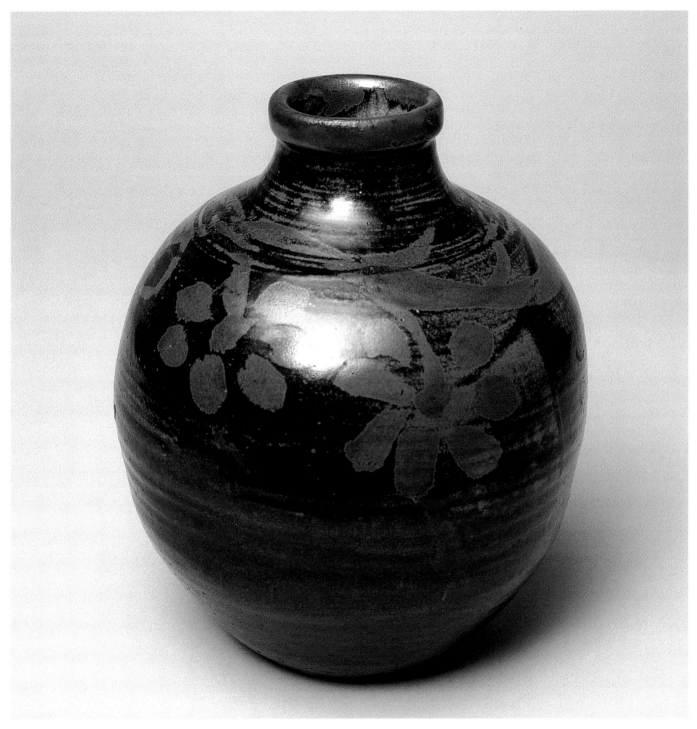

Plate 52: William Staite Murray, stoneware, tenmoku-glaze, 1926–7, ht: 27cm.
Even as late as 1927, the Sung influence in Murray's pots is still very strong.

brush decoration. He also influenced Murray to use better clay bodies than the rather dead, white, commercial body Murray had been using.

Murray was having problems with iron filings from the engineering works impregnating his clay and decided to move his pottery. In 1924, he constructed a two-chambered, oil-fired kiln in an outhouse in his garden at Wickham Road

in south-east London and had his first one-man show at Paterson's Gallery, where he exhibited every year until 1929. By now, his pots were very strong and began to show a unique personality. The Sung imitations were extremely accomplished and began to take on distinctive shapes. The brush-work pots were greatly improved and the abstract decorations became increasingly related to contemporary painting.

In 1925, William Rothenstein, Head of the Royal College of Art, offered the teaching post vacated by Dora Billington to both Murray and Leach. There were insufficient funds for them both to teach and to say that Rothenstein handled the whole affair with a lack of tact would be a considerable understatement. In the end, Murray received the post and Leach received a garbled account of what had happened. Bad feeling developed between them and what had started as a cooperative friendship turned into mild hostility. I suspect, though, that the differences in their attitudes to ceramics would have made this inevitable.

Murray's philosophy of ceramics was developing as quickly as his pots. He said of pottery in a lecture:

> It is in fact a very pure art, a direct formal expression, abstract in the sense that it is non-representational. Its formal beauty lies in the sympathetic or complementary relationship of its parts, its lyrical beauty in its painting or decoration, its tonal beauty in its colour and its timbre in the quality of its surface. It connects the arts of painting and sculpture, if sculpture is taken in its wide sense and its aesthetic power is equal to either.

There is no mention made here of function and Murray never made any purely functional pieces except some tiles that were mostly decorated either by his wife or his assistant.

Both Dalton and Hopkins held similar advanced views on the status of the potter and, no doubt, influenced Murray, but it is Murray who will be remembered for the attitudes that brought a great increase in the prestige of potters. In fact, there is not as much difference in practice between Leach and Murray as is often supposed. Both were inspired by many of the same sources; both had a strong sense of the spiritual qualities of ceramics derived largely from their interest in Buddhism. Leach's pots, despite his ideas, are often as non-utilitarian as Murray's and he did at least as much to foster the cult of the personality. The main difference lay in the price; Murray wanted to price his pots in guineas, while Leach wanted to price his in shillings.

Murray had met many painters and sculptors in the years he collaborated with Hamilton, and during the 1920s he increasingly exhibited with them, often at the Lefevre Gallery. He formed a close friendship with Ben Nicholson, as well as with other fine artists such as Henry Moore, Barbara Hepworth and Christopher Wood. In 1927, he became a member of the Seven and Five Society, a group of painters and sculptors with Nicholson as its president. The same year, he shared an exhibition at the Beaux Arts Gallery with Nicholson, Hepworth and Wood.

The next two years were an excellent time for Murray. His work was now very strong and individual. He was increasingly decorating his pots in a painterly manner using incised

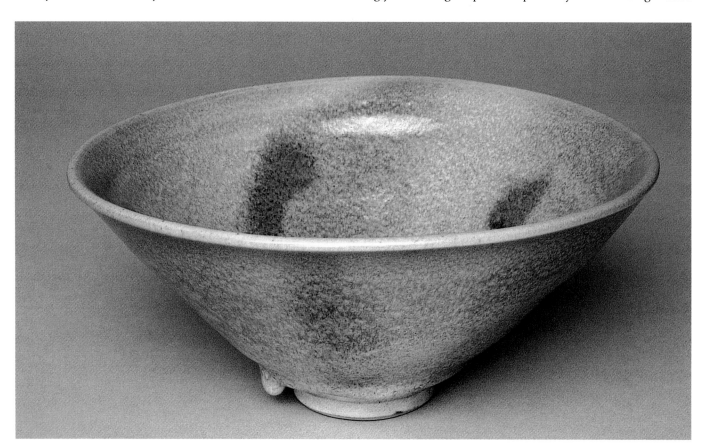

Plate 53: William Staite Murray, stoneware, chun-glaze, c.1930, dia: 20cm.

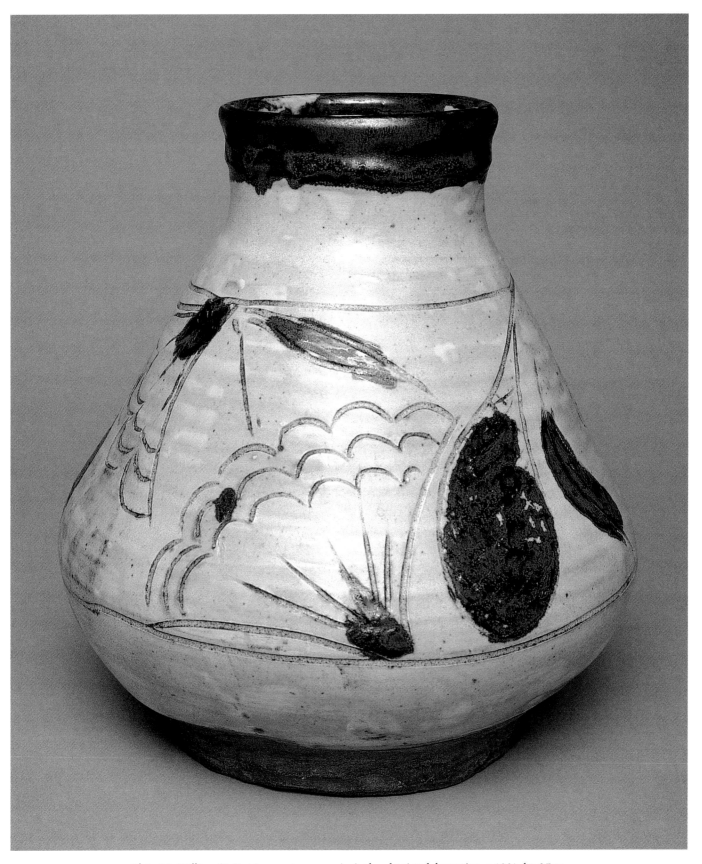

Plate 54: William Staite Murray, stoneware, incised and painted decoration, c.1931, ht: 25cm.
One of a series of 'Persian' pots made in the early 1930s.

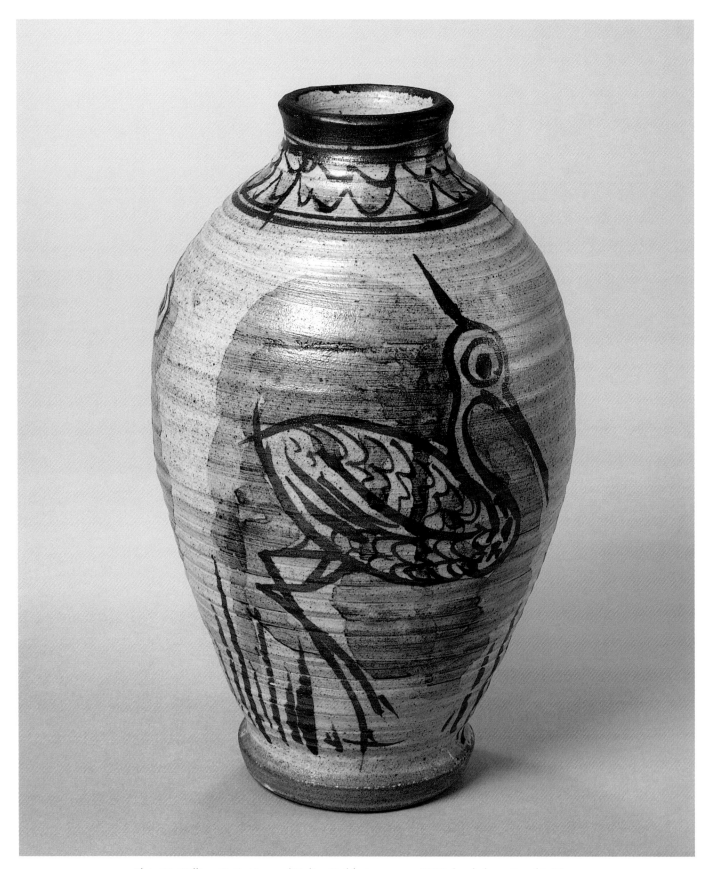

Plate 55: William Staite Murray, 'Wading Birds', stoneware, c.1930, brush decoration, ht: 27cm.
Exhibited in 1930 at the Lefevre Gallery and purchased by Cedric Morris, a painter with whom Murray had previously shared an exhibition.

or inlaid decoration as well as brushwork. He also began to give titles to many of his pots. While at Rotherhithe, Murray was having difficulty selling anything, but now he was a success. His 1927 show at Paterson's containing 300 pieces was exceptional, both for the quality of the work and for the sales. 'Cadence', a rather Hamada-looking pot now in the York City Art Gallery, became his first pot to sell for 100 guineas. It was bought by the Dean Eric Milner-White who formed, by far, the best collection of Murray's pots. The Paterson's exhibition in 1928, 264 pieces, was nearly as good as the one in 1927 and contained a much larger number of pots with figurative decoration. Charles Marriott, *The Times* art critic, described Murray as 'one of the most distinguished artists in Europe.'

Murray had bought a property at Bray in Berkshire and in 1929 he moved there, converting the large greenhouse into his workshop. He built a new kiln similar to the one at Wickham Road, but considerably larger. The larger kiln meant that Murray could make larger pots. He immediately began making the tall, anthropomorphic shapes that most people associate with Murray's pots. 'Madonna', 'Purple Night' and 'Bather' are three well-known pots done in this style that were exhibited in his one-man show at the Lefevre Galleries in 1930. Murray had become dissatisfied with

Paterson's and after the 1929 show he switched to Lefevre's, where he exhibited every year, but one, through to 1936.

Despite the artistic success of his work, the 1930s became an increasingly difficult time for Murray. For a start it was much more difficult for him to actually make pots. The move to Bray and teething problems with the new kiln severely reduced his output for at least a year. He was unable to make pots now in the winter, so his output, at best, was only about 200 pots a year, considerably less than previously. To make matters worse, in 1936, Murray damaged a nerve in his hand; an injury that took almost a year and a half to clear up.

Murray's biggest problem during this period was sales. His policy of asking very high prices, which had been so successful in the 1920s, began to come unstuck. This was owed to the more severe economic climate of the 1930s and to taking a good idea just too far. A tea-bowl, which might have been one guinea in the mid-1920s, became four guineas in the mid-1930s – roughly the weekly salary of an architect or a solicitor. For 'Daphne and Apollo', two very large pots, the price was 300 guineas – enough to buy a new terraced house. No doubt, the major reason that there was no Lefevre show of Murray's work from 1937–9 is that the Gallery was finding it impossible to sell his work.

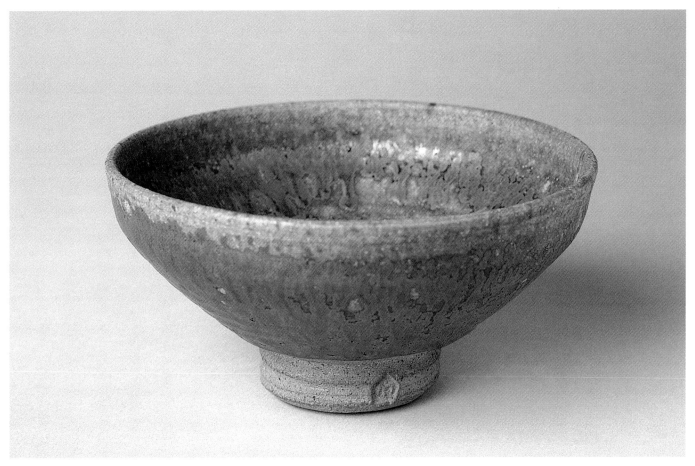

Plate 56: William Staite Murray, 'Autumn Wood', stoneware, c.1933, dia: 20cm.
This bowl has the classic Murray foot and a wonderful glaze effect that is probably due to misfiring.

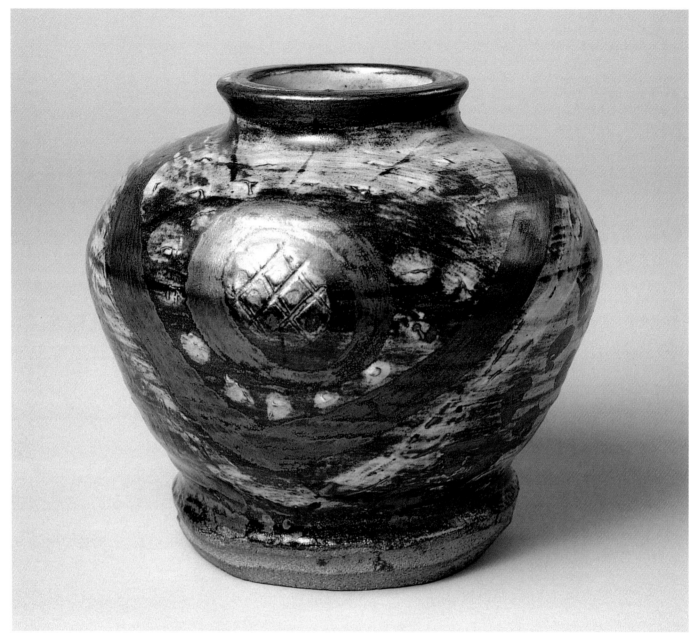

Plate 57: William Staite Murray, 'Alpha', stoneware, 1936, ht: 17cm.
This superb pot surprisingly didn't sell at two exhibitions, in 1936 and 1958, at the Lefevre Gallery.

During this period Murray produced some of his best and some of his worst pots. Many of his large undecorated pots and smaller bowls are wonderful. He used greatly exaggerated potting rings to break up the surface of the pot. Most of these pots have very thick lips. 'Who would want to kiss a girl with thin lips?' Murray would ask his students. He also developed a very characteristic approach to the foot of the pot, particularly the bowls. The feet are extremely thick, large and heavily turned. Murray's attitude to women's feet is not recorded.

Murray's decorated pots show the extremes of his talent. His brushwork had often been crude, but, usually, was very

well related to the form. Murray had some success with inlaid pots with decoration in a Western narrative style, but his painted pots with similar decoration done in the late 1930s are a total disaster. Even the best known of these pots, such as 'The Card Players', are almost unbelievably awful. On the other hand, some of the pots with more abstract decoration, 'Motet for Strings', 'Alpha' and 'Wheel of Life', for example, are absolute masterpieces.

Murray and his wife visited relatives in Rhodesia in 1939. It was not intended to be a long stay, but while they were there the war broke out and it seemed unwise to return. After the war, the health of Murray's wife deteriorated and

they stayed. All through his twenty-two years in Rhodesia, Murray never potted and took almost no interest when a pottery course began in nearby Umtali. He returned to England briefly in 1957 to help organize an exhibition, the following year, at Lefevre's, of the pots still sitting in his studio at Bray.

By now, Murray's reputation as a potter was at its lowest. His work had not been seen for twenty years; most of the students he had so strongly influenced were no longer potting; and the success of the Leach Pottery was at its height. Most Leach supporters had little time for Murray's work and many were outwardly hostile. Muriel Rose, who had success with her book, *Artist-Potters in England*, published in 1955, was one of his fervent detractors. Not surprisingly, the Lefevre show was not a great success and most of the pots were dispersed amongst Murray's relatives.

William Staite Murray's influence as a teacher is almost as important as his influence as a potter. In a way, it is

fortunate that he, rather than Bernard Leach, was given the teaching post at the Royal College of Art. It is unlikely that Murray would have taken students otherwise, whereas Leach already did.

During Murray's years at the RCA, a number of highly gifted artists turned to ceramics and produced, in some cases, quite remarkable work. Most of the pots made by Murray's students have the trademarks of Murray's own pots – heavy non-functional stoneware, pronounced potting rings, exaggerated feet, thick lips, an emphasis on surface texture. Many of the pots made in the late 1930s also are decorated with subjects from Greek mythology, a preoccupation of Murray's at that time. Many of Murray's students, while making pots that are reminiscent of his work, managed to create, very much, their own style.

Murray's teaching style would appear to have been somewhat unconventional. Basically, he left his students almost

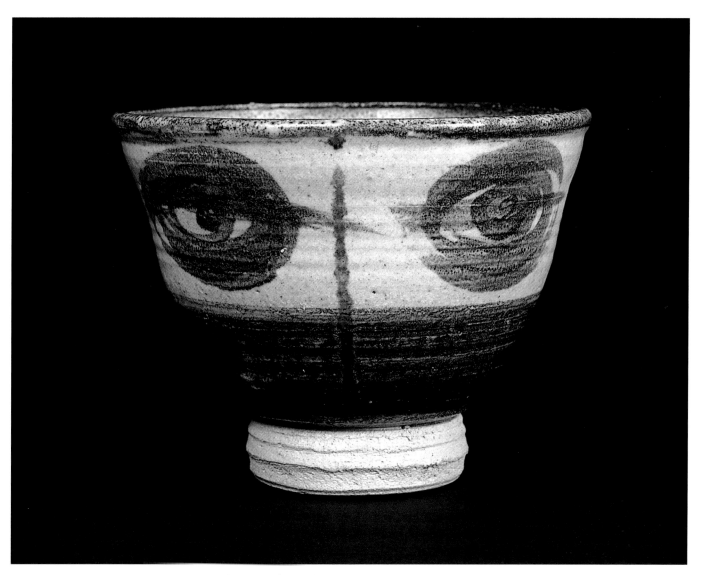

Plate 58: Heber Mathews, stoneware, c.1940, dia: 21cm.
The iron decoration is copied from the traditional Japanese Seto 'horse-eye' plates.

entirely alone. His main contact with them seems to have been attempts to 'steal' their better glaze recipes. Despite this, most of his students absorbed a very great deal from him. It is clear that Murray's teaching was strongly modelled on the Buddhist form of instruction. In 1957, Murray said, 'A Zen Master teaches by not teaching … it is only when the pupil has learnt by not-doing … then the pupil will hear the silence of the Master.'

It is difficult to discover much about Murray's early students. Little has been written about them and their pots are extremely rare. Reginald Marlow, Percy Brown, Constance Dunn and Philip Wadsworth are almost totally forgotten now.

The best known of Murray's early students was Heber Mathews. Mathews, like many others, went to the RCA to study painting, but quickly switched to pottery. He studied under Murray from 1927–31 before becoming pottery instructor at Woolwich Polytechnic School of Art, a post he kept until his death in 1959. Mathews potted sporadically all through the 1930s and, again, for about ten years after the war. Very few of his pots are dated, but it seems possible to get a rough chronology of his work. Initially, he made bowls and vases very much like Murray's. Some of his conical tenmoku bowls are almost indistinguishable. The vases are often paler in colour and much less decorated than Murray's. Mathews rarely did figurative decoration, but he was unusual in that he seemed to be more influenced by Japanese pots than any other pre-war British potter. In the late 1930s, he began making large, thin bowls with a flat white or pale yellow glaze. These excellent pots rely on a subtle incised decoration and are quite uncharacteristic of Murray's work.

Mathews's reputation was still very strong in the post-war years, but recently several of his relatives' collections have come to light, that have not enhanced this reputation. Many of these pots look weak and indecisive. Particularly poor are a number of functional pieces with extremely crude brush decoration that were probably made in the early 1950s.

Many people claim that Mathews had a very strong influence on the early development of Hans Coper because Mathews initially taught him how to throw. While there is a good deal of evidence to support this idea, I think rather too much has been made of it. Coper had many influences and his contact with Mathews was quite brief.

Margaret Rey was at the RCA under Murray from 1932 to 1935. She had entered as a student in the Design Department, but what was happening in the Pottery course seemed much more exciting. After leaving the RCA, she set up a studio in Wimbledon and had considerable success in the late 1930s. She featured in a number of group shows in London and Paris showing alongside many of the students of both Leach and Murray. Reviews of these exhibitions consistently single out her work. In 1938, she had a one-man exhibition at the Brygos Gallery in Bond Street. This exhibition contained over 250 pieces – including her whole range of work from major, large pots to beer mugs. The Victoria & Albert

Museum, the Contemporary Art Society, George Eumorfopoulos and Dean Eric Milner-White were amongst the purchasers. Sadly, this was to be her last exhibition of pots until 1987, when a small retrospective was organized in London.

Rey's pots show a great range of ability. She was equally at home throwing on a massive or a very small scale. Rey was more than capable of making the large figurative pots so often associated with Murray and his students. 'Persephone', in the Paisley Museum and 'Orion', in the Portsmouth Museum, are both superb pots and ' Ceres' is larger than anything Murray ever made. But she was at her best when she exhibited her much more subtle and quiet side. 'Gold Earth', in the Buckinghamshire County Museum, is, I think, one of the most successful pots of the 1930s. Many of her smaller pots, relying on the minimum of decoration, are also extremely fine.

After the war, Rey turned her attentions primarily to painting and sculpture, although she made a small number of pots. By the time I began collecting pots, Rey had disappeared into almost total obscurity. I found few people in the ceramics world who had even heard of her. She is by no means unique in being a fine potter who has been undeservedly forgotten. When it comes to ignoring its own major artists, Britain is, probably, the world leader.

The work of Robert J. Washington was also almost entirely forgotten in the post-war years. Washington was a painting student at the RCA from 1933 to 1937 and then stayed an extra year to study ceramics. Only a few dozen of his pots from the 1930s have survived – mostly tall bottles – which many mistake for Murray's work. They are, in fact, totally different in character and, in some cases, quite superb. 'Leda and the Swan', in the Fitzwilliam Museum, is equal to the best of Murray's pots.

Washington had a number of teaching posts both before and after the war. He also, at various times, raised chickens and Christmas trees. He had decided for personal reasons not to exhibit his work again and, apart from four pots in the Hay Hill shop in 1952, stuck to this. Consequently, he rarely made any pots and destroyed most of what he did make. Between 1959 and 1965, he made a large number of tall anthropomorphic bottles with female figures painted in a Picasso-inspired style. Less than a hundred pots from this period have survived. An exhibition of this work was held in London in early 1981 and the interest inspired him to begin potting again. Initially, his work was done in exactly his early 1960s' style, but in the 1990s he made series of highly experimental work with mixed success.

None of Murray's students took his ideas about the sculptural qualities of ceramics so much to heart – or with so much success – as Washington. Washington talked of the 'profile' of his pots and compared the quality of the line it makes to the quality of line in a drawing. There has been some criticism of his manner of decoration as being repetitive and too derivative of Picasso or Haile. While this may

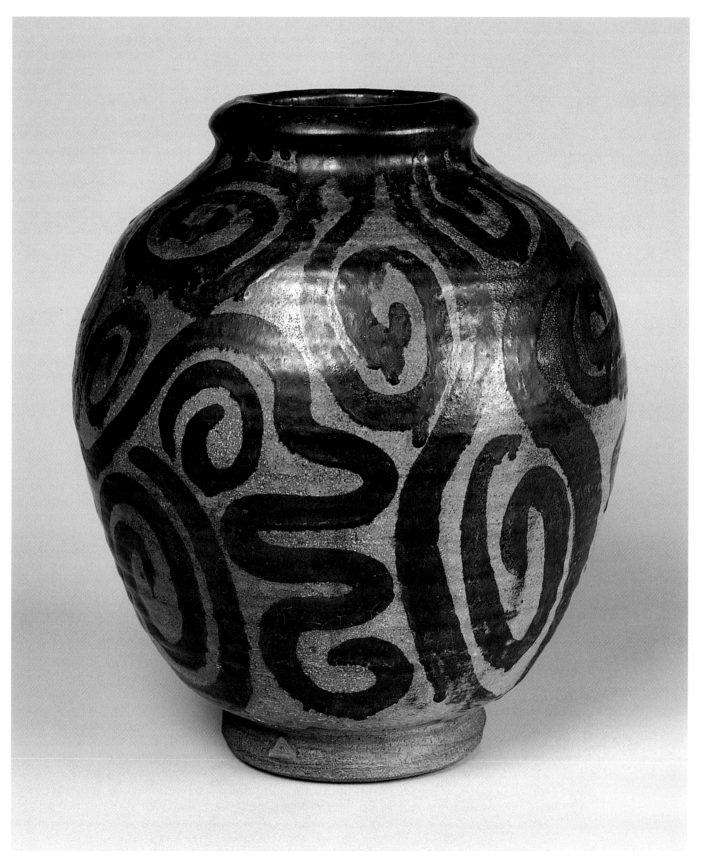

Plate 59: Margaret Rey, stoneware with iron decoration, c.1937, ht: 33cm
The influence of Murray, especially on the lip and foot of the pot, is clearly seen.

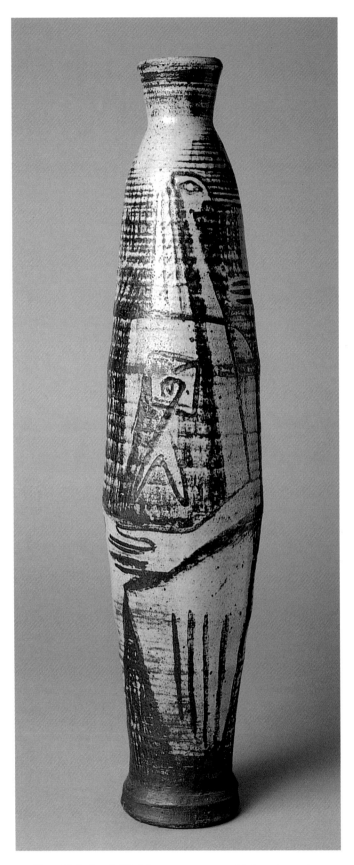

Plate 60: Robert J. Washington, stoneware with iron decoration, 1960, ht: 51cm.

be true, it rather misses the point. Washington's aim was not just to paint pots with female nudes. This is solely a vehicle to break up the surface of the pot and create a variety of texture. In many cases, he has intentionally created the decoration 'out-of-synch' with the form of the pot. His own favourite pots were the ones in which most of the figurative element has become obscured in the firing.

While Washington's pots are not always easy to live with, they are, I think, some of the most powerful and exciting pots made by any potter of his generation.

Gwilym Thomas's story is very similar. He was at the RCA in the late 1930s and after the war and made, but didn't exhibit, some quite stunning work. The best of these were tall stoneware bottles with female figures, produced in the 1960s. It was only after his death that many people were able to see them.

It is sad that so few of these pots had any exposure during the post-war period as, I am sure, they would have inspired others to look more closely at the ideas of Murray.

The most influential, by far, of Murray's students was 'Sam' Haile who entered the RCA in 1931 as a painting student. His professors made considerable objection to Haile's interest in Surrealism so he transferred to the ceramics department under Murray. After three years at the RCA, he spent a year at the Leicester College of Art where he taught full-time. Haile returned to London in 1936 where he taught part-time at both Kingston and Hammersmith Schools of Art and shared Rey's studio near Wimbledon.

Haile was an exceptional painter and initially his success came from his inclusion in the International Surrealist Exhibition held at the Burlington Galleries in the summer of 1936. Success in ceramics was soon to follow. In 1937, the Brygos Gallery exhibited sixty-five Haile pots in what was almost a one-man show. At least five British museums, the Contemporary Art Society and a number of major collectors, including Dean Eric Milner-White and Charles Laughton, all purchased pots.

Haile's pots from the late 1930s, mostly stoneware, are superb. Though his potting can be somewhat rough and crude, it has the most tremendous vitality. The figurative decoration on his pots is far more interesting than that of any other British potter of that time. Haile had little interest in Oriental art and was much more interested in relating ceramics to contemporary painting. His style was heavily influenced by Surrealism and by the paintings of Picasso as well as by Pre-Columbian, Cycladic and early Egyptian pots. I should point out that not only did Haile adapt modern painting style to ceramics ten years before Picasso did, but that, arguably, he adapted Picasso's painting style to ceramics better than Picasso did himself.

Haile married Marianne de Trey in 1938, and the following year they emigrated to the United States. There he survived for a time by doing odd jobs, but it was not very long before his work attracted a great deal of attention. He taught at the New York State College of Ceramics at Alfred

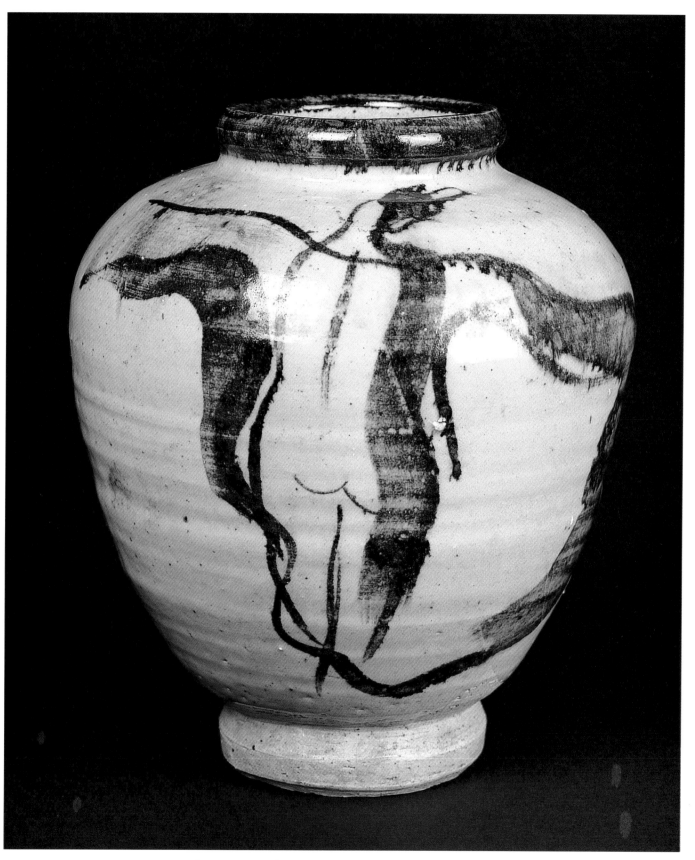

Plate 61: Sam Haile, stoneware, iron decoration, c.1935, ht: 25cm.
This pot, possibly based on Leda and the Swan, was owned by Margaret Rey for over fifty years.

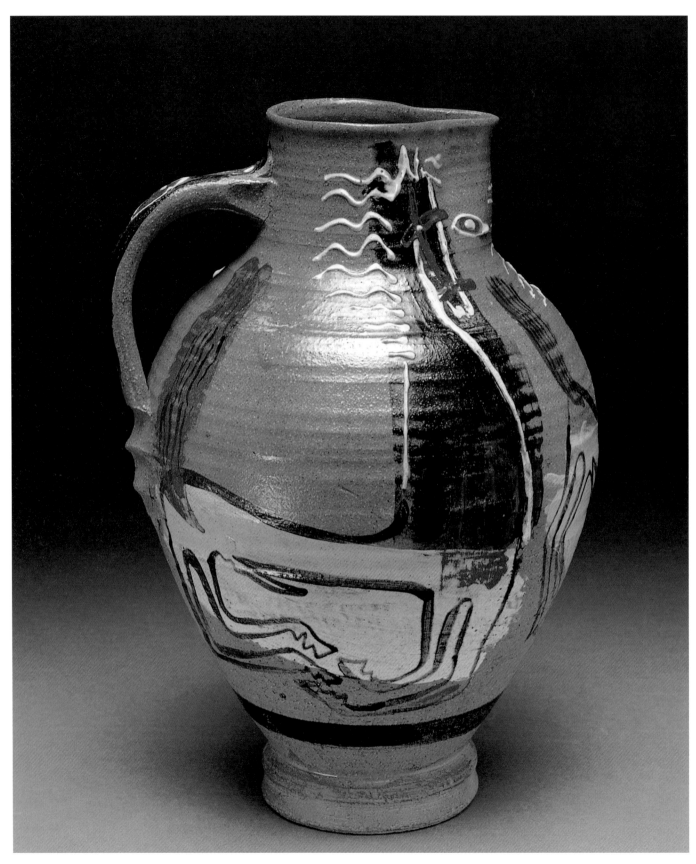

Plate 62: Sam Haile, slipware, 1938, ht: 28cm.
It was assumed that the pots exhibited in America were made there, but many had been made in Margaret Rey's studio and shipped over.

Plate 63: Sam Haile, slipware, 1947, dia: 43cm.

University and, then, at the University of Michigan at Ann Arbor before being drafted into the US Army.

While Haile had been successful in England, he was showing in a country, that by now, had become used to fine modern ceramics. In America, Haile's work was greeted as a 'fresh wind'. His influence there is almost unbelievable considering his short stay. American ceramics had really only just begun to develop and the 1940s and early 1950s were important in the same way as the 1920s had been in England. It was this period that laid the groundwork for the extraordinary outburst of energy in American ceramics that took place in the late 1950s. Probably, the only potter in the 1940s who had greater influence than Haile was the Finnish potter, Maija Grotell. Haile introduced to America many of William Staite Murray's ideas on ceramics, as well as a totally different approach to the use of glazes.

Haile was transferred to the British army during the war. In 1945, he began making pots at the Bulmer Brickyard at Sudbury in Suffolk. These pots, almost all slipware, are somewhat variable in quality. The best, such as the tall slipware jug in the Victoria & Albert Museum, are up to the high standard set by his pre-war work. Others are small functional pieces that exhibit little more than a lively sense of humour.

In 1947, Haile moved to Shinner's Bridge near Dartington in Devon – the pottery Bernard Leach had established before the war. He had just begun making stoneware again when he was killed in a motoring accident in 1948. The early death of one of the most inventive of modern potters – and the principal standard-bearer of Murray's ideas – is one of the greatest losses to British ceramics. I feel certain that, had Haile lived and continued to pot, he would have had as

Plate 64: Henry Hammond, stoneware, ash-glaze with iron brush decoration, c.1970, ht: 36cm.
This pot shows the pronounced throwing lines typical of William Staite Murray's students.

Plate 65: Henry Hammond, stoneware, brushed iron and cobalt, c.1980, ht: 13cm.
This matt glaze that varies from cream to light brown was the most commonly used by Hammond.

strong an influence on post-war British ceramics as he had on post-war American ceramics.

A.C. Sewter wrote, following one of several memorial exhibitions of Haile's work, 'Confronted by pottery such as Haile's even a person not normally interested in the crafts is forced to realize that pottery is a craft with a range and power of expression not less than that of painting.'

Another major pupil was Henry Hammond. Hammond studied at the RCA from 1934 to 1938. He was taught ceramics by Murray and design by Eric Ravillious and Edward Bawden. Hammond was in several group exhibitions in the late 1930s, but his work did not attract as much attention as some of Murray's other students. There is no accounting for this when seeing the quality of some of Hammond's early work. These stoneware pots were, almost always, covered in a pale buff slip-glaze and painted in iron. The forms were

heavy and somewhat crude, but the brushwork had a strength, freedom and spontaneity that is breathtaking.

Hammond was in the army until 1946. He then took up the post, which he had been given in 1939, of Head of the Ceramics Department of the Farnham School of Art (now the West Surrey College of Art and Design). Under Hammond's direction, Farnham became one of the best ceramics training grounds in England and in 1980 he was awarded the MBE for his efforts. Unfortunately, his teaching commitments have been one of the reasons that Hammond's output of pots was so depressingly small.

A studio was put at Hammond's disposal and from about 1946 to 1951 he made oxidized slipware using a local clay. Slipware was not the ideal medium for Hammond and his pots from this period seem comparatively weak and unresolved.

About 1951, Hammond returned to making stoneware. He had spent two weeks studying at the Leach Pottery at St Ives and attended the International Crafts Conference in 1952 at Dartington Hall where Leach and Hamada were the stars. It was now clear that Hammond was being drawn more towards the style of Leach than Murray. The outcome of this was that Hammond's work became a fusion of many of the ideas of these two great figures. From Leach he developed a fine sense of materials, a lightness of form and the influence of Oriental art. From Murray he retained the emphasis of heavy potting rings and bold, turned feet.

Almost all of Hammond's pots are either bowls or vases. He has occasionally made porcelain, sometimes using tenmoku or celadon glazes, but the great majority of his works are pale buff stoneware pots painted in iron. He has also painted over a green ash-glaze – some of his finest pots, in fact. In the 1980s, he also frequently painted with cobalt, copper and chrome oxides to add colour to the iron-brown. Hammond's forms are good, but have never been either innovative or outstanding. But as a decorator, Hammond is unequalled – except, perhaps, by Bernard Leach. His control over the whole range of brushwork from broad abstract designs to minute detailed paintings of grasses is quite amazing. When Hammond made a larger number of pots, such as for his 1959 one-man show at the Primavera Gallery in London, the strength and freedom of his decoration is amazing. At other times, when he was hardly potting, his brushwork became a bit tight. Fish and ducks (or wigeons, as he preferred to call them) were his most popular subjects, but, I think, it is in the depiction of grasses, reeds or corn where he really excelled.

Helen Pincombe was born in India, educated in Australia and came to England in 1925, at the age of 17. Pincombe had some training at all three of the major art schools, first Camberwell, then the Central, and, finally, the RCA where she arrived just as Murray was leaving. After Murray emigrated and the war started, the RCA was removed to Ambleside and Pincombe was asked to teach ceramics. She stayed there during the war years and then established her own pottery in Oxshott, Surrey, not far from that of Denise Wren.

Initially, many of Pincombe's pots were obviously influenced by Murray with heavy potting and pronounced potting rings. As time went on, she gradually produced pots that were much more influenced by Leach, though she always retained the wide turned feet. During the 1960s, she made many stoneware bowls that had great beauty, elegance and control of glazes. She often used brush decoration and also developed a distinctive striped pattern using wax-resist In many cases, she has used iron in the body to come through the glaze leaving spots.

Pincombe was also one of the first major potters to make much use of handbuilding techniques. It is hard to imagine today, but even as late as 1955, almost all pots

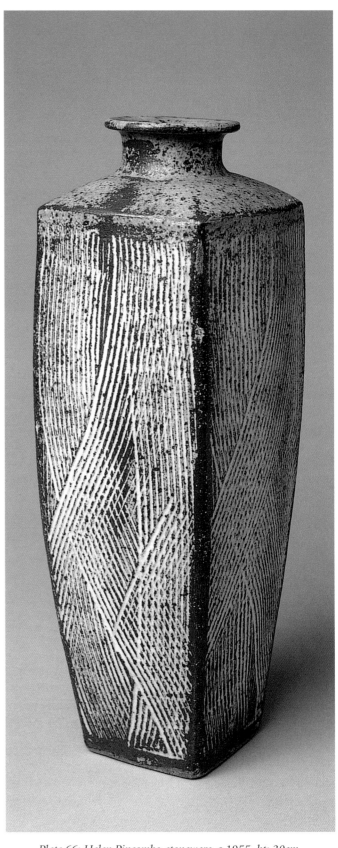

Plate 66: Helen Pincombe, stoneware, c.1955, ht: 30cm.
This slab-built bottle has a thrown top and incised lines filled with a white glaze.

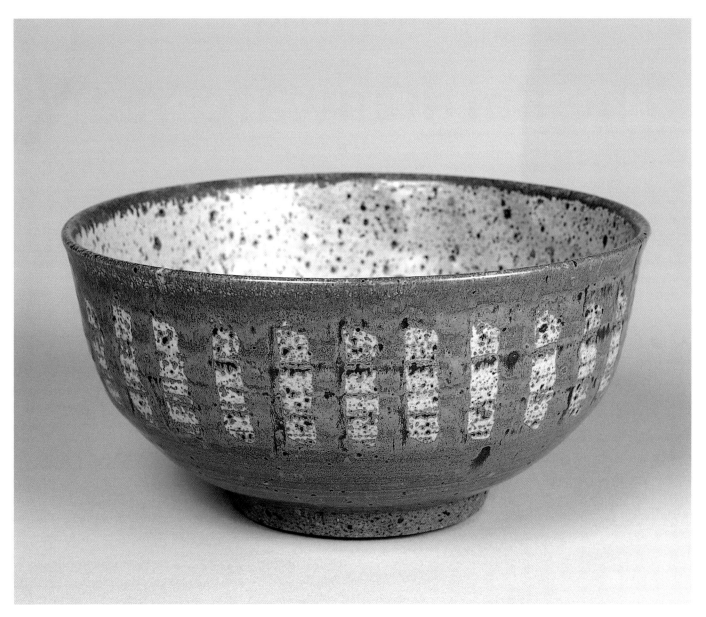

Plate 67: Helen Pincombe, stoneware, dolomite-glaze with wax-resist decoration, c.1965, dia: 27cm.

were thrown, though a few potters had made some use of moulding. Handbuilding techniques were taught in the art schools, primarily as a tool for sculptors, but, otherwise, coiling and slabbing were not taken seriously. Pincombe began making coiled pots right from the start of her career and took up slabbing after becoming inspired at a summer school course. Through the late 1950s and early 1960s, she made a series of tall, rectangular, slabbed bottles with thrown tops and wonderful glaze effects, occasionally using incised decoration. Pincombe's pots

were always very consistent, but the standard of these pieces, particularly, is uniformly high.

In the last two decades, Murray's reputation has begun to rise again. There can be little doubt as to the quality of his work or his historical importance. His attitude to ceramics is much more relevant to contemporary ceramics than any other potter of his time. I will be very surprised if it is long before Murray is widely considered to be one of the most important potters of the first half of the century – a figure of equal importance to Leach, Hamada, Kawai and Cardew.

Chapter 6

The Earthenware Years

There were few potters whose lives were not disrupted by the Second World War. Very few pots at all were made during the war years and, in 1946, when potters began working again, conditions were very different from the 1930s. Many basic materials were in short supply and the buying public had too

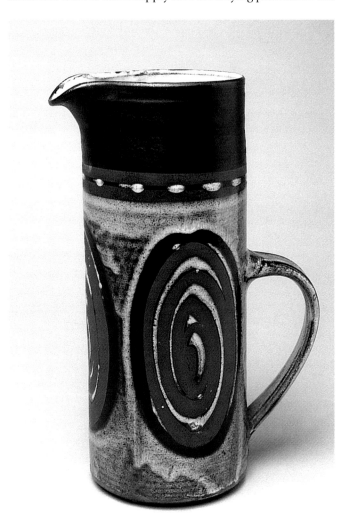

Plate 68: Briglin Pottery, tin-glazed earthenware, wax-resist decoration, ht: 25cm.

strong a memory of falling bombs to be very interested in ceramics. Before the war, there were many top galleries in London's West End exhibiting ceramics and top art reviewers, like Charles Marriott on *The Times*, regularly discussed ceramic work in the same context as 'fine' art. After the war, many of these galleries disappeared or stopped showing ceramics. Pots, once again, began to be frowned upon as 'just crafts'.

This was a period of transition – and crisis – for British studio ceramics. On the face of it, the outlook was disheartening. W.B. Dalton and William Staite Murray both emigrated; many other leading potters virtually ceased exhibiting.

The ten years following the war has often been perceived as an especially dull period for British studio ceramics. To a certain extent this is true, but part of this perception comes from the prejudice in the 1960s and 1970s against low-fired ceramics. Much of the most interesting pottery in this period was made in earthenware.

In the late 1940s, potteries producing domestic earthenware were springing up everywhere; some of the work produced was excellent. Perhaps the best known is the Rye Pottery. In 1947, Walter and John Cole bought and rebuilt the old Belle Vue Pottery in Rye and began producing work that was distinctive and of high quality. While most people do not consider Rye to be a studio pottery because of the production size and method, it was not really that different from many large-scale studio potteries.

About the same time, Brigitta Appleby and Eileen Lewenstein opened the Briglin Pottery in the heart of London. Briglin pots are amongst the quirkiest of British domestic ware. They are in dark red earthenware and decorated with distinctive wax-resist decoration, often highly stylized flowers or abstract swirls. I started with very little respect for these pots, but, like many, have gradually come to appreciate them more and more. Lewenstein left in 1958, but Appleby continued producing work with various assistants until 1990. This is quite extraordinary when you consider how unfashionable earthenware became and that they were producing very inexpensive pottery in a very expensive location. There are still few Briglin collectors and many of these collect the inferior little animal banks, but I will be very surprised if this doesn't change soon.

Most potteries were less eccentric. Ray Finch with Sidney Tustin continued producing large quantities of slipware in the Cardew tradition at Winchcombe Pottery. They were more suited to this sort of production than Cardew had been, though they never quite achieved his great artistic heights. Tustin once claimed, with possibly some exaggeration, that he made over a million pots in his lifetime.

Margaret Leach also worked in a post-Cardew style on a much smaller scale. She was at the Leach Pottery during the war (she is not related to Bernard as many suppose) and afterwards established the Barnhouse Pottery in Wales. There she produced excellent slipware very much in the Cardew tradition. She moved to Gloucestershire in the 1950s and continued there with her partner, Lewis Groves. Almost all her work is quite small and without any great artistic aspiration. Though it would be difficult to find a single outstanding pot by Margaret Leach, her work is consistently pleasing and of very high quality. Sadly, she stopped potting in 1956 when she married.

Sam Haile produced uneven, but often exceptional, slipware for a few years after the war and his wife, Marianne de Trey, though trained in textiles, also began potting. After his sudden death, she began making a range of slipware and tin-glazed tableware at Shinner's Bridge, eventually employing a number of assistants and producing quite large amounts of very attractive pots. The tin-glazed pieces, mugs, jugs and press-moulded dishes, were decorated with brush painting. While the painting on these pieces is far from masterly, they are charmingly decorative and redolent of the period. Even better were the pots made using a brown manganese slip combined with an opaque white glaze and sgraffito decoration. This produced a colouring like the underside of a mushroom and the designs are usually excellent. After a fire in 1957, de Trey changed to making similar designs in oxidized stoneware and about 1980 switched to making individual porcelain pieces, mostly small decorated bowls. While very attractive, these pots were good rather than outstanding and they came too late to be part of the porcelain craze of the 1970s.

Some of my favourite slipware was produced by Paul Barron who was first a pupil of Norah Braden's at the Brighton School of Art and then went to study pottery at the Royal College of Art during the early war years under Helen Pincombe. About 1948, he joined Henry Hammond at Farnham and shared his studio as well as teaching. Most of his slipware is almost mirror-black with trailed decoration. The shapes are strong and the decoration is distinctive and right for the forms.

Like Hammond, Barron devoted almost all his time to teaching and very little to making pots. He also switched to stoneware in the early 1950s, but came under criticism from avid Leach followers who felt that his work was over-decorated and with too much turning. In fact, Barron was a greatly under-rated potter who deserves more attention. The best of his work is highly individual and very good.

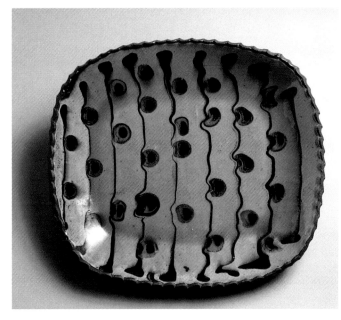

Plate 69: Margaret Leach, slipware, c.1953, w: 28cm.

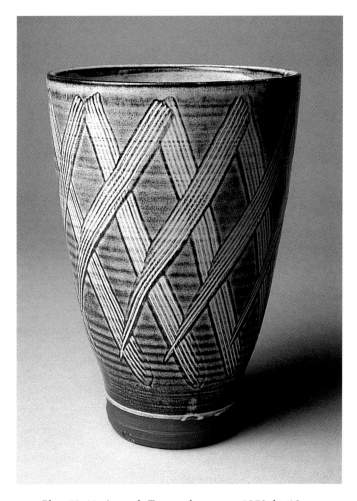

Plate 70: Marianne de Trey, earthenware, c.1953, ht: 18cm.
This glaze was also used by David Leach in the late 1950s.

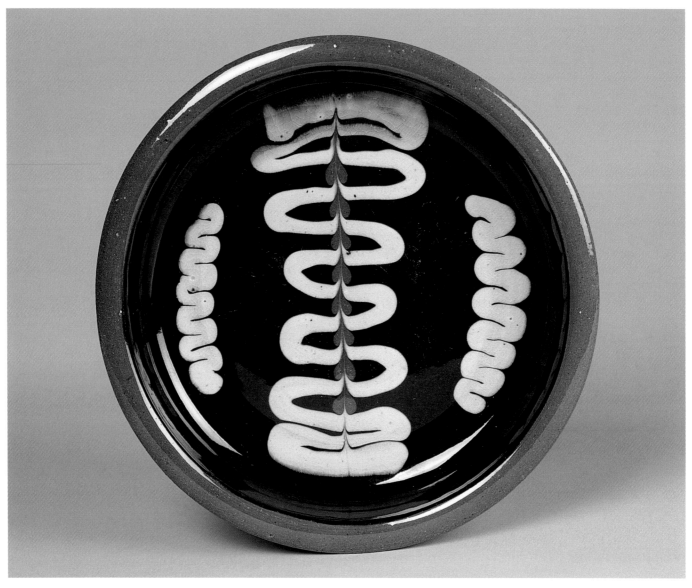

Plate 71: Paul Barron, slipware, c.1949, dia: 24cm.

He extensively used ash-glazes, which he had learnt about first from Braden and, later, from Katharine Pleydell-Bouverie. He also excelled with tenmoku decoration, some of his pieces approaching the complexity of those of Charles Vyse. Barron had a particularly unusual sense of form, partly influenced by Japanese ceramics. The centre of gravity of his pots was often very low, most noticeably in the small bottles he threw and beat into an oval shape. He relied much more heavily on dipped or poured glazes for decoration than on brushed design. He was one of the few potters whose work was equally good at high and low temperatures.

Another favourite of mine is Bernard Forrester. After varied experiences that included apprenticeships at both Minton's and the Leach Pottery and teaching at Dartington School, he set up his own pottery in 1952. For a few years he produced fascinating individual pots – bold, free shapes with incredibly varied painted decoration. Many were obviously Picasso influenced, but he also produced decoration influenced by Surrealism, post-war abstract painting, African bark painting and even Kandinsky. Almost all of the few pots I have seen have been quite stunning, but this period of his work is almost entirely unknown.

His big oil-fired down-draught kiln took too long to fill so he pulled it down, bought a bottle-gas kiln and switched to high temperatures. He then made pots decorated with ash-glazes, lustres and burnished gold, that I find almost impossible to believe were made by the same man. While they were extremely well crafted, they had none of the inspiration of his earlier work and were barely more than nice gift items for craft shops. But potters need to sell pots and these were much more commercial.

If there had been just a few isolated figures making earthenware in the early 1950s, then it would perhaps be a period best overlooked. There was, however, a whole group of potters

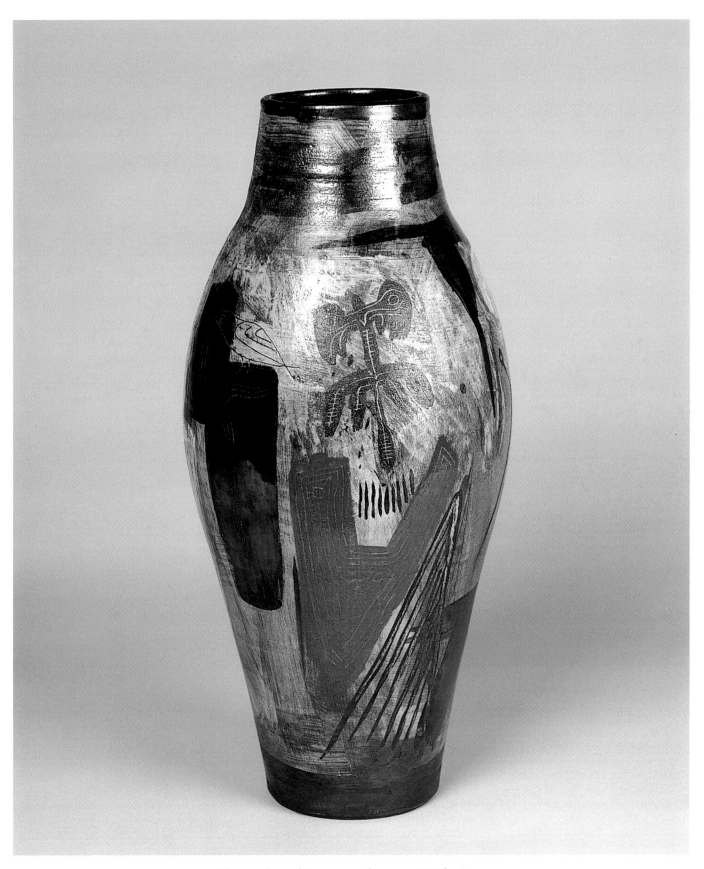

Plate 72: Bernard Forrester, earthenware, 1955, ht: 40cm.
This decoration is inspired by British surrealist painting – especially that of Sam Haile.

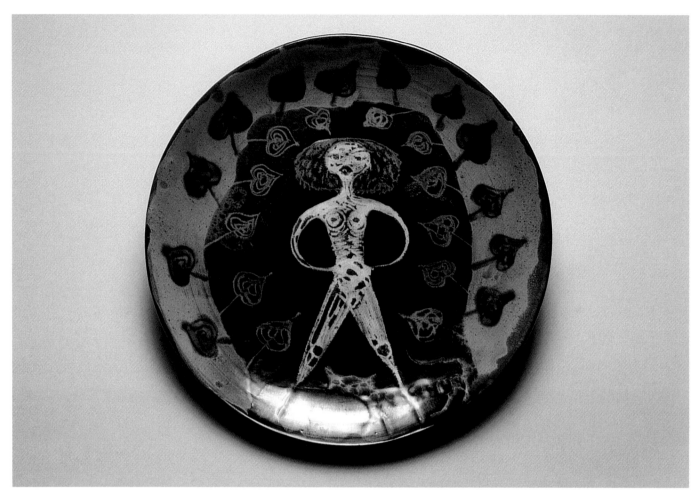

Plate 73: Steven Sykes, 'Yellow Girl', earthenware, c.1953, dia: 25cm.
Originally purchased by the Contemporary Art Society in 1954.

who radically broke away from established ideas and forged a fresh link between craft and design. Most of these potters worked in the then despised medium of tin-glaze.

Steven Sykes was trained in painting, stained glass and mosaics but worked in almost every medium. He is best known for his architectural commissions, especially the large angel mural at Coventry Cathedral. He also made figures, tile panels and, especially, dishes in tin-glazed earthenware. While the forms are nondescript the decoration is often fascinating, usually taking the form of either sprigged and impressed motifs or whimsical fairytale-like painting. There is a good grouping of his ceramics in the Victoria & Albert Museum. He had considerable exposure at the time, particularly at the 1951 South Bank Exhibition, but few people now know of his work.

The best known of the tin-glaze potters were William Newland, Nicholas Vergette and Margaret Hine whom Bernard Leach disparagingly called 'the Picassettes' because the work they did was inspired by the pots that Picasso had recently begun to make at Vallauris. All three were taught at the London Institute of Education and, from 1948 to 1954, they shared a studio in a Bayswater basement and very similar working methods. They made, often very eccentric, vessels

and figurines in tin-glazed earthenware; vessels were thrown or press-moulded and figurines were made from cut and altered thrown forms.

This is work that was highly experimental, fun, evocative of its time and radically threatening to a craft world dominated by Leach followers. The 'Picassettes' believed in 'applied craft' and had little desire to produce works of 'fine art' or of deep spiritual significance. In a number of coffee bars they not only created wall murals and free-standing sculptures but also door handles, light fittings and ceramic lamps.

Margaret Hine was best known for her animals, especially pigeons, that she produced both as figurines and as lovely painted dishes. Nicholas Vergette produced some quite wonderful bowls and a whole range of utterly bizarre semi-sculptural lamp-bases, candle-holders and figurines. He moved to America in the late 1950s where he worked primarily in bronze.

By far the most influential of the three was William Newland. He began by making some charming slipware dishes often painted with cockerels, as well as the tin-glaze work where he was particularly known for his bulls, both figurines and as painted decoration on large bowls. In the late

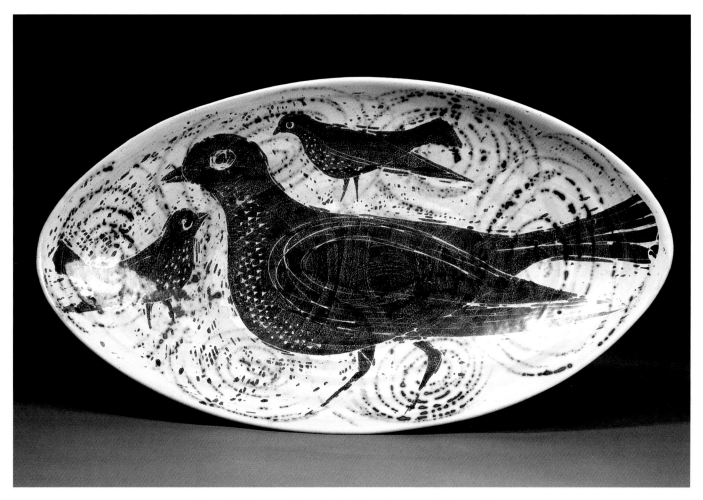

Plate 74: Margaret Hine, tin-glazed earthenware, c.1954, w: 58cm.
The oval dish was a widely used 1950s' form.

1950s he produced some exceptional thrown earthenware 'pumpkin' pots and groups of tall bottles. This work together with his teaching at the Central School had a strong effect on the early handbuilders. Dan Arbeid, Ian Auld, Gordon Baldwin, Ruth Duckworth and Gillian Lowndes were all taught at the Central. Because of his commitment to teaching, Newland made almost no work for nearly twenty-five years, but began working again after his retirement. Towards the end of his life he made some very fine pots including large slipware chargers painted with cockerels – an echo of his work of fifty years earlier.

While some dismiss the work of the 'Picassettes' as being too frivolous, it is almost impossible to dismiss the work of James Tower, one of the finest ceramic artists of the century. Tower studied painting at the Royal Academy Schools just before the war and at the Slade just after. His ceramic training came principally at the London Institute with Newland. While Tower's pots are clearly vessels, they are not intended as utilitarian objects and there was no idea of 'applied craft'. Tower referred to himself as 'an artist who happens to work in clay' and, from as early as 1951, he showed almost exclusively with the 'fine art' gallery, Gimpel Fils, and, consequently, his

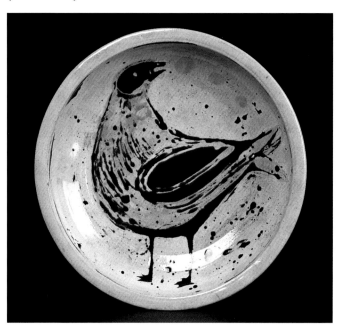

Plate 75: William Newland, slipware, 1954, dia: 24cm.
Birds were a favourite subject of Newland and Hine.

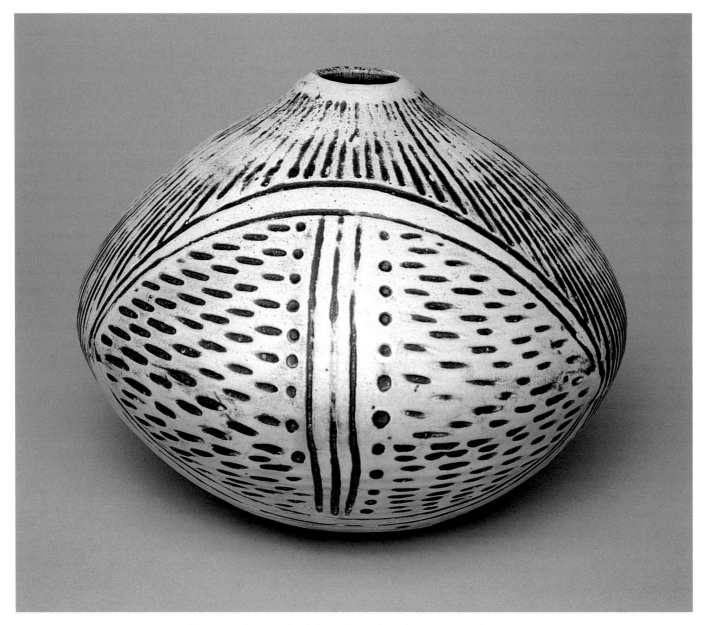

Plate 76: William Newland, 'Pumpkin Pot', earthenware, 1957, ht: 25cm.

work is far better known amongst 'art' collectors than it is amongst collectors of ceramics.

Tower's pots are tin-glazed earthenware fired to about 1100°C. Almost all his forms – sculptural, hollow vessels, bowls and dishes – were press-moulded. The pots were usually covered first in a black glaze and then in a white tinglaze (though, sometimes this was reversed). Decoration was made by drawing through the top glaze either when wet or dry, producing a wide range of different effects. He sometimes varied the black–white colouring by using various oxides to obtain blue, green, grey, beige or even red.

His pots are highly influenced by the tidal landscape he grew up in. The forms are very reminiscent of bivalve shells or flat fish: the surfaces of patterns in water, sand or tidal vegetation. The large, flat surfaces created by press-moulding

were ideal for his extensive decoration. Many of his powerful forms play on perspective and anticipate the 'optical pots' that others made twenty years later.

Tower taught ceramics, for many years, at Bath Academy of Arts and then was head of Fine Art at Brighton College of Art. For most of the 1960s and 1970s he only made terracotta sculptures for casting in bronze. This was probably more of a commercial than an artistic decision; his method of decoration was time-consuming and his gallery, that also represented several leading sculptors, had little sympathy with ceramics. These factors meant that his output of pots was extremely small. Sadly, his isolation from the normal 'craft' world meant that his influence on other potters has been smaller than would be expected. While the boundary between 'art' and 'craft' is, thank goodness,

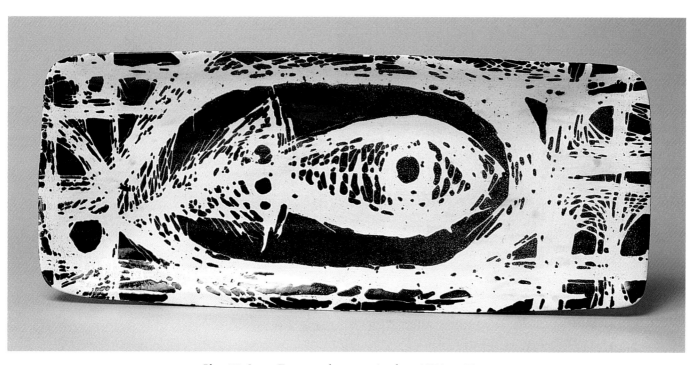

Plate 77: James Tower, earthenware, tin-glaze, 1954, w: 74cm.
The sea is a constant theme in Tower's ceramics.

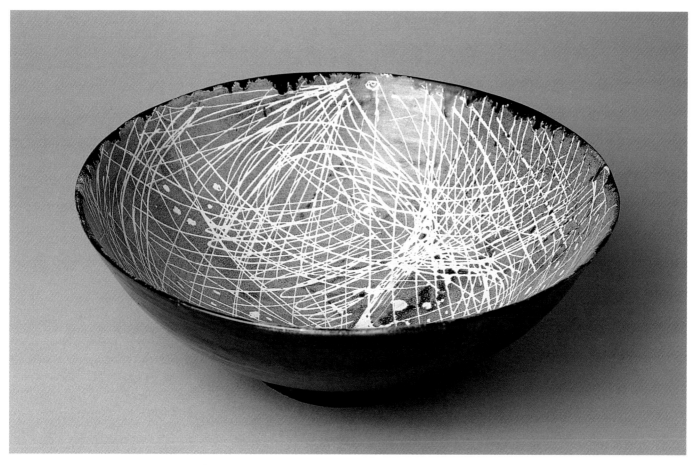

Plate 78: James Tower, earthenware, tin-glaze, c.1954, dia: 34cm.
A great deal of Tower's output was simple, press-moulded bowls.

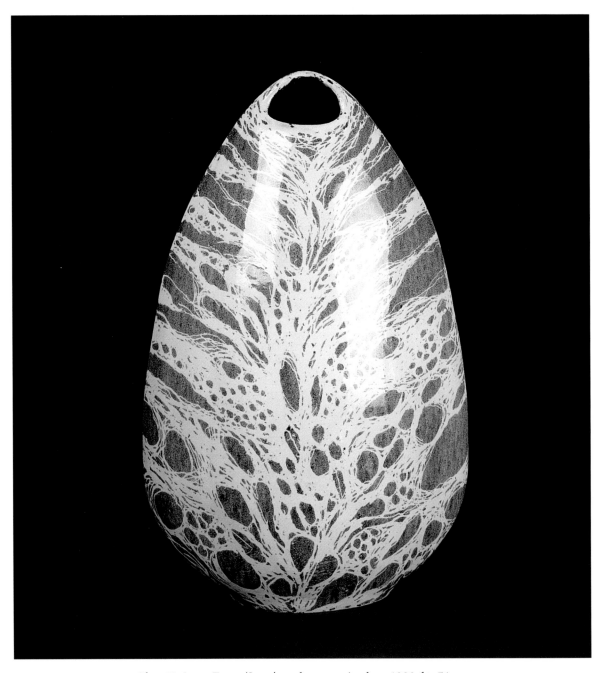

Plate 79: James Tower, 'Spray', earthenware, tin-glaze, 1980, ht: 54cm.
This is press-moulded in two halves and joined.

becoming more and more blurred, for the best part of thirty years after the war few would tolerate the middle ground.

He made a return to making pots and his 1978 exhibition at Gimpel Fils was a triumph. The new work was similar to that of the 1950s but, if possible, even better. The quality of the pots he made is both amazingly high and consistent and is one of the high points of British studio ceramics.

Earthenware, and especially tin-glaze, almost disappeared from serious studio ceramics for many years. Some of the

work done in the decade after the war could best be described as failed experiments. Michael Cardew's Kingwood pots and Henry Hammond's slipware would, probably, be examples.

Though some of the post-war attempts at new forms or new materials look, in retrospect, rather naïve, they did a great deal to break away from the tyranny of Sung-inspired stoneware and to pave the way for new work to emerge. Some of the earthenware pots made in the early 1950s are amongst the most underrated of the century.

Chapter 7

Lucie Rie and Hans Coper

The effects of the war on British studio ceramics were almost entirely negative. There was, however, one silver lining to this very dark cloud. Many fine artists left central Europe due to the troubles. The transformation of American painting in the 1940s brought about by European artists who had settled in New York is well known. The effect on British ceramics brought about by two Europeans who settled in London, Lucie Rie and Hans Coper, was no less dramatic. Their impact in the post-war years was as great as that of Leach, Hamada and Murray in the 1920s and 1930s.

Lucie Rie was born in Vienna in 1902. Her father was a prosperous doctor and her upbringing was privileged. Apart from the house in Vienna, her family had a country house at Eisenstadt. Rie loved the country and was very fond of sports. No doubt this relatively happy childhood helped in giving her the great strength of character that she possessed and helped her to carry on through two world wars and Hitler's destabilization of Central Europe.

Rie was encouraged by her drawing teacher to enter the Kunstgewerbeschule, the famous art school where great figures like Josef Hoffman and Oscar Kokoschka taught. She entered in 1922 as a general art student. Although she had greatly admired the Roman pottery she had seen in her relatives' collections, she had no particular leaning towards ceramics until she tried throwing a pot. From her first experience of a potter's wheel she was 'lost to it' and from that moment most of her energy was channelled into making pots.

At the Kunstgewerbeschule, she was a student of Michael Powolny whom she greatly liked, though her work bears no resemblance to his. Powolny was essentially a country potter and not the right man for the Kunstgewerbeschule or the Wiener Keramik that he co-founded. In contrast to most of the arts that had been transformed by the designs of the Wiener Werkstatte, ceramics had lagged far behind. Many of the works by Powolny and his contemporaries were frivolous figurines in earthenware with somewhat garish colours – little more than decorative kitsch. Rie quickly abandoned this approach in favour of simple thrown cylinders and bowls that owe more to metalwork designs, especially Hoffman's silver, than they do to the Wiener Keramik. Some of these early red earthenware pieces were burnished, but many had

the 'volcanic' glazes that, much later, she used to such great effect on her stoneware. Her first pieces were exhibited in Brussels in 1923 and in Paris in 1925.

In 1926, she left art school and married. Her maiden name was Gomperz and most of her Viennese pots are signed, 'L.R.G., Wien'. An apartment was found and a young architect and close friend, Ernest Plischke, designed it right down to the smallest detail. Though the next ten years were successful creatively it was not a happy period for Rie. She suffered the loss of many who were close to her either through death or emigration, her marriage was empty and anti-Semitism was increasing all the time.

Rie's success as a potter was also increasing all the time. By 1936, she was widely known and exhibited across Europe and had won Gold Medals at both the Brussels international exhibition and the Milan Triennale. In 1937, Hoffman took no less than seventy of her pots to the Paris international exhibition where she won the Silver Medal.

Also showing in the 1937 exhibition were Gertrud and Otto Natzler who later became famous as potters in America. Gertrud Natzler had followed Rie at the Kunstgewerbeschule and the Natzlers' pots show an obvious resemblance to Rie's work. They are also simple earthenware shapes and have even made extensive use of the 'volcanic' glaze effects. The Natzlers' pots are amazingly beautiful and very important in post-war America, but they owe a great deal to the influence of Rie.

Though Rie had avoided many of the worst effects of anti-Semitism, it became obvious that she had to leave Austria and in 1938 she came to England. Not only did she leave behind her own culture and the fairly comfortable life she had in Vienna, but she also left behind her reputation as a potter. In England, she was unknown and her work met with widespread criticism. W.B. Honey at the Victoria & Albert Museum said that she made earthenware pots with stoneware glazes. William Staite Murray dismissed her with the cryptic question, 'When are you going to start making pots?' Worst of all was the reaction of Bernard Leach. Leach was well known to Rie when she was in Vienna and his opinion was obviously important. He was interested in Rie and invited her to Dartington, but his comments on her work

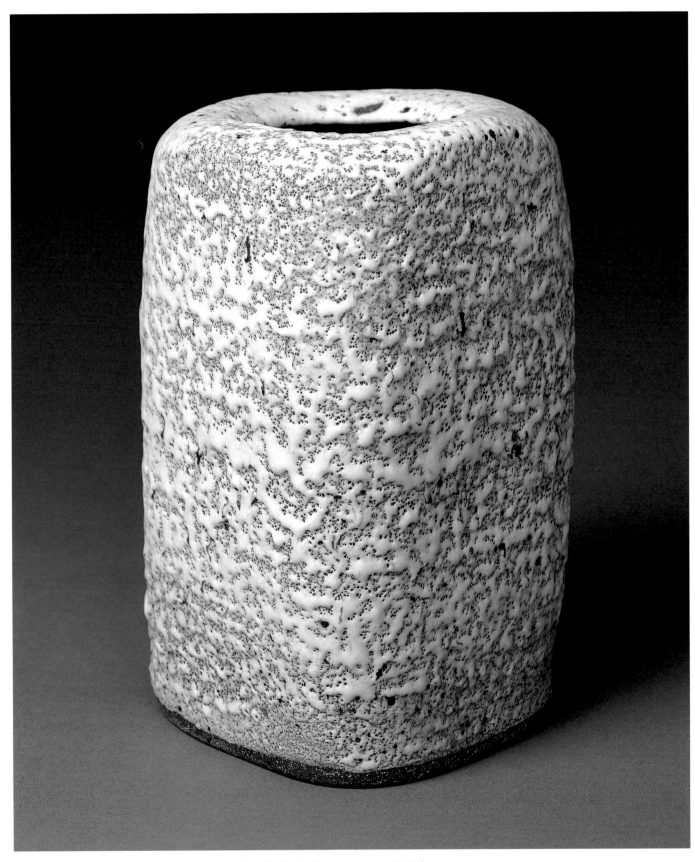

Plate 80: Lucie Rie, stoneware, c.1966, ht: 25cm.
Rie used these 'volcanic' glazes throughout her life.

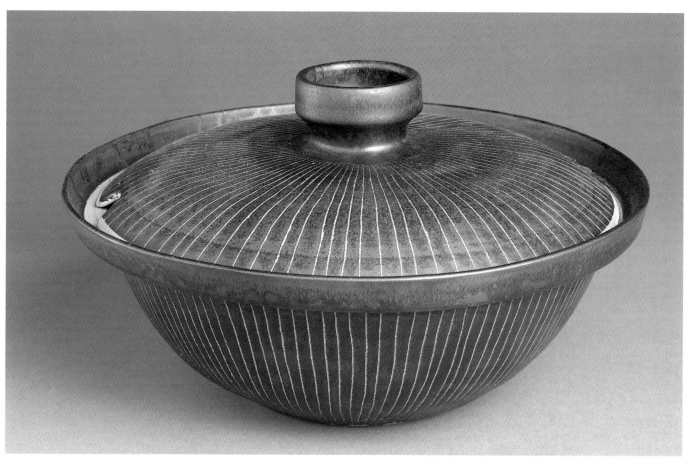

Plate 81: Lucie Rie, stoneware, manganese glaze, sgraffito decoration, c.1955, dia: 25cm.
This was made as a utilitarian object. The inside has a shiny white tin-glaze.

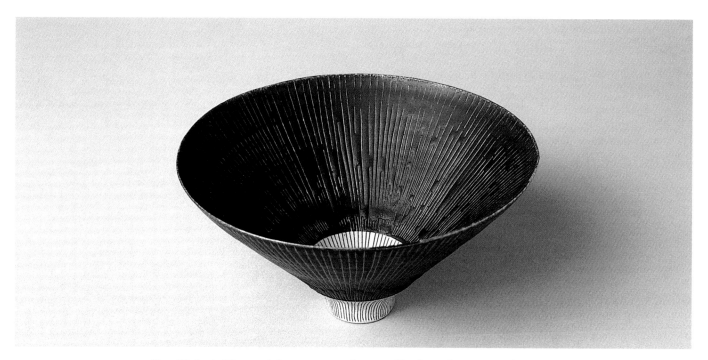

Plate 82: Lucie Rie, porcelain, manganese glaze, sgraffito decoration, c.1955, dia: 17cm.
The manganese in early pots has a chocolate appearance and becomes more bronze in colour from the 1970s.

were mostly disparaging. He felt her work was too thin, not robust enough and lacked humanity.

She was greatly impressed by Leach's approach, particularly his ideas about the 'completeness' of a pot and it speaks volumes for her strength of character that, in the face of all this, she did not become another 'Leach potter', though she did become one of his closest friends. Many of his ideas did, however, permeate her work. Anyone who has looked at the foot of a Rie pot will see one aspect of 'completeness'. The underside of her pots are usually decorated with just as much care as the more visible parts. The seal is carefully designed and placed. The foot is carefully turned and the foot-ring is smoothed. This, of course, was not Leach's idea of 'completeness'; he did not like turning and left the foot exactly as it came from the wheel.

In the 1960s, George Wingfield-Digby wrote, 'Here was a studio potter who was not rustic but metropolitan; her work had no nostalgic undertones of folk art.' It is ironic that it is this very quality that made it so difficult for some to accept her work. In Europe, it is totally acceptable for a potter to be considered without regard to a folk tradition, but in an England dominated by Sung pottery such an idea was almost impossible. Rie's work, while not modernistic, was totally modern. The 'volcanic' glaze effects were in sharp contrast to those of the Oriental wood-ash glazes. Her work was elegant, refined and sophisticated – a far cry from 'peasant pottery'.

In 1939, Rie found a garage in Albion Mews just north of London's Hyde Park. She converted the ground floor into her workshop and the upstairs into a tiny apartment complete with the Plischke furniture shipped from Vienna. For over half a century, the environment of her home and workshop remained essentially unchanged.

War broke out shortly after she moved into Albion Mews. Rie avoided internment, largely through the intervention of W.B. Honey's wife, and divided her time between a job in a glass button workshop and making pottery in her studio. Very few pots were made in the early 1940s and those that have survived show what a period of artistic crisis this was for Rie. This period when she tried unsuccessfully to incorporate Leach's style unquestionably produced the worst of her pots. The earthenware made at this time is unresolved and somewhat clumsy.

After the war, she reopened her pottery and developed a range of ceramic buttons, employing a number of people, mostly other refugees, to help make them. One of these refugees, Hans Coper, who arrived at her door in 1946, had a profoundly positive effect on her work. He gave her tremendous support and she regained all of the self-confidence that had been drained away by her friendship with Leach. Slowly the buttons faded out and they made more and more domestic ware. At first, somewhat Leach-inspired pots were made for Bendicks, a chocolate and coffee house in Bond Street, but soon she and Coper were producing a much better range of tableware. The large salad bowls with one lip pulled out were made as

early as 1947. The characteristic straight pulled handles appeared not long after.

Earthenware had obvious limitations and a large electric kiln was installed in 1948 which allowed her to fire to higher temperatures. Adapting to stoneware was not an easy task. There was by now a great deal of knowledge about Chinese glazes, but these were mostly reduction glazes fired to about 1300°C (as in *A Potter's Book*). Rie was doing oxidation firings at about 1260°C. She quickly overcame the obstacles; Leach's porcelain recipe only needed slight modification and she added lead to his black glaze to produce a wonderful silky mirror-like black. Most of the tableware is in a fine stoneware with a white tin-glaze on all surfaces that come in contact with food and a matt chocolate-brown manganese glaze on the outside. The principal decoration was sgraffito, which Rie had seen on stone-age pottery at Avebury. She used a needle to incise a network of fine lines through the dark glaze. Eventually, a rich yellow glaze (from uranium), a dark blue and a light blue resembling a celadon were added to the repertoire, though they were less frequently used. This domestic ware is wonderful to look at and wonderful to use – almost certainly the best produced by any potter in England.

Rie's first one-man show was held in 1949 at the Berkeley Galleries. They put on a further five shows of her work in the 1950s and 1960s, several shared with Coper. Though the work was still a bit uncertain, it was already clear how important a potter she would be. It was at this time that an early form of her famous seal mark was first used. Her reputation grew steadily. She exhibited at the Festival of Britain, the Stedelijk Museum in Amsterdam, the Röhsska Konst-slöjdmuseet in Gothenburg, Bonniers in New York and the Milan Triennale twice (winning another Gold Medal), all in the early 1950s. Heal's and the recently opened Primavera Gallery, both in London, also frequently showed her work. The Bonniers exhibition was very important in that it successfully introduced her work to America, where it has been met with enthusiasm ever since. It is mostly Americans who have been responsible for the very high prices her pots started commanding in the 1980s.

There have been few successful collaborations between potters and British industry in the twentieth century and a great opportunity was missed in the 1950s. Rie was asked by Wedgwood to design tea and coffee services in their famous Jasperware. Beautiful prototypes were made by Rie but never put into production by Wedgwood.

Rie's range in both stoneware and porcelain continued to increase and she added more and more individual pieces to the output of tableware. All Rie's pots are raw-glazed and once-fired. She started this method in Vienna. Before she had a kiln installed in the late 1920s, she carried her pots by tram across town to be fired. Once-firing halved the journeys (and breakages). Rie has perfected this raw-glazing technique that most potters find very tricky. The normal practices of dipping

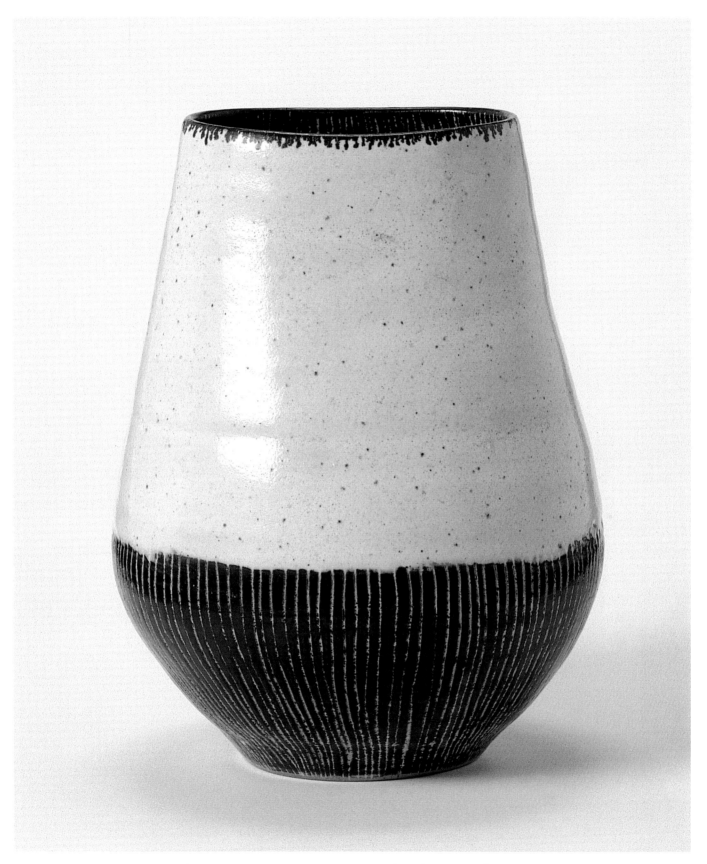

Plate 83: Lucie Rie, stoneware, manganese and tin-glaze, c.1958, ht: 19cm.
The rim is squeezed oval in this pot that uses her two most common standard-ware glazes.

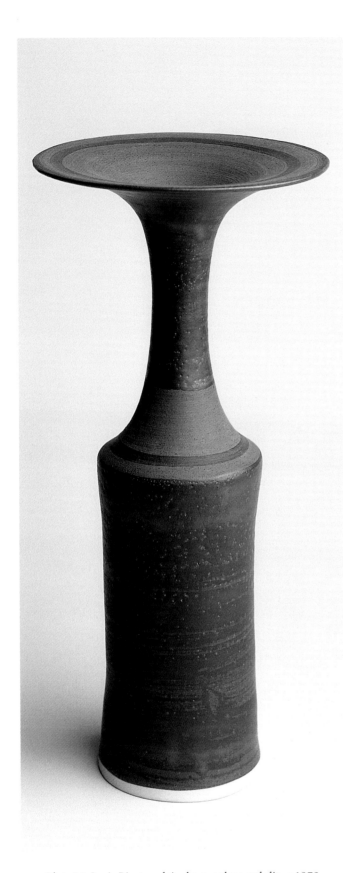

or pouring do not work and so the glaze (with gum arabic to help it stick) is applied with a house-painter's brush. This allows a great deal more control than other methods of applying glaze. The thickness of the glaze can be judged better and different layers can, if necessary, be built up.

Control is an important aspect of Rie's work. Quick expressionistic techniques and kiln 'accidents' that many potters use to great advantage were not suitable for her. The electric kiln and many of her working methods help her to achieve this control. Throwing rings were carefully smoothed away. Large vases or bottles were thrown in sections and joined. The wonderful flaring shapes of her bowls and the large recessed feet were achieved partly by skilful turning. Rie enjoyed turning and saw it as an important part of the creative process, rather than just as a corrective measure. Despite her tremendous control, Rie's pots never appear tight or mechanical. There is always that slight asymmetry of the rim or a departure from the round that gives her work so much life.

Rie's decorative techniques also differed from what was 'normal'. Most potters' decoration relied on coloured glazes enhanced by brush decoration. Rie only used a brush for applying glaze or, perhaps, to inlay slip into incised lines. She preferred to add oxides to the body which would come through the glaze. In 1967, she made an important (and much copied) technical breakthrough. Two clays of different colour were thrown together to produce a spiral pattern in the pot. These pots have, ever since, been amongst her most popular work. Rie also continued developing her use of sgraffito as well as inlay and fluting. I particularly like the densely cross-hatched bowls, usually a matt grey, that she called 'knitted bowls'.

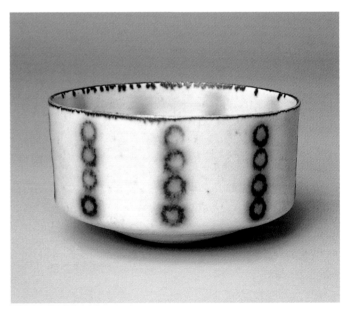

Plate 84: Lucie Rie, porcelain, bronze glaze and slip, c.1978, ht: 25cm.
She was particularly known for these 'trumpet' bottles.

Plate 85: Lucie Rie, porcelain, c.1959, dia: 13cm.
The ferrule of a paintbrush was used to make indents that are inlaid.
The manganese rim is used here in a restrained manner.

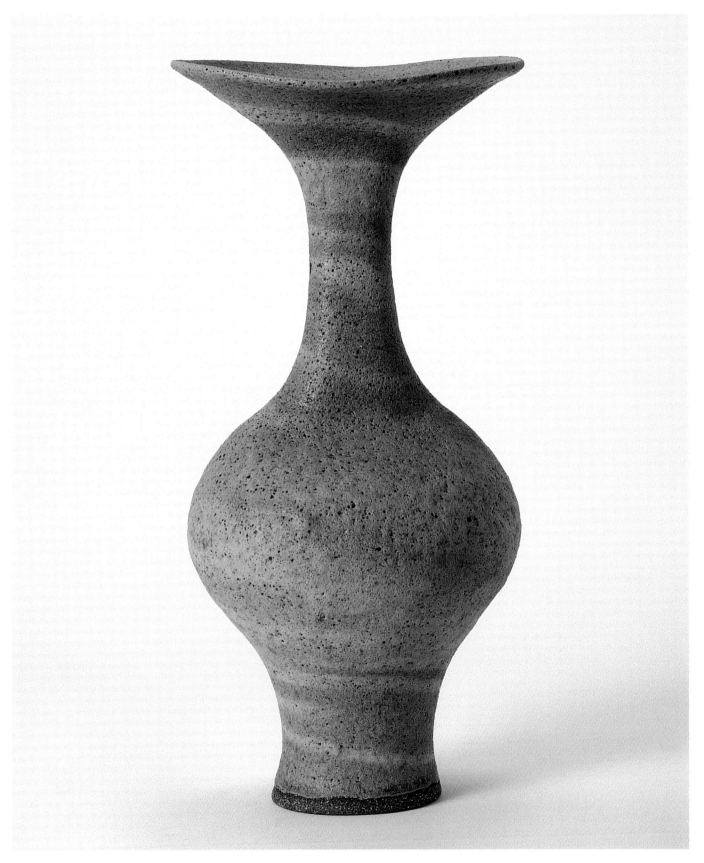

Plate 86: Lucie Rie, stoneware, c.1981, ht: 34cm.
This pot showing her 'spiral' effect is one used in a series of four postage stamps to commemorate Bernard Leach's centenary.

Rie's glazes became as diverse as her forms. Many of her pots are basically white. These are done with enormous variation – smooth, creamy, shiny white tin-glaze to deeply pitted 'volcanic' glazes. A whole range of subtle colour variations exists, depending on the composition of the clay body. Many other colours are also used. The uranium yellow has been extensively employed for bowls as well as greens and pinks (from copper). In the 1980s, she also made a beautiful, shiny apple-green and a more matt peacock-blue. To the original manganese glaze she added a shinier bronze glaze (from manganese and copper) which she used mostly on porcelain. Sometimes this was used for the whole pot enhanced by sgraffito or blue or terracotta coloured slips. At other times it just bands the rim, bleeding into another glaze.

The 1960s were a time of increasing exposure of Rie's talents. She began teaching part-time at Camberwell in 1960 and continued teaching for twelve years. Many fine potters passed through Camberwell and Rie's influence in those years, including Ewen Henderson, John Ward and Ian Godfrey. While Rie was hospitable, generous and courteous to everyone she came in contact with and had a wide circle of loyal friends, she was not, essentially, a very public person and teaching was a rare and not always comfortable, exposure for her.

Exhibitions both in England and abroad reached a peak in 1967 with two major exhibitions, one at the Boymans Museum in Holland and, even more importantly, a retrospective exhibition in London with over 300 pieces organized by the Arts Council. She was awarded the OBE the following year. By now, anyone with even the vaguest interest in modern ceramics knew of Rie's work. Though the closure of the Berkeley Galleries and Primavera's London shop removed two of her main outlets, her order books were always full and her financial constraints began to ease.

Another retrospective, this time organized by the Sainsbury Centre for Visual Arts, was held in 1981. In the same year Rie was awarded the CBE. With the deaths of Hamada,

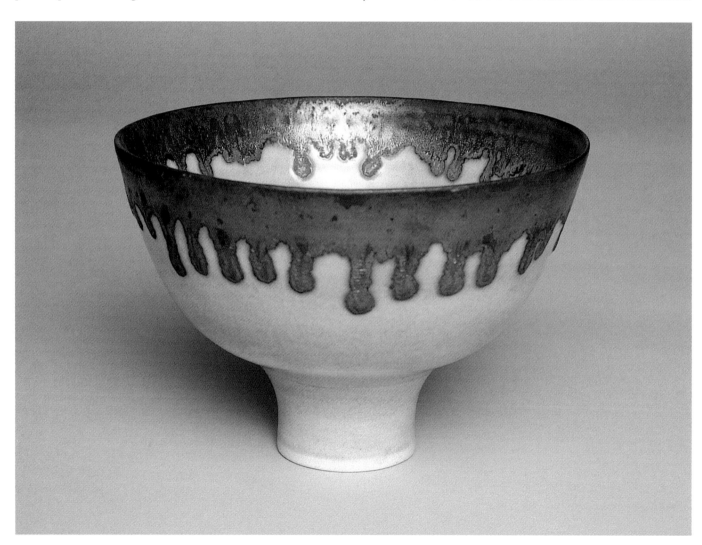

Plate 87: Lucie Rie, porcelain, uranium glaze with bronze rim, c.1980, dia: 16cm.
This yellow glaze is one of her most popular. This dramatic use of the manganese rim became a feature of many later porcelain bowls.

Leach, Coper and Cardew, she became widely acknowledged as 'the world's greatest living potter'. This is not a title, I suspect, she felt at all comfortable with. Despite the fact that it is difficult to see how she could have been much more successful, she always maintained a genuine humility. In 1991, she was created a Dame.

While the importance of her pots is unquestionable, there is also a great deal to be learnt from the attitudes of Lucie Rie. She was hard-working and dedicated and reached the very top of her profession. She transformed modern ceramics and proved that it is possible to achieve more than a subsistence living from making pots. This financial success was achieved slowly, with integrity and with little apparent change in her lifestyle. The artistic success was achieved with indifference to theory and without arrogance or competitiveness.

Inevitably, one comes back to Bernard Leach's statement, 'the pot is the man'. So much of the quality of her work is also the quality of her as a person. There is a strength that is eloquent without being aggressive. There is an elegance combined with humility. There is sophistication without being intellectual. There is a consistency that is timeless. Despite the many changes and innovations in her work it can be very difficult to date an individual pot. Despite many changes in ceramic fashions her work has never looked either trendy or anachronistic. Despite the very many imitators, no one has managed to duplicate the quality of her pots.

It is inevitable that the work of Lucie Rie is almost impossible to discuss in isolation from the work of Hans Coper. This is not just because of the similarity of their backgrounds or the tremendous influence they had on each other during their long friendship and, particularly, during the twelve years working together at Albion Mews. The pots of Rie and Coper also have a tremendous amount in common; in technique, in intent, in quality and in their huge influence on others.

Many have written of their work, trying to establish some polar relationship between them. One popular theory is that Rie's pots are feminine while Coper's are masculine. This rather strained observation seems to me superficial and faintly ridiculous. A second commonly held idea is that Rie's pots are 'functional' and Coper's 'sculptural'. This is almost total nonsense. Both potters and, I might add, most primitive potters as well as Leach, Hamada, Cardew and many others did not differentiate between form and function. Their pots are both 'functional' and 'sculptural'. Apart from a few early works, Coper was determined that every pot should be a container. Many of his pots even have an inner cylinder to hold the flower stems. Anyone who has put flowers in even Coper's most 'sculptural' work will see how much the pots were made with this in mind. It would be more difficult to make use of some of Rie's trumpet-shaped bottles.

Like Lucie Rie, Coper came from a well-off, Jewish, middle-class background. He was born and raised in Germany

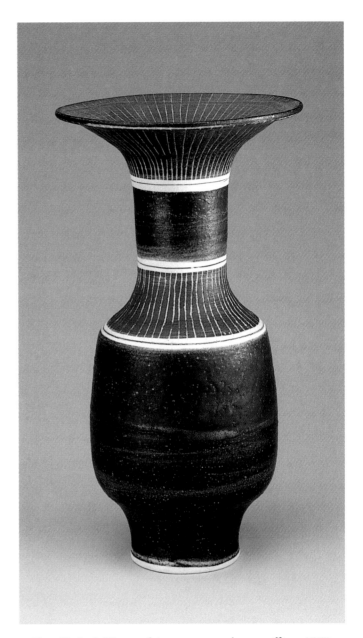

Plate 88: Lucie Rie, porcelain, manganese glaze, sgraffito, c.1980, ht: 19cm.

not far from the Czechoslovakian border. He had a very happy childhood that was in marked contrast to much of the remainder of his life, particularly his teens. Coper reached his teens the same year that Hitler became Chancellor, the Gestapo was formed and Dachau was opened. Increasing anti-Semitism caused the family to move first to Dresden and then to Leipzig and was probably the principal reason for his father's suicide in 1936. The rest of the family moved back to Dresden where Coper studied as a textile engineer, although he was already considering changing to sculpture. In 1939, he escaped from Germany, hiding in a hotel for six months in Wiesbaden while waiting for a safe way out. His mother, who was not Jewish, stayed behind.

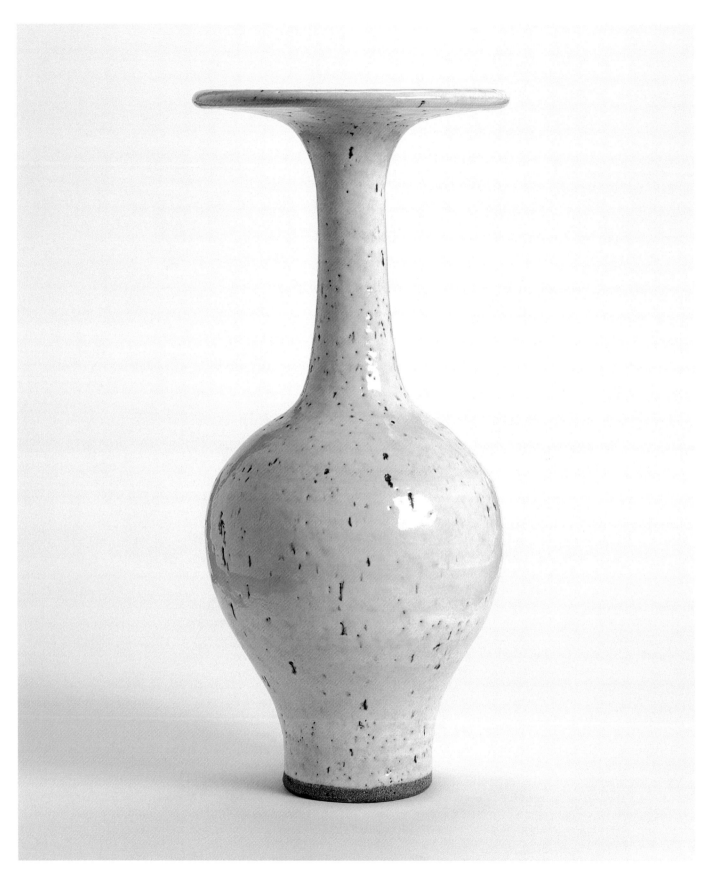

Plate 89: Lucie Rie, stoneware, c.1978, ht: 37cm.
Iron spots that are often an unwanted nuisance to potters are here used intentionally as part of the decoration.

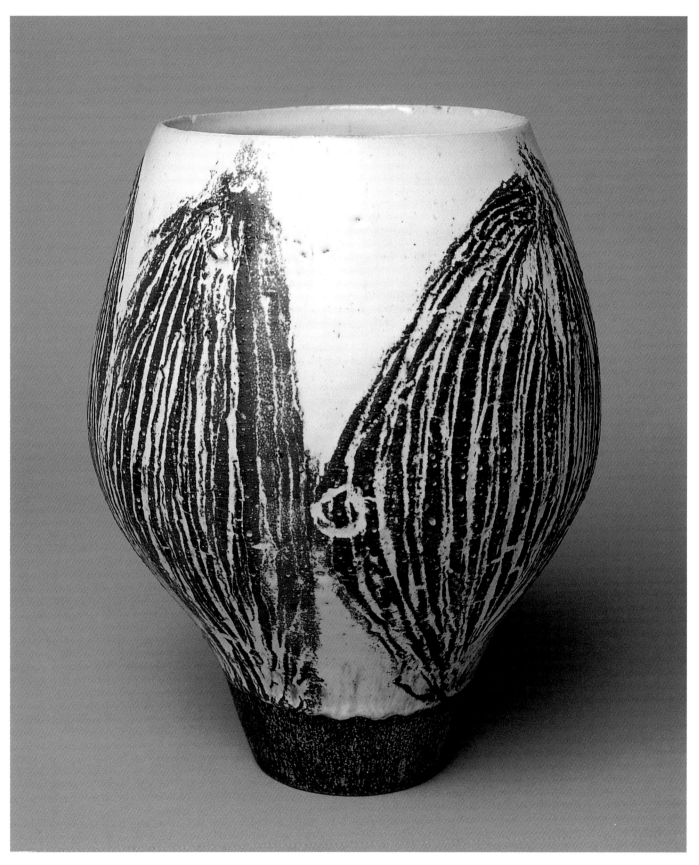

Plate 90: Hans Coper, stoneware, tin-glaze over manganese, sgraffito, c.1951, ht: 25cm.
The influence of Rie is quite strong in this wonderful early pot.

Coper arrived in England with little English and even less money. His predicament was made even worse by his arrest and internment, first in Lancashire and then in Canada. He returned to England as a volunteer to the Pioneer Corps of the British Army. Coper's health disintegrated and, eventually, he was discharged. Amongst his health problems were the first signs of ankylosing spondylitis, a disease causing progressive fusing of the spine and much pain. He took a job winding armaments in the day and drew and painted at night – still hoping to become a sculptor.

1946 brought some change to Coper's fortune when he began work at Albion Mews helping Rie to make press-moulded buttons. Coper took to handling clay extremely quickly and it was suggested by Rie that he learn to throw. Coper went to study briefly at Woolwich Polytechnic under Heber Mathews, one of William Staite Murray's leading students. Mathews was well known for having a strong interest in the relationship between surface and form and, if the choice of him as a teacher was accidental, it was a fortunate one.

Coper learnt quickly and was soon making domestic ware alongside Rie. Despite his being nearly twenty years younger and much less experienced than Rie, the relationship between them was much more one of co-inspirers than of pupil and master. He certainly strongly influenced Rie's designs and even modified her seal-mark as well as designing his own – an HC turned sideways to resemble a bowl on a wheel. He made little 'individual' work before about 1950 as he only worked on these in the evenings. Early attempts at sculpture were soon abandoned in favour of pots.

From the start, Coper shared many exhibitions with Rie, his first being in 1950 at the Berkeley Galleries. He also received much encouragement from Muriel Rose, an influential figure in the pottery world in the 1950s and from Henry Rothschild, founder of Primavera, who was one of the first to sell Coper's pots. Coper's first one-man show in England (of over a hundred pots) was held at Primavera in 1958, though, by then, he had already won the Gold Medal at the Milan Triennale and had a one-man show at Bonniers in New York. Despite all the early support, sales were relatively slow before the Primavera show and many were being bought by one collector. Some years later this collector smashed his collection of over fifty of Coper's best pots because he was worried that he was becoming too obsessed with them.

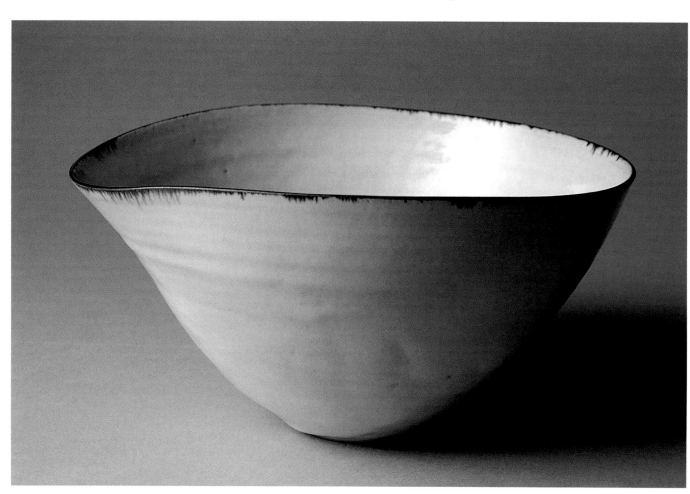

Plate 91: Hans Coper, stoneware, white tin-glaze, c.1955, w: 22cm.
A salad bowl made to Rie's design. Coper's standard-ware has both his sealmark and Rie's.

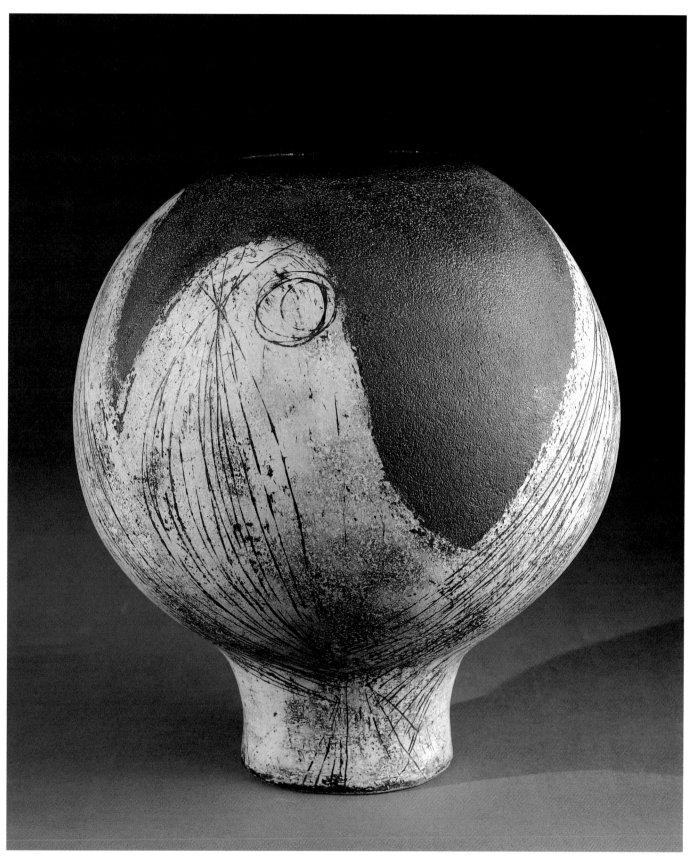

*Plate 92: Hans Coper, stoneware, white slip over manganese, sgraffito decoration, 1953, ht: 31cm.
This pot won the Gold Medal at the Milan Triennale.*

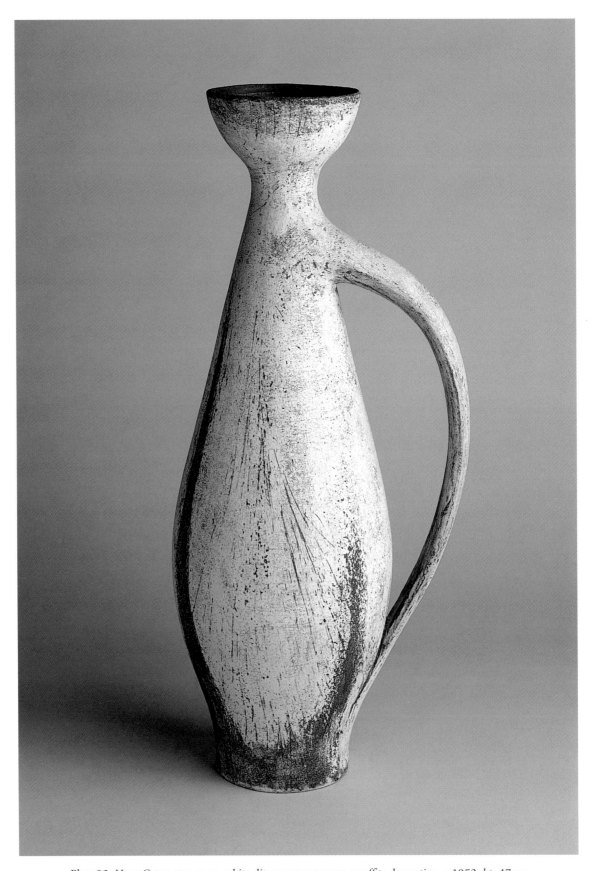

Plate 93: Hans Coper, stoneware, white slip over manganese, sgraffito decoration, c.1952, ht: 47cm.
Handles are rare on Coper's forms.

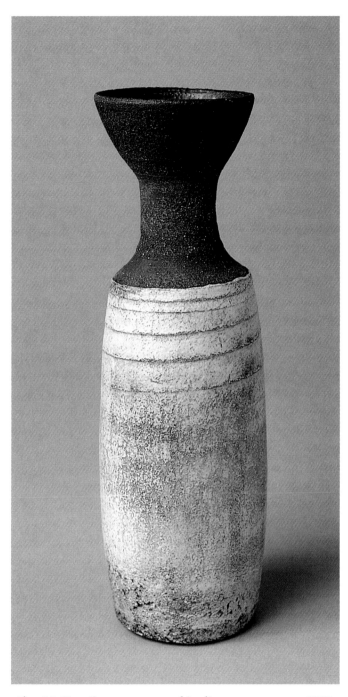

Plate 94: Hans Coper, stoneware, white slip over manganese, c.1958, ht: 22cm.
Coper maintained a high standard even in comparatively modest pots.

Plate 95: Hans Coper, stoneware, manganese black slip/glaze, c.1975, ht: 24cm.
Coper made many 'Cycladic' forms towards the end of his career.

Coper's techniques for making pots were very similar to Rie's. Though, initially, this was necessary owing to the system at Albion Mews, Coper did not very much change his method when he had his own studio. All his pots were thrown on a kick-wheel, most being made in two sections (for the larger or more complex pieces, occasionally more) and carefully joined. Coper really only ever used two different clay bodies and two different glazes. Some critics jibed unfairly that he also only had two different shapes. There

are actually three or four dozen basic shapes and the variations he made from the same shape were impressive. Usually pots were made in 'families' of similar form and often grouped together in exhibitions. The size could vary from a few centimetres to a metre.

Like Rie, Coper raw-glazed all his pots. Apart from a handful of early pieces, everything he made is basically either black or white. There is often a problem what to call glazes and this is particularly so with Coper. He tended to refer to

Plate 96: Hans Coper, stoneware, white slip over manganese, c.1971, ht: 21cm.
The 'spade' shape is one of the most popular with collectors.

Plate 97: Hans Coper, stoneware, white over manganese, c.1967, ht: 62cm.

his 'glazes', while purists often call them 'engobes' and most people think of them as 'slips'. The black pots were glazed with a mixture of iron oxide and manganese dioxide 3and burnished to produce a surface similar to graphite. The white slip was made from a combination of feldspar, whiting and china clay. Applying these with a brush meant that Coper could build up many layers, rubbing or sandpapering after each application. The 'white' pots always have layers of the manganese black underneath that are sometimes partly revealed. No potter has achieved such a harmony between the form and the surface as Coper. Never do his pots look as if they are wearing a coat as so many pots do. The surface of his pots always seems an integral part of the whole.

In his early pots, Coper made extensive use of sgraffito. Unlike Rie who used this technique to produce a controlled, repetitive, decorative effect, Coper used sgraffito in a bold, painterly manner – wide incisions often cutting across the form. The lines made on the black pots are filled with white glaze while the white pots were simply left with the darker manganese coating showing through. He gradually phased out sgraffito in favour of more subtle surface effects – changes in tone or texture or indentations in the pot. Before he moved his studio out of Albion Mews in 1959, sgraffito had almost entirely disappeared.

Coper's influences began to clarify more and more. While he was not against oriental ceramics and had a particular like for Hamada, there was no trace of the oriental in Coper's pots. Coper's main sources were modern European sculpture and early Mediterranean sculpture and ceramics. He admired tremendously Hans Arp, Marino Marini, Alberto Giacometti and, especially, Constantin Brancusi as well as Predynastic Egyptian pottery, Etruscan and Cycladic art. He also was influenced in his decoration by several modern painters, particularly Ben Nicholson.

While successful creatively, life was still not at all easy for Coper. The late 1940s and early 1950s brought him many problems with his finances, his family and his health. Albion Mews was too small for two potters and when Coper was offered space in Digswell House, a large Georgian house in Hertfordshire, newly organized as living and working space for artists, he reluctantly moved. He stayed there for almost five years. Although many of his most characteristic shapes were first developed at Digswell, it was not a prolific period for his pots. He began to discard a great deal more of his work and much of his time was taken up by various commissions from architects. These included several murals as well as designs for acoustic bricks, tiles and even a wash-basin. Perhaps the most satisfactory of these commissions was that of the candlesticks for Coventry Cathedral.

In 1963, Coper moved back to London to a house in Princedale Road. A year later he moved his studio to Hammersmith. These years in London, from 1963 to 1967, were the most prolific of his career. Most of the hour-glass shaped pots and many of those with discs were made during this period. A one-man exhibition of his work was held at the Berkeley Galleries in 1965 and he shared the large exhibition at the Boymans Museum in Holland in 1967 with Lucie Rie. It was in this exhibition that the most famous of all his shapes, the spade, first appeared.

By now, Coper had taken up part-time teaching. He was reticent, but Rie had begun teaching at Camberwell and the money was much needed. He taught at Camberwell from 1961 to 1969. In 1966, he was persuaded to teach one day a week at the Royal College of Art. It was here, even more than at Camberwell, that Coper's brilliance as a teacher really had its effect. His uncompromising, perfectionist attitude and his dictum, 'why before how', impressed every student he came in contact with. It would be difficult to find anyone who did not have the highest regard for him as a teacher. Coper taught until 1975 and his students at the RCA, the subject of a later chapter, were at the heart of the tremendous revival of interest in British ceramics that took place in the late 1970s. These students included Elizabeth Fritsch, Alison Britton, Jacqueline Poncelet, Carol McNicoll, Geoffrey Swindell, Jill Crowley and Glenys Barton – an impressive list. Coper's pots have been repeatedly imitated, but not by his students, all of whom have been highly individualistic.

In 1967, Coper bought and moved to a farmhouse near Frome in Somerset. He had barely finished making necessary alterations and organizing a workshop when he was approached by the Victoria & Albert Museum who wanted him to share a large exhibition in 1969 with the weaver, Peter Collingwood. Coper spent a full year making pots for this exhibition and, eventually, included over a hundred. The show was not a complete success from his point of view, but it did bring awareness of his work to a large number of people.

It was in this exhibition that the first of his famous 'Cycladic' pots appeared. Coper had made an earlier, somewhat unsuccessful, attempt to make thin, stable forms by sticking several pots together – 'tripots' as they were called. Now he threw a small drum-like base and mounted the form on this. The two parts were drilled and cemented together using part of a steel knitting needle for support. This meant that the point of contact between the base and the rest of the pot could be reduced to almost nothing. The pots were supported in the kiln by a collar – the reason for the bare ring of clay often visible on these pots. Some feel these 'Cycladic' pots are the best of all of Coper's work.

The first years at Frome were some of the happiest of Coper's life. He was making up to 200 pots a year and took part in many exhibitions. He also took long periods away from potting including one to design and build an extension to the farmhouse. But by about 1974, Coper's health began noticeably to deteriorate. It was widely believed that he was suffering from manganese poisoning, but, eventually, he was diagnosed as having motor-neurone disease. Increasing pain and immobility meant that he made smaller pots and the number he made decreased until he had to stop altogether in 1979.

Plate 98: Hans Coper, stoneware, manganese black slip/glaze, c.1963, ht: 33cm.
This is a typical shape from the Digswell years. Lucie Rie particularly admired this pot.

Coper's last show of new work was held in 1975. About thirty pots were shown and yet another new variation appeared in his work. On many of the pots the white slip had blistered or flaked off leaving patches of clay showing through.

In 1980, the Hetjens Museum in Düsseldorf arranged an exhibition for Coper's sixtieth birthday consisting of his pots drawn from collections in Germany and Holland. This was followed by a major memorial exhibition organized in 1983 by the Sainsbury Centre for the Visual Arts. This was shown at the Sainsbury Centre, the Hetjens Museum, the Boymans Museum and at London's Serpentine Gallery.

The news that Coper had stopped potting came at about the same time as the deaths of Leach and Hamada. This was a leading factor in the transformation of the pottery market that happened in the 1980s. While the prices of many potters' work rose beyond recognition, no one's prices leapt as much as Coper's. Throughout his working life, his pots were sold for tens of pounds. In 1980, a pot bought originally in 1970 for £55 was sold in auction for over £1,000. The ceramic world was shocked and most people assumed prices would fall again. I remember vividly making the rash prediction that a Coper pot would reach £10,000 by 1990 and being believed by no one. In the event, a Coper reached £10,000 in 1983 and, in 1986, one reached almost £40,000. I doubt the end will come even when a Coper pot sets a record for any piece of Western ceramics.

The prices for pots by Leach, Hamada, Rie, Fritsch and others also rose dramatically. Most pots by Bernard Leach would now sell for over a hundred times the original purchase price. In 1978, £100 for a pot would have been an enormous sum. Ten years later, £400 or £500 was almost standard exhibition price for the best work of even fairly unknown potters. By 1990 there were, at least, twenty potters whose best pots would cost over £1,000.

This huge change in the price of pots has brought about many changes in the ceramic world, not all of them welcome. Most early collectors are unable or unwilling to pay the new prices. Few still use their Lucie Rie coffee set or their Michael Cardew teapot. On the positive side, pots, at last, have become profitable. It is a sad fact of life that many people refuse to believe something can be any good unless it is also expensive. Critics and journalists suddenly began taking an interest, bringing many new collectors into the field. Some just collect with investment or social kudos in mind, but the majority have a genuine interest. With new collectors have come new galleries. These are not just new 'craft shops', but are galleries showing ceramics on the same level as 'fine art'. For the first time since the 1930s it became possible for at least some potters to make a decent living from pots without having to make and sell a hundred each week. This has enabled potters to radically change their working method and the sort of work they make.

Hans Coper was unintentionally partly responsible for these changes and it was, very largely, Coper's students who forged a new attitude to modern ceramics.

Plate 99: Hans Coper, stoneware, manganese black slip/glaze, c.1975, ht: 33cm.
A 'cycladic' arrow form.

Chapter 8

St Ives after the War

Ironically, the war, which caused so much havoc to British ceramics, was an important factor in the success of the Leach Pottery. Certainly much of this success must be credited to David Leach. Thanks to his technical training and practical mind, he put the Pottery on a firm basis in the late 1930s by introducing a number of technical improvements and by making the change from slipware to stoneware. Despite being damaged by a German land-mine in 1941, David Leach and William Marshall both being called up and suspicion that the pro-Japanese Bernard Leach was using the kiln fire to signal to the enemy, the Pottery somehow managed to keep in production throughout the war.

When the war ended, there was a huge increase in demand and most suppliers were not yet in production. The Leach Pottery had a mail-order catalogue out by 1946 and the major London retail outlets, tired of utilitarian wares and unable to get the decorated industrial wares from Stoke, were begging the Pottery to give them anything they could make. Liberty's, Heal's, John Lewis and Peter Jones all began stocking Leach standard-ware and demand exceeded supply thereafter. In David Leach's words this was 'a stupendous change from, say, 1937 when I went all over the country in a battered two-seater Morris with two suitcases of samples in the back … and jolly pleased with a £5 order at the end of the day'. Not only did this opportunity put the Leach Pottery on a sound financial basis for the first time, but it also gave much wider exposure to Leach's designs and studio pottery, in general.

Leach's formula of repetition ware as a basis for the production of individual pots had an advantage beyond the obvious commercial one. Most potters producing work at the wheel benefit greatly from working frequently. The freedom and fluidity necessary in creating thrown work that does not look laboured is, in most cases, only acquired by long hours at the wheel. I am sure that one of the reasons thrown pottery became unfashionable in the 1970s and 1980s is that many potters were so financially reliant on their teaching, rather than on their pots, that they simply did not have the time to keep this skill at its peak.

By 1952, there was a team of ten working at St Ives and the catalogue offered over seventy different items – everything from eggcups to entire tea services. Most of the pieces were

glazed in celadon, tenmoku, or in an oatmeal-coloured glaze that was suitable for brush decoration with iron or cobalt. Many of these pieces were decorated by Bernard Leach himself and they usually carry his painted initials. In addition,

Plate 100: Leach Pottery, stoneware, 1950s, ht: 22cm. Standard-ware designed by Bernard Leach was copied by many other studio potters.

there were the individual pots, mostly by Bernard Leach, but also some by David and other potters working in the Pottery.

From the time he began his apprenticeship in 1930, it had always seemed likely that David Leach would take over his father's Pottery, but when Bernard Leach decided to return to St Ives with his third wife, Janet, both David and his younger brother, Michael, decided to set up their own potteries. Michael Leach established the Yelland Pottery at Fremington in North Devon where he made good work in both slipware and stoneware. David Leach established the Lowerdown Pottery near Bovey Tracey in Devon where he has worked ever since. This pottery was organized very much in the same way as at St Ives – a small team making domestic ware as a basis for some individual pots.

For the first few years, while a large stoneware kiln was being built, he concentrated solely on the production of slipware, much of which is, by his normal standards, mediocre. In 1961, production of stoneware and porcelain began and this was much better. The style was very close to that of his father, but the difference in their nature made for very different pots. A fluted, celadon, porcelain bowl by David Leach looks nothing like the same thing made by his father. The Bernard Leach bowl would be thick, bold, rough, opaque with wide fluting and little difference in colour between body and glaze. David Leach's would be thin, smooth, translucent and with precise, narrow fluting and a wide range of colour – from jade green to 'ying ch'ing' blue – on a white body. Which one prefers is, of course, just a matter of taste, but it is generally felt that David's temperament was more suited to porcelain while Bernard's was more suited to stoneware.

David Leach did not have much time or interest in making individual pots when at St Ives. He considered himself more as part of a team. His commitments at St Ives as well as his teaching at the Penzance School of Art and the Loughborough College of Art, and his establishing of the excellent Friars Pottery at Aylesford in Kent and another at Sandefjord in Norway would have made it difficult to do individual work, anyway.

At Lowerdown, his gifts as an individual potter began to emerge. Many of David Leach's pots are incredibly beautiful. He is an outstanding thrower and is one of the few potters able to make really successful large pots. His technical skill is excellent. Many of his tenmoku and celadon pots show a remarkable degree of control. While his work is superficially similar to his father's, his pots are never copies.

David Leach's first major one-man show was held in 1966 at the Craftsmen Potters' Association and many more

Plate 101: David Leach, porcelain, celadon-glaze, 1979, dia: 11cm.
David Leach's fluted celadon porcelain bowls are one of the most familiar images of British studio ceramics.

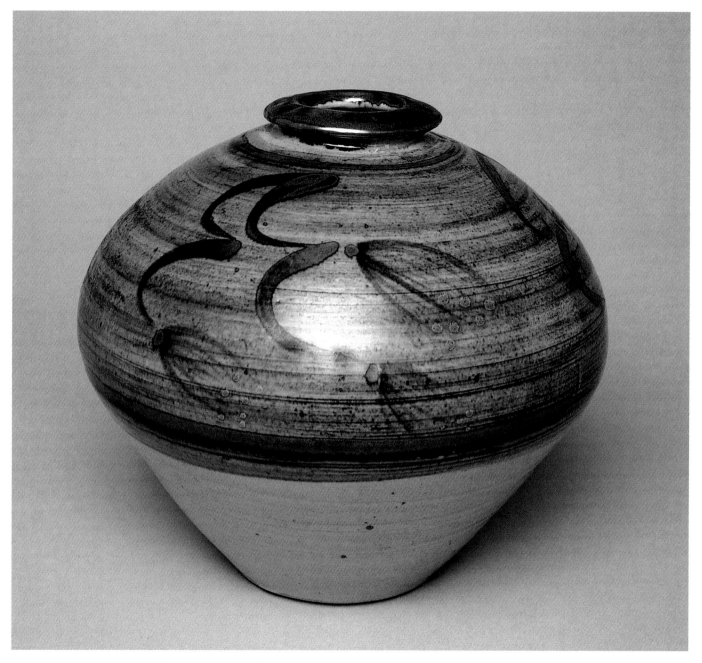

Plate 102: David Leach, stoneware, painted with iron and cobalt, c.1980, ht: 24cm.

followed in nearly every major craft shop in England. He also exhibited in New York, Washington, Tokyo, Istanbul, Copenhagen, Rotterdam, Düsseldorf, Heidelberg and Munich – all before 1980. In the 1980s, his success, if anything, was even greater. There have been few potters whose work is as universally popular as that of David Leach. It is very sad that, even today, some consider him to be simply a minor version of his father.

When David Leach returned to St Ives in 1937 after two years' technical training in Stoke-on-Trent, one of the many changes he made was the introduction of local apprentices. Previously, apprentices had mostly come from London art

colleges and only stayed a year or two and this was an attempt to get a more permanent staff.

The first of these local boys was William Marshall who joined the Pottery in 1938 at the age of fifteen. He stayed for almost four decades. Marshall became a skilled thrower and, eventually, became foreman at the Pottery and was almost entirely in charge of the production of the standard-ware. Towards the end of this period, particularly, he also made quite a number of individual pots.

The great majority of Marshall's work is in the style of either Bernard Leach or Hamada. The Leach-style pots are often uncomfortably close to the originals. This is, perhaps, not all

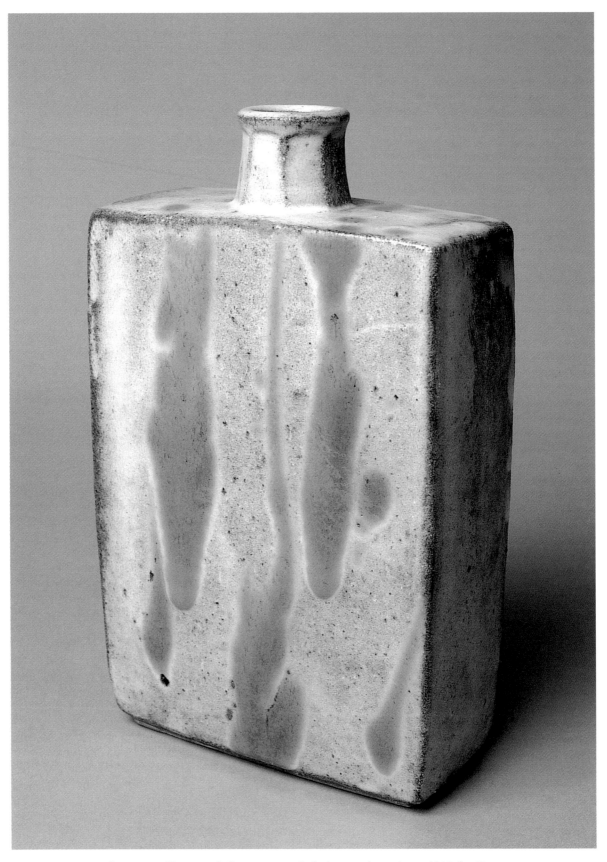

Plate 103: William Marshall, stoneware, splashed copper decoration, c.1987, ht: 29cm.
Moulded bottles like this are reminiscent of Hamada's later work.

that surprising. Towards the end of Bernard Leach's career, when he was suffering from increasing age and decreasing sight, many of his pots were thrown by Marshall. Leach would then 'refine' the pot and decorate it, but there is no doubt that this process greatly altered the nature of the larger pots.

Marshall's Hamada-style pots are much better and much more his own. He became especially adept at using hakeme. His small yunomis (a Japanese teacup) and teabowls in this glaze are often superb. He also made excellent rectangular, moulded bottles either with tenmoku or a splashed glaze and a number of large dishes all of which, though inspired by Hamada, were very obviously the work of Marshall. His use of porcelain has always been excellent.

After Leach stopped making pots the standard-ware was phased out and there was little reason for Marshall to remain at the Leach Pottery. In 1977, he set up his own pottery at Lelant only a few miles away where he remains today. At Lelant, he has not been nearly as prolific as many people would have hoped. As a result, the quality of his work has been, at times, very uneven. The best of Marshall's work, however, is truly excellent and he remains one of Britain's finest 'Oriental' potters.

Another local boy who made good was Marshall's cousin, Kenneth Quick, who joined the Pottery in 1945 at the age of fourteen. Quick seemed to possess a genuine natural talent. He soon became a very skilled potter and he developed a style of his own (though it owed much to Hamada) at a remarkably early age.

He had two periods at St Ives, from 1945 to 1955 and from 1960 to 1963. In the intervening years he had his own pottery at Tregenna Hill and spent six months in America. While visiting Hamada in Mashiko in 1963, Quick accidentally drowned.

This tragic incident cut short the career of undoubtedly one of the most promising potters to work at St Ives in the post-war years. Quick's pots are rare, but those that I have seen have often been fresh and original – especially those made at St Ives in the 1960s. Had he lived, it is possible that he could have helped revitalize 'Oriental' pots in the 1970s when they came under such attack.

The flow of visiting potters at St Ives continued. Many fine potters came from abroad, stayed for a while and returned to their own countries, often to further spread the Leach gospel. These include such important figures as Gutte Eriksen from Denmark, Shigeyoshi Ichino and Hamada's son, Atsuya, from Japan, John Reeve from Canada, Cecil Baugh from Jamaica and, most importantly, America's Warren MacKenzie. Many others were English including John

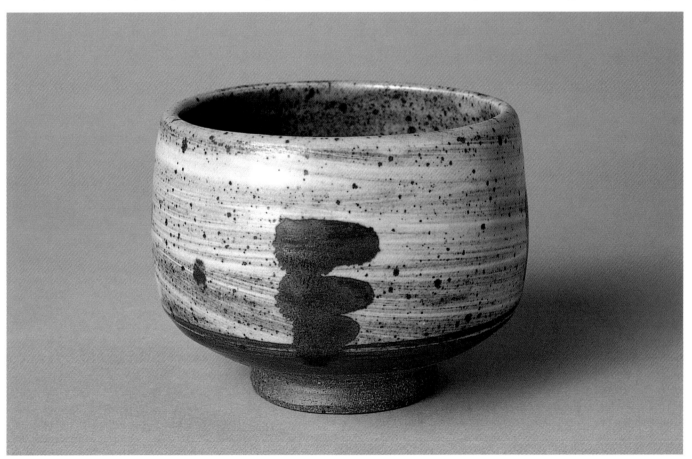

Plate 104: Kenneth Quick, stoneware, hakeme with iron decoration, c.1961, dia: 12cm.
The influence of Hamada is obvious in this bowl.

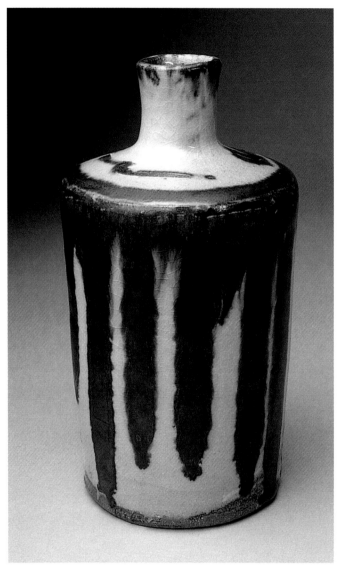

Plate 105: Shigeoshi Ichino, stoneware, c.1972, ht: 17cm.

accept and even buy Batterham's work. He has proved that the Leach method can still be as relevant today as it was fifty years ago.

Most of Batterham's pots are stoneware with a variety of green wood-ash glazes. He often adds an iron-glaze similar to tenmoku and has worked also with salt-glaze. He never uses brushwork, relying instead on simple cut or incised designs for decoration. His large bottles and jars are quite wonderful. He is one of the few throwers who works really well on a large scale and his cut-sided decoration is unequalled.

Initially, Batterham's work was made in large quantity and sold at low prices as domestic ware in craft shops and smart kitchen shops. Over the years, he has reduced production and included more 'individual' pots at somewhat higher prices. While this has obviously meant less dinner plates and more large pots, the nature of his work is fundamentally unaltered. The difference between an 'individual' potter, Hans Coper, for example, who makes many similar pots in refining a shape and a 'repetition' potter, such as Batterham, is not as great as is often supposed. Whether one labels pots as domestic ware or individual pots is unimportant. All that really matters is the life and quality they have. In Batterham's work the quality is always extremely high. His particular interpretation of 'Orientalism' became widely copied in the 1980s and 1990s.

Probably the finest of all 'repetition' potters was Harry Davis. Davis joined the Leach Pottery in 1933 while still in his early twenties. With Bernard Leach away in the Far East and David Leach away at Stoke, he actually ran the Pottery (with Laurie Cookes).

In 1937, Davis went to the Gold Coast to set up the pottery at the Achimota College – a project that was taken over by Michael Cardew when he left. He also travelled and worked in the Americas. In 1946, he returned to England and established the Crowan Pottery at Praze, in Cornwall, with his wife, May. Davis was an advocate of intermediate technology and he converted an old mill so that the pottery was water-powered.

Crowan was set up very much along St Ives lines, but without the production of individual pots. Davis concentrated solely on domestic ware – making the vast majority of the pots himself. The quality and practicality of Crowan pots is exceptionally high. The body was so strong that Davis could test his dinner plates by standing with his feet on each side of the rim and rocking. His skill as a thrower was legendary. There are many apocryphal stories of Davis exactly duplicating one of his broken teacups years after it had been made – not an easy task.

Crowan wares are either porcelain or a fine stoneware and are usually decorated with brushwork or with wax-resist. The designs are simple and unpretentious with much less of the Oriental influence than Leach's designs. He was assisted by his wife and a very small team of assistants who mostly performed the various preparation tasks and helped with kilning. Amongst the potters who worked with Davis

Bedding and David Leach's son, John, who have both produced excellent work.

Perhaps, the best of all the young English potters to work at St Ives is Richard Batterham. He had always wanted to make pots and when he attended Bryanston School in Dorset he learnt how to do so under the tuition of the aptly named Donald Potter. He then spent two years at the Leach Pottery before setting up his own pottery near Blandford in Dorset.

Batterham is a potter direct from the heart of the Leach tradition. His inspiration is Oriental, Korean Yi, and so on, but no one would mistake a Batterham for an Oriental pot or a Bernard Leach. He produces beautifully made domestic ware, unsigned, with low technology and great humility. His designs are superb and he quickly developed a highly personal style. Many of those who, generally, have nothing good to say about English 'Oriental' pots, readily

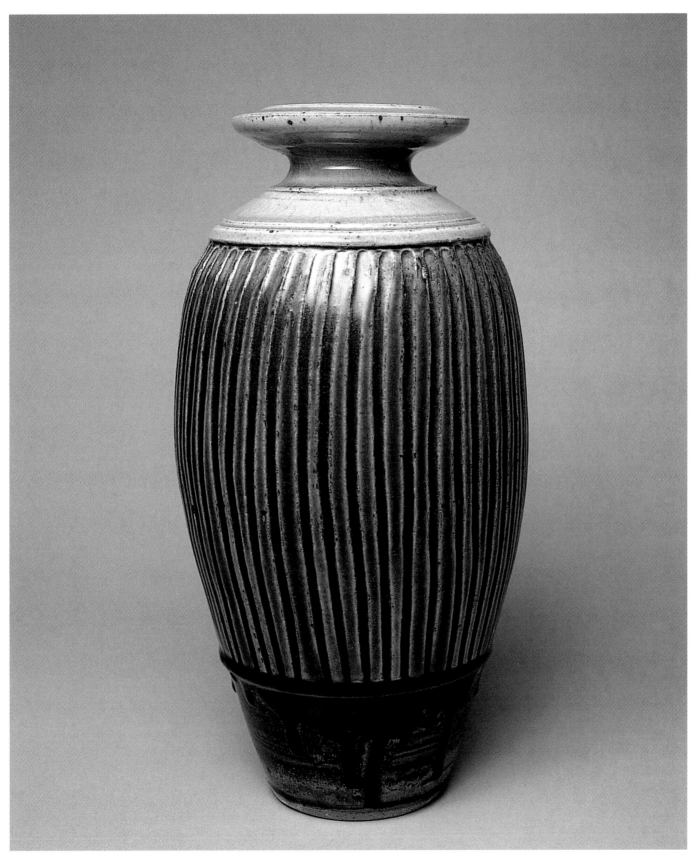

Plate 106: Richard Batterham, stoneware, ash-glaze, 1990s, ht: 39cm.
Batterham's ash-glazes have been imitated by many younger potters.

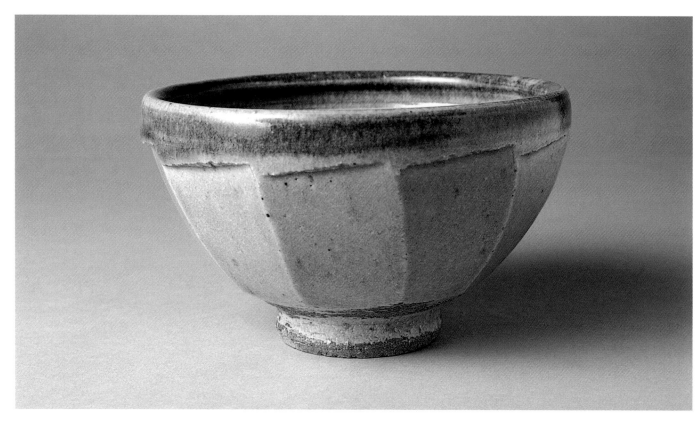

Plate 107: Richard Batterham, stoneware, ash-glaze, 1994, dia: 17cm.
Batterham has a distinctive style of cutting.

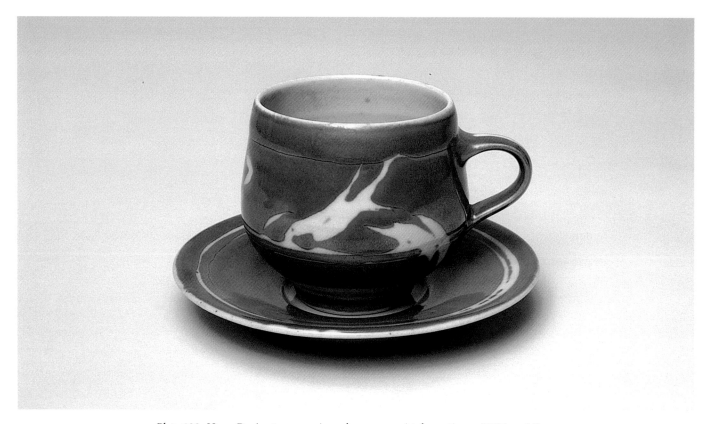

Plate 108: Harry Davis, stoneware, iron-glaze, wax-resist decoration, c.1955, w: 16cm.

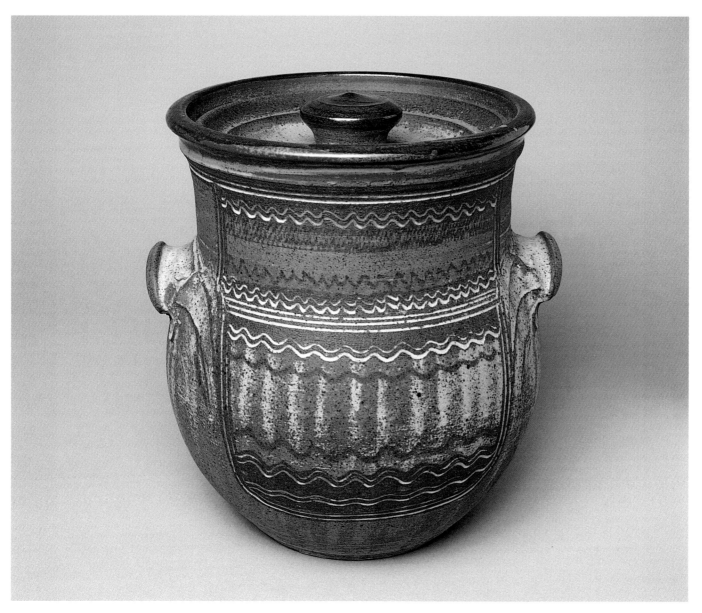

Plate 109: Michael Casson, stoneware, iron-glaze, c.1980, ht: 32cm.

in the early 1950s were the two great German potters, Karl Scheid and Margaret Schott. Davis often worked with Germans who, he felt, were the only ones who worked as hard as he did.

In 1962, the Davises emigrated to New Zealand taking most of their equipment with them. There, they established the Crewenna Pottery and continued very much as before. Davis continued to travel extensively – particularly, in the Third World – and to spread his version of the Leach philosophy. He remained in New Zealand until his death in 1986. Today, his fine work has, undeservedly, been forgotten by many.

Of course, not all 'Leach' potters actually worked at St Ives. Throughout England and much of the rest of the world, potters read *A Potter's Book* and set up production in

the prescribed manner. Most of these potters produced very dreary work, but there were many who were excellent. Two of the best are Michael Casson and Geoffrey Whiting.

Through his teaching, lectures, books and television appearances, Michael Casson became something of a minor celebrity. If there is a popular, archetypal image of the country potter – beard, chunky sweater and wholemeal bread – then Casson seemed to most perfectly fit that description. His skill and influence as a communicator have been at least as important as his influence as a potter and he was highly instrumental in the revival of salt-glazing.

Casson is a very skilled potter who, especially in stoneware, has produced a lot of very good work. His pots are amongst the most popular of any potter, but some collectors feel that his work is lacking in some way. Perhaps, the

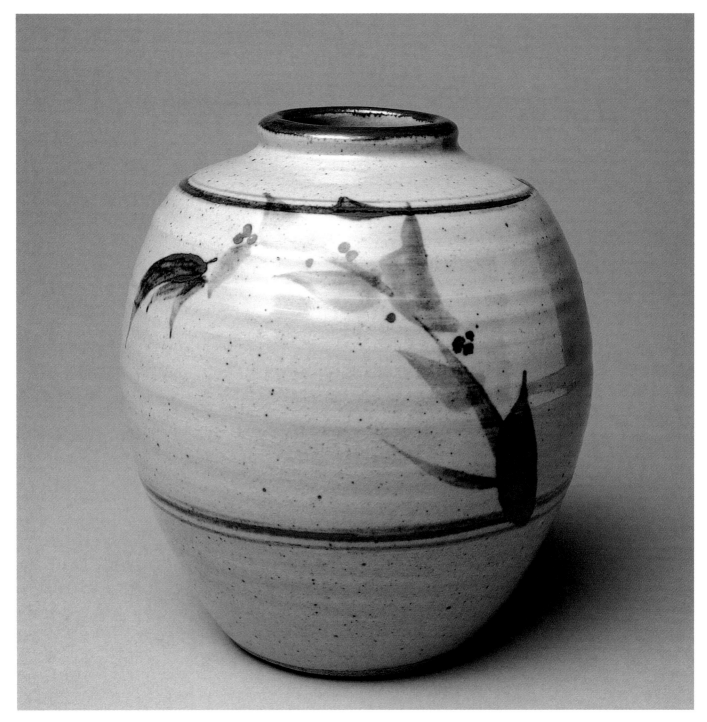

Plate 110: Geoffrey Whiting, stoneware, painted with iron and cobalt, c.1980, ht: 18cm.
If Whiting had made his work at the Leach pottery he would probably be much better known.

emphasis is too much on 'craft' rather than 'art'. His jugs are an exception to this. Apart from Cardew's slipware, Casson's jugs are, possibly, the finest that any potter in this country has made.

Although Geoffrey Whiting was little more than a visitor at St Ives, he was as much a 'Leach potter' as it is possible to be. While his pots are thoroughly in the Leach tradition (and some of his utilitarian pots are almost indistinguishable from Leach standard-ware) most of his work has an instantly recognizable individual style. Whiting's pots have little of the roughness sometimes seen in some 'Leach potters' – detractors sometimes describe his work as 'pretty'. He worked in a wide variety of decorative styles, both in stoneware and porcelain. Invariably, the pots were simply and beautifully executed and his small teabowls and teapots, in particular, are often quite superb. Despite being one of the

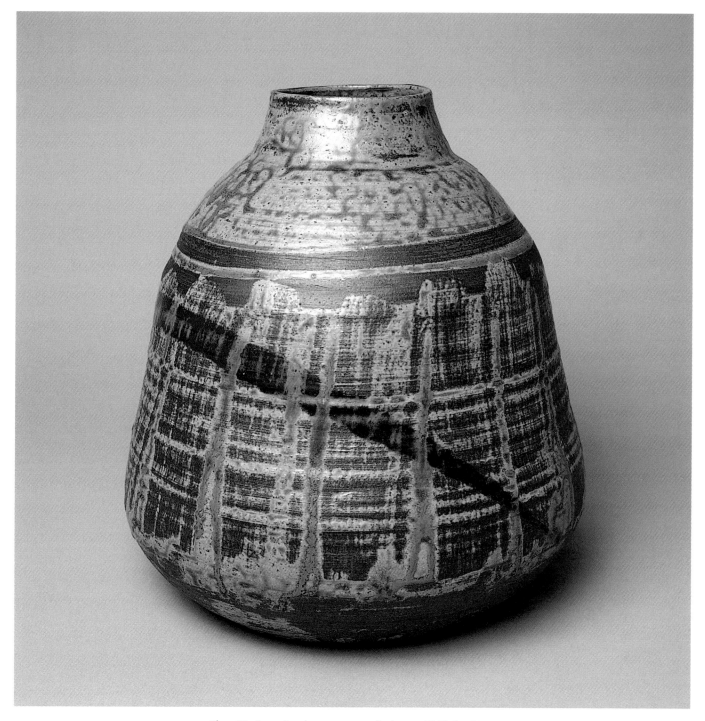

Plate 111: Janet Leach, stoneware, ash-glaze, c.1980, ht: 31cm.
She often made her green glazes using local stone.

few 'Oriental' potters to have had a touring retrospective he is still not as known as he deserves to be.

The strongest and, probably, the most interesting of all the post-war St Ives potters was Janet Leach. She is one of the most under-rated potters in England. She was born Janet Darnell in Texas in 1918, but, later, moved to New York. Her early training was both in pottery and sculpture. This is somewhat ironic in view of her outspoken criticism of

ceramic sculpture. After her ceramics training at Alfred University in the late 1940s she organized a small pottery also in New York State.

Bernard Leach, Yanagi and Hamada toured the USA in 1952. Later, Janet Leach wrote, 'The import of meeting Hamada at Black Mountain College in the autumn of 1952 was so strong that it changed my entire life.' In 1954, she went to Japan for two years where she spent six months at

Mashiko with Hamada and travelled and learnt a great deal. She also had a lengthy stay at the Tamba Pottery, which deeply influenced her work. It was here that she learnt the technique of firing in the Bizen manner where the pots are fired unglazed and decorated by the action of straw or wood ash placed in the kiln.

In 1956, she came to England, married Bernard Leach and settled at St Ives, effectively also taking over management of the Leach Pottery. There has been a great deal of unfair criticism over Janet Leach's phasing out the production of standard-ware and the endless flow of students at St Ives. For years, she astutely handled the business and management of the Leach Pottery even though she had little interest in domestic ware and it meant that her own individual work had to take second place. It was only natural that she should run the Pottery according to her own interests when Bernard Leach ceased to take an active part. However, this – together with her often abrasive manner – did not make her popular.

Right from the start, it was clear that Janet Leach was not going to imitate her husband's pots. Her work had a very great deal in common with Japanese peasant pottery –

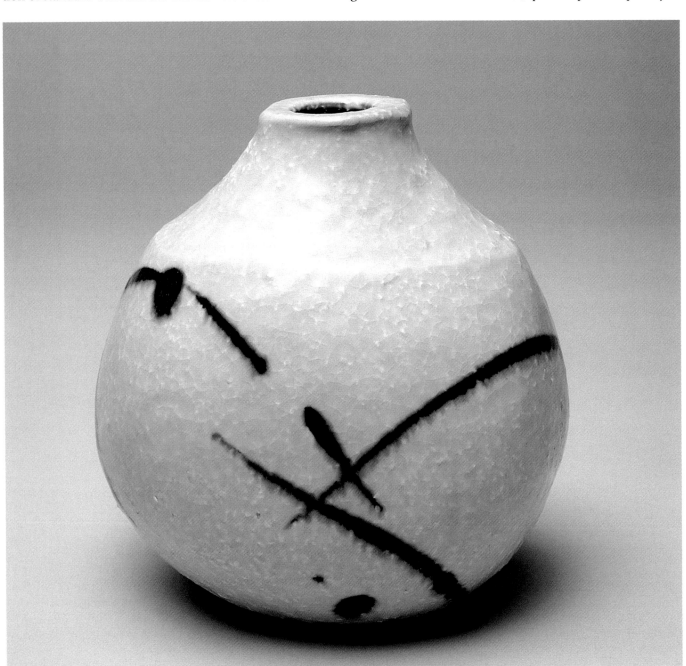

Plate 112: Janet Leach, porcelain, celadon-glaze with trailed iron decoration, c.1978, ht: 17cm.
This pot is made in a mould. It is interesting to compare this to the very different Hamada porcelain pot made fifty years earlier.

squat, asymmetrical, rough, often with dry surfaces – but little in common with the Leach–Hamada style almost universally used by St Ives potters. She did, however, come very far in producing the East–West synthesis that was so central to Bernard Leach's philosophy. Her pots are obviously Japanese, obviously Western and obviously Janet Leach.

The power of her work, particularly on a large scale, is its most notable feature. Many who are used to the more gentle varieties of 'Oriental' pots find her work offputting and frightening. She was capable, though, of a wide range of moods in her work. Some of her pots are very quiet and calm; others are very aggressive. Often her pots are dented or scored with a stick or tool and this violence to the clay seems to communicate itself to whomsoever sees the pot. Undersized lugs or weak handles were often placed in pairs, emphasizing the asymmetry.

Janet Leach, in common with many throwers who are prolific, produced work of variable quality. She placed great importance on exhibitions and her best pots were almost always kept back. Much of her best work, unseen in England, has gone to Japan, where she is greatly appreciated and had regular exhibitions. Too many people have judged her work on examples that they have seen in craft shops. Those pots of hers in craft shops had usually been considered by Janet Leach as below her exhibition quality and were also pots that had failed to find a buyer. A second-rate Janet Leach is a second-rate pot, but the best of her work is magnificent.

Though she has experimented with a variety of techniques, her pots, generally, fall into four distinct categories. Firstly, are the wood-fired 'Bizen' pots. These pots, perhaps closest to the potter's heart, are the most difficult for the unaccustomed eye to accept. A second variety are her ash-glazed pots. She used a variety of ash-glazes and in the 1980s experimented extensively and successfully with a Dorset Hamstone glaze. Janet Leach used the variable kiln conditions rather than trying to control them. These glazes, usually green, were often fired to a very liquid state so that they made their own pattern in the kiln.

Though she occasionally slab-built her stoneware, most pots were thrown. Not so with her unusual use of porcelain. The clay was very heavily grogged and couldn't be thrown; therefore most pots were slab-built or moulded. The pots were glazed with the standard St Ives 'ying ch'ing' celadon and iron decoration was poured or trailed. The result, thick and textured, is totally unlike anyone else's porcelain.

The fourth type of her pots is usually the most popular. The stoneware body, either a rust-red or a purple-black produced by the addition of chrome ore and bauxite to the clay, was left largely unglazed. A white, semi-opaque glaze was then poured on the pot, usually covering the inside of vases, but only appearing on the outside in sword-like slashes or dramatic splashes cutting across the form. In the 1980s, she also added the combination of a black glaze on the black body.

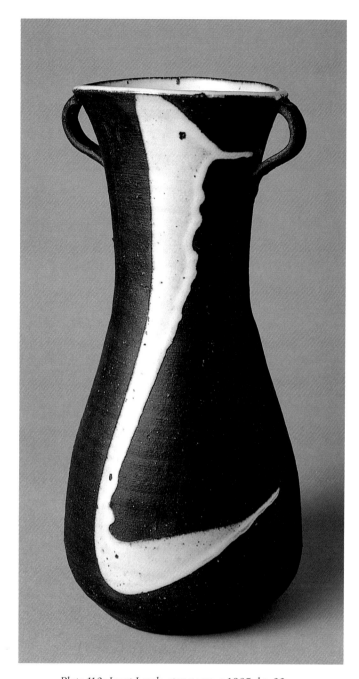

Plate 113: Janet Leach, stoneware, c.1985, ht: 32cm.
The combination of a black body and a poured white glaze is common in Janet Leach pots of the 1980s.

For twenty years the Leach Pottery had been just Janet Leach and one or two other potters – very different from its first fifty years. For many, this change was a very sad one. For others, it had been welcome and overdue. With her death in 1997, the long-term future of the Pottery is in some doubt. Whatever one thinks of the values held by Bernard or Janet Leach, one thing is clear: many excellent potters worked at St Ives both before and after the Second World War. The mark they have left on the development of British studio ceramics cannot be erased.

Chapter 9

Handbuilding

Today, when so many of our best potters use handbuilding techniques, it is almost impossible to realize how much handbuilding was a totally revolutionary concept in British studio ceramics before the late 1950s. Apart from isolated experiments, all pots were thrown, basically round and usually with a smooth, shiny glaze. This obviously had something to do with the great practical advantages for work that was supposedly functional. Thrown pots are quicker to make and more durable. Smooth, round pots are nicer to hold and easier to clean. There was, however, a certain cultural myopia involved. Many 'primitive' cultures make exquisite and practical vessels by coiling.

Helen Pincombe had worked in the post-war years with handbuilding techniques, but her pots, like Leach's moulded ones, were firmly rooted in the Oriental tradition. Generally, handbuilding was considered to be only suitable for amateurs. By the 1960s, however, a whole new group of potters emerged with little interest in Oriental ceramics or the potter's wheel. They were mostly trained as sculptors or painters and found themselves working in clay with source material drawn as much from contemporary art as anything else. For many of these potters, the Central School and William Newland provided their main ceramic training and the Primavera Gallery, opened just after the war by Henry Rothschild, became their main showplace.

One of the finest of the potters who began handbuilding in the 1950s is Gordon Baldwin. He had two years' training at the Lincoln School of Art under one of Bernard Leach's pupils before a further period of study at the Central School.

Baldwin's pots of the mid- and late 1950s display the dichotomy that has always existed in his work between the 'vessel' and the 'sculpture'. On the one hand, he was making stoneware bowls – tableware, almost – decorated in a manner influenced strongly by contemporary artists like Victor Pasmore. At the same time, he was making highly sculptural pots that were very much part of the modern movement in British sculpture. Baldwin was very drawn to the work of William Turnbull and Eduardo Paolozzi, two leading figures in sculpture who were teaching at the Central School. Baldwin used a wide variety of techniques – throwing, coiling, slabbing, press-moulding – in creating his pieces.

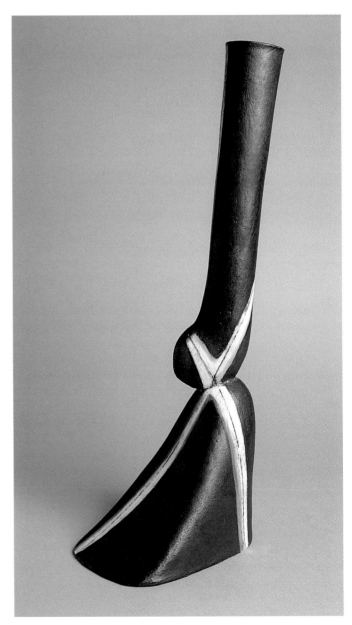

Plate 114: Gordon Baldwin, painted earthenware, 1985, ht: 62cm. This was part of Lilianna Epstein's excellent collection of Baldwin's work.

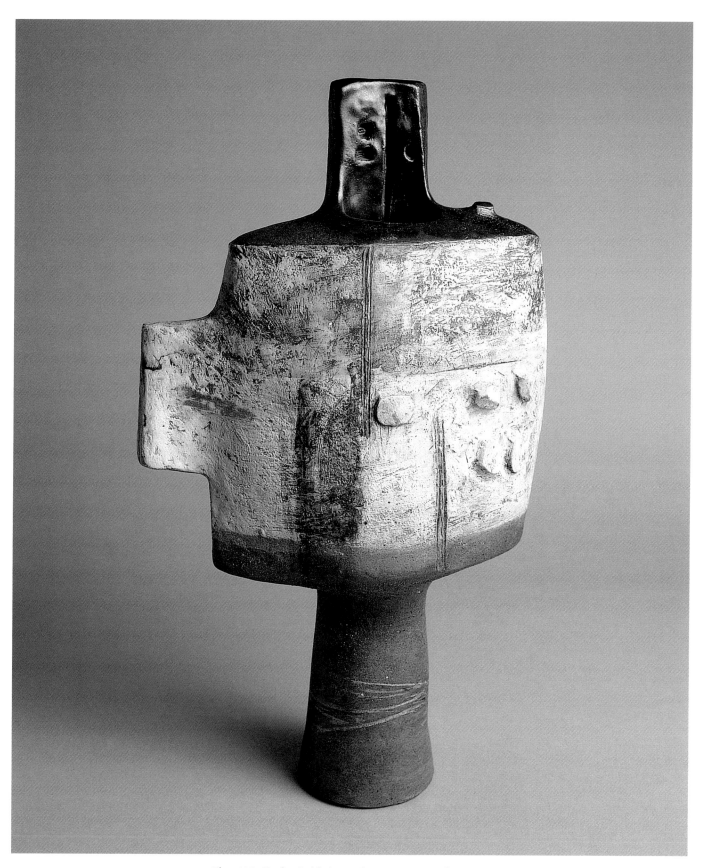

Plate 115: Gordon Baldwin, earthenware, c.1959, ht: 55cm.
The influence of other British sculptors is evident in his early series of pots called, 'The Watcher'.

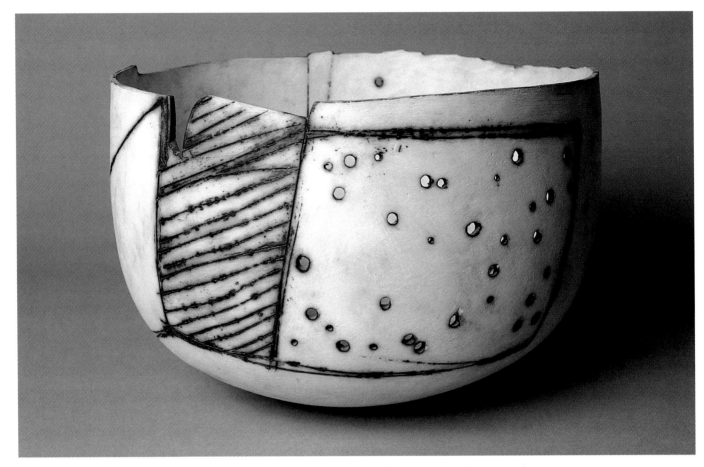

Plate 116: Gordon Baldwin, painted earthenware, 1986, dia: 31cm.
Baldwin's bowls are coiled and some have 'torn' rims and perforations.

In the late 1960s and early 1970s, Baldwin continued to produce work that was far from conventional ceramic forms. Many of these pieces were glazed in a mirror black. Some were obviously derived from landscapes; others from Baldwin's great interest in music, particularly Cage and Stockhausen. His interest in Surrealism also showed itself strongly at this time. In the mid-1970s, perhaps his most successful series of pots had titles like 'Arp Box' or 'Small Lidded Vessel for Jean Arp'. Arp was one of the leading sculptors of the Surrealist movement.

About this time Baldwin's work turned from predominantly black to predominantly white and he began concentrating more on earthenware. He developed a slip that gave a dry white surface that he applied very thinly in many layers. The figurative elements and letters disappeared in favour of drawing or painting on the white surface. Often pieces were reworked and refired several times. Some pots could be worked on for many months. While Baldwin's work gives the impression of random events – edges that look like torn cardboard, painted marks that defy explanation – it is highly controlled.

While Baldwin has, undoubtedly, been one of the finest potters of the last thirty years, his work has been slow to be recognized in Britain. I am sure that one of the major reasons is the arbitrary distinction between 'art' and 'craft'. In Britain, no one knows quite what to do with work, like Baldwin's, that ignores this boundary. Baldwin makes ceramic sculptures that are developments of the bottle, the bowl or the box. His series of pots entitled 'Painting in the Form of a Bowl' neatly displays this dilemma. To label Baldwin's work as 'craft' while, for example, the decorative plates of painter, Bruce McLean, are labelled as 'art' is too ridiculous to need further comment. No such problem exists abroad where Baldwin is recognized as a major artist virtually everywhere he exhibits. Fortunately, this is now changing rapidly in Britain.

Baldwin is relatively prolific for a handbuilder, often working in series of related forms. His work can be somewhat variable in quality, but the best of his work is wonderful. For many years it was quite difficult to see his best work; avid collectors bought many pieces before they left his studio, and craft shops in Britain were reluctant to show work that was too large, too expensive and too far from being fashionable for their tastes. Now he is represented by a specialist ceramics gallery, Barrett Marsden, and is seen even in Britain as a major international ceramic artist.

Another artist whose ceramic work is closer to 'sculpture' than to 'pots' is Gillian Lowndes. Lowndes also started as a sculptor at the Central School before spending several

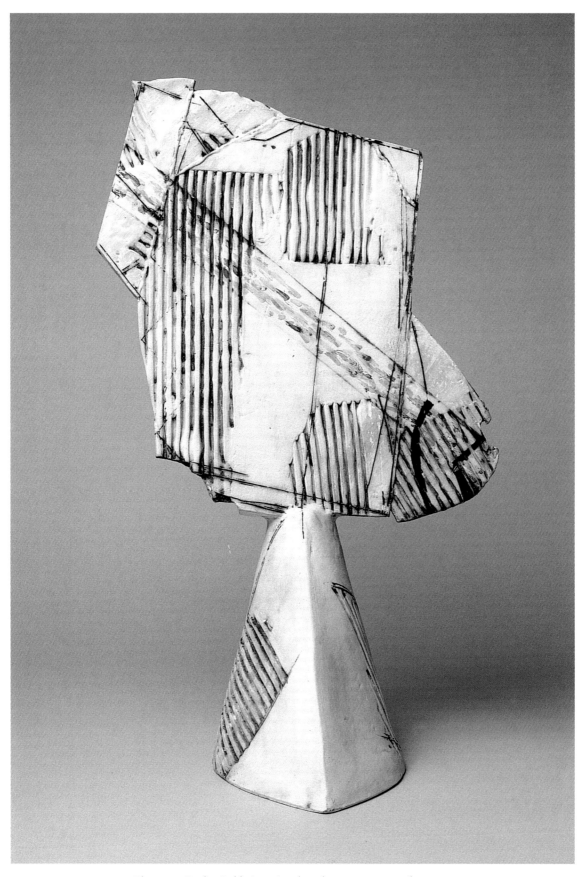

Plate 117: Gordon Baldwin, painted earthenware, 1983–4, ht: 56cm.

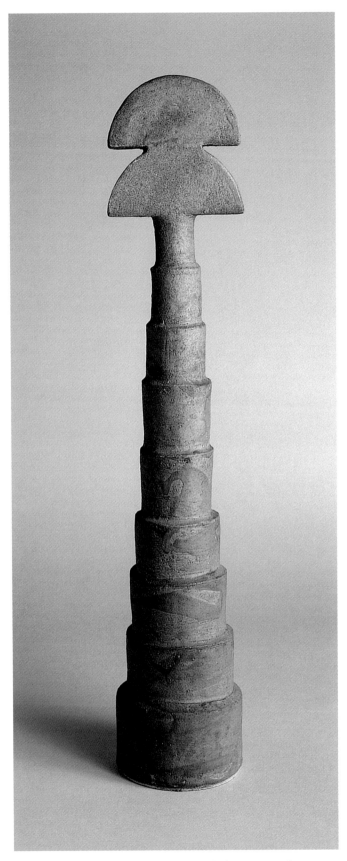

Plate 118: Gillian Lowndes, stoneware, ash-glaze, c.1960, ht: 59cm. Constructed of slabs of heavily grogged clay bent into rings.

years studying and working in Paris. She returned to London in 1960 and set up a pottery with two other potters in Bloomsbury.

Over the years, her work has gone through many transformations and she has always been well out of the mainstream of British ceramics. Her first exhibition at Primavera in 1961 consisted of small pinched pots. Afterwards she produced coiled stoneware pots that Hans Coper likened to drainpipes. Double-walled drum forms and cushion-like wall murals also appeared. Lowndes always pushed at the limits of what could be done with ceramics. Her influences were as widespread as Japanese pottery and Claes Oldenburg.

These wall murals, made after a two-year stay in Nigeria, first showed an increasing trend of 'assemblage' in her work. Other materials soon became incorporated in the clay. A series of pieces was made by dipping fibreglass in porcelain slip and supporting the structure with wire. This was followed by 'brick bags' in which bricks were contained in a bag of slip-covered fibreglass and held together with wire.

Her work of the mid-1980s became even more of a ceramic collage. A major exhibition of her work was held at the Crafts Council's Gallery in London in 1987. This was, probably, the strongest work Lowndes had yet produced. Bits of tile, springs, wire, broken industrial cups are covered in sand and slip and the whole thing is fused in the kiln. The resulting pots are wonderful. Her work of the 1990s could scarcely be described as ceramics at all.

Like Baldwin, Lowndes is a fine artist whose work – long ignored because it can't be categorized – took a long time to come to the forefront. Like Baldwin, she is an inspiring teacher and her work seemed to get better all the time. It would be difficult to predict what sort of work she will produce next.

Of all the early handbuilders, it was Ruth Duckworth who had the greatest influence. Though Duckworth only made pots in England for a relatively short time, she transformed British studio ceramics almost as much as Lucie Rie and Hans Coper had done a decade earlier.

Like Coper, Ruth Duckworth was born in Germany into a middle-class, Jewish family. While she suffered few of the hardships that Coper did, life in Hamburg under Nazi rule was very difficult. For a start, she was not allowed to enter an art school, so she came to England in 1936 and enrolled at the Liverpool School of Art where she studied, somewhat unsuccessfully, painting, drawing and, particularly, sculpture. During the war years, she had a travelling puppet theatre and worked, for a time, in a munitions factory.

After the war, Duckworth studied stone carving at Kennington School of Art and spent nearly three years carving tombstones three days a week. Her sculptural work culminated in a large commission, Stations of the Cross in St Joseph's, New Malden, Surrey, that was executed with her husband, Aiden Duckworth.

Duckworth had begun working in clay and approached Lucie Rie for some glaze recipes. Rie suggested that she

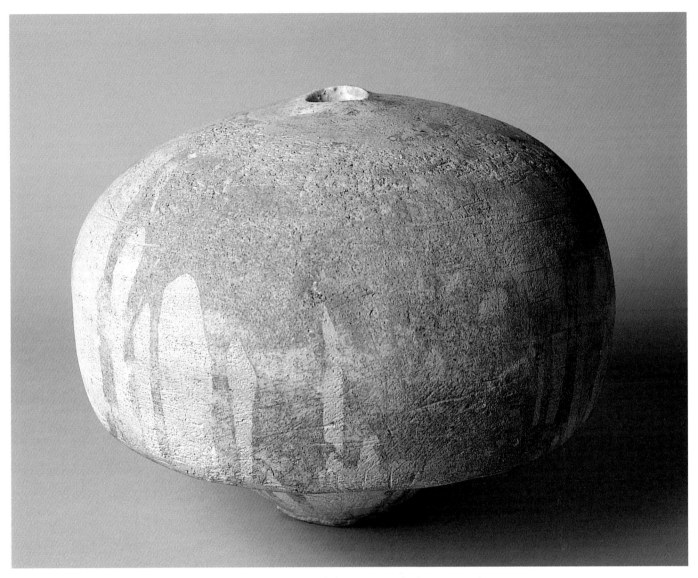

Plate 119: Ruth Duckworth, coiled stoneware, ash-glaze, c.1960, ht: 27cm.
Asymmetrical spherical pots with small apertures were given the name 'pebble pots'.

would need some training and Duckworth enrolled at the Hammersmith School, but only stayed a year. She found 'the teaching was too doctrinaire. A pot must have a foot, a middle and a lip.' She spent a further two years studying at the Central School.

About 1959, Duckworth started seriously concentrating on clay in her studio near Kew Gardens. Most of her British pots fall into three distinct types. She started by producing fine tableware in stoneware and porcelain. Most were light, thrown shapes, but she occasionally also made cast pieces. She was especially known for producing beautiful, functional coffee sets. Very little of her tableware has survived and it has largely been forgotten.

Duckworth, by now, had become inspired by seeing the ancient Mexican pots in the British Museum and decided she wanted to handbuild. About 1960, she began making large, coiled stoneware pots. These were totally unlike

anything seen before in British studio ceramics. Heavy asymmetrical cylinders or ovoids were partially covered in a rough, dry glaze. Very often massive forms were built on very small bases giving a false impression of instability. These pots usually had poured ash glazes, that she handled quite differently from most other potters.

Duckworth's tiny, delicate, white, porcelain pots were in stark contrast to her rough, heavy stoneware. Most of these little porcelain pieces were pinched, though Duckworth occasionally slabbed or even threw. It is difficult to imagine what these pots must have looked like in the early 1960s to people accustomed to seeing the porcelain of Lucie Rie or Bernard Leach.

The most striking thing of all about Duckworth's pots, both stoneware and porcelain, is how organic they are. Many of her stoneware pots are inspired by the cross-sections of fruit or vegetables. Others have been compared to breasts or

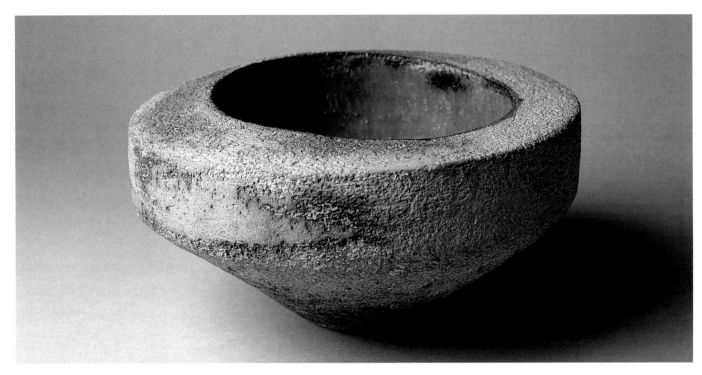

Plate 120: Ruth Duckworth, coiled stoneware, c.1958, dia: 26cm.
This very early pot was one of a group inspired by the cross-section of fruits and vegetables.

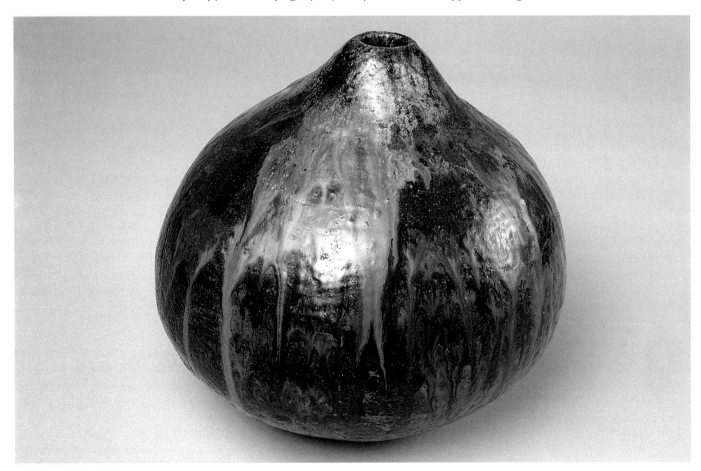

Plate 121: Ruth Duckworth, coiled stoneware, ash-glazes, c.1961, ht: 24cm.

Plate 122: Ian Auld, slab-built stoneware, ash-glaze, c.1959, ht: 45cm.
Impressed relief decoration based on African coins and other ethnographic ornaments.

to moss-covered stones. Indeed, 'pebble pots' became the term for the countless stone-like pots that many potters, imitating Duckworth, made in the 1960s. Partly this organic look comes from the handbuilding process itself. The asymmetry produced by handbuilding is subtly different from the asymmetry of squashing a thrown round form into an oval.

The porcelain was even more obviously derived from nature than the stoneware. Many of her pots are reminiscent of seed-pods, fungus or shells. Many of the best porcelain makers of the 1970s such as Peter Simpson, Mary Rogers, Geoffrey Swindell and Deidre Burnett were clearly at least partly influenced by Duckworth's work.

In 1964, Duckworth was offered a teaching post at the University of Chicago. Initially, she was intending to stay for only a year, but she ended up settling there. Ironically, one of the reasons that Britain has lost such an important potter is that Duckworth was unwilling to put her dogs in the required six-month quarantine if she returned.

Duckworth has now become one of the leading figures of American ceramics where her influence has been as large as it was in Britain. She has had many exhibitions in America and a number in Europe including a major one-man show at the Museum für Kunst und Gewerbe in Hamburg in 1976. Sadly, her work has not often appeared in Britain. Apart from a very brief period in 1967, she has never again worked in Britain. The exhibition that she shared with Janet Leach in 1987 at the British Crafts Centre in London was a rare opportunity to see her American work. The juxtaposition of Duckworth's small porcelain forms with Janet Leach's heavy stoneware was curiously reminiscent of the contrast in Duckworth's pots when she showed at Primavera in the early 1960s.

This contrast still exists in her work. On the one hand, she makes the delicate porcelain sculptures – somewhat different from the British ones. On the other, she makes large stoneware wall murals. It is this mural work that is probably the major reason that she has stayed in America. The relationship between architecture and art is often difficult in Britain. In America, while far from perfect, there are many more opportunities for artists to do large public works. The 1976 mural, 'Clouds over Lake Michigan', which Duckworth executed for the Dresdner Bank in Chicago, measures 270sq ft (25sq m). Duckworth wanted to work large and it was unlikely that many such commissions would be available in England.

Duckworth refers to herself as an American sculptor, but to describe her as a British potter would be no less accurate. Her forms were born out of the environment of British ceramics in the 1950s and, particularly, the Central School. It is in the medium of clay that she has made such an important contribution. However, in Britain, the lack of appreciation of pots that are not vessels has meant that her work has become fairly unknown.

Duckworth described herself as 'spitting into the wind'. I hope that the retrospective exhibition of her pots, being prepared as I write, will re-establish her reputation in this country. I am sure that many of her British pots will look almost as radical today as they did when they were made.

Another highly influential handbuilder is Ian Auld. While Duckworth was primarily responsible for making coiling and pinching acceptable techniques, it was Auld who made slab-building acceptable. For nearly twenty years, he concentrated almost exclusively on this method.

Auld had begun painting while in the Navy during the war. Immediately afterwards he entered art school: first at Brighton Art School and later at the Slade. His first real experience with pottery came in 1951 when he was taught by William Newland. Auld then worked at a small commercial pottery in Berkshire for six months before becoming technical assistant at the Central School.

In 1954, he was asked to start a pottery department at the Baghdad Art School. He spent almost three years in the Middle East, travelling extensively. Middle Eastern art and, particularly, Persian ceramics became one of the many influences on his work.

Auld returned to England and, in 1957, built a kiln in Essex. Previously, he had done very few pots and these were mostly in bright earthenware glazes. Now he began working in stoneware. His early works show a Japanese influence. The clay is heavily grogged and quite rough. The flat surfaces are decorated with impressed plaster of Paris seals or incised or combed. A wide variety of glazes were used, but usually to produce a dry, sandy surface. Few potters have achieved a more successful fusion of clay and glaze than Auld.

Most of Auld's pots are rectangular slabbed bottles, but he also did a variety of other work. Occasionally, he even made coiled pots 'to get round pots out of my system'. He also made a few solid sculptural forms and a number of cutout slab pots based on castle crenellations or medieval ironwork. Roman glass was another important source of inspiration for his slab bottles. While Auld's pots are mostly based on vessels, they are not intended to be functional. Most of his pots are neither expressly utilitarian nor expressly sculptural.

Auld spent two years in Nigeria in the early 1970s on a research fellowship. When he returned, his work changed quite noticeably. The thick slabs with their hard edges were replaced with thinner, 'softer' ones. The building process seemed more complex with slabs overlapping. The surfaces seemed influenced by the patterns in African art.

Unfortunately, fashion in the ceramic world was moving in another direction. Interest in delicate, pretty porcelain peaked in the mid-1970s and nothing could be further from Auld's work. His 1976 exhibition at the British Crafts Centre did not go well and Auld ceased potting. His interests in ethnographic art and his major teaching commitments took all of his time. Many people tried to get him to pot again, but he made very few.

Auld's influence as a teacher is as important as his influence as a potter. He had a number of teaching posts during

Plate 123: Ian Auld, slab-built stoneware, c.1993, ht: 19cm.
Though made for an exhibition in the 1990s, this has the thin overlapped slabs typical of his 1970s pots.

his career, culminating in his appointment in 1974 as head of ceramics at the Camberwell School of Arts and Crafts. Camberwell was a fine school, but it had had little major influence on ceramics since the days of W.B. Dalton at the beginning of the century. Under Auld's leadership, a first-rate staff of part-time teachers was assembled and brilliant students began to emerge. Linda Gunn-Russell, Jim Malone, Julian Stair, Sara Radstone, Henry Pim and Angus Suttie were just a few of the students who graduated from Camberwell in the next few years. Much of the best work of the 1980s came from these young potters.

Modelling and carving were two other techniques that were little used in the twentieth century. In the 1960s, both were taken up enthusiastically by Ian Godfrey. While many potters employ a different tool for nearly every task, Godfrey did almost everything with just one – a penknife.

Godfrey was trained, mostly as a painter, at the Camberwell School where he was influenced by Lucie Rie. In 1962, after art school, he helped set up a workshop in City Road in London and began making pots. He first exhibited that

year at Primavera and, subsequently, had two one-man shows there in 1965 and 1968.

Godfrey's highly stylized pots usually have a thrown base that is then carved or has modelled additions. He used a wide variety of references to other cultures in his work and often his pots look like something unearthed from some odd, ancient civilization. Some see his work as little more than contrived ceramic kitsch, but work with a sense of humour often gets denigrated in this way. For most, the eccentric fantasy world of Godfrey's pots are a delight.

Technically, Godfrey's pots are always very skilful. The carving of perforated bowls is a difficult task that Godfrey perfected. The clay of the thrown bowl must be just the right dryness for this to be done. Some of his carved bowls are as much as 18in (46cm) in diameter.

Modelling, however, was the technique he employed most. To a thrown base he would add small modelled figures. Some were small bowls with birds lining the rim; others were rings or drums with farms or little Japanese-like villages on them. Ducks, fox heads, rainbows, flowers and

Plate 124: Ian Godfrey, stoneware, c.1974, ht: 31cm.
A typical Godfrey 'fox-box'. Most also have animals on the inside.

much else were added. His 'fox boxes', the best known of these pots, sometimes had well over a hundred added modelled details, some removable.

Godfrey had two large one-man shows in the early 1970s at the British Crafts Centre, but, after 1976, he spent most of his time abroad. Consequently, many who started collecting ceramics after this time are unaware of his work.

Support for contemporary ceramics slumped in the 1950s and 1960s and many of the fine handbuilders never got anything like the attention they deserved. These included: Louis Hanssen, a Canadian poet who produced some stunning Duckworth-like stoneware pots before his death at only 34; Bryan Newman, who produced inventive sculptural cityscapes and bridges alongside his domestic pots; Anthony Hepburn, an early experimenter with casting whose work fits more closely with 'funk' pottery; and Alan Wallwork, who made some excellent handbuilt vases alongside his more commercial work.

Dan Arbeid is another handbuilder who made some excellent pots at this time. He started his career as a cutter in tailoring and didn't work with clay until a two-year stay in Israel in the mid-1950s. He returned and studied at the Central School where he became the technical assistant at the end of 1957.

Plate 125: Alan Wallwork, slab-built stoneware, ht: 20cm.

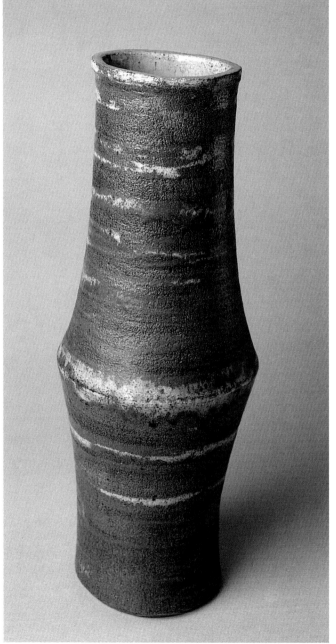

Plate 126: Dan Arbeid, coiled stoneware, c.1965, ht: 42cm.

Plate 127: Bernard Rooke, coiled stoneware c.1968, ht: 27cm.
It is important to distinguish between Rooke's individual pots and his more common commercial work.

Most of Arbeid's pots are coiled stoneware, but he also worked with raku and porcelain and used a variety of making techniques. His first one-man exhibition was held at Primavera in London in 1959 and he exhibited widely in the 1960s. Arbeid's pots are very organic in nature and usually are very coarse. This rough, rather ugly, look of his pots has not made them extremely popular, but they are amongst the most expressive that have been made in Britain.

Arbeid has had as much influence as a teacher, particularly at the Central School, as he has had as a potter. He was never prolific and, over the years, became more and more involved with teaching and less and less involved with making pots.

Probably the most commercially successful of the early handbuilders was Bernard Rooke. He studied painting and lithography but became interested in ceramics through Gordon Baldwin at Goldsmiths College. From the start, Rooke combined inventive individual pots with commercial designs.

Rooke's 1960s pots are heavy, handbuilt vessel forms with dry, textured surfaces, many decorated with his own invented language of Klee-like doodles and quasi-mystical devices. His versions of 'pebble pots' are probably the best that were made. Some of his spade forms (that predate those of Hans Coper) with their sculptural bases and heavily incised surfaces are superb. Other pieces have discs inserted into great rents in the rim. His work is unusual in that it shows very little influence of other ceramics. Rooke's love is painting and it was artists such as Klee, Dubuffet, Rauchenberg, Pollock and particularly, the Spanish abstract artists, Tapies and Millares, that inspired him most.

Rooke was interested in the commercial possibilities of his work and designed fountains, murals (including the one at the original Cranks restaurant) and, most successfully, lampbases. Using mostly press-moulding and later slip-casting, he produced a wide variety of decorative and sometimes quite bizarre objects. The financial success of this venture freed him from part-time teaching, gave him the freedom to experiment and allowed him to purchase a large, disused mill in Suffolk where he still lives today.

Rooke's ideas were ahead of their time – some of his work still looks radical even now. It was this inventiveness that proved instrumental in removing him from the ceramic scene. The CPA, who had given Rooke a one-man show, objected to exhibiting any pots with cast elements or pieces that were assemblages of clay and metal. Rooke, who already had an ambivalent attitude to the British craft world and a good market for his pots in Scandinavia, decided, for almost twenty years, to only exhibit in his own showroom and abroad.

As time went on, the individual pots became more erratic in both quality and quantity and the commercial pieces began to look more like kitsch than inspired design. He eventually turned over most of the commercial work to his sons and concentrated primarily on painting. Today he is better known for his lampbases than his pots and few people are aware of how great the early work is.

There were a large number of potters who took up handbuilding at this time. Much of their work was superb; much of it was dreadful; and some now looks rather dated. Whatever the quality of the work, there is no doubting what an important innovation it was. Both the look and the techniques of handbuilding opened up vast new possibilities for anyone working in clay. On the one hand, this – together with the influence of Rie and Coper – provided the base on which most contemporary studio ceramics is built. On the other hand, it gave the untalented potter free rein to create some of the most terrible rubbish imaginable.

Many of the finest early handbuilders, even Ruth Duckworth, have been largely forgotten or ignored in this country. I have little doubt that, as years pass, their importance will become more recognized.

Chapter 10

The Royal College of Art

The revolution in ceramics that began with the hand-builders of the 1960s reached its maturity in the 1970s. The influence of the 1960s potters, an increasing awareness of American 'funk' ceramics and the change in emphasis in art colleges from 'pottery' to 'ceramics', all contributed towards the creation of a 'new ceramics'.

The major breeding ground for these new ceramicists was the Royal College of Art and the major influence, as a teacher, was Hans Coper. Coper taught at the Royal College of Art from 1966 to 1975 and, during that time, he had some extremely gifted pupils. These pupils totally transformed British studio ceramics – even more radically than William Staite Murray and his RCA students had done in the 1930s.

While all of the RCA students acknowledge Coper's towering influence, they have all moved far from his work. Coper was dedicated to throwing and to functionalism; he worked in black and white, in stoneware, with a relatively small number of forms. Coper's work came from a tremendous attitude of humility. By contrast, Coper's students generally have rejected throwing, moved well away from function, employed a vivid use of colour, avoided stoneware, been highly eclectic in form and shown relatively little humility.

Critics have cited this as evidence that they are guilty of the 'individualism at any cost' disease that has often infected the world of 'fine art'. I prefer to think that what these potters share is a vision of freedom. Whichever viewpoint you adopt, there is no doubting their impact or the fantastically high quality of the work they have made.

The major commercial boost for these potters came from the formation of the Crafts Council in 1971. In the tiny crafts community, the Crafts Council had enormous power. They had their own large gallery just south of Piccadilly Circus, financial control of the British Crafts Centre and, eventually, their own shop in the front entrance of the Victoria & Albert Museum. They had *Crafts Magazine*, the ability to fund expensive publications and to generate publicity. They had extensive grants available for chosen craftsmen. Not only did they purchase for their own large collection, but they also advised and aided several of the more active museums.

All this was wonderful for the promotion of crafts and would have been even better had it been evenly distributed. However, the main thrust of the Crafts Council's activities were directed towards the promotion of a handful of women potters who were leaving the RCA. The size of this imbalance can be seen in the Crafts Council's own collection: they acquired, for example, more than twenty pieces each by Jill Crowley, Jacqui Poncelet and Liz Fritsch as opposed to two by Michael Cardew and none by Katharine Pleydell-Bouverie or William Marshall. To some extent this is understandable. The work of these women was new, exciting, often colourful, visually immediate and extremely good. On the other hand, there are many fine potters who did not get much share of the spoils.

One outcome of all this was that there was suddenly a place for figurative ceramics and three of the RCA students produced some excellent work.

Mo Jupp left the RCA in 1967. Although his time there only briefly overlapped with Coper's, Jupp had also come in contact with Coper earlier at Camberwell.

Jupp has given the great majority of his time to teaching and, consequently, has produced very little work over the years, but he has been one of the champions of sculptural ceramics. His work has always been highly inventive and often highly provocative.

He is still, probably, best known for the wonderful series of helmet forms that he made about 1972. While being based on the idea of protection, these extraordinary 'helmets' are often extremely sinister and are not, to put it mildly, to everyone's taste. The helmet series disturbed a few people, but his next series totally outraged many. In 1973, he exhibited at the British Crafts Centre a series of little porcelain temples adorned with cane or white feathers and containing gold or silver genitalia. Most people, upset by the explicit sexual content, complained about putting feathers on pots.

Since 1978, Jupp has concentrated almost entirely on the female form ranging from only a few inches high to life-size; many have a superficial resemblance to Giacometti sculptures. He has been very influential but his work invariably meets with a mixed reaction. As always, some have

Plate 128: Jill Crowley, stoneware, c.1999, ht: 26cm.
One of Crowley's rare vessels; the index finger is the lid handle of this teapot.

problems with ceramics that are not vessel-based. The irony of referring to pots by their 'body', 'foot', 'lip', 'neck', and so on, and not appreciating ceramics based on the human form is often overlooked.

Glenys Barton is another ceramic artist who has avoided almost all references to the vessel in her work. Though she has occasionally made purely abstract work, much of her output is based on the human form – her own, usually. Most of her pieces are cast in bone china and finished by hand. Sometimes they are glazed, rather in the manner of raku, but often they are left just as white china.

Barton's chosen path as a ceramic artist has been as different as her work. She has exhibited almost exclusively through a 'fine art' gallery. She has often made her work in editions, sometimes, interestingly, in collaboration with Wedgwood, the traditional enemy of studio ceramics. In fact, apart from choice of material, it is difficult to think of any difference between Barton's methods and those of most sculptors. If her work were cast in bronze,

it would come under the wing of the Arts Council and be put in the Tate Gallery. Cast in china, it is under the wing of the Crafts Council and supposedly belongs in the Victoria & Albert Museum.

In the year following Glenys Barton at the RCA came Jill Crowley. Crowley was another of Coper's students who largely disregarded the vessel. She is known for her humorous head-and-shoulders portraits of bald, middle-aged men. Other series of her work include: cats' heads on black plinths, mermaids, almost pornographic female torsos, and children's hands. Her series of zoomorphic teapots and of self-portrait 'goldfish bowls' are popular amongst those who prefer vessels.

The surface look of Crowley's pottery together with its tremendous ironic humour has reminded many of the work of the painter Jean Dubuffet. Others, less charitably, have dismissed her work as ceramic cartoons or imitative of American 'funk' ceramics. These criticisms are almost entirely unfair. Cartoons have little more than humour, while Crowley's

work is usually exciting as well. There is no American 'funk' potter that Crowley has, even vaguely, imitated and, one might add, very few American 'funk' potters who are as good. It would be more accurate to say that Crowley is one of the very best of the British 'funk' potters.

Of all the potters who went through the Royal College of Art, it was Elizabeth Fritsch who most captured everyone's imagination. From the time her work first appeared, it was clear that this was the most important artist in ceramics since Hans Coper appeared twenty-five years earlier. No other potter in the 1970s had as much impact or influence as Fritsch had. No other potter produced work with such instantaneous appeal.

Fritsch's main interest was music not ceramics. She studied first at the Birmingham School of Music and, later, at the Royal Academy of Music. She applied to the RCA, but was initially turned down because she showed, in the words of the department head, Lord Queensberry, 'only a few pots

Plate 129: Elizabeth Fritsch, 'Floating Pillars', stoneware, painted with slips, 1975, ht: 28cm.
Optical effects on this flattened vase are reminiscent of Bridget Riley.

that had been given a very low biscuit fire, perhaps, alongside a baked potato'. She was eventually admitted despite having 'little technical understanding of the subject'. Four years later, with Coper's help, she emerged having solved many of the problems with her work. Apart from the inspiration Coper gave to all his students, he also had many years' experience working in the slip/glaze boundary.

The first thing noticeable about Fritsch's pots was how different they were technically. The handbuilt pots of the 1960s were heavy, roughly potted and generally made with materials similar to those used by Bernard Leach. While Fritsch's work was in stoneware – oxidized anywhere between 1150 and 1300°C – that was where the similarity ended. By coiling, pinching and scraping, she produced pots that seemed paper thin with none of the expected signs of making. The decoration was also totally different. Though her early pots were thinly stained with the body showing through, she soon changed to more highly

Plate 130: Elizabeth Fritsch, stoneware, painted with slips, c.1976, ht: 24cm.
This pot is fully three-dimensional, unlike most of Fritsch's pots.

coloured surfaces produced by painting with thick layers of slip. These intricate and often optical decorations are, despite being brightly coloured and somewhat jazzy, amazingly calm and serene.

There are many influences on Fritsch's pots and she often points them out by lengthy titles or notes in her exhibition catalogues. Music has continued to be a major source material and she cites the paintings of Piero della Francesca as another. One can certainly see echoes in her work of both Mediterranean culture and English painted pottery of the late nineteenth and early twentieth centuries.

A year after Fritsch graduated in 1971, she went to work as an artist in the famous Danish porcelain factory, Bing & Grondahl. She had her first one-man show in Denmark, but this work was in porcelain fired at 1400°C and when she returned to England her experience there was of little practical use. She worked at Gestingthorpe in Suffolk for two years producing work for her first British one-man show at the Crafts Council's gallery in 1974.

In 1976, she moved to Digswell, where Coper had lived and worked earlier. Here, she prepared pots for her show 'Improvisations from Earth to Air' at the British Crafts Centre later that year. This was followed in 1978–9 by a travelling retrospective of her work and the announcement that she was not making any more pots. It had seemed that music, children and, perhaps, a lack of commitment had brought an early end to her career. Despite no new pots, interest in Fritsch's work continued to grow and, in 1981, due to a bizarre auction room mix-up, one of her pots sold for over £3,000.

Cynics pointed out that at those prices, Fritsch would begin to make pots again. They were right and soon a few pieces began to appear. In 1984, an exhibition, 'Pots from Nowhere', with over fifty pieces was held at the RCA. Fortunately, she has continued to make pots since, but rarely with the success of her early work. Some of the pots of the 1990s have been comparatively very poor.

While Fritsch's pots are clearly vessels, they are far from being functional. For a start, many of them are not truly three-dimensional. She describes it as the 'shadowy space half-way between two and three dimensions'. This squashing of the depth of the pot works wonderfully with the optical tricks of the decoration, but combined with the lightness of the pots makes them too unstable for anyone who wants to use them.

Fritsch has often emphasized her desire to make pots that one wants to hold in the hand. Owners of her pots do not often share this desire, partly because her work is fragile and expensive and partly because her pots easily take fingerprints and can, occasionally, be extremely difficult to clean. Most of her pots only really work when viewed from one angle. This has the advantage that her work is exceptionally photogenic but many people miss the changes in form that simply don't happen in a '2½ dimensional' object. While her pots toy with the idea of being useful it is clear that they are purely decorative objects.

Plate 131: Elizabeth Fritsch, 'spout pot', stoneware, painted with slips, c.1974, ht: 26cm.
She has made a number of this very successful form.

Fritsch's pots are full of these contrasts: vessels that cannot be used, an illusion of dimensions that are not there, the shift between the substantial, earthy world of clay and the insubstantial, airy world of music. Biggest of all these contrasts is that between the precision of the machine and the hand of the artist. Fritsch pots have a near perfection that has been copied by many who have followed her. The lines are so even and straight that it is difficult to imagine they were put on with a brush; the pots give the illusion of perfect symmetry. You have the false impression that these pots could be made quickly by a machine, yet they are meticulously created by an artist with devotion to detail.

Plate 132: Elizabeth Fritsch, 'Counterpoint', stoneware, painted with slips, 1989, ht: 32cm.

These pots on which, sometimes, weeks of energy have been lavished are the extreme opposite to the immediate, spontaneous work of Hamada or Leach, but they have the same life and harmony. The beauty, the skill and the ambiguity of Fritsch's pots have placed them at the forefront of this century's ceramic work – and placed her as the most important British potter of the 1970s.

Jacqui Poncelet graduated from the RCA the year after Fritsch. The impact and influence of her early work was also enormous.

These early pieces are tiny bowl forms in bone china. They were made by first casting the forms in moulds and then by extensive carving. Some were partly stained, but many were left in plain white china. These excellent little pots were first shown in 1972 and provoked an immediate response. On the one hand, bone china was the material that Bernard Leach and his followers most hated as being bland and lifeless. These bowls are also too thin and unstable for any use and so, naturally, many reacted to them very negatively. On the other hand, the quality of this work and

Plate 133: Elizabeth Fritsch, stoneware, 1989, ht: 39cm.
Many of her pots of the 1990s have minimal decoration.

Plate 134: Jacqui Poncelet, bone china, c.1972, ht: 11cm.
These bowls were highly influential on makers of porcelain in the 1970s.

the apparent potential of a featureless white body attracted many. The popularity of Poncelet's china pieces spawned countless vague imitations from dozens of other potters. Few of these imitations had anything like the quality of Poncelet's work.

The china pieces had severe limitations for Poncelet both in terms of colour and, especially, in terms of size and she only worked in this medium for a few years before making a radical change. Around 1976, the first of her new work began to appear. These were larger angular stoneware pots, slab-built and often with hard-edge designs. They were met with howls of outrage by many of her followers.

Poncelet travelled a great deal in America in the late 1970s and the influence of American painting, particularly Frank Stella, was very strong. Much of her work of these few years was somewhat unresolved and some of it was absolutely dreadful, but not long after her return to England she seemed to get back to producing excellent work.

In 1981, a powerful group of new work was shown at the Crafts Council Gallery. These 'boat' forms are shallow bowls slab-built in high-fired earthenware. By cutting and joining slabs of contrasting clays and then glazing and painting with bright enamels, Poncelet created a stunning surface effect. The contrast between the richly decorated flat surfaces and the undecorated 'rim' puts a tremendous emphasis on the edges.

By 1985, the 'boats' and 'shoes' had evolved into more sculptural forms based on lobster claws, conches and starfish. The colours – oranges and greens – seemed even more vivid. The forms were getting far removed from the vessel. These changes – from small bowls to large sculptures, from London craft galleries to New York art galleries – continued and by the late 1980s she had almost totally abandoned working in clay.

In 1973, two more superb ceramic artists, Carol McNicoll and Alison Britton, graduated from the RCA.

Carol McNicoll is another potter to have sharply divided people's opinions. Of all the potters in this chapter, she has produced the most functional work, but with the most unconventional technique. McNicoll's pots are slip-cast and

Plate 135: Jacqui Poncelet, stoneware, painted decoration with wax-resist, c.1981, w: 44cm.
These 'boat' or 'shoe' forms were also used by other potters in the 1980s.

elaborately assembled like some strange form of ceramic origami. This comparison is inevitable because of her use of clay to imitate other materials – especially paper. Many of her bowls and vases look as if they have been made from crumpled or pleated paper and are extremely humorous. This humour – an important element of her work – runs deeper than just being a quick joke. It is also an ironic look at materials and methods of constructing a vessel. She has always been prepared to take risks and to push functional ceramics to its limit.

The intention of slip-casting was partly to allow the production in fairly large quantities of functional wares. In practice, McNicoll's teaching commitments and her restlessness have meant that her output has been rather small and she has rarely repeated herself. As well as her wonderful 'functional' pots, she has often made more elaborate 'one-off' pots using similar techniques. The time needed to produce these as well as the high prices they needed to command did not always make them a practical alternative.

In addition, McNicoll has always designed a wide range of semi-factory ware. This rare (and much welcomed) collaboration between a good potter and the ceramic industry has produced some wonderful designs. Whether these designs will be seen as being fashionable and stylish or as being dated

and kitsch will probably have more to do with the times than the work, but there is little question of the importance of McNicoll's contribution to British ceramic art.

McNicoll's work is considered to be part of the 'funk' ceramic movement in Britain. It is often highly ornamental and shows her interest in Japanese Oribe ware and, particularly, in Palissy. In the 1980s, her work appeared in TV commercials, on record sleeves and was often sold in shops more associated with ceramic kitsch than serious craft. At the same time, major museums and collectors were buying her pots and a retrospective exhibition of her work was held at the Crafts Council's gallery. This popularity on many levels is not that surprising. Her work is joyful, colourful, photogenic, easily appreciated and, sometimes, a lot more functional than it looks. It also has been innovative and has made an intelligent statement about the nature of ceramic function.

One of the very best of the potters to emerge from the Royal College of Art is Alison Britton. Though her initial impact was not as dramatic as that of Fritsch or Poncelet, the quality of her work was just as high.

Britton studied ceramics at the Central School before attending the RCA. Significantly, two of her contemporaries there were Richard Slee and Andrew Lord, two of the most interesting British 'funk' potters. Following her years at the

Plate 136: Carol McNicoll, cast earthenware, painted decoration, 1990, ht: 38cm.

Plate 137: Carol McNicoll, cast earthenware, painted decoration, c.1989, w: 25cm.
This is not one of McNicoll's more functional tewares.

RCA, Britton shared a studio at the 401½ Workshops in Wandsworth Road where Barton, Crowley, McNicoll and Poncelet had all been working.

Through most of this time, Britton's work had been somewhat tentative. Much of her output was tiles – commissions for bathrooms, and so forth – and it was only in 1975, when she moved studios, that she really began to develop her three-dimensional work. Her first one-man show was held at the Amalgam Gallery in London in 1976, but more important were her two later exhibitions in 1979 and 1981 at the Crafts Council's gallery. These two exhibitions firmly established her as one of Britain's leading potters.

Britton's pots are slab-built, sometimes in stoneware, but, more often in high-fired earthenware painted in underglazes and coloured slips. Unlike many potters of her generation who have emphasized thinness and lightness in their work, Britton's pots are comparatively massive. Her pots are all vessels, that she describes as being on the 'outer limits' of function. Her usual form, the jug, gives a maximum implication of usefulness and allows her to play with the spout and the handle as means of rearranging the shape. The change of angles in her work is one of its most important features. More than with almost any other potter, it is necessary to see Britton's work from all sides. In a time

when, sadly, more people see pots in Sunday supplements than galleries, this has meant that her work has not always been as appreciated as it should have been.

Britton's early tiles are mostly decorated in a narrative form and many of her pots from the 1970s are painted in a manner extended from this. Narrative painting in modern British ceramics is surprisingly rare and few have done it as well as Britton. Her narrative pots usually have birds or Egyptian figures on them. Over the years her decoration has moved further and further towards abstract expressionism and many of her later pots were decorated before being built. Though this change in her decoration has tended to make the humour in her work much more understated, it has greatly added to the already powerful nature of her work.

Had I been asked in 1980 who would be the most important British potter of the 1980s and 1990s, I would have chosen Alison Britton. If she has, perhaps, failed to live up to this very high expectation, it is undoubtedly due to her divided time. Britton put much energy into her other roles as teacher, writer, mother and Crafts Council member and this, inevitably, reduced her energy for potting. Like many contemporary potters, her yearly output is measured in tens rather than hundreds. She has been influential as a teacher and is the most perceptive writer on contemporary ceramics,

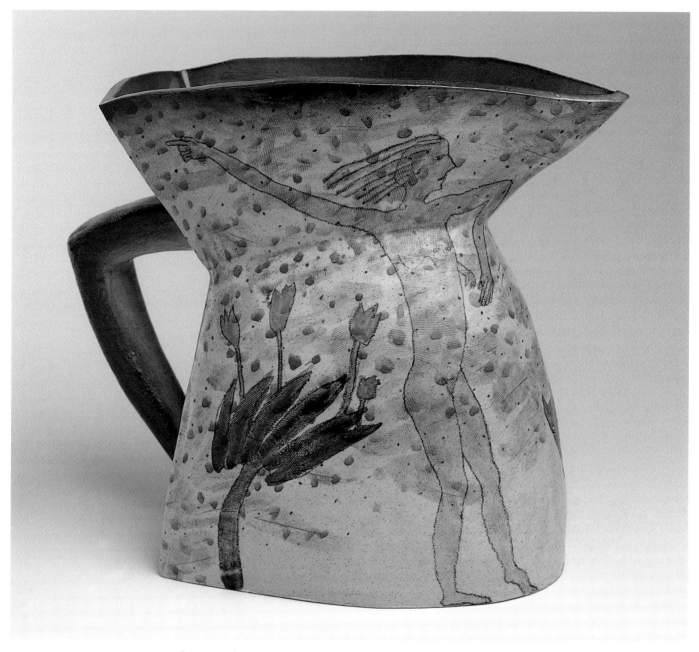

Plate 138: Alison Britton, earthenware, painted decoration, 1979, ht: 23cm.
Figurative decoration only is on Britton's early work.

but there have been times when the pots have fallen far short of her masterpieces of the early 1980s. In recent years the quality of her work has returned.

Britton has produced some of the most powerful, expressive and interesting pots. I know many collectors who greatly prefer her work to the more acclaimed pots of Elizabeth Fritsch. She is still in her early fifties – a time when many potters have produced some of their best ceramics – and I am confident that she will continue to create dynamic work.

Geoffrey Swindell is a potter who, despite being at the RCA when Coper was teaching, failed to get the same attention and publicity as many others. This had almost nothing to do with his work, but was largely due to the fact that he was a man and not London-based. Much of the publicity, particularly that of the Crafts Council, was aimed at the fact that most of the best new ceramic artists were women which was compared to the erroneous idea that most of the great potters of previous decades were men.

Swindell was born in Stoke – the heart of British pottery. Many of his family had worked in various pottery factories in the area. Swindell studied painting and then ceramics at Stoke-on-Trent College of Art before attending the RCA.

His early pots, mostly in porcelain, are small pinched or press-moulded forms that are based on helmets, shells, or

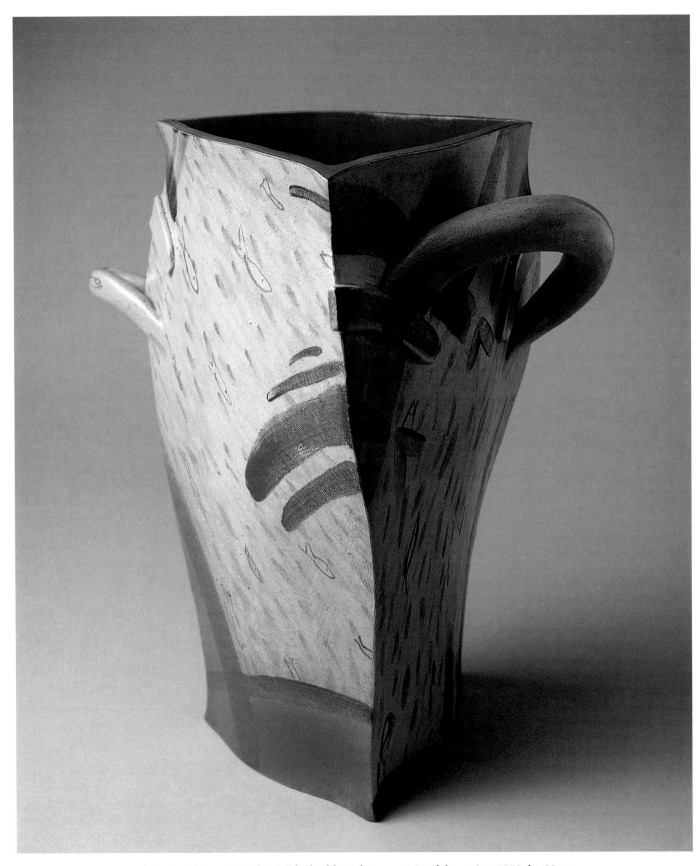

Plate 139: Alison Britton, 'Pot With Shoals', earthenware, painted decoration, 1978, ht: 33cm.
Britton forms are more complex and asymmetrical than they look in photographs.

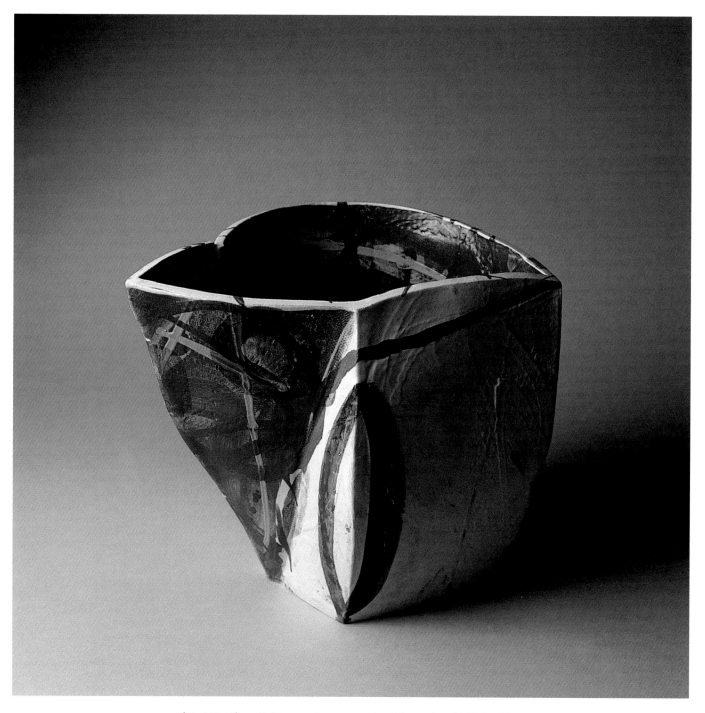

Plate 140: Alison Britton, earthenware, painted decoration, 1988, ht: 28cm.
Britton's best pots of the 1980s are amongst the finest work of the century.

his interest in tin toys, but by the late 1970s his pots had evolved into the 'flower bud' form that most people associate with his work. These delicate dome shapes rise from a tiny base and often have a flange reminiscent of the pots of Hans Coper. Many are decorated with enamels and lustres and Swindell has extensively used a crackled dolomite glaze. Sand-blasting the surface is another technique that Swindell learnt from Coper. Usually, strong contrast is used

on his pots – between the subtle colouring of the dolomite glaze and the bright lustres or between the rough sand-blasted surface and the smooth glazes.

Swindell's technique for making these pots is highly unusual. Instead of using the expected pinching method, Swindell throws a large 'blank' of porcelain and then turns it down when it is leather-hard to a wafer-thin pot. Thus, a lump of clay that weighs about 2lb ends up as a pot weighing about

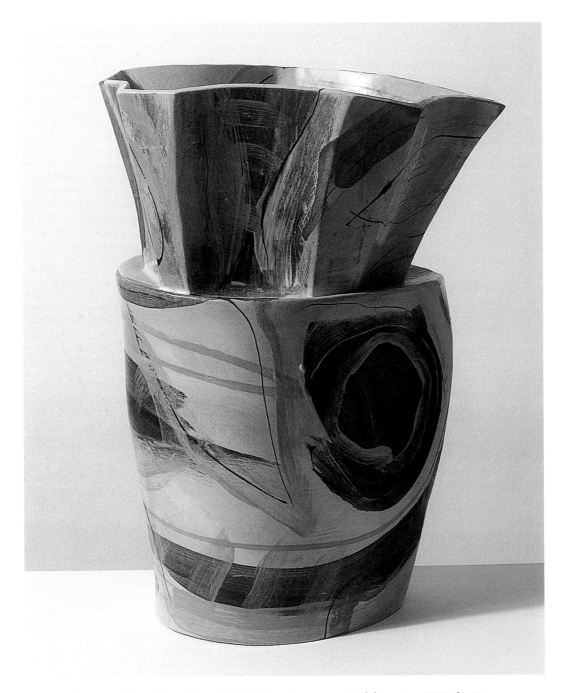

Plate 141: Alison Britton, 'Pot with Collar', earthenware, painted decoration, 1996, ht: 46cm.

4 oz. Because of his working method, Swindell has a relatively high loss rate and is not very prolific.

Although Swindell has not had the success he deserves in England, he is widely collected nearly everywhere else. His large one-man show in 1978 at the National Museum of Wales has, probably, been his most important British showing. If you visit collectors in America, Germany, Holland or Switzerland you are bound frequently to come across his work.

With his precise forms and his dedication to refining specific shapes, in some ways, Swindell's work is closer to Coper's than any other of Coper's students. I am sure that,

in time, he will be recognized in Britain as one of the most gifted potters of his generation.

In the 1960s there was more than a suspicion that Britain's place as the world leader in ceramic art was to be usurped by America. The large group of brilliant potters that emerged from the Royal College of Art during the few years of Hans Coper's teaching largely ended that. They broke new ground in the 1970s and, together with other potters who later emerged from Camberwell, have transformed British ceramics almost as radically as Leach, Hamada, Cardew and Murray had done a half-century earlier.

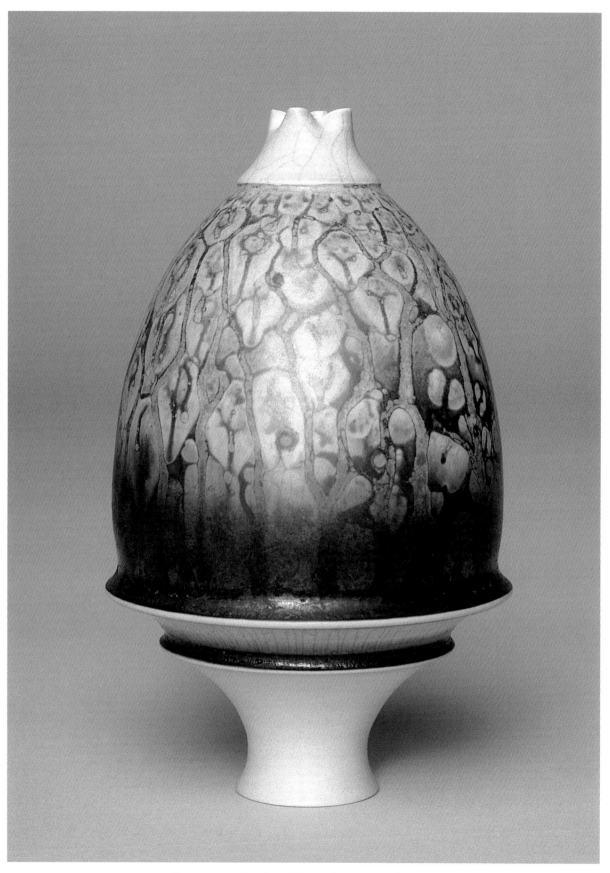

Plate 142: Geoffrey Swindell, porcelain, c.1985, ht: 13cm.

Chapter 11

Trends and Fashions

There is nothing new about fashions in ceramics. These fashions have existed as long as pots have been made. The 'Sung' pots of about 1930 or the heavy, stoneware, sculptural pots of about 1960 are just two examples of ceramic trends in Britain in the twentieth century. It does seem, however, that in recent years these fashions have come and gone with increasing rapidity and have contained an increasing quantity of banal work.

Usually, every trend has been inspired by a trendsetter – a potter who has produced fascinating work in an unexpected way. Usually, there are also several other potters who produce very good work along similar lines. But for every one of these, there are dozens who turn out endless boring and derivative pots. The rather amateurish nature of craft shows and many craft shops has tended to help promote the mediocre – pots for presents rather than pots for collectors. Of course, in time, good pots look even better and bad pots look worse, but it can often be difficult initially to sort out the trendsetters from the merely trendy.

One of the best and most interesting of the trendsetters has been Martin Smith. He studied at Ipswich School of Art and then at Bristol Polytechnic before attending the Royal College of Art from 1975 to 1977.

During his time at the RCA, Smith perfected his technique of making large black raku bowls. These pieces were usually thrown and turned, but Smith also used slab-building, slip-casting and press-moulding. Poured glazes were replaced by spraying on a white glaze over masked areas to give a geometric pattern. His two London exhibitions following his degree show established him as an important new ceramic artist. Although it attracted attention in London, Smith's raku was even better known in other parts of Europe. He exhibited in Germany, Holland and Switzerland and his work was bought by a number of European collectors.

Raku firing is a technique that developed in Japan. The thick porous body and the incredible surface variations made it ideal for use in the Tea Ceremony. Bernard Leach brought raku technique to England in 1920, but soon abandoned it. In the 1950s, American potters, especially Paul Soldner, began to use raku in an entirely new way, but in Britain raku was largely abandoned. Some potters, Jill Crowley particularly, had successfully employed raku, but usually it was just made at potters' weekends to produce pastiche tea-bowls.

Smith's raku bowls were far removed, both in style and in scale, from Japanese tea-bowls and the possibilities were immediately clear. Soon it seemed as if half the potters in England were going to make raku. In fact, some of this work was quite superb.

Roger Perkins, a young potter from the Camberwell School, began making large decorated raku bowls and dishes of very high quality. Often the blackened and textured raku exterior was combined with painted glazing inside.

Robin Welch had already begun making excellent individual raku pots. Welch had started making thrown stoneware in the 1950s and was known for his wonderful standard-ware produced by the jig-and-jolley, but the raku was some of his best work yet.

Most dedicated of all is David Roberts, who makes very large and successful raku pots usually with pronounced crackled glazes. Today, Roberts is one of the few good potters still concentrating on raku.

Ironically, Martin Smith stopped making raku in 1978, several years before the fashion peaked. His raku pots are now highly sought after. Roger Perkins changed styles dramatically – to making undecorated torsos – and Robin Welch has concentrated mostly on painterly stoneware pots. For each potter making interesting raku there were dozens doing quite awful work. Most of the really poor raku has, thankfully, also disappeared and, in retrospect, the fashion was quite short-lived.

Between 1978 and 1981, Martin Smith's pots were hardly exhibited at all in Britain. The travelling exhibition in 1981–2, 'Forms around a Vessel', showed what a radical change his work had undergone. Traditional bowls had been replaced by bowls on plinths or angular vases. These forms were based on elements of Renaissance Italian architecture and were quite a shock for anyone used to his earlier work. Like many contemporary potters, Smith has concentrated on the change in shape when viewed from different angles.

Technically, the pots were also entirely changed. Smith was now using a fine-grained red earthenware. The pots were

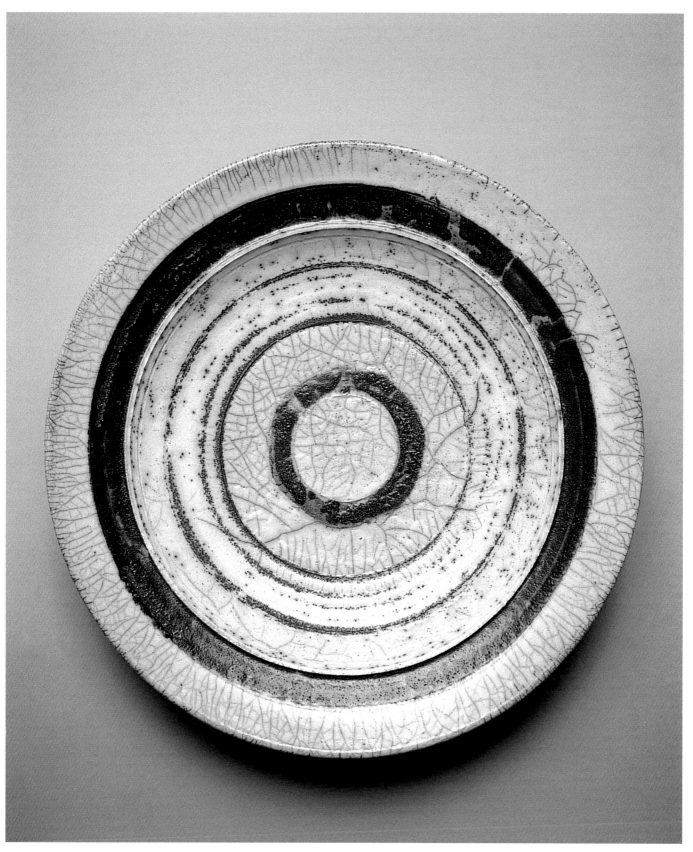

Plate 143: Robin Welch, raku, c.1980, dia: 33cm.
Welch was a fine potter long before his more familiar painterly style.

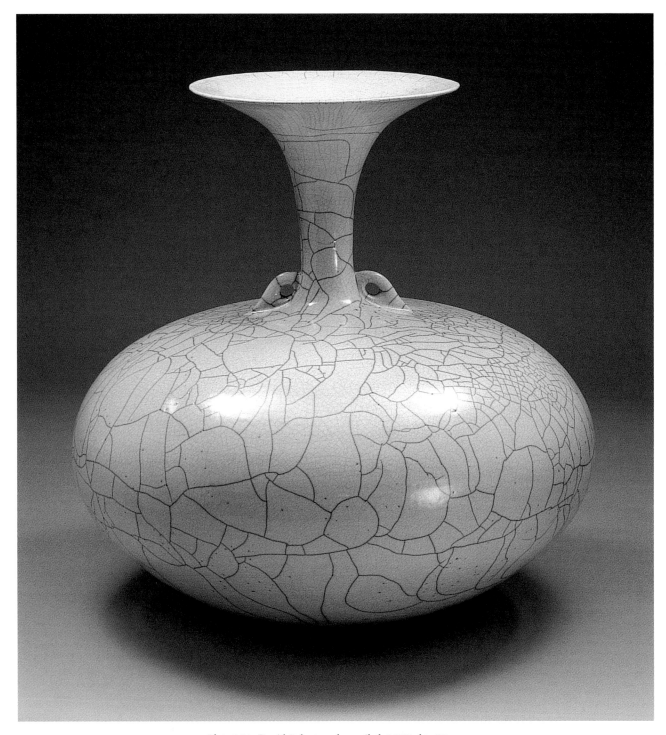

Plate 144: David Roberts, raku, coiled, 1989, ht: 58cm.
Heavily crackled glaze caused by rapid cooling is common in raku.

made by creating a mould from a full-sized model. Where more than one mould was necessary, the pots would be joined with an epoxy adhesive. Many of the forms had a metallic aluminium or slate finish on the inside; others were decorated with slips. Often there was a sharp contrast between the flat red surface on the outside and the inside surface that was either metallic or roughened with exaggerated

fingermarks. Red earthenware, the stuff of bricks and flower pots, has always been both the most common and the most despised clay material. Largely through the success of Martin Smith's pots, it has become increasingly popular with a wide variety of ceramic artists.

There was no further major exhibition of Smith's work until 1985 when new work was shown at the British Crafts

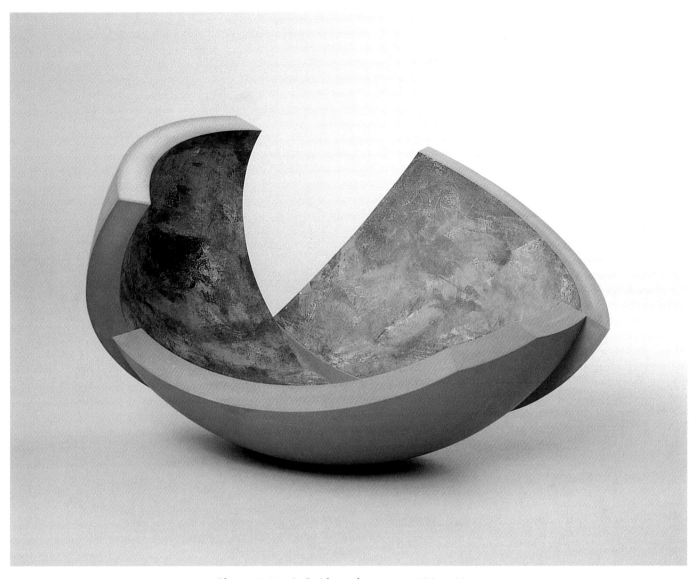

Plate 145: Martin Smith, earthenware, c.1985, w: 33cm.
Smith reinvigorated 'brick' in much the same way as he did with raku.

Centre. Once again, his forms had changed noticeably. The elaborate architectural shapes had been replaced by deceptively simple bowls created by cutting up and reassembling sections of a sphere. The contrast between inside and outside was achieved by subtle abstract decoration in underglaze colours opposed to the polished red clay. Many felt that this was the strongest work he had yet produced and the exhibition was almost entirely sold within minutes of opening.

Throughout the 1990s, Smith worked with these geometric forms with metal leaf to contrast with the red (or sometimes white) earthenware. This fascinating exploration of changes in shape and light has established Smith as one of the major ceramic artists of the last quarter century.

Another highly influential and much copied potter is Mary Rogers. She attended St Martin's School of Art and then worked for several years as a calligrapher and graphic designer. Rogers was brought up near the Crown Derby

factory and had been aware from childhood of the high regard in which the painters there were held, but her first direct experience of working with clay came through her husband, sculptor Bob Rogers. She had an immediate feeling for clay and went to nearby Loughborough College to study under David Leach.

Although she had her own kiln as early as 1960, it wasn't until 1965 when she exhibited in London and at the Derby Museum that there was much awareness of her work. Rogers's 1960s pots are all handbuilt stoneware and based on natural forms such as pebbles and shells. She had collected a wide range of natural history objects from childhood and these have always provided the raw material for her ceramics. This was an approach that Ruth Duckworth had been pursuing before her departure to America in 1964.

About 1970, Rogers switched from making coiled stoneware pots – often quite large – to making small pinched pots

Plate 146: Martin Smith, earthenware, platinum leaf, 1995, dia: 45cm.
This is from the 'Seen and Unseen' series.

in porcelain. Throughout the 1970s she concentrated exclusively on working in porcelain. Her style was much better suited to this medium and her reputation steadily grew until the late 1970s when she was one of the most sought-after potters in Britain.

Rogers perfected the technique of pinching delicate and translucent bowls. Some pots only had a matt-white glaze, but most were stained or painted in a pointillist manner. Many of her bowls had a wafer-thin crinkly edge that later became a ceramic cliché. The first pieces were mostly based on a dried piece of marrow, but soon she was working from an incredibly wide range of natural forms – leaves, flower petals, twigs, seed pods and many others. While most of her forms come from these intimate details of nature, occasionally she would paint landscapes in her bowls or carve and pierce the rim to form silhouetted trees – another widely copied effect.

Rogers's work went through a crisis towards the end of the 1970s. She was commissioned to write her excellent book, *Mary Rogers on Pottery and Porcelain*, and, perhaps because of the energy spent on this project, her pots became somewhat uninspired and repetitive. She had a brief and

unsuccessful flirtation with making raku before returning to her original medium of stoneware.

Throughout the 1980s, Rogers continued to make her small porcelain bowls and added a range of larger stoneware forms. Sadly, she had to give up working in clay and now only paints.

Rogers's porcelain pots first appeared at about the same time as Jacqui Poncelet's bone china. In one sense, the two types of pots are totally opposed in style and feeling. Poncelet's are hard-edged and obviously moulded – a contrast to the exaggerated organic made-by-hand quality of Rogers's pots. On the other hand, the similarity between them is obvious: both were tiny, fragile, unusable bowls with translucent, white bodies and stained colours.

The combined effect was enormous and soon every craft shop was flooded with copies and modifications of every conceivable aspect of their work. The copies of Mary Rogers seemed to be particularly abundant. There were so many delicate pots with lacy edges that 'frilly-knicker porcelain' became a widely used generic name. Some of these pots were excellent, but most were precious and unspeakably bad. I remember being given a small

stoneware piece encrusted with little pinched porcelain mushrooms that was so dreadful it almost put me off collecting ceramics.

Of all the excellent little porcelain pots made, few were better than those of Peter Simpson. Simpson also began working in the early 1970s with pots based on natural forms. He created little pots like seed pods with many layers of thin ceramic wafers. These pots were very different in feeling from those of Rogers. While Rogers's pots seemed soft, friendly and inviting to pick up and hold in the hand, Simpson's were somewhat prickly and sinister.

Simpson's output was never very large and few of these impossibly fragile pots have survived intact. Simpson abandoned porcelain and turned his attention to making large stoneware sculptures, but, in recent years, his time has been taken up with teaching commitments and he has ceased working in clay.

Dorothy Feibleman is another potter who has produced superb porcelain. She came to England from her native America and began making pinched agate-ware bowls. This is a laborious technique that involves combining different coloured clays into a block rather like a stick of Brighton rock. This is then sliced and used to make pinched bowls.

Plate 147: Mary Rogers, porcelain, painted, c.1980, dia: 13cm.
One of many of Rogers' pinched petal forms.

Plate 148: Mary Rogers, porcelain, painted, 1984, dia: 15cm.
Unlike true agate-ware in which the colour runs through the body, this decoration is painted.

Plate 149: Peter Simpson, porcelain, c.1972, ht: 11cm.

Feibleman's pinched and pierced bowls are, at times, breathtakingly beautiful. Unfortunately, the incredible amount of time needed to make them has meant that they have always been extremely expensive and, for this reason alone, not widely collected in Britain. Most of her pots and much of her excellent ceramic jewellery goes abroad. She rarely exhibits and, consequently, is not as well known as she should be.

Deirdre Burnett and Ursula Morley-Price are two other potters who have had great success with pots vaguely in the Rogers style. At one stage, Deirdre Burnett's porcelain was almost as popular as that of Mary Rogers's but I can't recall having seen any new work of hers in the 1990s. In the last few years some wonderful larger stoneware bowls have begun to appear. Ursula Morley-Price, whose pots are the frilliest of all, has exhibited widely and not only in Britain: in France, Germany and America her work has been shown repeatedly. Many potters who work in porcelain have found it easier to sell their work abroad.

The fashion for 'frilly-knicker porcelain' has gone – at least in Britain. Unfortunately, the backlash against delicate porcelain pots was so severe that it has hindered the appreciation of great potters like Mary Rogers and Geoffrey Swindell. No doubt, it has also prevented many younger potters from experimenting with this sort of work.

Not everyone turned to porcelain to make thin, lacy pots. Many were attracted to porcelain (and also bone china) because of its smooth, clean white surface. The pot was used as a surface to draw on like a three-dimensional piece of paper.

Of all the potters who worked in this way, Nicholas Homoky, a graduate of the Royal College of Art, produced the finest pots. Most of his pots are precise, classical, thrown bowls or cups with inlaid black lines in simple abstract designs. Occasionally, he would draw teapots or cups – playing with the contrast between the drawn shape and the actual shape of the vessel.

While the work of Homoky and a few others is excellent, the whole style was very limited in scope. There was also the problem that such precise, controlled work in such blank materials began to look more like industrial prototypes than 'studio ceramics'. From the hands of lesser artists came pots that are bland and totally lifeless. This did not seem to prevent them from being popular with interior decorators who equated these pots with hi-tech kitchens and mock-Bauhaus chairs.

With so much white porcelain in the shops and so much criticism of Leach's 'brown pots' in the air, it was not difficult to predict that the next fashion in ceramics would be bright colour. By 1980, Elizabeth Fritsch, Jacqui Poncelet

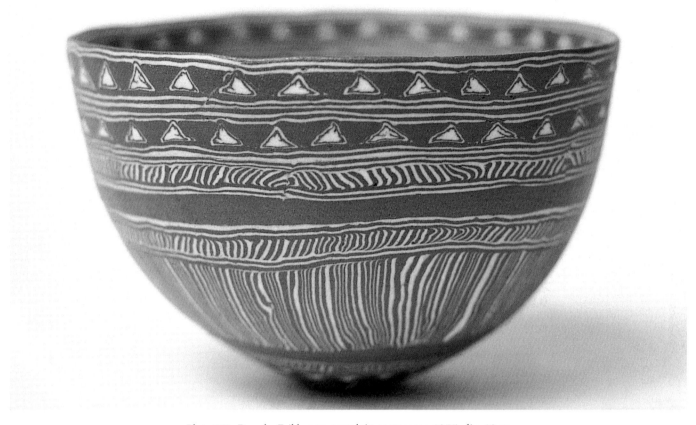

Plate 150: Dorothy Feibleman, porcelain agate-ware, 1975, dia: 12cm.

and Carol McNicoll had all been making colourful work for some time, but it was Janice Tchalenko who was at the heart of the colour craze.

Tchalenko studied ceramics at the Harrow School of Art. The emphasis there was very much on making pots in the Leach tradition and, through most of the 1970s, Tchalenko continued to make pots in this context. In 1979, she began experimenting with brightly coloured decoration and, the following year, she was given a Crafts Council grant to continue research.

The success of Tchalenko's new work was rapid. She produced a range of tableware – bowls, jugs, teapots – thrown in stoneware with sponged, slip-trailed and painted decoration. These pots were utilitarian, hardy, inexpensive and, most importantly, bright and cheerful. At last there was a real alternative to the 'Oriental' standard-ware of Leach and his followers and the refined standard-ware of Lucie Rie and her followers. Tchalenko's pots were soon amongst the most popular in Britain and she could barely make enough to satisfy the demand.

This success probably reached its peak in 1985 when the prestigious New York art gallery, Blum Helman, put on a one-man exhibition of Tchalenko's pots with comparatively high prices. She cut down her output and was soon exhibiting

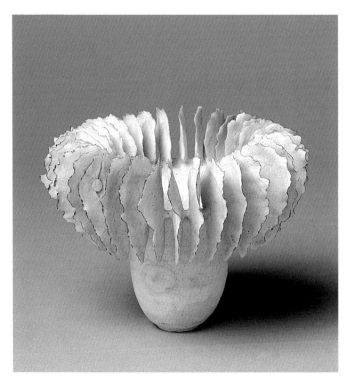

Plate 151: Ursula Morley-Price, porcelain, c.1982, dia: 13cm.

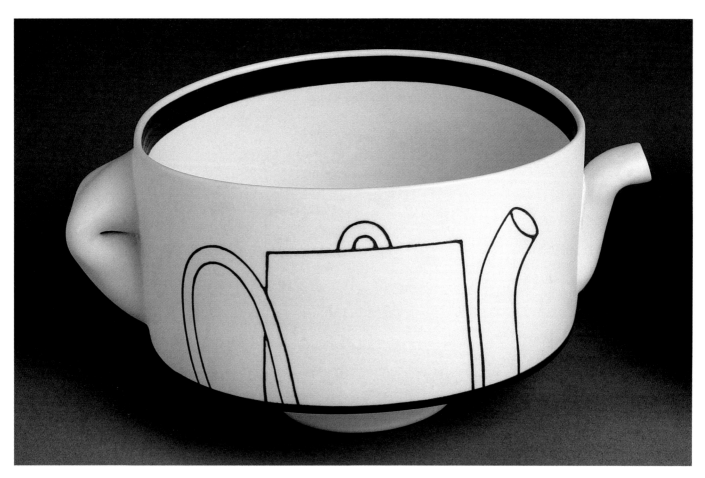

Plate 152: Nicholas Homoky, porcelain, inlaid black slip, c.1981, w: 19cm.

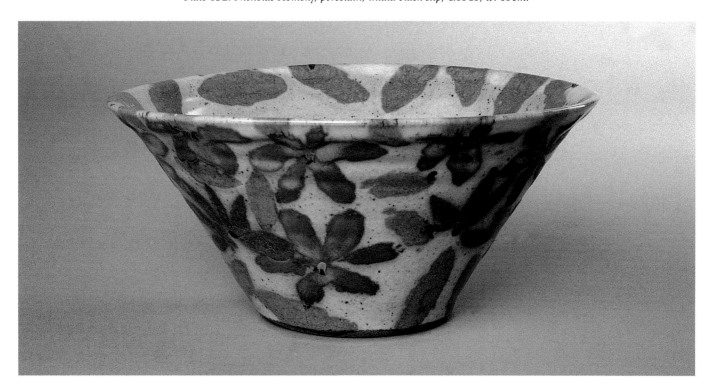

Plate 153: Janice Tchalenko, stoneware, c.1980, dia: 25cm.

her more expensive pots in Britain. Already there had been a minority of people who felt that, although brilliantly decorated, Tchalenko's pots were somewhat weak in shape. To this group was added another who strongly objected to the elevation of her work from standard-ware to 'art'. This criticism has no more validity applied to the work of Tchalenko than it has to that of Leach and Cardew or the early work of Rie. Tchalenko continued to produce fine individual pots and also had great success with designs for commercial production, most noticeably those done for the Dart Pottery.

Tchalenko was copied, usually very badly, by dozens of potters and soon the craft shops and fairs were so filled with 'wallpaper-on-clay' that it became far easier to find something to match your curtains than to find a really good pot.

There were, however, a small number of excellent potters whose styles fit the prevailing mood. Sutton Taylor makes large, highly decorative, thrown earthenware bowls. He has concentrated on perfecting lustre glazes using gold, silver and copper in reduction firings. His pots are totally different in style from those of Tchalenko, but are similar in having a

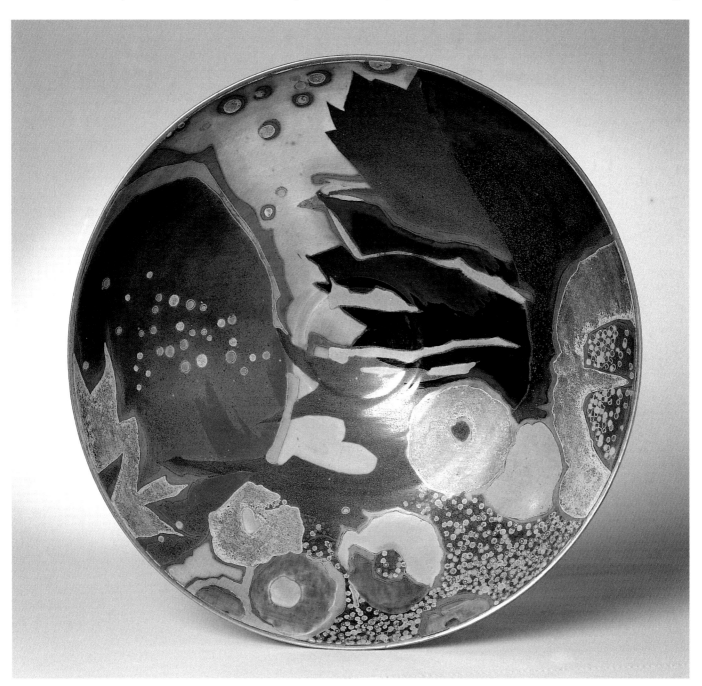

Plate 154: Sutton Taylor, earthenware, lustre glaze, c.1985, dia: 42cm.
One of the few artists to make good use of lustre-ware.

colourful, densely decorated surface. He continued to produce highly successful work throughout the 1990s.

Sandy Brown has also been working in a colourful, decorative manner. Brown, who spent years in Japan, combines in her stoneware the rough quality and fluid clay handling of Japanese Mingei pottery with an exuberant painting style reminiscent of New York abstract paintings of the 1960s. Although her work can be somewhat uneven in quality, the best examples are superb.

With the huge rise in interest and price of ceramics over the last twenty years it is inevitable that more 'fine art' galleries and painters are taking an interest.

The history of collaboration between painters and ceramics is somewhat chequered. There have been a number of high points. The work made by Paul Gauguin and Ernest Chaplet or by Joan Miró and Josep Llorens Artigas are two examples. Picasso's ceramics are even better known. In Britain, some of the pots painted at the Omega Workshops were of interest. In general, however, when decorating ceramics, painters produce work that is mediocre painting and poor ceramics.

Such talented painters as John Piper, Phillip Sutton, John Hoyland and Bruce McLean have all had exhibitions of decorated pots that have illustrated this point. It is not really very surprising that this should be the case. Painters are simply not trained to paint in colours that change when they are fired; and on surfaces that shrink and can distort in shape. Only rarely do these painters even make their own forms.

Happily, there are a small number of painters who have been more conscientious about their ceramic work and David Garland is a good example. Garland has developed a range of thrown, earthenware domestic pots, slip decorated and painted – many in blue and white. His work often resembles a cross between Mediterranean tin-glazed ceramics and the paintings of Franz Kline. Some of his larger bowls are particularly good.

Ceramic fashions will continue to come and go. Usually, something new and good comes from each one. Inevitably,

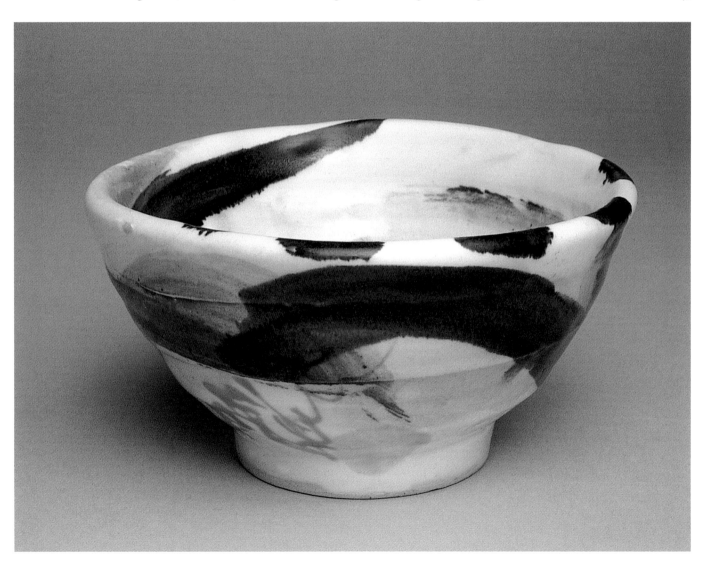

Plate 155: Sandy Brown, stoneware, painted decoration, 1994, dia: 15cm.

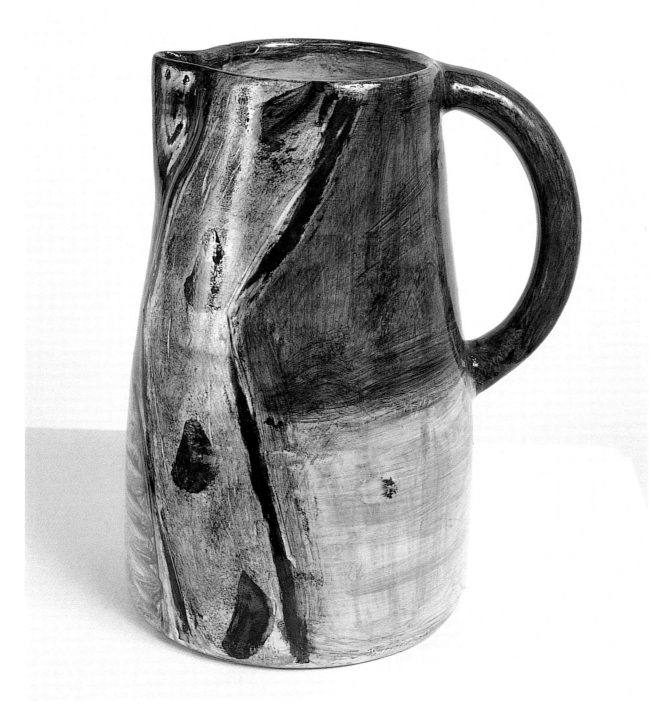

Plate 156: David Garland, earthenware, painted decoration over white slip, 1990, ht: 30cm.

these trends are very annoying to those who regularly visit exhibitions and craft shops. It is, however, partly because of these changing fashions that there is such a diversity of interesting work in Britain today. Fashions may pass, but some of the best work in that style will continue to be made. It is still possible to see superb new raku or 'frilly-knicker porcelain' even though these types of pots have ceased to be fashionable.

Chapter 12

The Camberwell School

At certain times, an especially good group of artists suddenly emerges from one particular place. The Leach Pottery in the early 1920s, the Central School in the late 1950s, the Royal College of Art in the late 1930s and again around 1970 have all been examples of this.

The Camberwell School of Art and Crafts has also had two such periods. The first was near the beginning of the century under the leadership of W.B. Dalton when William Staite Murray, Charles Vyse, Reginald Wells and others were students. For many years after the Second World War, the Head of Ceramics at Camberwell was Dick Kendall, Bernard Leach's son-in-law. During this time, Camberwell was a leading school for ceramics but, despite many fine teachers and students, no cohesive group of potters emerged.

In 1974, Ian Auld took over the post and, almost at once, brilliant young potters began coming out of Camberwell. Between 1975 and 1980, at least a dozen of Britain's most promising young potters graduated. Susan Barrow, Sue John, Henry Pim, Sara Radstone and Angus Suttie were all in the same year. When one looks at the list of visiting teachers – Gillian Lowndes, Glenys Barton, Janice Tchalenko, American potter Scott Chamberlain and many others – it is not surprising that so much talent would emerge. Two of the most influential of the teachers during this period were Colin Pearson and Ewen Henderson.

Colin Pearson studied painting at Goldsmiths' College before becoming interested in ceramics. He trained at the Winchcombe Pottery and then worked at the Royal Doulton Pottery and as David Leach's assistant at the Friars Pottery at Aylesford in Kent. When Leach left, Pearson managed the pottery for five years before setting up his own studio in 1961.

For most of the 1960s, Pearson primarily made domestic stoneware – some with an influence of medieval English pottery, but most with the Oriental influence so prevalent at that time. About 1970, he began to concentrate more and more on individual pieces, and small appendages started appearing on the shoulders of his pots. The familiar 'wing forms' with which Pearson is so associated made their first appearance in his 1971 exhibition at the British Crafts Centre. Pearson's work of the early 1970s is quite outstanding – perhaps the best he has ever done. Black basalt stoneware,

porcelain with celadon glazes, pots with flowing ash-glazes – all were fresh and powerful. Many people feel that Pearson's pots have not changed that much in style from this time, but this misconception is because he has only rarely abandoned the use of wings or other modified handles. These appendages are an important aspect of Pearson's work as they vastly alter his thrown cylinder shapes. The decorative

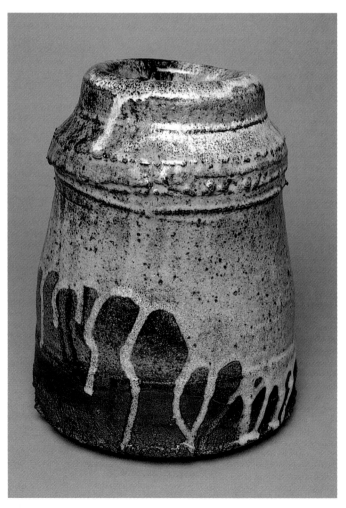

Plate 157: Colin Pearson, stoneware, c.1970, ht: 24cm. This pre-'wing' pot shows a strong Japanese influence.

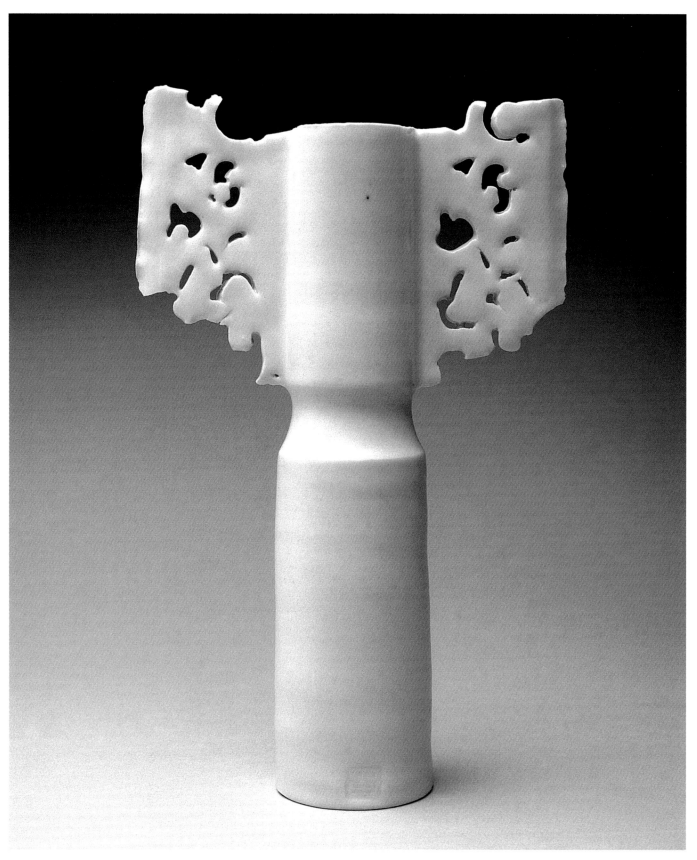

Plate 158: Colin Pearson, porcelain, c.1972, ht: 28cm.
The wings are made by pressing sections of wood into soft clay and are applied when leather-hard.

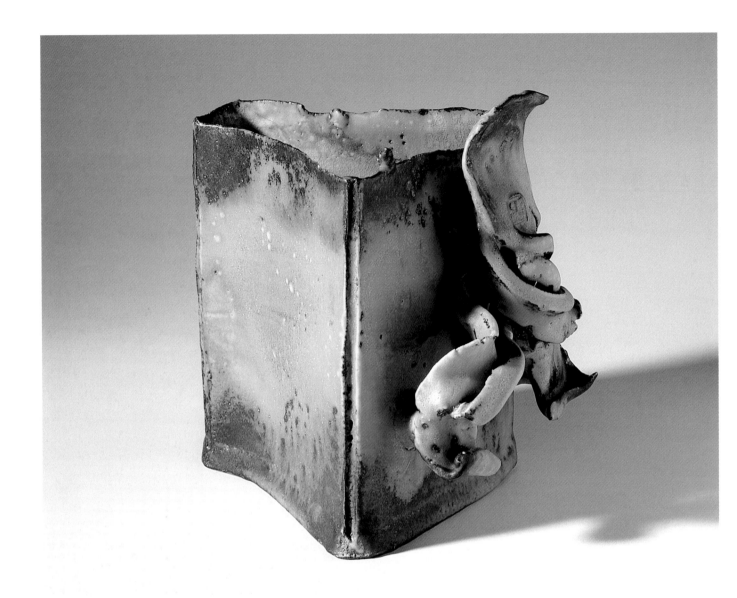

Plate 159: Colin Pearson, stoneware, 1994, ht: 22cm.
In the 1990s, Pearson often replaced 'wings' with convoluted handles.

nature of these often elaborate wings was used – together with jagged, torn rims – to contrast the plain surface of the rest of the pot.

There have been considerable changes to Pearson's techniques over the years; from reduction firing in a gas kiln to oxidation in an electric one and from dip glazing to spraying. His forms have become more complex and often involve assembling thrown and slabbed sections. He has introduced distinctive handled jugs and increasingly added colourful glazes to the black, grey and bronze more frequently used in the 1980s.

The very individual nature of Pearson's pots has always meant that he has been somewhat apart from the mainstream of British ceramics. His 'wings' have divided people's opinions; many, especially abroad, consider him to be one of the finest of British potters while some dismiss his work as

gimmicky. There is little doubt, however, that he has been one of the most successful potters at combining the very different nature of the Oriental-inspired vessel and the sculptural pot.

Pearson's influence as a teacher at Camberwell is most noticeable in the work of two highly talented potters, Dan Kelly and Colin Gorry, who both make thrown stoneware vessels with some characteristics of Pearson's work.

Although born in Staffordshire, Ewen Henderson did not develop an interest in ceramics until relatively late. He worked for a timber preservation company in Cardiff for seven years and only entered Goldsmiths' College as an art student at the age of thirty. Henderson was initially interested in painting but became attracted to clay and attended Camberwell from 1965 to 1968, when both Lucie Rie and Hans Coper were on the teaching staff. The influence of Coper's earlier work and of Rie's techniques are both apparent in Henderson's pots.

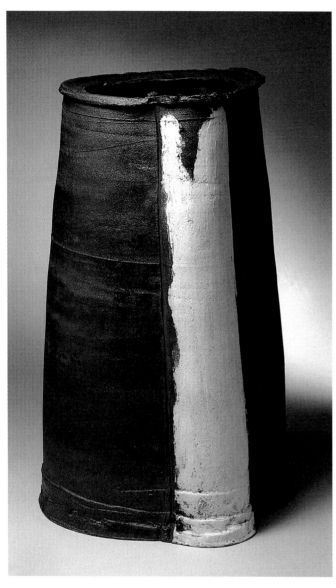

Plate 160: Dan Kelly, stoneware, c.1998, ht: 63cm.

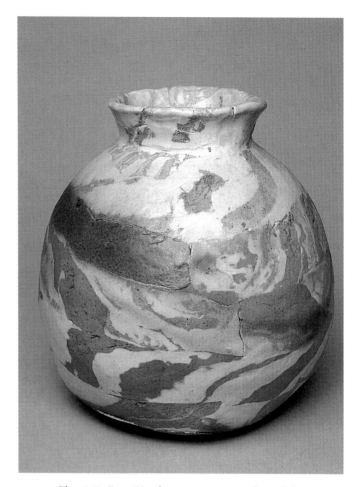

*Plate 161: Ewen Henderson, stoneware and porcelain,
c.1978, ht: 26cm.
A dramatic example of mixing clays.*

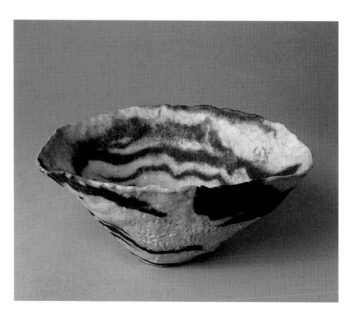

*Plate 162: Ewen Henderson, stoneware and porcelain,
1980, w: 25cm.*

It was clear from the start that Henderson was going to be an unusual potter. His early work – thrown with ash-glazes – was unexceptional, but it was very different from either the Leach tradition or the mainstream of contemporary ceramics. Henderson soon switched to handbuilding and, during the 1970s, evolved his unique style of handling clay.

At a time when precision and prettiness were the strongest unifying factors in British ceramics, Henderson's pots were anarchic and revolutionary. His thin stoneware pots were aggressively asymmetrical with rough pitted surfaces in muted colours – sometimes described as resembling poppadoms. Many had cracks in the rim or the remains of shells (on which the pots often sit in the kiln) stuck to the base.

This was the antithesis of the porcelain of Mary Rogers or the controlled decoration of Elizabeth Fritsch. Henderson's pots defied being categorized. On the one hand, they were clearly as modern as anything else being made. On the

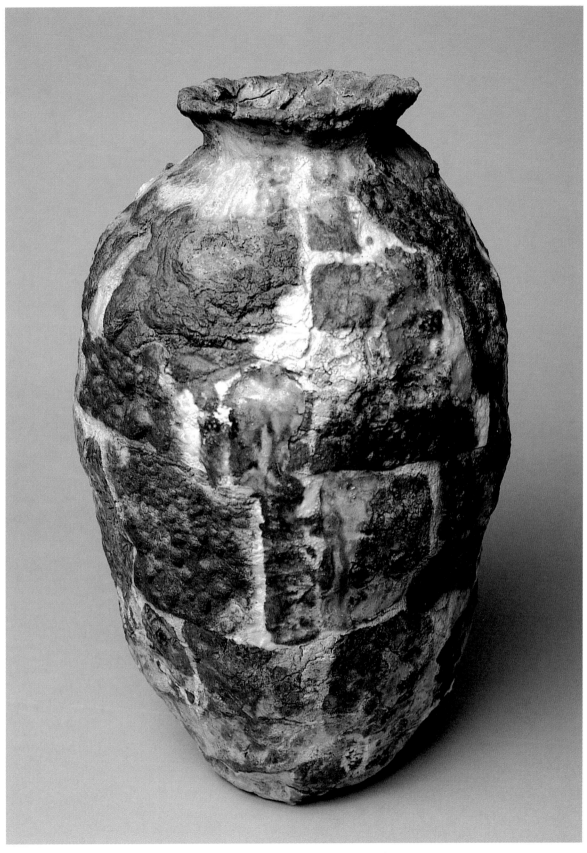

*Plate 163: Ewen Henderson, stoneware, c.1982, ht: 33cm.
Many of Henderson's shapes are surprisingly classical.*

other, these pots could almost have been unearthed from some ancient Mediterranean culture.

Henderson's work continued to change and improve. He was always eager to take risks and develop new techniques. Lucie Rie began mixing differently coloured clays in her famous 'spiral' pots in 1967, when he was her pupil at Camberwell. In the late 1970s mixing clays became one of Henderson's principal techniques – he began by using layers of porcelain and stoneware, sometimes to form obvious patterns, at others to form a seemingly random collage. From this he moved to making pots from different stoneware

clays. This is extremely difficult to do because each clay behaves differently when fired. Henderson solved this problem by bonding the different clays to a central stoneware core to form a laminate rather like plywood.

Henderson has been described as an anti-craftsman – a comment on his intentions rather than his technical ability. Unlike most contemporary potters who tend to look at clay, glazes and kilns as obstacles to be controlled and overcome, Henderson seemed to revel in the vagaries of making ceramics. Clays that shrink, crack, warp and bloat; glazes that run, crawl and bubble are celebrated in his

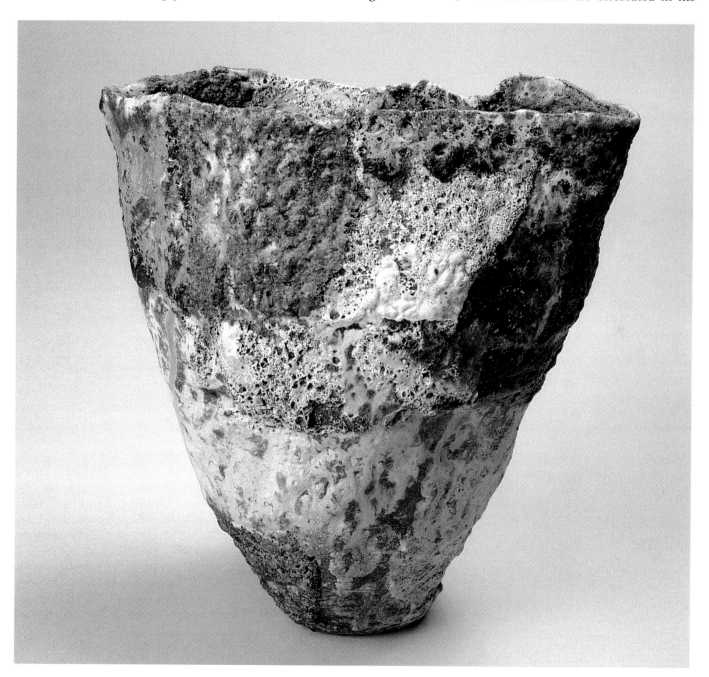

Plate 164: Ewen Henderson, stoneware, c.1985, ht: 32cm.
This pot was chosen for Henderson's retrospective exhibition at the British Crafts Centre.

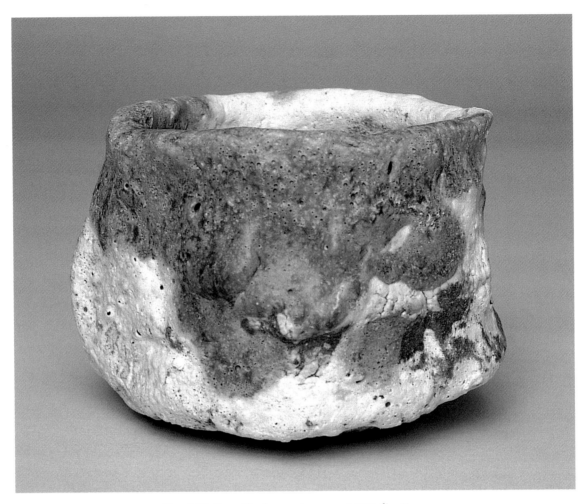

Plate 165: Ewen Henderson, stoneware, 1987, dia: 11cm.
Teabowls are Henderson's most collected pots.

pots. Sometimes, as far as I am concerned, he has carried this too far. I remember, when I arranged an exhibition of Henderson's pots in 1981, having to reject a few that wouldn't stand unless one side was supported by a pebble. He was horrified that I should cling to the view that a pot should be relatively stable.

One of the strongest aspects of Henderson's work has been his teabowls. He always made them alongside his larger pots and they are at the heart of his work. Most of his new techniques were worked out on his teabowls, some of which are exceptionally fine pots. Because of the teabowls and his attitude to handling clay he is one of the few British potters who is widely collected in Japan.

Henderson's pots went through many transformations in the mid-1980s. There were narrow 'boat-form' bowls, tall bottles and a rather less successful series of torso-forms. Slowly the small cracks became crevices and gaping holes. The protuberances became larger and larger until the pots looked less like vessels and more like sections of some rugged mountain. He began to call himself a sculptor instead of a potter, to distance himself from the craft world and to reject most of his early pots.

Landscape, that is such an obvious inspiration in these pots, has always been an important aspect of his work. Many of his 1970s pots are reminiscent of geological striations or fossils. Henderson has painted landscapes in watercolour that, when possible, he exhibited with his ceramics. The colouring of his pots has a lot in common with his watercolours and they have been described, unflatteringly, as 'water-coloured carrier bags'.

The sculptural nature of Henderson's work increased in the 1990s. Pieces based on skulls and bones, huge monoliths and large forms where he experimented with additions of paper clay, all appeared. These changes did not always please everyone.

There is little immediate appeal in Henderson's pots. They are not pretty, colourful, functional or easy to appreciate. They break easily, scratch furniture and occasionally shed little bits of their surface. Collectors are usually very slow to buy their first Henderson pot, but are then usually keen to acquire more.

Similarly, the craft establishment has been relatively slow in recognizing the importance of Henderson's work – a situation not helped by his vociferous criticism of almost

everybody in the craft world. However, the quality and power of his work have won more and more admirers and he is now widely seen as being one of the most important potters of the last quarter-century. Many would go further and claim he is the finest potter to have emerged since Hans Coper and the American, Peter Voulkos, in the 1950s.

Henderson moved from being a maverick with a handful of supporters to being a leading figure in British ceramics. His pots have slowly changed the look of studio ceramics and, particularly, handbuilding. His pots are spontaneous, free and seem to come direct from the heart – not from the head, as is much of the controlled and intricately planned work of many of his contemporaries. A whole generation of younger potters are now beginning to incorporate aspects of his work into their own.

Many of the Camberwell graduates have followed Henderson in making asymmetrical handbuilt pots with emphasis on a richly textured surface. Sara Radstone has been the one who – at least superficially – has emulated him most.

Her early stoneware vessels with their uneven bases, cracks, ragged broken rims, craggy textured surfaces and subtle coloration were often mistaken for Henderson's. Her method of handbuilding – often compared to making a collage – was also similar. Radstone's pots grow through improvisation and she sometimes cut up and rearranged pieces of a pot or used pieces intended for one in constructing another.

Despite the obvious similarities, these pots were very different in nature from those of Henderson. Her pots are quiet and introverted without being boring or weak. While Henderson's are bold and assertive, Radstone's are calm and earthed. While Henderson's surfaces appear to have been created with expressionistic enthusiasm, Radstone's appear to have been built up slowly with meticulous and loving care. While his pots allude to a natural landscape, hers seem to allude more to an urban landscape. They are more reminiscent of peeling eroded walls, rusted sheet metal, or weather-scarred roofs than of anything pastoral.

Radstone's work of the 1990s changed considerably. The forms have become abstracted and less recognizable as

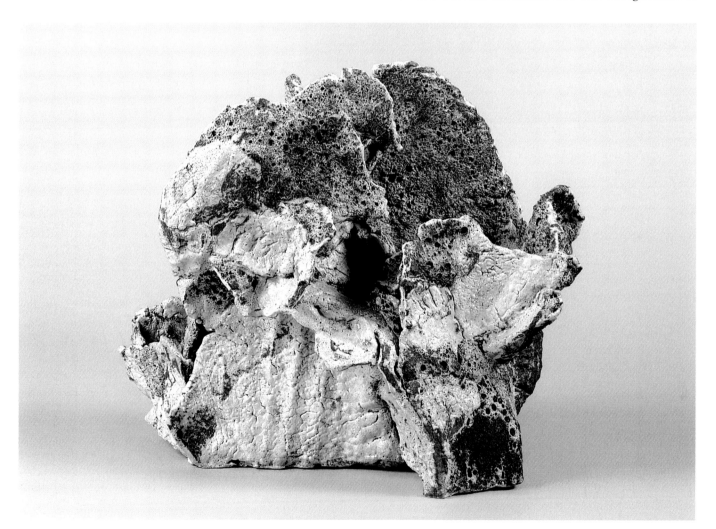

Plate 166: Ewen Henderson, 'Inner Ear', stoneware, 1988, ht: 36cm.
One of many pots based on skulls.

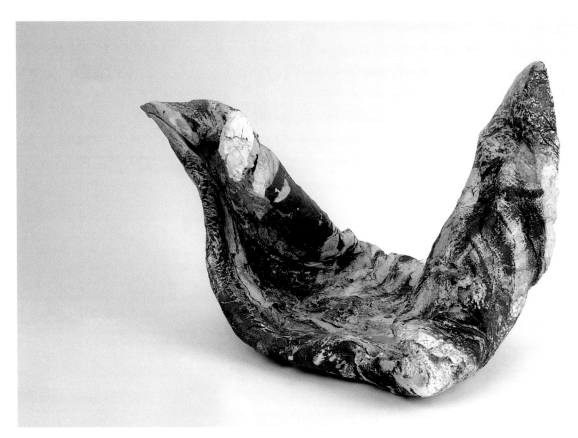

Plate 167: Ewen Henderson, 'Knotted II', mixed clay and paper, 1997, w: 64cm.
These paper clay pots have an alarming tendency to shed.

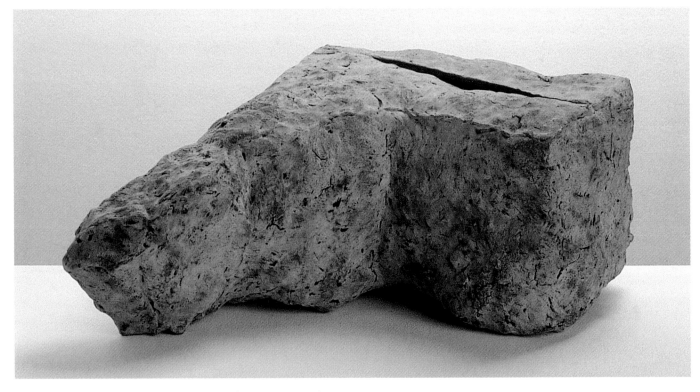

Plate 168: Sara Radstone, stoneware, 1989, w: 38cm.

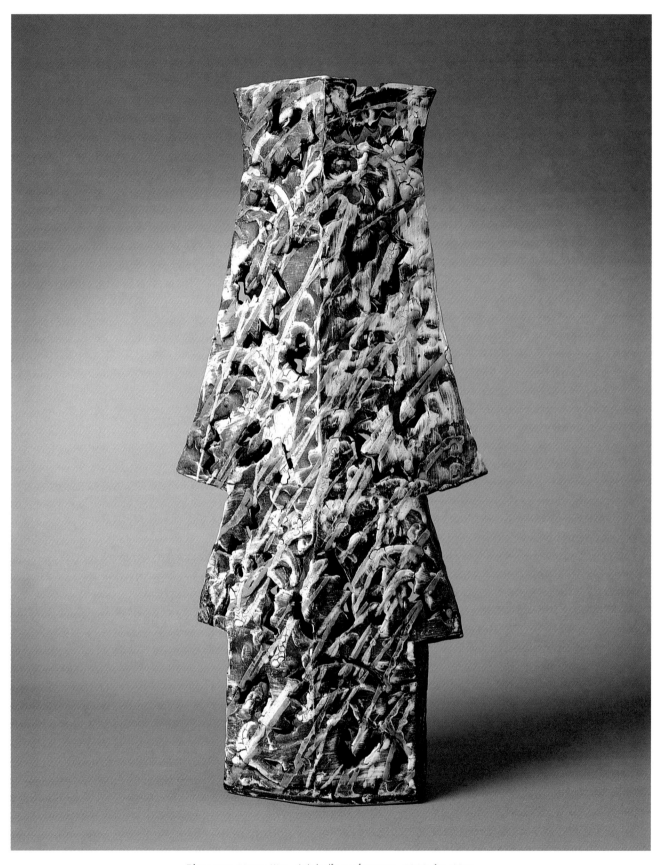

Plate 169: Henry Pim, slab-built earthenware, 1983, ht: 56cm.
This pot is pierced in many places.

vessels. Often they are elongated like reeds or poles, or have become wall-mounted 'volumes'. The surfaces have lost most traces of colour and become subtle variations of stony grey. The enigmatic nature of her ceramics is not to everyone's taste and some find her work too barren and unapproachable. Others find in her work a meaning and depth, often absent in other contemporary ceramics.

Henry Pim is another of the Camberwell graduates to be inspired by Henderson. His thin-walled stoneware vessel-forms were constructed using an unusual method. Having started with a drawing, Pim built a full-size paper model of the pot. This was then deconstructed and used as templates for cutting slabs that were given impressed patterns with carved plaster-of-Paris rolling-pins. After the pot was constructed, Pim applied slips and glazes, usually in a colourful and decorative manner. This idiosyncratic method seems to place an even greater emphasis on the surface. Sometimes his pots leave you uncertain as to whether they are actually clay.

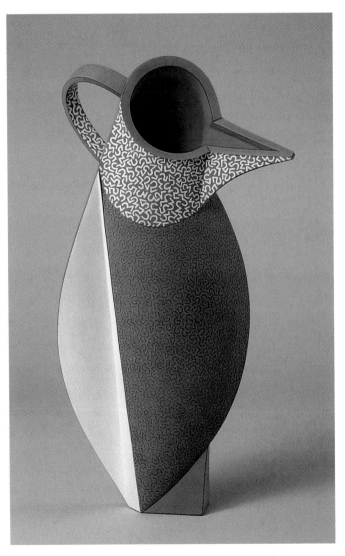

Plate 170: Linda Gunn-Russell, earthenware, 1985, ht: 38cm.

Many of Pim's shapes of the early 1980s were largely of classical Mediterranean influence – large urns (often made in pairs) and kylix-shaped cups were both common. His forms began to change radically and his 1986 and 1988 London exhibitions had shapes more reminiscent of boats, tanks or baby-carriages than of pottery vessels. Pim's pots although playful and decorative, are also thought-provoking. Like other Camberwell graduates, the technical quality of his ceramics and his willingness to experiment with new ways of working are important.

The teaching staff at Camberwell was varied and highly talented and most of the students were not influenced by just one tutor. While Radstone and Pim were clearly inspired by Henderson, others were almost untouched by his influence. The work produced was as diverse as the tall sculptures of Susan Barrow and the 'Oriental' pots of Jim Malone.

One of the most successful of the Camberwell students has been Linda Gunn-Russell. Initially her work was jokey, slip-cast functional forms, but in 1979 she began to exhibit her more familiar flattened slab-built jugs. Gunn-Russell's work has the same decorative '2½-dimensional' quality of that of Elizabeth Fritsch. Alison Britton once described it as providing 'a bit of quiet, witty and contemporary ornament'.

Although Gunn-Russell has worked with raku and various earthenware and stoneware bodies, many of her best pots are red earthenware painted in slips and underglaze colours with patterns similar to those sometimes found in Japanese decoration or in the paintings of Roy Lichtenstein. As her work evolved, the painted patterns and sponged designs were slowly replaced by more subtle decoration and the forms changed from overt vessels to more human shapes with greater roundness.

Some people have dismissed Gunn-Russell's work as being shallow; however, the fact that her pots were amongst the most popular and immediately accessible does not necessarily mean that they are superficial. Her excellent sense of form and technical control raise her ceramics to a higher level.

For many, the best of all the Camberwell students was Angus Suttie. He was born and raised in Scotland and did a number of odd jobs as well as studying dramatics before coming to London. He didn't enter Camberwell until he was nearly thirty.

Suttie's early pots tend to defy description, but there are clear affinities with both folk art and Surrealism. His pots have the same freshness and humour, the same joyous colouring, the same lack of sophistication and the same desire to please that is found in much folk art. The sharp edge to the humour, the eccentric juxtapositions, the reliance on the inspiration of the unconscious are all related to Surrealism.

Suttie's method of handbuilding also related to collage. He would begin with almost random slab shapes or bits of pots and assemble them intuitively. Decoration was an important aspect of Suttie's ceramics and he applied slips, glazes and, sometimes, enamels or lustres in an exuberant painterly manner. While the pots were functional, the

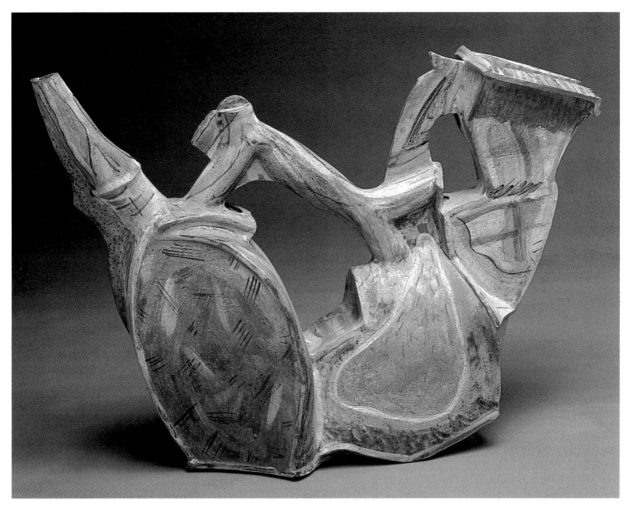

Plate 171: Angus Suttie, stoneware, c.1986, w: 46cm.
This 'jug' is not one of his least eccentric in shape.

shapes – teapots, cups, spoons, cheese dishes and so on – were used primarily as a starting point for the making process. Part of the humour of his work lies in the distortion of the functional vessel.

In the mid-1980s, Suttie temporarily changed from using red earthenware to using stoneware, resulting in his pots having more muted colours and less delicate shapes – and less humour. Suttie had always emphasized the importance of feeling in his work and, no doubt, this change was linked to the death of his partner.

Many of these pots are quite exceptional but seemed to divide those who looked at them. Many saw him as being the most interesting and inventive young potter in Britain. Others saw his pots as being awkward and over-decorated.

Suttie became increasingly interested in pre-Columbian ceramics and in more elaborate 'architectural' forms. His 1990 exhibition, shared with Sara Radstone, was a tour-de-force – immensely powerful pieces, many over 2ft (60cm) high.

The final pieces Suttie made are even more powerful – emotionally charged sculptural vessels that seem like somewhat sinister alien life forms. His death, at the age of only forty-six, was one of the greatest losses to British studio ceramics of the century.

The 1990s were not the best decade for these artists. Linda Gunn-Russell was one of a number of leading young potters championed by Anatol Orient. The closure of his Portobello Road gallery meant that she had much less public exposure in the 1990s. She took many years off to study traditional Chinese medicine. Henry Pim took up a teaching post in Dublin in 1990, and his ceramic sculptures have hardly been seen in England. Susan Barrow emigrated, and Colin Gorry has concentrated on his other career in the film industry. Colin Pearson has had increasingly poor health, and the final blow was Ewen Henderson's death, when he was only in his mid-sixties, at the end of the century. Despite these depressing facts, there is no doubting what a great body of work these artists have created and what a great influence they have had. Look at any art school degree show and you are bound to see at least one potter making pots more than a bit like Henderson's. Sara Radstone and Dan Kelly are still producing excellent ceramics and Linda Gunn-Russell has started making again. All three are still in their forties and may not yet have made their best work.

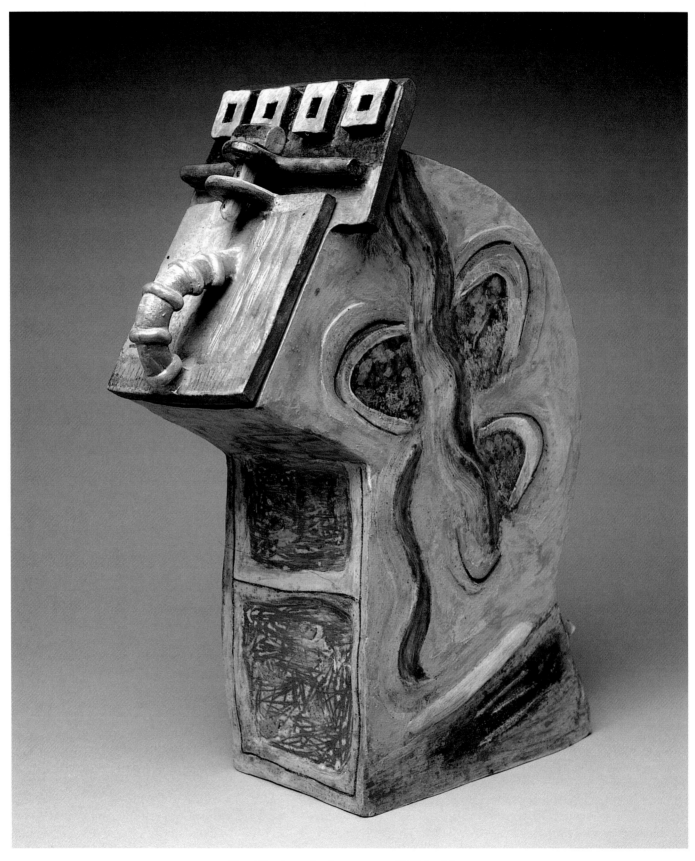

Plate 172: Angus Suttie, stoneware, 1987, ht: 36cm.
Suttie would have considered this box to be entirely functional.

Chapter 13

Diversity in Britain

If there was a single decade when British studio ceramics was at its very best, it was almost certainly the 1980s. Most of the 1970s graduates from the Royal College of Art and Camberwell were producing some of their finest work ever; many of the older generation of potters were still going strong and there seemed to be new and exciting potters emerging every year.

The range of work being produced was quite staggering. Pick almost any style of pot or any bizarre fashion and you were bound to have found at least one fine potter who was turning out quality work. From the most traditional functional pots to the most outlandish ceramic sculptures, every taste was catered for. This tremendous variety of work as well as the high standard of the individual potters solidified Britain's standing as a very exciting place for ceramics.

The back-up for potters was also better than at any time since the 1930s. The opening of Sotheby's Belgravia auction house and the interest of several dealers transformed the market for historical pots and these higher prices helped boost the market for contemporary ceramics. Several influential ceramics galleries opened and many craft shops greatly increased the quality of both their display and the work they exhibited. Pots regularly appeared in the Sunday supplements and other high-circulation magazines. Many museums reconsidered their approach to displaying their collections and even the Tate exhibited ceramics in their major St Ives retrospective.

In the 1980s, thrown pots and, more specifically, 'Oriental' pots, came in for tremendous criticism and abuse. Despite this fact, there were as many fine 'Oriental' potters working in the 1980s as at any time in the past. Some of these potters did not emerge until the 1970s.

One of the finest, Jim Malone, graduated from the Camberwell School in 1976. Although initially interested in painting, Malone switched to ceramics after seeing early Chinese and Korean pots in the Victoria & Albert Museum.

His pots are thrown stoneware (he also occasionally makes porcelain) very much in a style that would have met with Bernard Leach's approval. He uses a small range of familiar glazes: tenmoku, a celadon-like ash-glaze and

hakeme. His decoration is understated and sparse – incised or painted trees or fish; cut-sided, combed, or chatter-marked surfaces. His pots have a superficial resemblance to those of Richard Batterham (as well as, of course, the Oriental pots they both base their work on) and Malone emerged as a potter at a time when Batterham was, probably, at the height of his popularity.

Malone is not, even slightly, innovative and there are many talented potters in Britain working in a very similar style, but he stands well apart from most others because of the unsurpassed quality of his pots. It is nearly impossible

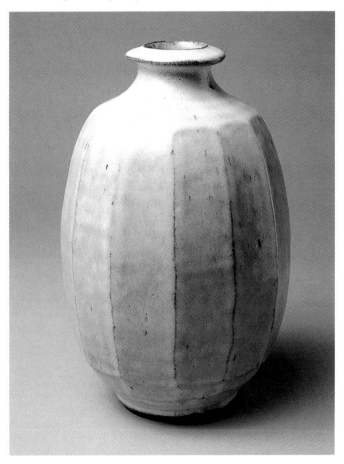

Plate 173: Mike Dodd, stoneware, ash-glaze, c.1990, ht: 26cm.

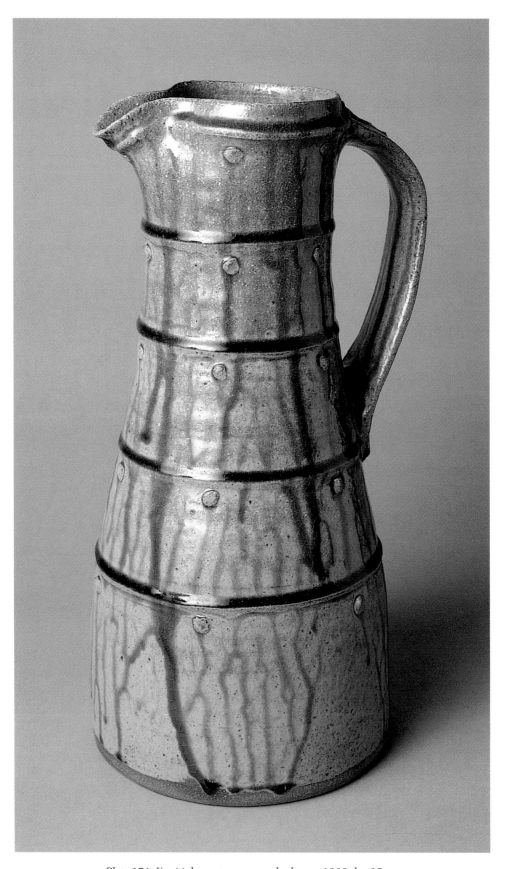

Plate 174: Jim Malone, stoneware, ash-glaze, c.1988, ht: 35cm.
This is work that Bernard Leach would have admired.

to describe the difference between a pot that just sits there and a pot that seems to 'sing', but nearly every collector of 'Oriental' British pots would agree that most pots don't 'sing' and Malone's do. Malone's pots have a generosity of form and a freedom of decoration that equals that of early pots by Michael Cardew.

Most potters who throw can only produce their best work when they spend much time at the wheel. Malone went through a comparatively poor period when he had heavy teaching commitments, but since the mid-1980s he has potted virtually full time and the high quality of his work has returned. His pots are a delight to look at, hold, or use.

Mike Dodd has also done exceptional work in the Leach/Batterham tradition. At times, when they were neighbours in Cumbria, the pots of Malone and Dodd were often uncomfortably close. While form is the strongest aspect of Malone's pots, Dodd's forte is ash-glazes, that he produces with incredible variety and often breathtaking beauty.

Malcolm Pepper was an 'Oriental' potter of a very different kind. He studied under Philip Wadsworth, one of William Staite Murray's followers, and his work displays little of the Leach influence. Pepper relied on a great technical ability and on a scholarly knowledge of Oriental ceramic techniques. His pots display a remarkable skill and confidence.

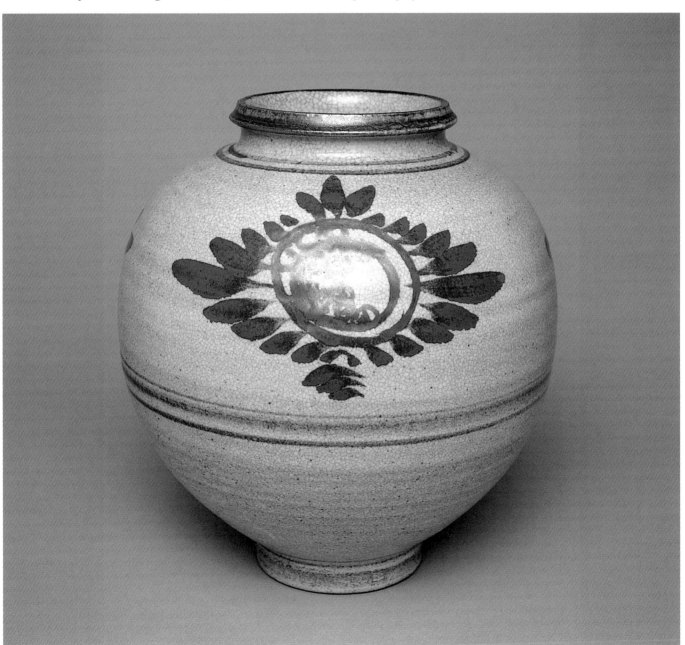

Plate 175: Malcolm Pepper, stoneware, iron decoration, c.1977, ht: 29cm.
The heavily crackled glaze and the strong turned foot are typical of Pepper.

Pepper used a wide variety of glazes in his work, but iron and cobalt brushwork on a buff or hakeme ground is most common. He was a master at crackle-glazes and also at controlling the difficult chun glaze. Pepper's brushwork had none of the spontaneity of the best brush artists and he sometimes overelaborated his designs, but his decoration has tremendous power. He was an accomplished thrower and his forms are also very strong. The pots are relatively heavy compared to those of Leach followers and have distinctive feet.

Pepper came to prominence in 1980 when he exhibited over a hundred new pots at the Casson Gallery in London. This was, probably, the finest work he had made and the exhibition attracted an enormous interest. Sadly, Pepper died, at the age of forty-four, shortly before this exhibition

opened – cutting short the career of one of Britain's finest potters. There have been several exhibitions of his work since his death, but Pepper is still relatively unknown.

One of the primary reasons few people know of Pepper is the great rarity of his work. He was head of the Ceramics Department at Southampton College of Art and, therefore, was not very prolific. He was also a perfectionist who destroyed much of his work. Added to this is the fact that he only signed his pots in the last few years of his life. Antique dealers have bought many of his early pots and sold them as being Chinese for very much higher prices – an ironic tribute to Pepper's skill.

Two of the finest 'Oriental' potters in Britain are, in fact, Orientals. Takeshi Yasuda and Poh Chap Yeap both became long-term residents of southern England.

Plate 176: Takeshi Yasuda, reduced stoneware, c.1986, ht: 27cm.
There are three different iron colourings here: the green glaze is similar to most ash-glazes, the blue-white is chun, the brown is applied oxide.

Plate 177: Takeshi Yasuda, oxidized stoneware, c.1990, ht: 10cm. This yunomi is in his 'sancai' glaze.

Although Takeshi Yasuda has been in Britain for many years and produced very fine pots it was not until the early 1980s that his work came into real prominence. Yasuda was originally interested in engineering and industrial design, but became interested in pottery after a visit to Mashiko, where Hamada was working. Yasuda became an apprentice for three years at the Dasai Pottery at Mashiko before establishing his own workshop there in 1966. He came to Britain in 1973 with Sandy Brown and, apart from short periods in Scandinavia, has been working here ever since.

Yasuda makes functional stoneware in a style that, although obviously Japanese, is highly individual. His early work had reduced iron glazes and slip-trailed decoration and he is best known for his 'three-coloured' or 'sancai' glaze – a high-fired imitation of the Chinese glaze frequently seen on pottery of the T'ang Dynasty. Yasuda's 'three-coloured' glaze is an oxidized ash-glaze over white slip with manganese.

The best feature of Yasuda's pots is in his handling of the clay. His work has been described as sensual or, even, sexual. He produces pots that emphasize the soft, plastic quality of clay – it would be easy to believe, at first sight, that the pots had never dried or been fired. This soft, liquid quality is particularly apparent in Yasuda's handles and rims and helps give his work a warm and human feel. Yasuda is a very skilled thrower and he leaves the pot very much as it comes off the wheel, smoothing and turning being kept to a minimum. His yunomis and flat dishes are exceptional.

Plate 178: Poh Chap Yeap, stoneware, c.1978, ht: 35cm. Yeap's popularity in the late 1970s and early 1980s equalled that of Lucie Rie.

In the wake of 1990s' minimalism, Yasuda has mostly produced creamware, but the lack of colour or decoration only emphasizes how good his work is.

Yasuda's reputation is continuing to grow and he is now one of the finest 'Oriental' potters working in Britain today. He is also much in demand as a teacher and a lecturer and has been a significant influence in the return to popularity of throwing in recent years.

Plate 179: *Poh Chap Yeap, stoneware, c.1980, ht: 18cm.*

Plate 180: *Joanna Constantinidis, porcelain, c.1982, ht: 33cm.*

Poh Chap Yeap was born in Malaysia and came to study law in London in his early twenties. He discovered ceramics when asked to work in a small studio pottery in Denmark. He studied from 1963 to 1967 at Hammersmith College of Art before working as a research student at the Royal College of Art.

Yeap's pots are superb stoneware and porcelain pots in traditional Chinese styles with particular attention to the quality of glazes. Unlike most potters who have limited themselves to glazes associated with the Sung Dynasty, Yeap has also used a wide variety of Oriental glazes from later periods. His control of these is so perfect that many feel that his pots are too technical and lack life.

Despite these criticisms, Yeap's work had a large and loyal following and during the 1970s he had tremendous success. He was widely exhibited including a group show in 1972 where the other potters were Leach, Hamada, Rie and Coper; a one-man show at Düsseldorf's Hetjens Museum in 1975; and the first show of a living potter at the Ashmolean Museum in 1977. In the late 1970s and early 1980s, he became one of the most sought after and expensive potters in Britain. Some pots at Liberty's were sold for over £1,000, an exceptionally high price at that time. After he retired about 1985, this reputation rather declined and he is surprisingly little known by those who have only recently begun looking.

Of course, not all potters who work at the wheel make 'Oriental' pots and there are many fine thrown pots being made in a wide variety of styles. Many of the best throwers first began working in the 1950s when wheel-made forms were more acceptable in the art colleges.

Joanna Constantinidis trained at Sheffield College of Art and has made thrown stoneware and porcelain since the 1960s. Her pots were basically altered cylinders, but she produced remarkable variety using this technique. During the 1970s she produced wonderful, deep conical porcelain bowls – often in celadon with swirls of red or brown – and tall stoneware vases that are superficially reminiscent of the 'white' pots of Hans Coper. In the 1980s, she concentrated on reduction firing of sprayed metallic oxides to give a soft, lustrous metallic finish to her pots. The forms of her pots became more sculptural and sometimes the cylinder shape was dramatically changed with slabbed bases and coiled additions. Much of her work, especially of this period, is exceptional.

Constantinidis never fitted neatly into any particular movement in contemporary ceramics and her work has never had anything like the attention that it deserves, but she was consistently one of the most interesting potters in Britain for many years.

Eric James Mellon is another potter whose work stands well apart from the mainstream of contemporary British ceramics. He was trained at Watford, Harrow and the Central School of Arts & Crafts and began potting in stoneware in the early 1960s.

Plate 181: Joanna Constantinidis, stoneware, c.1985, ht: 33cm.

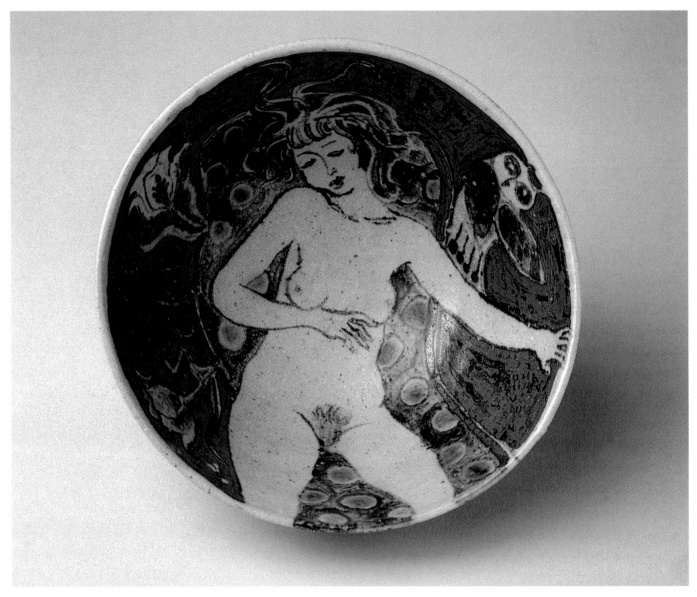

Plate 182: Eric James Mellon, stoneware, philadelphus ash, 1979, dia: 15cm.
From Mellon's 'Pluto and Persephone' series; the legs continue around to the reverse of the bowl, which is also heavily decorated.

Mellon had an early fascination with ash-glazes and his experiments in this area have, probably, been the most extensive since those of Katharine Pleydell-Bouverie fifty years earlier. Many of Mellon's pots of the 1960s are beautiful, thrown, ash-glaze bowls vaguely in the style of Henry Hammond or Helen Pincombe.

Mellon is a talented graphic artist and his narrative, figurative decoration soon replaced the glaze-test pots. Careful use of materials and integration of decoration and shape raise Mellon's work far above the usual standard of painter's pots. Although William Staite Murray, Sam Haile and, later, Alison Britton have successfully made narrative pots, Mellon is the only major modern British potter to have concentrated so strongly on narrative work or to have produced such a vivid personal vision.

Mellon has always made his pots in lengthy series elaborating a particular theme. For some years it was the circus that dominated his decoration, but in the mid-1970s he began working on series of pots based on Greek mythology – first, the story of Daphne and Apollo and then years of work on the three sons of Saturn. These themes included Europa and the Bull (Jupiter), a series involving the undersea kingdom of Neptune and his highly successful series, first shown in 1978, of Pluto and Persephone.

During the 1980s Mellon has increasingly used porcelain and a lighter palette. He has also largely replaced tree ashes with bush ashes such as philadelphus and escallonia that give much less distortion to the decoration. His new subjects have been 'The Annunciation' and the 'Theme of Tenderness', which have revealed a personal and poetic,

symbolic world filled with lovers, mermaids, moon-goddesses, bird-maidens and foxes (the fox is a Japanese symbol of good luck for the kiln-firing and always appears with Mellon's signature as well as occasionally being part of the decoration).

Figurative decoration has been comparatively rare in British ceramics this century and despite being occasionally out of fashion and too often ignored, Mellon has continued to carry on in his own eccentric manner. I have little doubt that his pots will be appreciated long after those of many of the more fashionable potters have been forgotten.

While there was no shortage of talented throwers, the great majority of fine young potters during the 1970s and 1980s used handbuilding techniques. Throwing has the advantage of great speed of production, which is necessary in the making of functional wares, but handbuilding gives the potter a greater freedom of form. Some art colleges have actively discouraged students from making forms on the wheel.

Despite the wide range of excellent thrown work being produced, the 1980s were dominated by handbuilders. There were delicate pinched bowls in porcelain, the angular sculptural forms of Britton, Smith, Suttie and McNicoll, and the rough asymmetrical pots of Henderson, Pim and Radstone.

Richard Slee, who graduated from the Central School in 1970, is a very different sort of handbuilder. Slee is one of the best British 'funk' potters. From a wide range of influences including pre-Columbian pottery, Sèvres porcelain, Staffordshire earthenware, Victorian art pottery, Surrealism

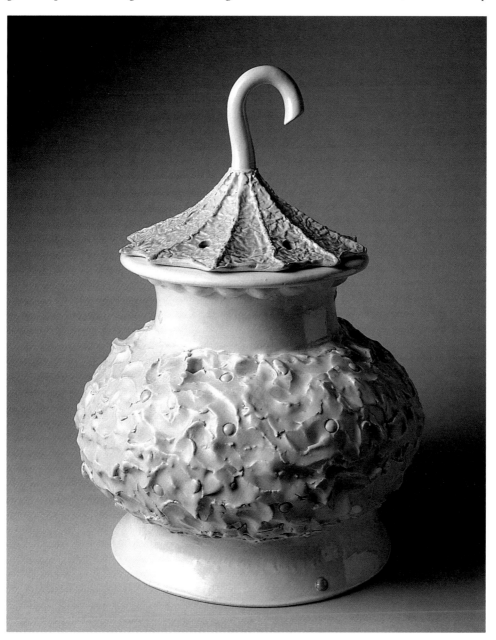

Plate 183: Richard Slee, earthenware, c.1985, ht: 48cm.

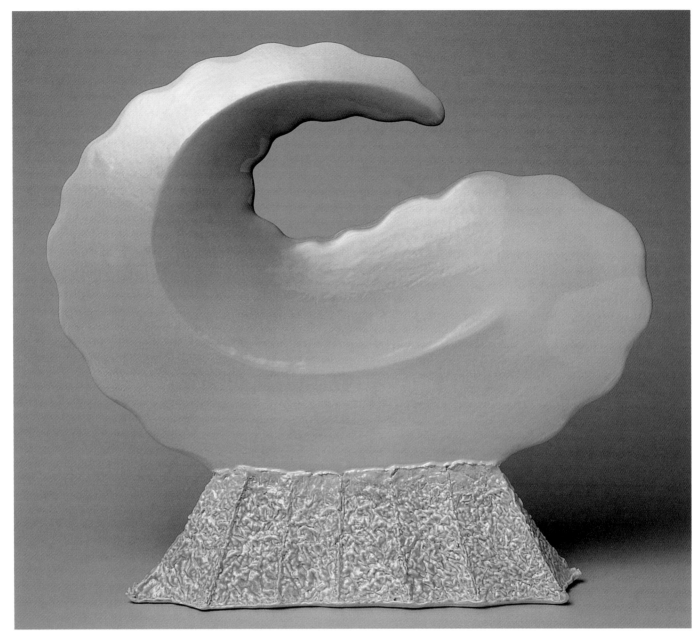

Plate 184: Richard Slee, 'Paisley', earthenware, 1984, ht: 40cm.
Purchased by Lilianna Epstein in Slee's 1984 British Crafts Centre exhibition.

and 'Krazy Kat' cartoons, Slee has concocted a kind of baroque ornamental style that is quite unlike anything else in British ceramics.

Slee's earlier pots, like those of Angus Suttie, are entirely functional – vases, covered jars, plates, and so on – yet they almost seem to defy the owner to use them. With his intentionally crude juxtapositions of colour, his excessive style, his constant 'quoting' of ceramics of the past, and his ability to stand conventional form on its head, Slee either delights or revolts the onlooker with his pots. Depending on their own preconceived ideas, people find his work either intelligent, creative and witty or, conversely, vulgar and commercial.

Slee uses a variety of handbuilding techniques – coiling, slabbing and modelling – in making his earthenware pots. Surface effects are achieved by both press-moulding and modelling. Slee's wide variety of lush colours come from using coloured clays, slips, underglaze colour and crayon, and occasionally enamels. In the 1990s, he often began adding little plastic figurines or other elements of kitsch and created series of work that were more sculptural.

'Funk' ceramics have had a very mixed reception in Britain and, for most of the 1970s, Slee's pots were barely known to collectors, although he was greatly respected by many other potters. In the 1980s, he seemed to exhibit more abroad than in Britain. Slowly his work has become better

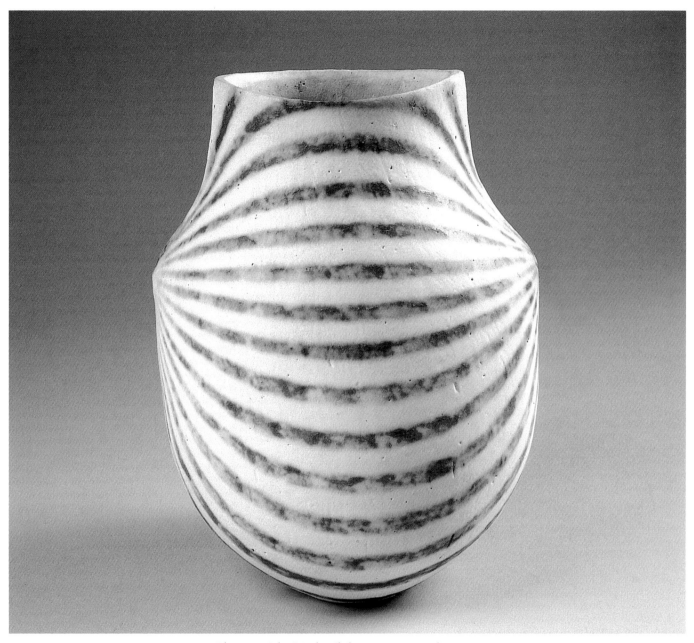

Plate 185: John Ward, coiled stoneware, 1988, ht: 27cm.

known and more universally accepted and now he is beginning to get the recognition he deserves. Slee has been one of the most influential ceramicists, but there is no one whose pots have been met with as much outrage.

Many potters rejected the idea of obviously handbuilt forms and made smooth, round, meticulously controlled coiled pots that an earlier generation would have attempted on the wheel. One of the most successful has been John Ward.

Ward enrolled in a part-time pottery course while working as a cameraman for the BBC. He became more and more interested and applied to Camberwell where he was a fulltime student from 1966 to 1970. Both Lucie Rie and Hans Coper were visiting teachers there and Ward was greatly inspired by their work.

Ward's work has much in common with that of Coper without being at all derivative. He has stuck to one stoneware body and uses a minimum number of glazes, concentrating on black and white. He has used a relatively small number of forms that have slowly evolved and that are a combination of classical shapes and modernity. Ward's serious approach to ceramics, and his hesitancy to write, teach, or enter into ceramic gatherings, is also reminiscent of Coper.

Ward's pots start with a small pinched base to which he adds flattened coils. The pot is scraped with a metal kidney and trimmed with a knife before being polished with a pebble. This gives a subtle and distinctive surface to his work that shows well under a white glaze. He works on several pots at the same time and fires them in an electric kiln.

When he had his studio in south-east London, most of Ward's pots were explorations of bowl shapes in monochrome glazes, usually white, but also black-brown and blue-green. In 1979, Ward moved to the coast of Wales and has made far more enclosed forms and decorated surfaces. Patterns of black and white or concentric circles painted in oxide are now common. Ward also increased his use of cutting and rejoining sections of the rim. First one cut was made producing a heart-shaped rim, then two and, eventually, quite complex forms emerged.

Most handbuilders survived largely on their teaching income and made very few pots for which they asked fairly high prices. Ward adopted the opposite approach by giving up teaching and living entirely on the income from his work. He has kept his prices artificially low (his pots sell for more in auction than in exhibitions). This, combined with the very consistent high quality of his pots, has meant that he easily sells everything he produces. He once told me that his exhibition schedule was completely booked for eight years in advance. His work is sought after in America and Europe as well as in Britain.

Jennifer Lee and Betty Blandino are two other exceptional potters working with somewhat the same handbuilding style.

Jennifer Lee was born and raised in Scotland and attended Edinburgh College of Art before receiving a travelling scholarship to America and then enrolling in the Royal College of Art. She is one of the finest potters to graduate from the RCA in the post-Coper years.

Lee's building techniques are very similar to those of Ward's – starting with a pinched base to which coils are added, scraped and smoothed. Like Ward, Lee burnishes the surfaces to compact the clay and refine the texture. The main difference in the two potters' techniques lies in the method of decoration. While Ward, like most potters, applies glaze to the surface of the pot, Lee adds oxides, body stains and underglazes to the clay so that the colour is infused through the pot. This is essentially the same method Lucie Rie developed for her 'spiral' pots in the late 1960s.

Colour is an important aspect of Lee's pots. She uses a wide range of ingredients to produce subtle colour variations. Often coils of different colours are used to create a banding effect, that is softened by the bleeding of colour that takes place in the scraping, burnishing and firing.

Lee has always worked within the form of the vessel and has been influenced by a wide range of early pottery. She has, more and more, tended to concentrate on slightly asymmetrical bowls with tilted rims. The purity and apparent simplicity of her forms are quite remarkable.

Lee has a natural ease with self-promotion and this combined with producing such wonderful work while still young meant that she developed a strong international reputation by the age of thirty.

Betty Blandino, by contrast, began potting relatively late in life. For many years, she was a full-time teacher before studying painting and pottery at Goldsmith's College in the

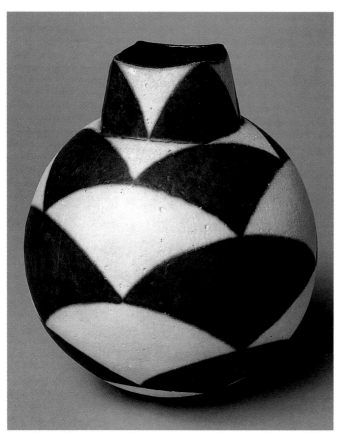

Plate 186: John Ward, coiled stoneware, painted with oxides, c.1985, ht: 20cm.

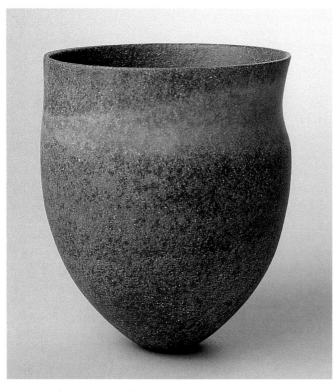

Plate 187: Jennifer Lee, stoneware, 1986, ht: 14cm.

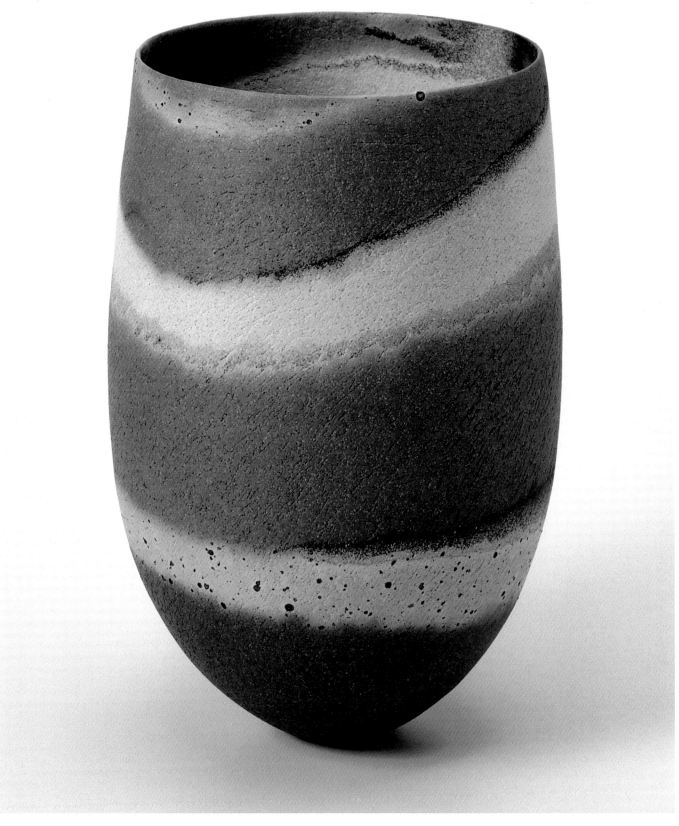

Plate 188: Jennifer Lee, stoneware, 1991, ht: 24cm.

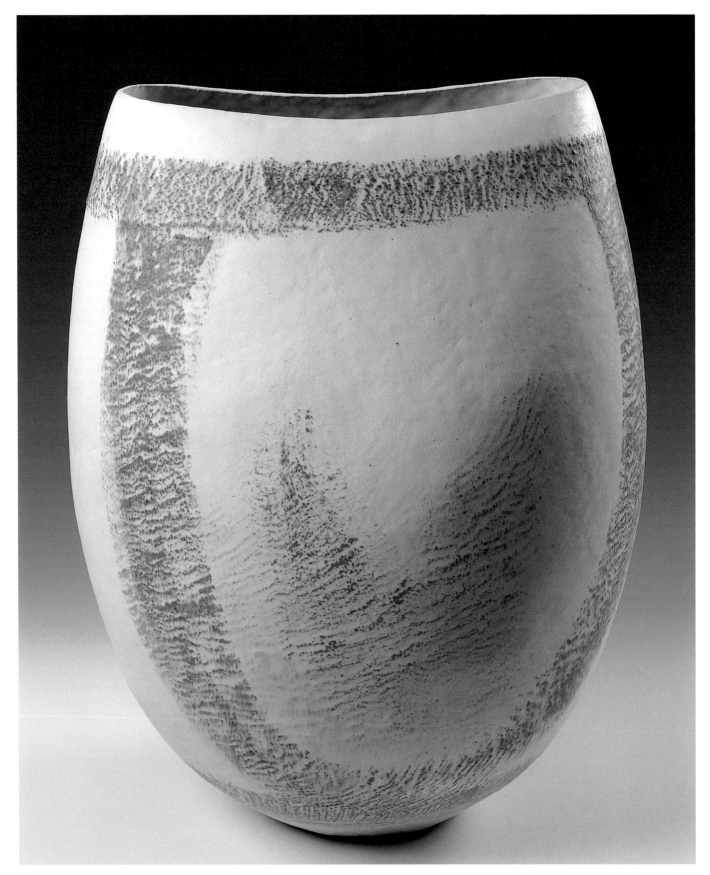

Plate 189: Betty Blandino, coiled stoneware, c.1988, ht: 43cm.

1950s. Throughout the 1960s she worked as an art administrator, mostly at the Upper Gallery (Whitechapel Art Gallery) in London. After a further period of study she moved to Wales and established her own pottery in 1973.

Blandino is a fine exponent of handbuilding techniques. Despite the fine quality of her pots, Blandino has often been in the position of second fiddle to John Ward, even though any similarity between their work is very superficial.

Blandino starts with a rough thick-walled bowl made with her fist from a ball of moist clay. This is then placed in a deep mould and pinched thinner and upwards until it has reached the point where successive coils can be added. The resulting pots usually have paper-thin walls and a thicker base that gives the pot greater stability. Her work is almost always asymmetrical and her shapes, while massive, are deceptively light and give the impression of rising. The surface texture created by her fingers and scraping is enhanced by her decoration. Usually this is a white slip that is painted on and then rubbed off, and coloured oxides (most often blue or green) that are rubbed into the surface.

While she often makes small forms, she is at her best when working on a larger scale. Blandino's pots have been of a quite consistently high quality for many years and she is deserving of wider recognition than she has, so far, received.

Magdalene Odundo has had no problem getting her work noticed. This Kenyan-born artist came to England in 1971 and trained in graphics before studying ceramics at Farnham. She spent three years teaching at the Commonwealth Institute in London before a further three years' study at the Royal College of Art. Long before Odundo graduated from the RCA in 1982 she was being heralded by some as the greatest potter to emerge since Elizabeth Fritsch. She had the

Plate 190: Magdalene Odundo, burnished coiled earthenware, 1984, ht: 25cm.

Plate 191: Magdalene Odundo, burnished coiled earthenware, 1990/1991, ht: 40cm.

Plate 192: Gabrielle Koch, 'Reel Bell', burnished earthenware, 1999, ht: 41cm.

dubious distinction of being the most hyped ceramic artist in Britain. Prices for her work, which were very high when she was a student, quickly reached a point where she was the most expensive potter of her generation.

Naturally, this high-profile promotion in a craft world not used to such things caused a great deal of discussion and not all of it favourable. If credit or blame is to be attached, then it probably more properly belongs to the promoters than to Odundo and the controversy tended to overshadow the fact that she is an extremely fine potter. At her best, she has a tremendous command of form.

Odundo's pots are coiled earthenware with layers of clay slips. The pots are heavily burnished both before and after the application of the slip. Unlike stoneware, where the high firing temperature destroys the sheen, highly burnished earthenware retains a glossy surface. All her pots are black, orange or a combination of both.

While the influence of African pottery on both Odundo's techniques and forms are obvious, her work is not at all imitative. Odundo has a unique sense of shape that is entirely modern – and entirely necessary, as the potential monotony of burnished earthenware puts great emphasis on form.

Odundo's output has been surprisingly small and sometimes surprisingly uneven in quality but, in general, she has lived up to her promotion and been one of Britain's finest potters.

Gabrielle Koch is another foreign-born potter working in burnished earthenware with tremendous success. While she

Plate 193: Judith Trim, raku, lustre glaze, c.1985, ht: 36cm.

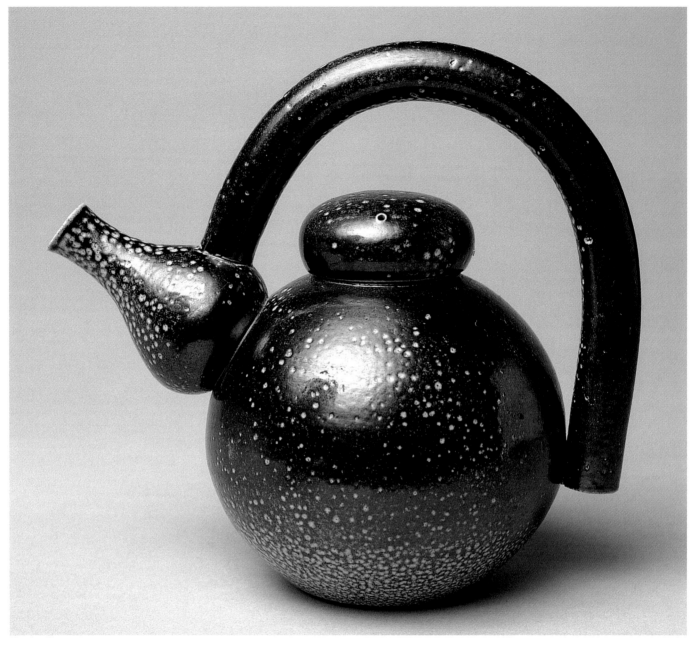

Plate 194: Wally Keeler, stoneware, salt-glaze, c.1985, ht: 19cm.
This is the sort of pot for which Keeler has been most admired.

does not possess the brilliance of form of Odundo she does achieve a feeling of monumentality in her vessels together with a great variety of surface variation.

Judith Trim is another handbuilder who had fairly considerable success. She trained at Bath Academy of Art in the 1960s, but did not make any work for over ten years and was 'more or less self-taught' as a potter.

Her pots first came to attention about 1980 when she produced a series of tall coiled, flared vases, sawdust-fired with striped necks. These were instantly popular and gained her considerable recognition. She expanded her range of shapes to include deep conical bowls and 'sun bowls' and 'star

bowls' – large flat bowls heavily decorated with slips and lustres. Her surface treatments also became more varied. Burnishing, smoke-firing in a sawdust kiln, sgraffito, slip painting and metallic lustres were all used.

Trim usually worked with either stoneware clay or red earthenware, but firing was at a low temperature causing her pots to be more prone to damage than most. Her desire to create pots that 'appear to float … in conflict with gravity' had the unfortunate side-effect of creating pots that are quite unstable.

Despite this problem, Trim's pots have many admirers. Her work is thoughtful in its use of symbolic references and radiates great warmth and calmness. Her 'Tear Jars', particularly,

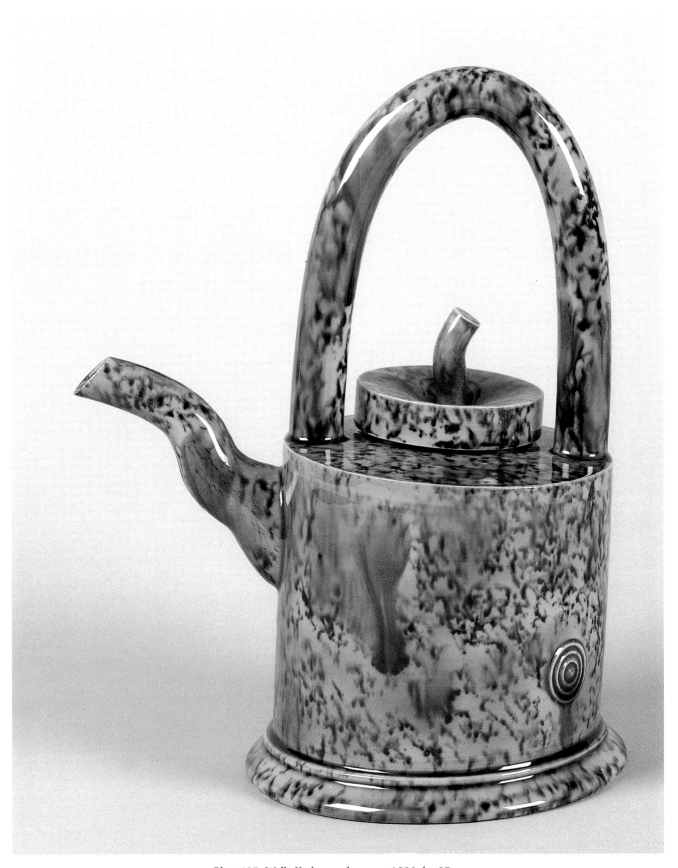

Plate 195: Wally Keeler, earthenware, 1998, ht: 27cm.

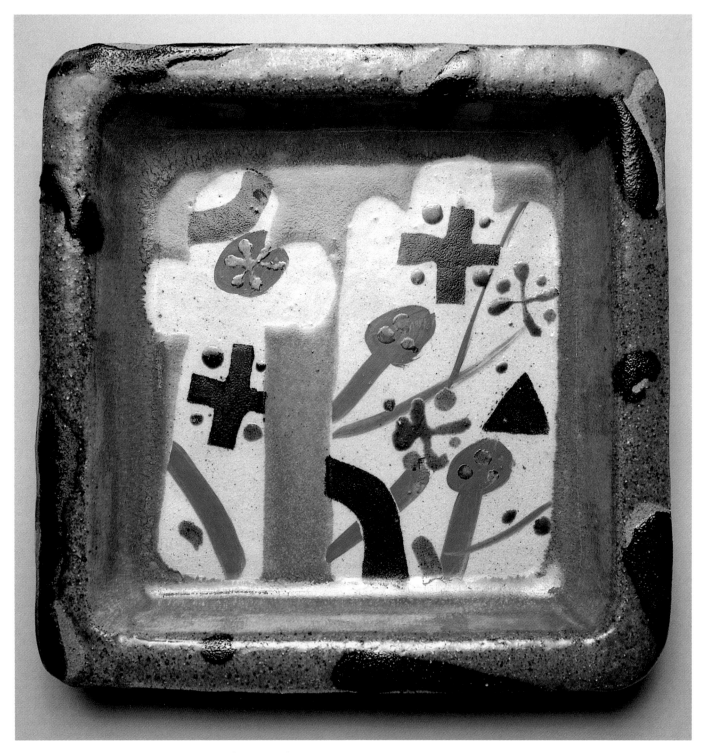

Plate 196: John Maltby, stoneware, c.1979, dia: 28cm.

have immense beauty. Sadly, she was one of several potters who died, still in their prime, at the end of the century.

While the majority of potters making individual pots now use handbuilding, it is not often suitable for the making of domestic ware. Pots for use have long been at the heart of British studio ceramics and the quality of work produced in Britain today is second only to that produced in Japan.

Much of the standard-ware made is still very much in the Leach tradition – some of it very boring, but much of it excellent. Although standard-ware production has stopped at the Leach Pottery, others have continued along the same

lines. One of the best makers of domestic ware has been John Leach (son of David, grandson of Bernard), who has kept the family tradition going.

At the opposite end of the domestic pot spectrum are many potters who make functional pots in styles well apart from the mainstream. One of the more popular potters in Britain has been Alan Caiger-Smith who made highly decorated, lustred, tin-glazed earthenware at his Aldermaston Pottery for forty years.

In between, there are domestic potters working in a post-Cardew style, a post-Rie style and a post-Tchalenko style. There are few ceramic possibilities that have not been exploited. One of the most successful areas has been a revival of salt-glazed wares led by Wally Keeler and centred on the Harrow School of Art.

Keeler was a student at Harrow in the early 1960s and later taught there with Michael Casson, another salt-glaze enthusiast. A number of fine students emerged at this time, including Jane Hamlyn whose salt-glazed domestic ware is amongst the best.

Keeler's early work went through a number of changes. He worked with both oxidized stoneware and raku, but it was when he turned to salt glaze that his work began to become better known. Over the last twenty years, he has become increasingly known both in Britain and abroad and is now widely considered as one of this country's leading potters.

Keeler is a very good thrower and a skilled craftsman. Although it is his fine technical control that is at the heart of the quality of his pots, it is Keeler's unique sense of form for which he is best known. Keeler's pots – particularly his jugs and teapots – are reminiscent of medieval leatherware or the galvanized metal containers in widespread use before being replaced by plastics. The surface quality of the pitted blue or brown salt-glaze enhances this effect. In the 1990s, Keeler also began making wonderfully distinctive and colourful versions of eighteenth-century creamware.

However one views the rather surreal and gentle humour of Keeler's pots, they seem friendly and wanting to be held and used. His best work is animate and has a remarkable amount of personality.

John Maltby is another potter with a highly individual style who has mostly concentrated on functional pots. Initially, he trained in sculpture in Leicester, but became interested in

pottery and later worked with David Leach at the Lowerdown Pottery. Maltby has now had his own pottery workshop in Devon for nearly forty years.

Maltby's early work is of Oriental-inspired domestic pots somewhat in the Leach style. Because of the similarity of the sealmarks, several of his early pots, including a teapot, have surfaced in auction houses as being made by William Staite Murray. Maltby slowly evolved a personal style of decoration that owes more to St Ives' post-war painting than it does to St Ives' pots. His cheerful and colourful semi-abstract paintings on pots of landscapes, flowers or boats are very appealing.

Maltby works mostly in reduced stoneware and usually with forms that give a broad near-flat surface to decorate. He is best known for his large press-moulded dishes or thrown shallow bowls, but he made a wide variety of forms including delightful small lidded boxes. Decoration is usually applied with a combination of brush and trailing.

Maltby was making decorative functional pottery before Janice Tchalenko became popular. Somewhat perversely, when colourful domestic ware came into fashion, Maltby moved towards less functional forms and more subdued colouring. In recent years, he has made quirky folk art-like ceramic sculptures. His idiosyncratic approach to ceramics has always given his pots great appeal.

There is so much depth of talent in British ceramics that it would be possible to add dozens of other potters without diminishing the quality. The difference between ceramics in Britain and most other countries was brought home to me by the experiences of a friend of mine. She was enrolled in a ceramics course in one of Britain's art colleges and was repeatedly pressurized to leave on the grounds that her work was not up to standard. She finished the course, returned to her native country and, within a year, became one of the most successful potters there. While there are many major ceramic artists scattered all over the world, most people would acknowledge that Britain is still the leading country.

The 1980s brought a continued increase in interest in British studio ceramics and even higher prices for fine modern pots. Throughout much of the East, especially in Japan, ceramics are considered an equal to sculpture and painting. There are signs that, very slowly, more people in the West are coming to share this opinion.

Chapter 14

The End of an Era?

After the highs of the 1980s it was perhaps inevitable that the 1990s would be disappointing, and there is a widespread perception that it was a poor decade for British studio ceramics. To a certain extent this is true; most of the older generation were no longer active, many of the middle generation were producing work well below their normal standard and there seemed to be fewer exciting young potters. There was, however, still a great deal of excellent work being done.

There is no doubt that the major theme of the decade was minimalism. Many potters began simplifying forms, using little or no decoration and switching to monochrome glazes. The Victoria & Albert Museum dubbed this 'the new white' (in contrast to the 'old brown' of the Leach tradition). As much of the work was porcelain with a celadon-glaze it was not particularly new or white. Exhibition spaces often followed suit; new galleries tended to be 'white cubes' with acres of near empty plinths.

Plate 197: Edmund de Waal, porcelain, celadon-glaze, c.1999, dia: 31cm.

Plate 198: Edmund de Waal, porcelain, celadon-glaze, 1999, ht: 40cm.
Tall lidded boxes are a favourite form of de Waal's.

Plate 199: Julian Stair, porcelain, c.1994, ht: 21cm.
Many prefer Stair's pots when they are not too precise.

Like other trends, minimalism threw up countless mediocre artists and a few genuine stars. There is no doubt that the biggest of these stars is Edmund de Waal.

De Waal was an apprentice to Geoffrey Whiting in the early 1980s and after taking a degree at Cambridge University he made stoneware in the Leach tradition without attracting a great deal of attention. He studied in Japan in the early 1990s and on returning began making thrown porcelain celadon vessels still much in the Leach tradition. The response to his new work was tremendous and in only a few years de Waal became probably the most critically and commercially successful young British potter of the century. De Waal's pots are excellent but the adulation they received was out of proportion. Every trend-conscious collector wanted one on his mantlepiece – seemingly at any price.

In reality, de Waal's ceramics resonate with that of the Leach potters of the late 1960s and early 1970s who produced somewhat similar porcelain. What he did bring that was new was a much greater sense of the plasticity of the clay – a very Japanese trait. His subtle variations of the surface are different from the more architectural fluting of Leach. He has also successfully potted on a large scale. Porcelain is a difficult medium to work in and while some Japanese potters have achieved remarkable technical control it has been very rare in Britain.

De Waal has brought a rigorous intellectual approach to ceramics. He is a prolific writer and has actively tried not to confine his ceramics to being 'plinth art' – an approach that the dramatic rise in his prices will possibly doom to failure. It is remarkable to me that someone who writes about ceramics so much from the head can still produce pots that are so lively and seem to come from the heart. He is still under forty and I suspect he hasn't yet made his best work.

Julian Stair has been another excellent maker of thrown porcelain. Right from his degree show in 1981 at the Royal College of Art, the work has been of high standard. Initially, most of his pots were vases or bowls with fine lines – often blue – banding the surface. Sometimes the bands were very precise, at other times they bled across the surface. He gradually introduced more overtly functional shapes and eliminated colour in favour of cutting or surface modulations. In recent years, he has often used cut, altered and reassembled forms. Alongside his porcelain, Stair has often made similar pots in a terracotta body, providing an excellent contrast.

Stair's pots have always been excellent at conveying the potential solidity of porcelain and the best of his work manages to be fluid at the same time. If he has a fault as a potter it is that occasionally the work becomes too tight and, at its worst, can more resemble prototypes for industrial production than studio pottery.

Stair provides an example of how changing fashions can affect artists' fortunes. In the 1980s when colourful, expressionistic pots were popular, his work was often criticized for being too cold, intellectual and precise. In the 1990s, fashion

Plate 200: Julian Stair, porcelain, 1995, ht: 10cm.

Plate 201: Rupert Spira, porcelain, c.1999, dia: 24cm.

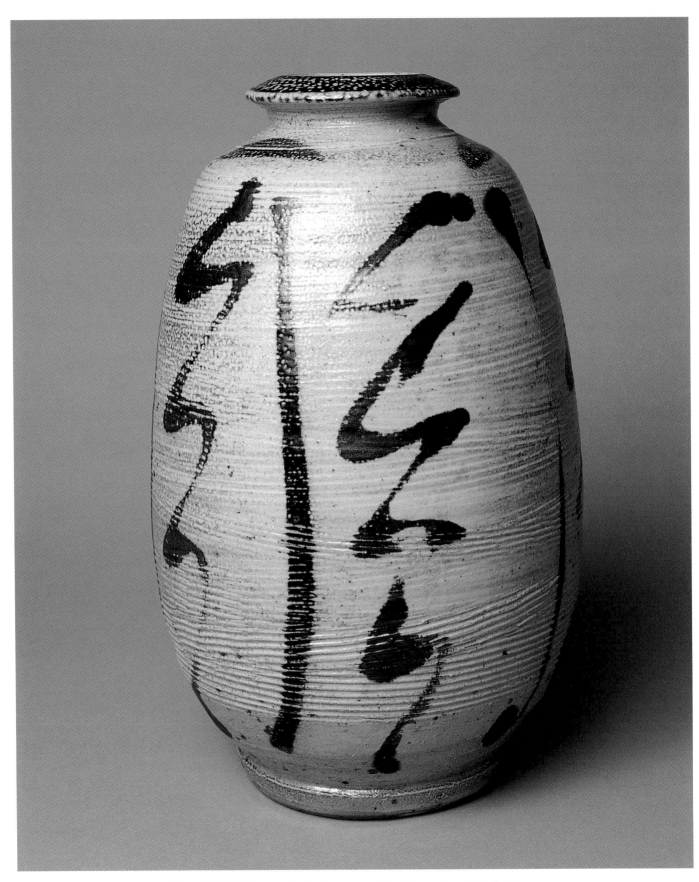

Plate 202: Phil Rogers, salt-glazed stoneware, brush decoration, 1991, ht: 31cm.

caught up with Stair and he began to get some of the recognition that he had always deserved.

Rupert Spira has also had great success in the craze for minimal pots. He trained with Henry Hammond and was one of the last (and one of the best) of Michael Cardew's apprentices. Spira's early work was functional stoneware very much in the Cardew tradition. He had a good sense of form and an excellent touch with brushwork designs. His tin-glazed bowls and plates with brush designs are amongst the finest pots made in the Cardew style. He also produced a range of tiles with seductive glazes.

Spira gradually reduced the functional forms to simple cylinders and open bowls, eliminated brush designs and concentrated on monochrome glazes. It is these glazes that make his work really stand out. He uses a wide range of glazes; copper reds and greens and almost every blue imaginable, from the palest celadon to almost a midnight blue. The richness and depth of the surface is so tantalizing that it can be difficult to pull your eye away.

Spira is still a young potter and his work is starting to change again. I am certainly eager to see what he produces next.

Despite the successes of many individual potters, I cannot help feeling that minimalism as a movement was largely a failure. However awful some of the excesses of previous fashions were, at least they tried to be inventive and fresh. We learnt almost as much from the horrors as the masterpieces. Minimalism has just played it a bit too safe. The only thing in the ceramic world more boring than a dull 'old brown' pot is a dull 'new white' one.

There has been, of course, much else on offer and, as ever, there is fine traditional work being made. Phil Rogers and Edward Hughes have both been making familiar 'oriental' pots.

Phil Rogers has been around since the early 1980s but for many years he was largely in the shadow of Batterham, Malone and Dodd. He is best known for his ash-glazed pots, that keep getting better and better and he is now on an equal footing with the others. In addition to his ash-glazes, Rogers developed an excellent style of salt-glaze – looking like a cross between the Martin Brothers' gourd pots and Hamada's work in hakeme. His bottle forms are very strong and his teabowls, I think, are the nicest to use of any British potter's working today.

Edward Hughes is one of British ceramics best kept secrets. He trained in Japan and, although he has been potting in Cumbria since 1985, few people in the rest of the country know of his work.

Hughes is the complete 'oriental' potter. He makes totally functional reduced stoneware and porcelain that is equally

Plate 203: Edward Hughes, stoneware, copper glaze, 1999, dia: 15cm.

Plate 204: Ken Eastman, 'All the Things', stoneware, 2000, ht: 53cm.

suitable as 'plinth art'. His forms have the solidity of the work of a potter like Richard Batterham but also have that wonderfully fluid handling of the clay that often comes from a Japanese training. He works well on almost any scale and his ash-glazes are as lovely as anybody's.

Most of Hughes's best pots are sent to Japan where he has a large and loyal following but, in Britain, he seldom exhibits outside Cumbria. His major 1997 exhibition at the Daiwa Anglo-Japanese Foundation in London's Regent's Park was a rare opportunity for many people to see what he is capable of making.

There have also been a number of good younger potters working in more contemporary styles. Ken Eastman, at first glance, would seem to be a protégé of Alison Britton. He makes slabbed, painterly forms that explore the complexity of the interior space. But the character of his work is totally different from that of Britton. While she explores the limit of the vessel, his pots are much more architectural; they

Plate 205: Elspeth Owen, stoneware, c.1990, w: 12cm.

could almost be abstracted building designs or stage sets. While Britton's painting is expressionistic and gestural, his is cool, muted and meditational with no obvious patterns to serve as reference points.

Eastman's work has been some of the most original of the 1990s. His ceramics are part sculpture, part painting and part poetry.

The influence of Ewen Henderson also began to show, though most of the potters making rough, asymmetrical and sagging forms were not taught by him. Almost every art college degree show seems to contain at least one would-be Henderson. Much of this work has been very good.

Lawson Oyekan is a young potter who was raised in Nigeria but trained at the Royal College of Art. His large, handbuilt forms are excellent examples of post-Henderson work. Sometimes the holes and tears are so numerous the pots are almost like a lattice. He is a potter of enormous potential.

Elspeth Owen is a contemporary of Henderson's and her exquisite, small pinched stoneware bowls with their dry surfaces are superficially similar to his early work. She gained a much wider acceptance in the 1990s.

A potter whom I very much like is Aki Moriuchi. She took up pottery late and trained at Harrow in her forties. Moriuchi's pots are thrown stoneware vessels in which the sagging, warping forms are accentuated by heavily volcanic white glazes that seem to erupt like lava from the pots. She is not a potter who is exceptionally consistent in quality, but the best of her work is immensely powerful and very accessible. People who would run from a Henderson or a Radstone pot often like her work.

The blurring of the line between 'ceramics' and 'sculpture' has been another continuing theme. There has been an increasing amount of figurative work in clay. While this has been heralded in the craft world, I am not sure how much of this work would hold up if compared to that of Britain's better sculptures. Some of the more abstract ceramic sculptural work would probably fare better.

Felicity Aylieff has been a maker of quirky and interesting vessel forms. Recently she has begun adding glass and other materials to the clay body, closing the apertures and working on a larger scale. The results are wonderful sculptural forms that have lost most traces of their vessel origins and look more as if they are made of marble than clay.

Jean Lowe did not take up pottery until she was in her sixties. She makes sea-washed pebbles on a large scale in coiled stoneware. Her work is quiet, introspective and has a highly spiritual quality. She is one of my favourite contemporary sculptural potters. Lowe's work provides ample proof, if needed, that ceramic sculpture can live happily in the 'fine art' world. Like James Tower and Glenys Barton, Lowe has almost always been shown in an 'art' rather than a 'craft' setting. Often she exhibits at Roche Court near Salisbury, which specializes in the very best of modern British sculpture.

The ceramic artist who has had the most success in the 'fine art' world is, undoubtedly, Grayson Perry. Perry's

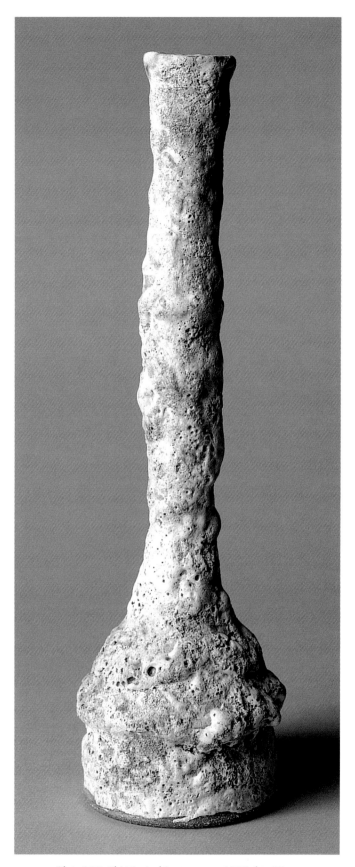

Plate 206: Aki Moriuchi, stoneware, 1998, ht: 36cm. Moriuchi specializes in these 'volcanic' glazes.

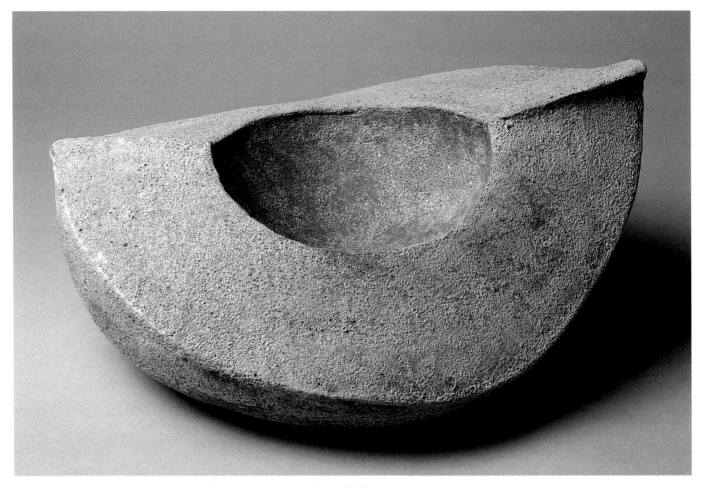

Plate 207: Jean Lowe, 'Pebble LIII', stoneware, 1996, w: 41cm.
This is one of her smallest pieces.

background was more in painting, writing and performance art than in clay; his ceramic training came primarily from Adult Education evening classes. He makes coiled earthenware pots with a wide variety of decorative techniques – relief-modelling, impressed text, transfers, drawing into the clay. What is utterly different about his work is the subject matter that he depicts. Murder, child molestation, cannibalism and nearly every other suppressed issue in our society appear on his pots. His images are occasionally scatological, often seditious, frequently pornographic and usually designed to shock.

Initially, Perry's pots were of extremely poor technical and ceramic quality with imagery that had all the subtlety and wit of the average fart joke. I must confess to having seen absolutely no merit in this work at all and some credit must be given to the art galleries who persevered with him. Gradually his forms have become stronger, the surface techniques more skilful and he has developed a better sense of the integration between form and decoration. With this has come an increasing maturity with his handling of the subjective imagery. Perry once described his pots as 'stealth bombs' and, as his pots become more visually

seductive and the imagery becomes more witty and complex, he is beginning to realize this aim. He is certainly the most savage social critic in, the normally rather genteel, British studio ceramics.

Perry has never really been part of the rest of the ceramic world. He has been shown by several prestigious art dealers, had a great deal of art press coverage, attracted very high prices and is the only potter to have been given a major showing in the Saatchi Gallery. Perry is still young and is beginning to become a major force in British ceramics but many feel that he hasn't yet deserved quite such success.

Stephen Dixon has also successfully explored the area of narrative social commentary. His earthenware vessels often take the form of covered boxes with modelled figures and decorative elements, that have some of the innocence of Staffordshire pottery and some of the cynicism of German expressionism. His work provides both a commentary on ceramic history and a satire on contemporary morals and politics.

Dixon and Perry have not been greatly admired by many of the traditional collectors of studio ceramics, but it is clear that this is a type of work that has been lacking in previous

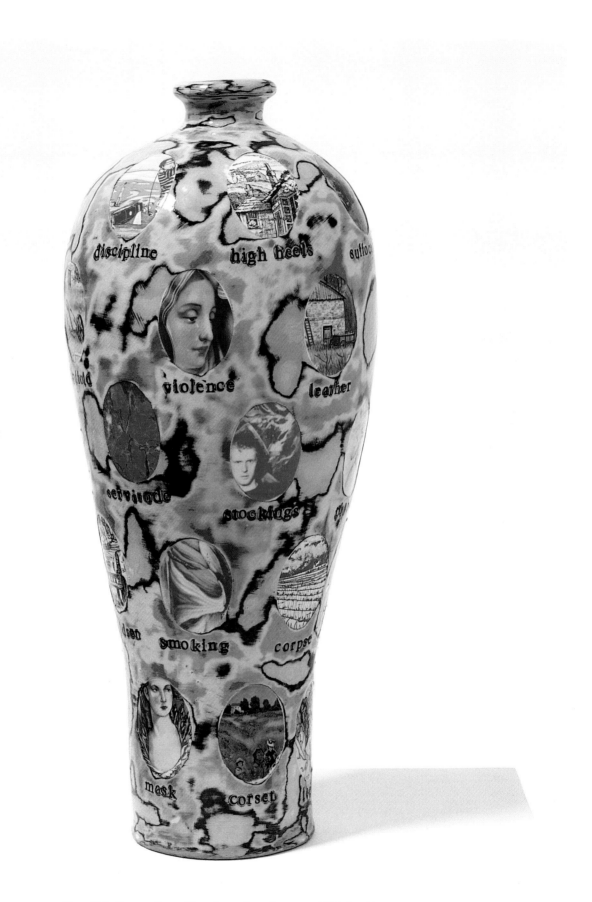

Plate 208: Grayson Perry, 'Transference', earthenware, 1996, ht: 54cm.

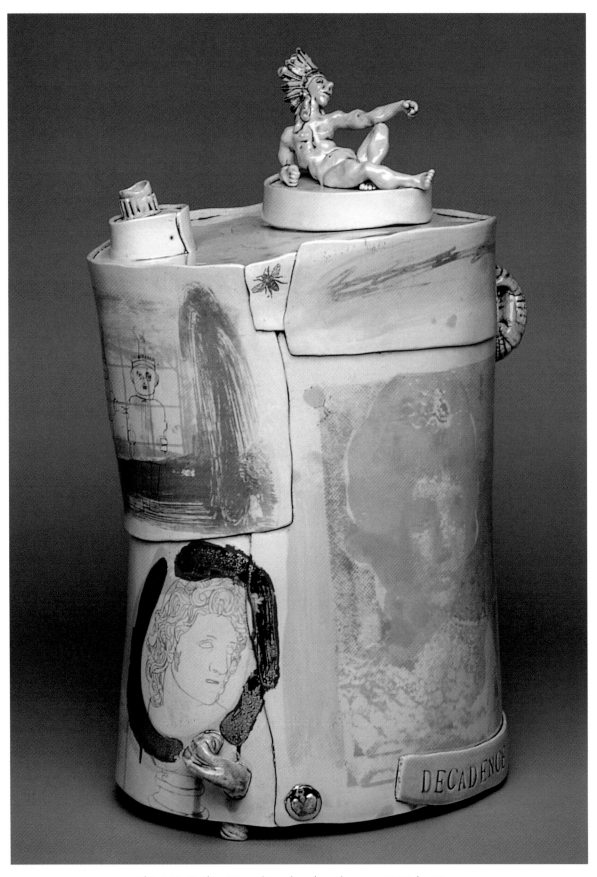

Plate 209: Stephen Dixon, 'Decadence', earthenware, 2000, ht: 54cm.

Plate 210: Kate Malone, 'Starfish Clinging Onto A Rock', earthenware, c.1989, ht: 32cm.

decades and of which we will be seeing a great deal more in the future.

There have been many complaints in recent years that British studio ceramics have become too cold and sterile; too pretentiously arty and intellectual. If there is a single artist who disproves this idea, it is Kate Malone.

Malone graduated from the Royal College of Art in 1986 and, quite soon thereafter, began to dazzle us with some of the most joyful and exuberant pottery produced in the

century. Her vessel forms are supercharged observations from nature that come firmly out of a long tradition of European ceramics. Some of her work is not that different from pottery made by Palissy in the sixteenth century, Whieldon or Wedgwood in the eighteenth century, Minton in the nineteenth century, and many others.

She usually works in themed series of pieces – first 'Fruits of the Sea', followed by 'Fruits of the Earth', 'The Allotment' and 'Nuts and Berries'. Unlike many others producing

Plate 211: Kate Malone, 'Millennium Jug', stoneware, crystalline glaze, 2000, ht: 27cm.

colourful functional pots, Malone has the uncanny ability to not cross the line into either pastiche or kitsch. Though the pots are, first and foremost, decorative, they are never 'merely decorative'. She seems to work equally well in either the most complex pots, involving untold hours of modelling and up to a dozen firings, or in the least complex involving a single mould and a simple glaze.

She also works well on any scale. In 1989, she founded Balls Pond Studios in Islington – a collective of about a dozen ceramic artists. This made having an enormous kiln practical and Malone was able to undertake large public commissions including a gigantic pineapple for the foyer of the Manchester City Art Gallery and a 2m diameter clock with a giant teapot atop that spouts steam every hour on the hour. Her tiny moulded 'Fruits of Your Dreams' – only a few centimetres across – are equally successful and are sold for relatively little. Creating large public commissions, individual pots for collectors and inexpensive production pots is indicative of her desire to reach a wide audience.

Her natural enthusiasm and her ability as both publicist and businesswoman have allowed her to steer successfully around public officials who consider artists to be unreliable and a craft establishment who have often regarded her work as not being serious enough.

Malone began also working in stoneware and, in 1994, was given a grant by the London Arts Board to research crystalline glazes. This unpredictable technique has rarely, if ever, been used so appropriately or so well. Malone once described herself as 'a gardener of pots' and it is apt that she should be employing glazes that literally grow. While stoneware glazes meant subduing her carnival colours, the depth of these glazes combined with the crystalline effects create a surface that is tantalizing in itself.

Malone seems to take an almost child-like joy in being a craftsman and in making work that pleases. This communicates itself in the pots, that are a delight to the eye, often wonderfully tactile to the hand and sometimes even contain loose balls to produce bell-like sounds when moved. Her pots are the antithesis of those of most other leading ceramicists of her generation.

Around the end of the century a number of our leading potters died. This has aggravated an increasingly widespread feeling that this is the end of an era and that the heyday of British studio ceramics has passed. In one sense this is totally

Plate 212: Kate Malone, 'Sliced Owl Fruit', stoneware, crystalline glaze, c.2000, dia: 26cm.
These 'fruits' are made with moulds.

untrue. Britain is still producing outstanding potters who are making wonderful ceramics. This is unlikely to change and we can eagerly look forward to the new work of both our more senior potters and of the next generation.

What has changed is the world context in which to place this work. A truly international ceramics market is now developing. There are now fine ceramic artists in a great many countries. Collectors, galleries, museums and publishers have a considerable impact on art history. In time, the centre will shift to wherever the most money is being spent and it is fairly safe to say that it won't be in Britain. For much of the twentieth century, Britain – or, more accurately, southern England – was the most important centre for studio ceramics in the world and a disproportionately high number of the finest potters worked there. It is almost inevitable that this will change. The contribution of artists like Leach, Murray, Cardew, Newland, Duckworth, Rie, Coper, Fritsch, Britton, Henderson and many others to the development of studio ceramics cannot be overemphasized and will probably never be equalled.

Public Collections of British Studio Ceramics in the United Kingdom

Entries are arranged in alphabetical order by the town in which the institution is located. Listed is the name and address, the approximate total number of studio pots (including potters not covered in this book), the period of active collecting, and any specific emphasis or personal collection included. Collections with fewer than ten pieces have not been included. Museum and Education Authorities' collections for lending to schools are also not included as they are not normally available for viewing. Most institutions only display a small proportion of their collection and an appointment to see specific works is recommended.

England

1. Alton – The Allen Gallery, Church Street, Alton, Hants GU34 1BA. 80 pots, 1945–.
2. Aylesbury – Buckinghamshire County Museum, Church Street, Aylesbury, Bucks HP20 2QP. 275 pots, 1960–. Particularly strong on the 1960s.
3. Barnard Castle – The Bowes Museum, Barnard Castle, Co. Durham DL12 8NP. Martin Brothers and Bernard Moore only.
4. Barnsley – Cannon Hall Museum, Cawthorne,Barnsley, South Yorks S75 4AT. 49 pots, 1880–.
5. Bedford – Cecil Higgins Art Gallery, Castle Close, Bedford MK40 3NY. 25+ pots – some from the Hand-ley-Read collection.
6. Birmingham – City Museum and Art Gallery, Chamberlain Square, Birmingham B3 3DH. 80+ pots and 55 pots on long loan. Good group of Ruskin Pottery.
7. Bolton Museum and Art Gallery, Le Mans Crescent, Bolton, Lancs BL1 1SE. 75 pots, since 1980.
8. Bradford – Cartwright Hall, Lister Park, Bradford, BD9 4NS. 50 pots. 1970–4 and since 1984.
9. Bristol Museum and Art Gallery, Queens Road, Bristol BS8 1RL. 75 pots and 96 in the Fishley Holland Collection. 1930s and since 1970.
10. Burnley – Townley Hall Art Gallery and Museums, Burnley, Lancs BB11 3RQ. 100+ pots, since 1986.
11. Cambridge – Fitzwilliam Museum, Trumpington Street, Cambridge, CB2 1RB. 130 pots, actively from 1970. Emphasis on pre-1914 and post-1945.
12. Cambridge – Kettle's Yard, Castle Street, Cambridge, CB3 0AQ. 20+ pots, 1920s–1970s.
13. Cheltenham Art Gallery and Museum, Clarence Street, Cheltenham, GL50 3JT. 65+ pots, 1927 onwards. Especially Winchcombe Pottery.
14. Coventry – Herbert Art Gallery and Museum, Jordon Well, Coventry, CV1 5RW. 25+ pots, since 1965.
15. Derby – University of Derby, Kedleston Road, Derby, DE22 1GB. 365+ pots. The Ballentyne Collection formally housed in Sudbury Hall.
16. Exeter – Royal Albert Memorial Museum, Queen Street, Exeter, EX4 3RX. 70+ pots, 1939–45 from Crafts Advisory Committee; since 1970 work by West Country potters.
17. Farnham – Craft Study Centre, The Surrey Institute of Art & Design, University College Farnham Campus, Falkner Road, Farnham, Surrey GU9 7DS. 800 pots, since 1970. Particularly strong on 1920s–1940s. Bequests of Bernard Leach and Katharine Pleydell-Bouverie including her glaze notebooks.
18. Gateshead – Shipley Art Gallery, Prince Consort Road, Gateshead, Tyne and Wear NE8 4JB. 100+ pots, since 1976.
19. Halifax – Bankfield Museum and Art Gallery, Boothtown Road, Halifax, HX3 6HG. 45+ pots, 1940s and since 1970.
20. Hereford – City Museum and Art Gallery, Broad Street, Hereford, HR4 9AU. 30+ pots, since 1970.
21. Hove Museum and Art Gallery, 19 New Church Road, Hove, Sussex BN3 4AB. 30+ pots, since 1970. Also pots from the South East Arts craft collection.
22. Kendal – Abbot Hall Art Gallery, Kendal, Cumbria LA9 5AL. 40+ pots, since 1962.
23. Kingston upon Thames – Museum and Heritage Centre, Fairfield West, Kingston upon Thames, KT1 2PS. 84 pots, including 46 Martin Brothers. Ernest Marsh Collection.
24. Leeds – Lotherton Hall, Aberford, Leeds, LS25 3EB. 80+ pots, since 1974.
25. Leicester – Leicestershire Museum and Art Galleries, 96 New Walk, Leicester, LE1 6TD. 200 pots, since 1920. Emphasis on Leach and post-1970 work.
26. Lincoln – Usher Gallery, Lindum Road, Lincoln, LN2 1NN. 11 pots, 1939–42.

27. Liverpool National Museums & Galleries on Merseyside, William Brown Street, Liverpool, L3 8EN. 325+ pots. The Ernest Marsh Collection, emphasis on early potters.
28. London – Crafts Council, 44a Pentonville Road, London N1 9BY. 380+ pots, since 1972. Collection is of post-1970 work and is mostly for loan to other museums.
29. London – Victoria and Albert Museum, South Kensington, London SW7 2RL. 850+ pots, since 1851. The National Collection of Studio Ceramics.
30. London – Pitshanger Manor Museum, Mattock Lane, Ealing, London W5 5EQ. The Grundy Collection of Martin Brothers.
31. Maidstone – Museum and Art Gallery, St Faith's Street, Maidstone, Kent ME14 1LH. 50+ pots.
32. Manchester City Art Gallery, Mosley Street, Manchester, M2 3JL. 150+ pots. Frank Ollerenshaw Collection acquired in 1948.
33. Middlesbrough – Cleveland Crafts Centre, 57 Gilkes Street, Middlesbrough, Cleveland TS1 5EL. 400+ pots, since 1980.
34. Newcastle upon Tyne – Laing Art Gallery, Higham Place, Newcastle upon Tyne, Tyne and Wear NE1 8AG. 50 pots, 1930s and 1940s. Emphasis on local potters.
35. Norwich Castle Museum, Norwich, Norfolk NR1 3JU. 70+ pots, since 1979. Emphasis on Martin Brothers and post-1979 work.
36. Norwich – Sainsbury Centre for Visual Arts, University of East Anglia, Norwich, Norfolk NR4 7TJ. The Sainsbury Collection.
37. Nottingham Castle Museum, The Castle, Nottingham, NG1 6EL. 70+ pots, since 1950. Mary Lander Collection.
38. Oldham Art Gallery, Union Street, Oldham, Greater Manchester OLI 1DN. 40 pots, 1930s and 1940s.
39. Peterborough – City Museum and Art Gallery, Priestgate, Peterborough, Cambs PE1 1LF. 13 pots, since 1984.
40. Plymouth – City Museum and Art Gallery, Drake Circus, Plymouth, PL4 8AJ. 180+ pots, especially Martin Brothers and Leach.
41. Portsmouth – City Museum and Art Gallery, Museum Road, Old Portsmouth, Hants PO1 2LJ. 205 pots, since 1967.
42. Reading – Museum and Art Gallery, Blagrave Street, Reading, RG1 1QH. 130+ pots, 1967– 77 and since 1988.
43. Royston and District Museum, Lower King Street, Royston, Herts SG8 5AL. 100 pots, since 1975. The Keatley Trust.
44. St Ives Tate Gallery, St Ives, Cornwall, TR26 1TG. Leach, Hamada and followers, loan from Wingfield-Digby Collection.
45. Salford Museum and Art Gallery, Peel Park, Salford, M5 4WU. 20 pots.
46. Salisbury and South Wiltshire Museum, The King's House, 65 The Close, Salisbury, SP1 2EN. 20 pots, 1980–5.

47. Sheffield – City Museum, Weston Park, Sheffield, S10 2TP. 25 pots, 1900–10 and 1970–80.
48. Southampton City Art Gallery, Civic Centre, Southampton, SO9 4XF. 60+ pots. Milner-White Collection given in 1939; some 1970s purchases.
49. Stoke-on-Trent City Museum and Art Gallery, Hanley, Stoke-on-Trent, ST1 3DE. 900 pots, Dr Henry Bergen Collection (550 pots) given in 1948, Robert Pinchen Collection given in 1993, purchases since 1979.
50. Swindon Museum and Art Gallery, Bath Road, Swindon, SN1 4BA. 85+ pots, since about 1970.
51. Taunton – Somerset County Museum, Taunton Castle, Taunton, Somerset TA1 4AA. 40+ pots and many Martin Brothers and Eltonware, since about 1970.
52. Totnes – Dartington Hall Trust, High Cross House, Dartington Hall Estate, Totnes, Devon. Leach Tradition, Rie and Coper.
53. Truro – Royal Cornwall Museum, River Street, Truro, Cornwall TR1 2SJ. 45+ pots. Mostly pre-1940.
54. Wakefield Art Gallery, Wentworth Terrace, Wakefield, WF1 3QW. 20 pots, since 1950s.
55. York City Art Gallery, Exhibition Square, York, YO1 2EW. 200+ pots, since 1925. Dean Milner-White Collection of pre-1960 stoneware, also modern purchases.
56. York – Yorkshire Museum, Museum Gardens, York, YO1 7FR. 3,100 pots. The William Ismay Collection.

Northern Ireland
57. Belfast – Ulster Museum, Botanic Gardens, Belfast, BT9 5AB. 200+ pots, since 1983.

Scotland
58. Aberdeen Art Gallery, Schoolhill, Aberdeen, AB9 1FQ. 70+ pots, late 1930s and since 1980. Particularly Scottish potters.
59. Dundee – McManus Galleries, Albert Square, Dundee, DD1 1DA. 28 pots, 1960s and 1980s. Particularly Scottish potters.
60. Edinburgh – Royal Museum of Scotland, Chambers Street, Edinburgh, EH1 1JF. 230+ pots, since 1960.
61. Glasgow – Art Gallery and Museum, Kelvingrove, Glasgow, G3 8AG. 200+ pots, 1940s and since 1960.
62. Paisley Museum and Art Gallery, High Street, Paisley, Renfrewshire PA1 2BA. 500+ pots, 1957–67 and since 1977.
63. Perth Museum and Art Gallery, George Street, Perth, PH1 5LB. 180 pots and 46 Martin Brothers. Mostly Perthshire potters.

Wales
64. Aberystwyth Arts Centre, University College of Wales, Penglais, Aberystwyth, SY23 3DE. 700+ pots, 1920s, 1930s and since 1977. Sydney Greenslade Collection.
65. Cardiff – National Museum of Wales, Cathays Park, Cardiff, CF1 3NP. 153 pots, irregularly since 1920s.
66. Newport Museum and Art Gallery, John Frost Square, Newport, Gwent NP9 1HZ. 100+ pots, since 1975.

Selected Bibliography

GENERAL

Birks, Tony, *Art Of The Modern Potter* (Country Life Books, London, 1967. Revised edition, 1976).

Birks, Tony and Cornelia Wingfield-Digby, *Bernard Leach, Hamada and Their Circle* (Phaidon/Christies, Oxford, 1990).

Cameron, Elisabeth and Phillipa Lewis (eds,. *Potters on Pottery* (Evans Bros, London, 1976).

Casson, Michael, *Pottery in Britain Today* (Alec Tiranti, London, 1967).

Clark, Garth, *The Potter's Art* (Phaidon Press, 1995).

Cooper, Ronald G., *The Modern Potter* (John Tiranti, London, 1947).

Dormer, Peter, *The New Ceramics: Trends and Tradition* (Thames and Hudson, London, 1986).

Fournier, Robert and Sheila, *Public Collections of Studio Pottery* (Ceramic Review, London, 1994).

Frankel, Cyril, *Modern Pots: The Lisa Sainsbury Collection* (Thames and Hudson, London, 2000).

Harrod, Tanya, *The Crafts in Britain in the 20th Century* (Yale University Press, 1999).

Houston, John, *The Abstract Vessel* (Bellew Publishing, London, 1991).

Lane, Peter, *Studio Porcelain: Contemporary Design and Techniques* (Pitman House, London, 1980).

Lane, Peter, *Studio Ceramics* (William Collins, London, 1983).

Lane, Peter, *Ceramic Form* (William Collins, London, 1988).

Leach, Bernard, *A Potter's Book* (Faber & Faber, London, 1940).

Rice, Paul and Christopher Gowing, *British Studio Ceramics in the 20th Century* (Barrie and Jenkins, London, 1989).

Riddick, Sarah, *Pioneer Studio Pottery: The Milner White Collection* (Lund Humphries/York City Art Gallery, 1990).

Rose, Muriel, *Artist Potters in England* (Faber & Faber, London 1955. Revised edition, 1970).

Saunders, Robert A., *The Studio Ceramics Collection at Paisley Museum and Art Galleries* (Renfrew District Council Museums, 1984).

Vincentelli, Moira and Anna Hale, *Catalogue of Early Studio Pottery in the Collections of University College of Wales, Aberystwyth* (University College of Wales, Aberystwyth, 1986).

Watson, Oliver, *British Studio Pottery* (Phaidon/Christies, Oxford, 1990).

Whybrow, Marion, *The Leach Legacy* (Sansom and Co., Bristol, 1996).

Wingfield-Digby, George, *The Work of the Modern Potter in England* (John Murray, London, 1952).

Yates-Owen, Eric and Robert Fournier, *British Studio Potters' Marks* (A & C Black, London, 1999).

GROUP EXHIBITION CATALOGUES

'Artist Potters Now: Touring Exhibition of Contemporary Ceramics Made By Potters Working in Britain Today', Oxfordshire County Museum Service, 1984.

'British Ceramics', Museum Het Kriuthuis, s-Hertogenbosch, The Netherlands, 1985.

'British 20th Century Studio Ceramics', Christopher Wood Gallery, London.

'Ceramic Forms', Crafts Advisory Committee and British Council, 1974.

'Fast Forward: New Directions in British Ceramics', Institute of Contemporary Arts, London, 1985.

'Fifty-five Pots and Three Opinions by Peter Dormer, Martina Margetts, Peter Fuller', The Orchard Gallery, Londonderry, 1983.

'Lucie Rie and Hans Coper: Potters in Parallel', Barbican Art Gallery, London, 1997.

'New Ceramics', Ulster Museum, Belfast, 1974.

'Nine Potters', Fischer Fine Art, London, 1986.

'Pandora's Box', Crafts Council, London, 1995.

'The Pleasures of Peace', Sainsbury Centre for Visual Arts, Norwich, 1999.

'Potted History', Gardner Centre, Brighton, Sussex, 1986.

'Seven in 76', City Museum and Art Gallery, Portsmouth, 1976.

INDIVIDUAL POTTERS

Baldwin, Gordon
'Gordon Baldwin: a Retrospective View', Catalogue to Exhibition, Cleveland Crafts Centre, Middlesbrough,

Barton, Glenys
'Glenys Barton: New Sculpture', Flowers East (London, 1993).

Britton, Alison
'The Work of Alison Britton', Catalogue of Exhibition, Crafts Council, London, 1979.

Dormer, Peter and David Cripps, *Alison Britton in Studio* (Bellew Publishing, London, 1985).

Brown, Sandy
'Sandy Brown: the Complete Picture', Catalogue of Touring Exhibition, Oriel 31, Welshpool, Powys, 1987.

Cahillane, Glenda
'Glenda Cahillane Ceramics', Catalogue of Exhibition (Austin/Desmond Fine Art, London, 1997).

Caiger-Smith, Alan
'Tin-glaze and Smoked Lustre Pottery by Alan Caiger-Smith and Aldermaston Pottery 1955–1985', Catalogue of Exhibition, Stoke-on-Trent City Museum and Art Gallery, 1985.

Cardew, Michael
'Michael Cardew: a Collection of Essays', Crafts Advisory Committee, London, 1976.

Clark, Garth, *Michael Cardew: a Portrait* (Faber & Faber, London, 1978).

'Michael Cardew and Pupils', Catalogue of Exhibition, York City Art Gallery, 1988.

Constantinidis, Joanna
'Joanna Constantinidis: Ceramics from Twenty-five Years, Catalogue of Touring Exhibition, The Ballentyne Collection, University of Derby, 1995.

Cooper, Waistel
'Waistel Cooper – Forty Years of Individual Pottery', Catalogue of Exhibition, Manchester City Art Galleries, 1994.

Coper, Hans
Birks, Tony, *Hans Coper* (William Collins, London, 1983).
'Hans Coper', Catalogue of Exhibition, Galérie Besson, London, 1998.

De Trey, Marianne
'De Trey at Dartington', Catalogue of Exhibition, High Cross House, Dartington, Devon, 1995.

Duckworth, Ruth
Duckworth, Ruth and Alice Westphal, *Ruth Duckworth*, Exhibit A, Gallery of American Ceramics, Evanston, IL., 1977.

Eastop, Geoffrey
Eastop, Geoffrey, *The Hollow Vessel*, Bohun Gallery, Henley-on-Thames, 1980.
'Geoffrey Eastop: 40 Years of Change in Studio Pottery', Catalogue of Exhibition, Portsmouth City Museum, 1992.
Coatts, Margot, *Geoffrey Eastop: a Potter in Practice*, Ecchinswell Studio, Newbury, 2000.

Fritsch, Elizabeth
'Elizabeth Fritsch: Pots about Music', Leeds Art Galleries and Leeds Art Collections Fund, 1978.
Dormer, Peter and David Cripps, *Elizabeth Fritsch in Studio* (Bellew Publishing, London, 1985).
Lucie-Smith, Edward, *Elizabeth Fritsch* (Bellew Publishing, London, 1993).

Godfrey, Ian
'Ian Godfrey', Catalogue of Exhibition, Galérie Besson, London, 1989.

Haile, Sam
Rice, Paul, Marianne Haile, Victor Margrie and Eugene Dana, *Sam Haile: Potter and Painter 1909–1948* (Bellew Publishing/Cleveland County Council, 1993).

Hamada, Shoji
Leach, Bernard, *Hamada Potter* (Thames & Hudson, London, 1976).

Hamlyn, Jane
'Jane Hamlyn: for Use and Ornament', Catalogue of Exhibition, Llantarnam Grange Arts Centre, Wales.

Hammond, Henry
'A Fine Line – Henry Hammond 1914–89', Crafts Study Centre, Bath, 1992.

Hasegawa, Keiko
'Keiko Hasegawa', Galerie für Keramik und Kaligraphie, Hamburg.

Henderson, Ewen
'Ewen Henderson: a Retrospective View', British Crafts Centre, London, 1986.
'Ewen Henderson at Amalgam', Catalogue of Exhibition, Amalgam, London, 1979.
'Ewen Henderson', Midland Arts Council/Marston House, 1995.
'Ewen Henderson: Recent Work', Catalogue of Exhibition, Austin/Desmond Fine Art, London, 1998.

Homoky, Nicholas
Hepworth, Anthony, *Nicholas Homoky* (Marston House, 1997).

Koch, Gabrielle
'Gabrielle Koch', Catalogue of Exhibition, Gallery K, London, 2000.

Leach, Bernard
'Bernard Leach: Fifty Years a Potter', Catalogue of Exhibition, Arts Council, London, 1961.
Leach, Bernard, *A Potter's Work* (Evelyn, Adams and McKay, London, 1967).
'The Art of Bernard Leach', Catalogue of Exhibition, Victoria and Albert Museum, London, 1977.
Hogben, Carol (ed.), *The Art of Bernard Leach* (Faber & Faber, London, 1978).
'An Exhibition of the Art of Bernard Leach, His Masterpieces Loaned by British Museums and Collectors', Catalogue, Ohara Museum of Art, Japan, 1980.
'Bernard Leach: Potter and Artist', Catalogue of Touring Exhibition, Crafts Council, London, 1997.
De Waal, Edmund, *Bernard Leach* (Tate Gallery Publishing).

Leach, David
Fournier, Robert (ed.), *David Leach: A Potter's Life with Workshop Notes* (Fournier Pottery, Lacock, Wilts, 1977).

Leach, John
'John Leach: Potter', Rufford Craft Centre, Notts, 1988.

Leach, Michael
'Michael Leach: Potter 1913–1985', Catalogue of Exhibition, North Devon Museum, 1995.

Lee, Jennifer
Jennifer Lee: Ceramics (The Wooley Dale Press, London, 1987).
Jennifer Lee: Handbuilt Ceramics (J. Lee, London, 1993).

Lowndes, Gillian
'Gillian Lowndes: New Ceramic Sculptures', Catalogue of Exhibition, Crafts Council, London, 1987.

Malone, Jim
'Jim Malone: Artist Potter', Catalogue of Touring Exhibition, Bolton Museum Art Gallery, 1997.

Malone, Kate
'Fruits of the Earth and Sea', Catalogue of Exhibition, Manchester City Art Galleries, 1994.
'The Allotment: New Ceramics by Kate Malone', Catalogue of Touring Exhibition, MAC, Birmingham, 1998.

McNicoll, Carol
'Carol McNicoll Ceramics', Catalogue of Exhibition, Crafts Council, London, 1985.

Martin Brothers
Haslam, Malcolm, *The Martin Brothers Potters* (Richard Dennis, London, 1978).

Mellon, Eric James
'Eric James Mellon, Ceramics, Drawings, Paintings 1966–1986', E.J. Mellon, Bognor Regis, 1986.
Mellon, Eric James, *The Ceramist as Artist* (South East Arts, 2000).

Moore, Bernard
Dawson, Aileen, *Bernard Moore Master Potter 1850–1935* (Richard Dennis, London, 1982).

Murray, William Staite
Haslam, Malcolm, *William Staite Murray* (Crafts Council/Cleveland County Museum Service, 1984).

Odundo, Magdalene
'Magdalene Odundo', Catalogue of Exhibition, Museum Het Kriuthuis, s-Hertogenbosch, Netherlands, 1994.
Perry, Grayson
'Grayson Perry – Ceramics', Catalogue of Exhibition, Birch and Conran, London, 1987.
Pleydell-Bouverie, Katharine
Katharine Pleydell-Bouverie (Holburne Museum and Crafts Study Centre, Bath, 1980).
Katharine Pleydell-Bouverie: a Potter's Life 1895–1985 (Crafts Council/Crafts Study Centre, Bath, 1986).
Poncelet, Jacqueline
'Jacqui Poncelet: New Ceramics', Catalogue of Exhibition, Crafts Council, London, 1981.
Rie, Lucie
'Lucie Rie: a Retrospective Exhibition of Earthenware, Stoneware and Porcelain 1926–1967', The Arts Council, London, 1967.
Houston, John (ed.), *Lucie Rie: A Survey of Her Life and Work* (Crafts Council, London, 1981).
Birks, Tony,. *Lucie Rie* (Alphabooks, Sherborne, Dorset, 1987).
'Lucie Rie', Catalogue of Exhibition, Galérie Besson, London, 1988.
Roberts, David
Green, Lynne, *Painting With Smoke – David Roberts – Raku Potter* (Smith Settle, W. Yorkshire, 2000).
Rogers, Mary
Rogers, Mary, *On Pottery and Porcelain* (Alphabooks, Dorset, 1979, Revised 1984).
Rogers, Phil
'Phil Rogers – Tradition Renewed', Catalogue of Exhibition, Pucker Gallery, Boston, 2001.
Slee, Richard
Houston, John, *Richard Slee: Ceramics in Studio* (Bellew Publishing, London, 1990).
Smith, Martin
'Martin Smith', Leeds Art Galleries, 1981.
'Martin Smith: Ceramics 1976–96', Museum Boymans Van Beuningen, Netherlands, 1996.
Suttie, Angus
'Angus Suttie: The Whole Works', Anatol Orient, London, 1985.
'Angus Suttie 1946–1993', Catalogue of Exhibition, Contemporary Applied Arts, London, 1994.
Taylor, Sutton
'Sutton Taylor Lustreware', Catalogue of Exhibition, Leeds Art Galleries, 1980.
Vaizey, Marina, *Sutton Taylor: A Lustrous Art* (Hart Gallery, London, 1999).

Taylor, William Howson
Ruston, James H., *Ruskin Pottery* (Metropolitan Borough of Sandwell, West Bromwich, 1975).
Tchalenko, Janice
Tchalenko, Janice and Oliver Watson, *Janice Tchalenko: Ceramics in Studio* (Bellew Publishing, London, 1992).
Tower, James
'James Tower: Recent Sculpture', Catalogue of Exhibition, Gimpel Fils, London, 1963.
'Tower, James 1919–1988', Catalogue of Retrospective Exhibition, Hove Museum and Art Gallery, 1989.
Vyse, Charles
'Charles Vyse 1882–1971: Figures and Stoneware Pottery', Catalogue of Exhibition, Fine Art Society, London, 1974.
Wadsworth, Philip
'The Ceramic Art and Paintings of John and Philip Wadsworth', Catalogue of Auction, Phillips, London, 1992.
Washington, R.J.
'R.J. Washington 1913–1997', Chelmsford and Essex Museum, 1999.
Wason, Jason
'Jason Wason Ceramics', Austin/Desmond Fine Art, London, 1998.
Wells, Reginald
'Reginald Fairfax Wells: Sculptor, Potter, Designer 1877–1951', Catalogue of Retrospective Exhibition, Luton Museum Service, 1998.
Whiting, Geoffrey
'Geoffrey Whiting – Potter', Catalogue of Touring Exhibition, Aberystwyth Art Centre, 1989.
Wren, Denise
'The Oxshott Pottery: Denise and Henry Wren', Catalogue of Retrospective Exhibition, Holburne Museum and Crafts Study Centre, Bath, 1984.
Yasuda, Takeshi
'Takeshi Yasuda Ceramics', Catalogue of Exhibition, Cleveland Crafts Centre, Middlesbrough, 1987.
Yeap, Poh Chap
'Studio Ceramics by Yeap Poh Chap', Catalogue of Exhibition, Arbour Fine Art, Singapore, 1984.

JOURNALS
Ceramic Review, 1970–. Craftsmen Potters Association of Great Britain, London.
Ceramics in Society (previously *Studio Pottery*), 1993–. Paul Vincent, Exeter.
Crafts, 1973–. Crafts Council, London.

Index of Potters

Dates should be considered as tentative. Many potters are not consistent signers and some sealmarks are very similar – pots should not be attributed by marks alone. The numbers following *Collections:* refer to the appendix of public collections.

Appleby, Brigitta (née Goldsmith), b. 1926, Leipzig, Germany; d. 2000
Came to England, 1934

Co-founder and principal potter for Briglin Pottery, domestic red earthenware decorated with wax-resist or sgraffito; also small animals.

Studio: Baker Street, London, 1948–59
Crawford St, London, 1959–90

Impressed 'Briglin', 1948–90

Impressed marks, 1957–90

Arbeid, Dan b. 1928, London
Training: Central School of Art and Design, London, 1957–9

Handbuilt stoneware pots mostly with ash-glazes and heavy surface texture; some thrown work and some porcelain with celadon-glaze. Did not pot 1983–8 and very little produced afterwards.

Studio: Ceramics Factory, Beersheba, Israel, 1956
Abbet Art Centre, New Barnet, Herts, 1957–63
Wendons Ambo, Essex, 1963–83
Brighton, Sussex, 1988–
Collections: 2, 6, 9, 22, 29, 33, 62, 65

Incised, impressed or painted mark DA

Painted mark

ARBEID

Astbury, Paul b. 1945, Cheshire
Training: Stoke-on-Trent College of Art, painting and ceramics, 1949–51

Slabbed and press-moulded sculptural stoneware and porcelain; experiments with broken and reassembled images.

Studio: Hammersmith, London, 1973–9
Shepherd's Bush, London, 1979–
Collections: 28, 29, 38, 43, 49, 56, 57, 64

Impressed mark
(some early work painted or incised)

Auld, Ian b. 1926, Brighton; d. 2000
Training: Brighton College of Art, 1947–8
Slade School of Fine Art, painting and print-making, 1948–51
London University Institute of Education, 1951–2
Central School of Art and Design, technician, 1952–4

Reduced slab-built stoneware vessels with dry ash-glazes, often decorated with incised patterns or impressed seals; very little work made after 1976; some coiled pots, sculptural work and earthenware, 1957–66.

Teaching: Camberwell and Central Schools of Art, 1958–64
Camberwell School of Art and Crafts, Head of Ceramics Dept, 1974–84
Studio: Odney Pottery, Cookham, Berks, 1952
Baghdad, Iraq, started pottery department in art school, 1954–57
Wimbish, Saffron Walden, Essex, 1957–66
Chippenham, Wilts, shared with Gillian Lowndes, 1966–87
Halstead, Essex, 1988–2000
Collections: 1, 2, 6, 11, 14, 15, 25, 29, 33, 41, 42, 56, 62

Painted mark *HA*

Impressed mark

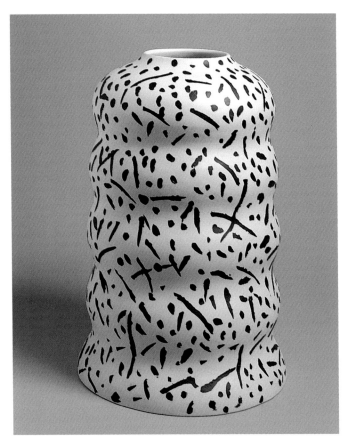

Plate 213: Felicity Aylieff, porcelain, inlaid decoration, 1998, ht: 38cm.

Aylieff, Felicity b. 1954, Bedfordshire
Training: Bath Academy of Art, 1972–7
Goldsmiths College, 1978
Royal College of Art, London, 1993–6

Handbuilt earthenware and porcelain vessels, 1981–98; larger sculptural pieces in aggregates of porcelain, terracotta and glass, 1993–.

Studio: Bath, various studios, 1981–
Collections: 29, 60, 65

Incised 'F. Aylieff'

Baldwin, Gordon b. 1932, Lincoln
Training: Lincoln School of Art, painting and pottery, 1949–51
Central School of Art and Design, painting and pottery, 1951–4; technical assistant, 1956–7

Sculptural handbuilt pieces in earthenware and stoneware with painted and incised decoration on slip usually in a small series of variations on a theme; mirror-black work, late 1960s and early 1970s; domestic ware, late 1950s and early 1960s.

Studio: Eton, Berks, 1957–96
Market Drayton, 1996–
Collections: 2, 6, 7, 11, 12, 18, 22, 24, 25, 26, 28, 29, 32, 33, 35, 39, 41, 42, 43, 48, 50, 56, 57, 60, 61, 62, 64

Painted marks

Barrett-Danes, Alan and Ruth
Alan: b. 1936, Kent
Training: Medway College of Art, 1951–5
Stoke-on-Trent College of Art, ceramics, 1955–7
Ruth: b. 1940, Plymouth. Married Alan in 1962
Training: Plymouth College of Art, 1956–60
Brighton College of Art, ceramics, 1960–1

Worked jointly until 1982 on handbuilt fantasy pieces in stoneware and porcelain. Alan made thrown tableware and raku jug forms after. Ruth continued modelled forms.

Studio: Slough, Berks, 1962–8
Cardiff, 1968–74
Abergavenny, Gwent, 1974–
Collections: 29, 41, 49, 57, 62, 64, 65, 66

Did not mark work until 1985

Alan incised mark

Ruth incised mark

Barron, Paul b. 1917, Wantage, Berks; d. 1983
Training: Brighton College of Art under Norah Braden, 1937–9
Royal College of Art, ceramics under Helen Pincombe, 1946–9

Thrown individual pots in reduced stoneware mainly with ash-glazes. Slipware, 1948–51.

Studio: Bentley, Hants, shared with Henry Hammond, 1948–83
Teaching: West Surrey College of Art and Design, Farnham, 1949–82
Collections: 1, 2, 15, 17, 29, 32, 42, 49, 56, 60, 61, 62, 66

Impressed mark

Barrow, Susan b. 1949, Brisbane, Australia
Training: Kelvin Grove College of Advanced Education, Brisbane, 1967–8
University of Queensland, Brisbane, 1968–71
Camberwell School of Art and Crafts, London, 1976–9

Early work is coiled or slab-built earthenware sculptural forms with painted decoration; later, tall pots with narrow bases and an exuberant use of colour.

Studio: Australia, America and England

Barry, Val (now Valerie Fox), b. 1937, Barnsley, Yorks
Training: Sir John Cass School of Art, London, ceramics, 1967–70

Thrown or slabbed sculptural pieces in stoneware and porcelain, 1970–84; working in bronze 1984–.

Studio: Crouch End, London, 1970–
Collections: 2, 14, 15, 19, 25, 29, 32, 33, 36, 56, 62, 64

Impressed mark

Barton, Glenys b. 1944, Stoke-on-Trent
Training: Royal College of Art, ceramics, 1968–71

Sculpture, mostly based on the human form with some abstract work. Early work slip-cast in porcelain or bone china; crackled earthenware glazes in the early 1980s; fibreglass faced in ceramic in the late 1980s; limited edition pieces produced with Wedgwood, 1976.

Studio: King's Cross, London, shared with Jacqui Poncelet, 1972–4
Wandsworth, London, 1974–84
Creeksea, Burnham-on-Crouch, Essex, 1984–

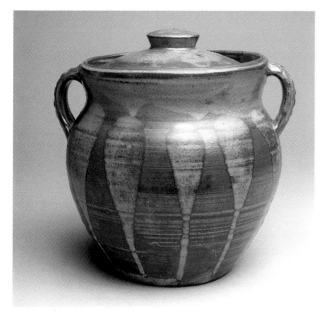

Plate 214: Svend Bayer, stoneware, c.1970, ht: 22cm

Collections: 6, 22, 24, 25, 28, 29, 32, 35, 41, 42, 48, 49, 56, 60, 62, 64

Incised or painted signature often with year

Batterham, Richard b. 1936
Training: Bryanston School, Dorset, 1949–54; largely self-taught

Thrown domestic stoneware in the Leach tradition, mainly with ash-glazes, some salt-glaze; decoration through beating, cutting, combing, incising or ridging.

Studio: Leach Pottery, St Ives, 1957–8
Durweston, Dorset, 1959–
Collections: 1, 7, 9, 11, 14, 15, 17, 18, 27, 28, 29, 33, 35, 37, 42, 44, 49, 50, 55, 56, 57, 60, 61, 62, 64, 65

Does not mark work

Bayer, Svend b. 1946, Kampala, Uganda
Came to England from Denmark in 1962
Training: Exeter University, geography and economics, 1965–8

Domestic and garden pots in wood-fired stoneware.

Studio: Wenford Bridge, Cornwall, with Michael Cardew, 1969–72
At H.C. Brannams, Barnstaple, Devon, 1972–3
Set up pottery with Todd Piker, USA, 1974
Established pottery, Sheepwash, Devon, 1975–
Collections: 16, 17, 27, 28, 29, 32, 33, 42, 49, 56, 57

Does not sign his work,
impressed mark on some early pots

Bedding, John b. 1947, London
Training: Sir John Cass School of Art, London, 1967

Stoneware and porcelain in the Leach tradition until *c.*1980. Since 1980, mainly raku in fine clay.

Studio: Local potteries, St Ives, Cornwall
Leach Pottery, St Ives, apprentice 1969–71, permanent staff, 1972–9
At Jean Tessier, Villenaux, France, 1971
Ichino Pottery, Tamba, Japan, 1979–80
Established workshop, St Ives, 1980–
Collections: 38, 56

Impressed mark

At Leach Pottery also impressed

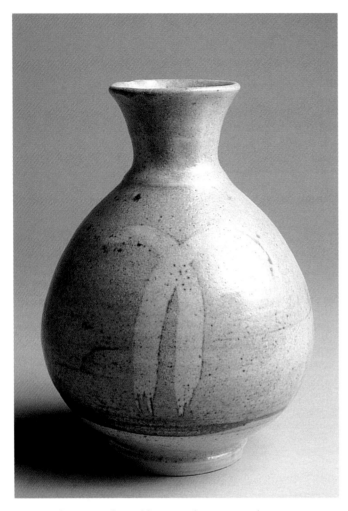

Plate 215: John Bedding, porcelain, c.1974, ht: 20cm.

Plate 216: Suzanne Bergne, porcelain, 1990, dia: 22cm.

Bergne, Suzanne b. 1939, Upper Silesia, Germany
Training: Munich and Vienna Universities, 1958–63
Croydon College of Art and Design, ceramics, 1977–80

Thrown porcelain, mostly bowls, with poured glazes, 1980–95; slabbed sculptural work in porcelain paper-clay, smoked or raku-fired, 1997–

Studio: Athens, 1980–4
Hong Kong, 1984–7
Upper Slaughter, Glos, 1987–
Collections: 10, 29, 56

Impressed marks 1980–7

1987–

Sculptural work with signature and date in pen

Bew, John (Odney Pottery) b. 1897; d. 1954
Training: Camberwell School of Art under Hopkins, *c.*1922

Founder and principal potter, Odney Pottery, domestic earthenware.

Studio: Farleigh, Surrey, 1930–6
Odney Pottery, Cookham, Berks, 1942–1954.
Collections: 29, 37
Impressed 1942–54 'Odney' or 'Odney Handmade England'

Billington, Dora b. 1890, Stoke-on-Trent; d. 1968
Training: Hanley School of Art

Best known as an educator. Designed and decorated pots for industrial firms. Made stoneware and earthenware with brush decoration. Ceased potting mid-1950s.

Teaching: Royal College of Art, 1915–25
Central School of Art, London, 1924–*c.*1955
Publications: The Art of the Potter, 1937
The Technique of Pottery, 1962

Studio: with Bernard Moore, 1912–15
London, 1915–*c.*1955
Collections: 25, 29, 32, 49, 64

Painted mark on B. Moore wares

Painted or incised mark, 1920–

Blandino, Betty b. 1927, London
Training: Bishop Otter College, Chichester, 1945–7
Goldsmiths' College, London, painting and pottery, 1957–8
London University Institute of Education, 1971–3

Thin-walled coiled and pinched individual pots, coloured with oxides; late 1990s work sometimes white and lightly burnished.

Studio: St Hilary, Cowbridge, South Glamorgan, 1973–8
St Briavel's Common, Lydney, Glos, 1978–87
Summertown, Oxford, 1988–
Collections: 9, 10, 11, 13, 15, 18, 20, 25, 27, 33, 49, 55, 56, 64, 65, 66

Impressed mark

Bowen, Clive b. 1943, Cardiff
Training: Cardiff College of Art, painting, 1959–63

Thrown domestic and garden slipware, raw-glazed and wood-fired.

Studio: Yelland Pottery, Devon, with Michael Leach, 1965–9
Brannam Pottery, Barnstaple, works as thrower, 1970
Shebbear Pottery, Beaworthy, Devon, 1971–
Collections: 7, 16, 21, 25, 28, 29, 37, 49, 55, 56, 57, 62, 64, 65

Impressed mark

Braden, Norah b. 1901, West Heathley, Sussex; d. 2001
Training: Central School of Art and Design, 1919–21
Royal College of Art, 1922–4

Thrown stoneware with ash-glazes in the Leach tradition. Very little work made after 1936.

Teaching: Brighton School of Art, 1936–
Studio: Leach Pottery, St Ives, 1925–7
Coleshill, Berks, with Pleydell-Bouverie, 1928–36
Sussex, *c.*1938–45
Collections: 2, 9, 11, 13, 16, 17, 27, 29, 32, 38, 44, 49, 55, 56, 60, 61, 62, 64, 65

Impressed mark

Painted or incised mark

Britton, Alison b. 1948, Harrow, Middlesex
Training: Leeds College of Art, 1966–7
Central School of Art and Design, ceramics, 1967–70
Royal College of Art, ceramics, 1970–3

Slab-built vessel forms, often derived from jugs, in high-fired oxidized earthenware with painted decoration. Mostly tiles until 1975. Written many articles and pamphlets on ceramics.

Teaching: Royal College of Art, 1984–
Studio: 401½ Workshops, Lambeth, London, shared with Carol McNicoll, 1973–5
King's Cross, London, 1975–87
Stamford Hill, London, 1987–
Collections: 1, 5, 6, 7, 15, 18, 21, 24, 25, 27, 28, 29, 33, 35, 41, 43, 57, 58, 60, 61, 62, 64

Incised signature with year

Brown, Percy b. 1911, Wolverhampton; d. 1996
Training: Wolverhampton School of Art, 1927–32
Royal College of Art, sculpture, 1932–4

Primarily sculpture in terracotta or bronze; thrown stoneware influenced by William Staite Murray.

Teaching: Leicester College of Art, 1935–45
Leeds College of Art, 1946–50
Hammersmith School of Art, 1950–7?
Studio: Leicester, 1935–45
Leeds, 1946–50
London, 1950–95
Collections: 25, 49

Incised or painted marks

Brown, Sandy b. 1946, Tichborne, Hants
Training: Daisei Pottery, Mashiko, Japan, 1970–3

Thrown or slabbed stoneware tableware and individual pots and figures with colourful expressive painted decoration. Shared studio with Takeshi Yasuda, 1973–91.

Studio: Monk Sherborne, Hants, 1973–5
Meshaw, Devon, 1975–81
South Molton, Devon, 1981–93
Appledore, Bideford, Devon, 1994–
Collections: 18, 28, 29, 33, 49, 56, 57, 58, 61, 64
Signature trailed in red glaze incorporated into the decoration

Buck, Steve b. 1949
Training: Harrow School of Art, 1979–81

Handbuilt earthenware sculptural forms, early work – smaller with bright colours and metallic finishes; later work – larger with textured surfaces and more organic forms.

Studio: London, 1981–
Collections: 28, 29, 33

Does not mark work

Burnett, Deirdre b. 1939, Simla, India
Came to England, 1947
Training: St Martin's School of Fine Art, London, 1962–4
Camberwell School of Art and Crafts, ceramics and metalwork, 1964–7

Pinched individual work in oxidized porcelain and some stoneware.

Studio: East Dulwich, London, 1967–*c.*1972
Upper Norwood, London, *c.*1972–
Collections: 2, 18, 19, 29, 33, 36, 41, 56, 64

Impressed mark

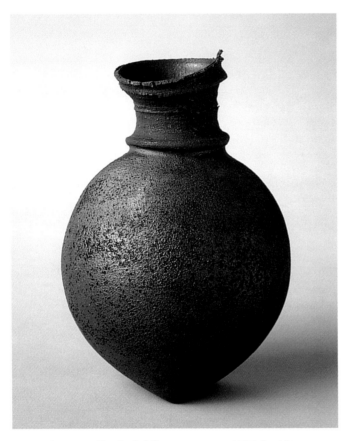

Plate 217: Glenda Cahillane, stoneware, 1997, ht: 15cm.

Cahillane, Glenda b. 1955, Lurgan, Northern Ireland
Training: Northern Ireland Polytechnic, Belfast, 1974–8
Royal College of Art, London, 1978–81

Thrown and assembled vessels in stoneware, applied slip and multi-fired.

Studio: Docklands, London, 1983–7
East Dulwich, London, 1987–
Collections: 57

Incised initials, *c.*1993–; not marked previously

Caiger-Smith, Alan b. 1930, Buenos Aires, Argentina.
Came to England *c.*1932, MBE, 1988.
Training: Camberwell School of Art and Crafts, painting and drawing, 1947–8.
King's College, Cambridge, history and Eng. lit., 1949–52
Central School of Art, evening classes in ceramics, 1954

Produced with assistants functional tin-glazed earthenware, mostly with lustre glazes and brush decoration. Since 1993 has only worked part-time and without assistants.

Publications: Tin-Glaze Pottery in Europe and the Islamic World, 1973
Lustre Pottery – Tradition and Innovation in Islam and the Western World, 1985
Pottery, People and Time, 1995
Studio: Established Aldermaston Pottery, Berks, 1955–93
London, 1957–63, concurrently
Collections: 1, 5, 7, 11, 13, 14, 15, 17, 18, 19, 21, 22, 24, 25, 27, 28, 29, 33, 35, 37, 41, 42, 43, 48, 49, 50, 54, 56, 57, 59, 60, 61, 62, 64, 65, 66

Painted or incised mark, early

London, 1957–63

Painted or incised personal mark with year mark

Campavias, Estella b. 1918, Istanbul, Turkey; d. 1990
Came to England, 1947
Training: Chelsea Pottery, *c.*1954

Earthenware, 1954–56; stoneware, 1957–61, colourful glazes. Made bronzes from 1974

Studio: Burgh Street, London, 1954–90
Collections: 29, 62

Impressed, incised or painted marks, 1954–6

1957–

Cardew, Michael Ambrose b. 1901, Wimbledon; d. 1983
Training: Exeter College, Oxford, Lit., Hum., 1919–23

Thrown domestic slipware until 1942 and at Kingwood. Otherwise stoneware.
Awarded CBE, 1964; MBE, 1965; OBE, 1981

Studio: Braunton Pottery, Barnstaple, Devon, 1921–2
Leach Pottery, St Ives, 1923–6
Winchcombe Pottery, Glos, 1926–39 and 1941–2
Wenford Bridge Pottery, St Breward, Cornwall, 1939–83
Achimota College, Ghana, pottery instructor, 1945–8

Volta Pottery, Vume-Dugame, Ghana, 1945–8
Kingwood Pottery, Surrey, 1948
Abuja Pottery, Nigeria, 1951–65
Collections: 1, 2, 4, 6, 9, 11, 12, 13, 15, 16, 17, 19, 22, 24, 25, 26, 27, 28, 29, 32, 33, 35, 37, 38, 41, 43, 44, 49, 53, 54, 55, 56, 58, 61, 62, 64

Impressed personal marks, 1923–4

1924–83

Impressed pottery marks: Leach Pottery

Winchcombe Pottery

Wenford Bridge Pottery

Volta Pottery

Abuja Pottery

Kingwood

Carter, Chris b. 1945, Warwickshire
Training: Stoke-on-Trent College of Art, 1965–78

Domestic pottery in oxidized stoneware, 1971–86; individual thrown pots usually with tenmoku glazes, 1987–91; matt textured surfaces, 1991–

Studio: Grendon, Atherstone, Warks, 1971–
Collections: 14, 27, 36

Impressed marks, 1971–75

1976–86

1987–90

1991–

Cass, Barbara (later Wolstencroft) b. 1921, Germany; d. 1992
Came to England, 1950
Training: Berlin, sculpture, 1940s

Thrown stoneware vessels, 1956–88.

Studio: York, 1952–61
Henley-in-Arden, Warks, 1962–8
Stratford-upon-Avon, 1968–88
Collections: 2, 14, 29, 32, 49, 54, 55, 56, 60, 62

Incised 'BC' with 'York' or 'Arden'

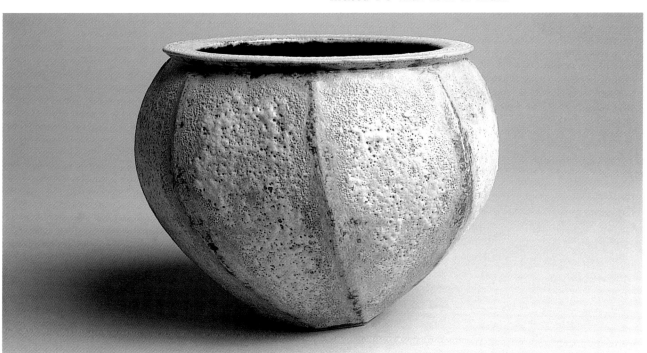

Plate 218: Chris Carter, stoneware, c.1993, ht: 15cm.

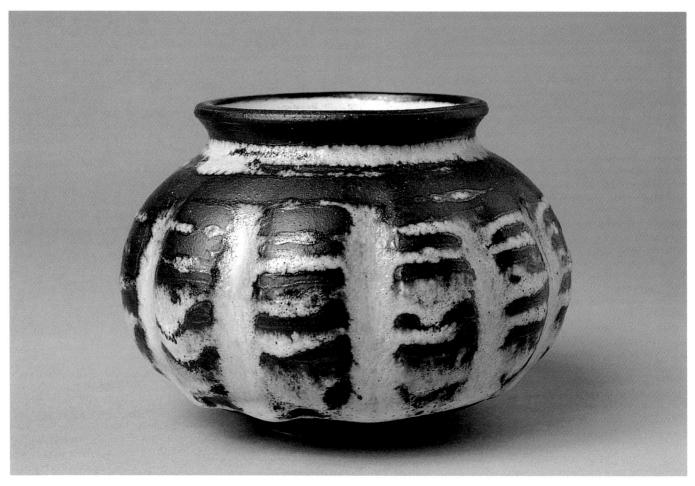

Plate 219: Barbara Cass, stoneware, c.1965, ht: 8cm.

Casson, Michael b. 1925, London
Training: Essentially self-taught
Hornsey School of Art, 1948–52.

Mostly individual functional pottery; tin-glazed
earthenware, 1952–9; oxidized stoneware, 1960–3,
thereafter reduced stoneware; since 1980, mainly salt-glaze.
Presenter of BBC series, *Craft of the Potter*, 1975

Publications: Pottery in Britain Today, 1966
Craft of the Potter, 1976.
Teaching: Harrow School of Art, 1963–73; Cardiff School
of Art, 1982–92
Studio: Bloomsbury, London, 1952–9
Prestwood, Bucks, 1959–77
Upton Bishop, Ross-on-Wye, Herefordshire, 1977–
Collections: 1, 2, 7, 11, 15, 17, 18, 20, 21, 24, 25, 27, 28,
29, 31, 32, 33, 35, 37, 39, 41, 49, 51, 56, 57, 60, 61, 62,
64, 65, 66

Usual painted or impressed mark

Others painted or impressed; 1953–5

1955

1977–9

Clark, Kenneth b. 1922, Wellington, New Zealand
Training: Slade School, London, painting, *c.*1949
Central School of Art & Crafts, ceramics, *c.*1949

Vessels and tiles, primarily in tin-glaze earthenware;
ceramic designs and architectural commissions. Married
Ann Wynn Reeves, 1954.

Studio: West London, 1952–80
Lewes, Sussex, 1980–
Collections: 56

Incised or printed 'KENNETH CLARK POTTERY'

Painted initials with year

Constantinidis, Joanna b. 1927, York; d. 2000
Training: Sheffield College of Art, ceramics, 1945–9

From 1970s – thrown and modelled reduction-fired stoneware often sprayed with metal oxides to provide a lustre; porcelain deep bowls with celadon or lustre glazes; porcelain tableware, 1980s–; early work is functional stoneware.

Studio: Great Baddow, Essex, 1950–2000
Collections: 2, 6, 7, 8, 11, 14, 15, 21, 24, 25, 27, 28, 29, 31, 33, 35, 42, 43, 50, 56, 61, 62, 64

Impressed mark

Cooper, Emmanuel b. 1938, Derbyshire
Training: Dudley Training College, 1958–60
Bournemouth School of Art, 1960–1
Hornsey School of Art, 1961–2

Individual stoneware and porcelain pots, mostly bowls and jugs, many in the Lucie Rie tradition; tableware, *c.*1965–86. Co-founder of *Ceramic Review* and prolific writer on ceramics.

Studio: assistant to Gwyn Hanssen and Bryan Newman, 1963–4
Notting Hill Gate, London, 1965–73
Finsbury Park, London, 1973–6
Primrose Hill, London, 1976–
Collections: 1, 14, 28, 29, 33, 41, 49, 56, 60, 61, 64

Impressed marks 1973–90,

1980–

Cooper, Robert b. 1949, Sheffield
Training: Kingston upon Thames College of Art, 1972
Royal College of Art, London, graduated 1982

Handbuilt vessel forms – mostly lidded or sealed boxes, 1980s; later, ritual vessels, jug forms and larger works containing shards of earlier uncompleted forms.

Studio: South London, 1981–5
South East London, 1985–
Collections: 18, 28

Painted signature

Cooper, Waistel b. 1921, Ayr, Scotland
Training: Edinburgh College of Art, painting, 1938–9 and 1945–6

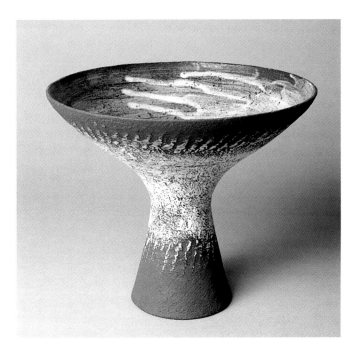

Plate 220: Waistel Cooper, stoneware, c.1975, ht: 22cm.

Thrown stoneware vessel forms often with dry, textured surfaces, wood and vegetable ash-glazes.

Studio: Porlock, Devon, 1952–5
Culborne, Porlock, Devon, 1955–83
Barbican Pottery, Penzance, Cornwall, 1983–
Collections: 2, 8, 15, 16, 25, 27, 32, 33, 37, 41, 51, 56, 58, 59, 60, 61, 62

Painted signature

Coper, Hans b. 1920, Chemnitz, Germany; d. 1981.
Came to England, 1941

Individual thrown and sometimes reassembled stoneware vessel forms, coated with a matt black manganese oxide or with layers of white slip and manganese oxide. Assisted Lucie Rie in making buttons and domestic ware, 1946–59.

Studio: Albion Mews, Bayswater, London, with Lucie Rie, 1946–59
Digswell, Herts, 1959–63
Princedale Road, London, 1963–4
Hammersmith, London, 1964–7
Frome, Somerset, 1967–79
Collections: 1, 2, 6, 8, 9, 11, 14, 15, 17, 18, 22, 24, 25, 28, 29, 32, 33, 35, 36, 37, 41, 43, 49, 50, 54, 56, 60, 61, 62, 64, 65

Impressed marks

Domestic ware also has impressed mark of Lucie Rie

Corser, Trevor b. 1938, Oldham, Lancs

Training: Leach Pottery, apprentice, 1964–5

Thrown stoneware and some porcelain in the Leach tradition.

Studio: Leach Pottery, St Ives, 1966–
Collections: 35, 49, 56

Impressed marks

Cox, George James (Mortlake Pottery); d. *c*.1933
Earthenware usually with monochrome slip glazes.

Publications: *Pottery For Artists, Craftsmen and Teachers*, 1914
Pottery: Mortlake Pottery, London, 1911–14
Emigrated to USA, 1914.
Collections: 23, 29

Incised 'Mortlake' usually with year, initials of GJC and assistant, and crescent or cross

Cronin, Philippa b. 1957, Devon
Training: Loughborough College of Art, 1976–7
Buckinghamshire College of Higher Education, ceramics and silver/metal, 1977–80

Handbuilt earthenware with forms based on the human figure; early work – slabbed, with finely ground surfaces and inlaid with stained slips; later work – coiled and shaped with coloured slips applied in layers.

Studio: South Hill Park Arts Centre, Bracknell, Berks, 1981–3
Kingsgate Workshops, London, 1984–

Incised mark

Crowley, Jill b. 1946, Cork, Eire
Training: Bristol Polytechnic, ceramics, 1966–9
Royal College of Art, ceramics, 1969–72

Sculptural, mostly figurative, stoneware painted with slips, underglazes and glazes, some raku and porcelain.

Studio: 401½ Workshops, Lambeth, London, 1972–81
Brixton, London, 1982–
Collections: 6, 24, 25, 28, 29, 33, 35, 41, 43, 57, 58, 60, 61, 62

Incised signature (sometimes 'J Crowley') *Jill Crowley*

Dalton, William Bower b. 1868; d. 1965
Training: Manchester School of Art, 1888–92
Royal College of Art, 1892–6

Mostly thrown stoneware with a Chinese influence.

Teaching: Principal of Camberwell School of Art, 1898–1919
Publications: *Craftsmanship and Design in Pottery*, 1957; *Notes from a Potter's Diary*, 1960; *Just Clay*, 1962.
Studio: Longfield, Kent, 1909–41
Emigrated to USA, 1941, and established a pottery at Stamford, Connecticut
Collections: 17, 29, 32, 38, 45, 55, 56

Incised or painted mark

Dan, John d. *c*.1980
Large individual stoneware vessel forms, 1950s–1970s.

Studio: Wivenhoe, Essex, 1950s–*c*.1976
Collections: 56, 62

Impressed initials and incised mark

Davis, Derek b. 1926, Wandsworth, London
Training: Central School of Art, London, painting, 1945–8
Ceramics – self-taught

Thrown stoneware and porcelain with oriental and ash-glazes, especially sang-de-boeuf glazes, 1970s; thrown, slabbed or press-mould vessels with painted decoration, 1980s–. Domestic earthenware, 1951–5.

Studio: Hillesden, Bucks, 1951–5
Arundel, Sussex, 1955–
Collections: 1, 14, 21, 25, 29, 33, 39, 41, 48, 49, 50, 56, 57, 58, 60, 62

Painted or incised marks
1950s

1962

1962– often with year

Davis, Harry b. 1910; d. 1986
Training: Bournemouth Art School

At Crowan Pottery he made functional ware in fine stoneware, usually decorated with brushwork or wax-resist.

Publication: *The Potter's Alternative*, 1987
Studio: Poole Pottery, Broadstone, Dorset, *c*.1932
Leach Pottery, St Ives, run in Leach's absence, 1933–7
Achimota College, Ghana, 1937–42
Works in South America, 1943–6

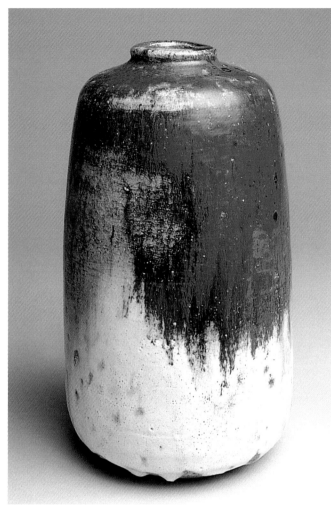

*Plate 221: Derek Davis, stoneware, sang-de-boeuf glaze, c.1979,
ht: 27cm.*

Estabished with his wife, May, Crowan Pottery, Praze,
Cornwall, 1946–62
Crewenna Pottery, New Zealand, 1962–76 and 1979–86
Iziuchara Pottery, Peruvian Andes, 1972–9
Collections: 14, 17, 18, 29, 33, 49, 55, 56, 62

Crowan Pottery impressed seal

de Trey, Marianne b. 1913, London, of Swiss parents
Training: Royal College of Art, textiles, 1932–6

Slipware, 1945–7; functional ware with assistants,
earthenware from 1948 to *c.*1960 then oxidized stoneware
until *c.*1985; thrown, individual porcelain and some
stoneware. Married Sam Haile, 1938.

Studio: Bulmer Brickyard, Sudbury, Suffolk, with Sam
Haile, 1945–7
Shinner's Bridge, Dartington, Devon, 1947–
Collections: 1, 11, 16, 29, 32, 33, 40, 49, 56, 60, 62, 65

Impressed mark on functional ware

Impressed personal marks

de Waal, Edmund b. 1964, Nottingham
Training: Apprentice with Geoffrey Whiting, 1981–3
Cambridge University, English Literature, 1984–6

Thrown porcelain vessels glazed with celadon, 1995–;
stoneware and some porcelain in the Leach tradition,
late 1980s.

Studio: Sheffield, 1987–92
Mejiro Ceramics Studio, Tokyo, 1992–3
London, 1995–
Collections: 11, 27, 28, 29, 49, 56

Impressed mark

Dixon, Stephen b. 1957, Peterlee, Co. Durham
Training: University of Newcastle-upon-Tyne, fine art,
1983–6
Royal College of Art, ceramics, 1986–7

Modelled figurative vessels in glazed earthenware, 1986–;
garden pots and sculpture, 1986–96; some large-scale
public works and printed plates and vessels, 1996–.

Studio: Pancras Road, Kings Cross, London, 1986–91
Rossendale, Lancs, 1991–6
Didsbury, Manchester, 1996–
Collections: 18, 27, 28, 32, 33, 35, 49, 57, 66

Occasional sprigged mark

Dodd, Michael b. 1943, Sutton, Surrey
Training: Bryanston School, Dorset
Cambridge University, Natural Science, 1962–5
Hammersmith College of Art, London, 1966–7

Thrown stoneware vessels primarily with ash-glazes in the
Leach tradition; some porcelain.

Studio: Edburton, Sussex, 1967–71
Whatlington, Battle, Sussex, 1971–5
Cider House Pottery, Townshend, Hayle, Cornwall, 1975–9
Peru, 1979–80
Carlisle, 1981–6
Boltongate, Carlisle, 1986–94
Chedington, Dorset, 1995–*c.*1999
Glastonbury, Somerset, *c.*1999–
Collections: 6, 14, 17, 28, 29, 33, 49, 56, 57, 64

Unmarked 1967–71 and 1975–9

Impressed mark 1971–5

Impressed marks 1981–

Duckworth, Ruth b. 1919, Hamburg, Germany
Came to England, 1936
Training: Liverpool School of Art, sculpture, 1936–40
Kennington School of Art, stone carving, 1946
Hammersmith School of Art, 1955
Central School of Art and Crafts, ceramics, 1956–8

Thrown or cast domestic ware, late 1950s; asymmetrical coiled stoneware pots, late 1950s–1960s; pinched porcelain sculptural vessels, *c.*1962–; large sculptural works and wall-panels; 1964–.

Studio: Kew, Surrey, 1956–64
USA, 1964–
Collections: 1, 2, 8, 9, 14, 25, 29, 33, 37, 41, 43, 56, 57, 60, 62

Painted or impressed mark

Painted mark

Dunn, Constance (née Wade) dates not known
Training: Cambridge School of Art, 1921–4
Royal College of Art, ceramics, under Dora Billington and then William Staite Murray, 1924–30

Thrown stoneware in the Chinese tradition influenced by W.S. Murray.

Studio: Billingham, Durham, *c.*1933–late 1950s.
Collections: 27, 29, 32, 34, 38, 56, 58, 62

Incised or impressed mark

Eastman, Ken b. 1960
Training: Edinburgh College of Art, design, 1979–83
Royal College of Art, ceramics, 1984–7

Slab-built stoneware forms painted with slips and oxides.

Studio: Pancras Road, London, 1987–91
Leominster, Herefordshire, 1992–8
Shropshire, 1998–
Collections: 6, 18, 28, 29, 35, 43, 60

Signature with year

Eastop, Geoffrey b. 1921, Norbury, London
Training: Goldsmith's College, London, 1950–2

Thrown and altered forms in stoneware and porcelain. Helped John Piper with his ceramics as well as making his own pots, 1969–84. Later work in hand-built stoneware.

Studio: Odney Pottery, Cookham, Berks, 1953–4
Aldermaston Pottery, Berks, with Caiger-Smith, 1955–61
Padworth, Berks, 1961–9
Fawley Bottom, Henley-on-Thames, Oxon, 1969–84
Ecchinswell, Newbury, Berks, 1985–
Teaching: Berkshire College of Art and Design, 1962–87
Collections: 2, 6, 11, 22, 29, 35, 37, 41, 42, 48, 49, 65

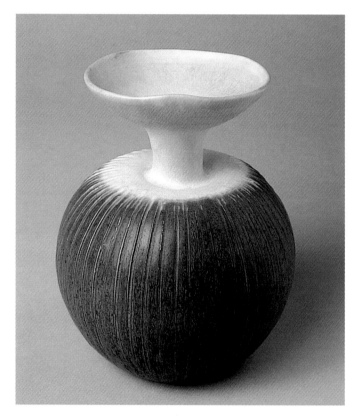

Plate 222: Geoffrey Eastop, porcelain, c.1974, ht: 15cm.

Painted mark, 1955–61

Painted marks, 1961–

Eeles, David b. 1933, London
Training: Willesden School of Art, London, 1947–53

Tin-glazed earthenware, 1955–62; slipware, 1955–63; oil-fired stoneware, 1963–75; wood-fired stoneware and porcelain, 1975–; some raku from 1996.

Studio: Hampstead, London, 1955–62
Mosterton, Beaminster, Dorset, 1962–
Collections: 27, 33, 49, 51, 56, 62, 64, 66

Impressed, incised or painted mark

Eglin, Phillip b. 1959, Gibraltar
Training: Staffs University, 1979–82
Royal College of Art, London, 1983–6

Handbuilt multi-fired earthenware figures and some
figurative buckets and plates; some porcelain figures.

Teaching: Staffs University, 1987–
Studio: Pancras Road, London, 1986–7
Mucklestone, Staffs, 1987–92
Newcastle-under-Lyme, Staffs, 1992–
Collections: 6, 11, 18, 21, 27, 28, 29, 41, 49, 60

Does not sign work consistently

El Nigoumi, Siddig b. 1931, Sudan; d. 1996
Came to England, 1957–60, permanently, 1967
Training: Khartoum Art School, Sudan, calligraphy, 1952–5
Central School of Art, London, 1957–60

Handbuilt pots in burnished red earthenware with incised
decoration; some stoneware.

Teaching: West Surrey College of Art and Design, Farnham,
1968–
Studio: Farnham, Surrey, 1973–96
Collections: 1, 7, 15, 21, 29, 32, 33, 49, 56, 64

Incised signature with year and scorpion mark

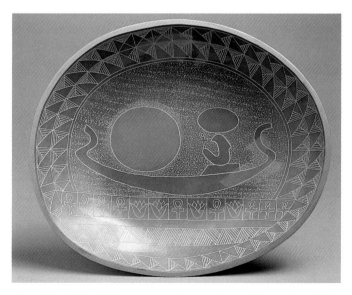

*Plate 223: Siddig El Nigoumi, earthenware, incised decoration, 1980,
w: 39cm.*

Epton, Charlotte b. 1902; d. 1970
Training: Royal College of Art, London, *c.*1920–3

Stoneware mainly in the Leach tradition, 1927–32;
stopped working when she married the painter, Edward
Bawden; some work with Joanna Constantinidis, 1950s.

Studio: Leach Pottery, St Ives, Cornwall, 1927–30
Essex, 1930–2
Collections: 29

Impressed mark

Feibleman, Dorothy b. 1951, Indiana, USA
Moved to England, 1973
Training: Rochester Institute of Technology, New York,
1969–73

Agate ware laminated in porcelain and parian, mostly
small bowls and jewellery; white pieces since 1995.

Studio: Retford, Notts, 1973–5
Brixton, London, 1975–
Collections: 2, 18, 19, 29, 56, 57, 62

Impressed mark, 1973–5

late 1990s

Most work is unsigned

Finch, Raymond b. 1914, London
Training: Central School of Art and Design, 1935–6

Slipware in style of Michael Cardew 1936–60; functional
thrown stoneware from 1959 with some individual pieces.

Studio: Winchcombe Pottery, Cheltenham, Glos, 1936–;
as owner from 1946
Collections: 1, 2, 13, 15, 17, 18, 22, 27, 28, 29, 32, 33, 35,
37, 41, 42, 49, 50, 56, 60, 61, 64, 66

Impressed seals Winchcombe Pottery

Impressed personal seal on slipware

Impressed seal early 1950s

Impressed personal seal on stoneware

Finnemore, Sybil dates not known
Training: Central School of Art, *c.*1925

Thrown stoneware usually brush-decorated.

Studio: Yellowsands Pottery, Isle of Wight, 1927–32
Bembridge Pottery, Isle of Wight, 1949–61
Collections: 29, 64

Incised or painted 'S. FINNEMORE' sometimes
with year

Impressed mark, Yellowsands Pottery

Impressed mark, Bembridge Pottery

Fishley, Edwin Beer b. 1832; d. 1912
Slipware in the Devon tradition – often cut decoration to
show the red body.

Studio: Fremington, North Devon, 1865–1906.
Collections: 1, 6, 9, 11, 14, 16, 17, 23, 29, 33, 48, 61, 62

Incised

E B Fishley
Fremington
N Devon
(year)

Forrester, Bernard b. 1908, Stoke-on-Trent; d. 1990
Training: Minton, apprentice modeller, 1922–9
College of Art, Newcastle, drawing and painting,
*c.*1930–2
Leach Pottery, St Ives, apprentice, 1932–4

Thrown slipware vessels with painted decoration,
mid-1950s; oxidized stoneware and porcelain with
wood ash-glazes, lustres and often burnished gold;
from late 1950s.

Teaching: Dartington Hall School, 1934–72
Studio: Dartington Pottery, Devon, 1934–72
Broadhempston, Devon, 1952–90
Collections: 15, 37, 56

Painted marks

Fournier, Robert b. 1915, London
Training: Central School of Art and Crafts, London,
ceramics under Dora Billington, 1945–6

Thrown and handbuilt domestic and individual
earthenware pots, 1946–59; oxidized stoneware, 1961–87;
porcelain, 1971–87. Shared studio with his wife Sheila
(1930–2000) from 1960.

Studio: Ducketts Wood Pottery, Wadesmill, Herts, 1946–59
Greenwich Studios, London, 1961–5
Castle Hill Cottages, Brenchley, Kent, 1965–71
Lacock Pottery, Lacock, Wilts, 1971–87
Collections: 27, 56, 60, 61, 64

Impressed and painted marks

There are also marks for each pottery

Frith, David b. 1943, Lancashire
Training: Flintshire Technical College, Art Department,
1958–61
Wimbledon School of Art, London, 1961–2
Stoke-on-Trent College of Art, 1962–3

Wide variety of domestic and individual thrown vessels;
reduction-fired stoneware, 1970–; oxidized stoneware,
1968–70; slipware, 1963–8.

Studio: Denbigh, Clwyd, 1963–75
Brookhouse Pottery, Denbigh, 1975–
Collections: 7, 27, 29, 49, 56, 57, 65, 66

Impressed mark

Brookhouse Pottery 1963–75

1975–

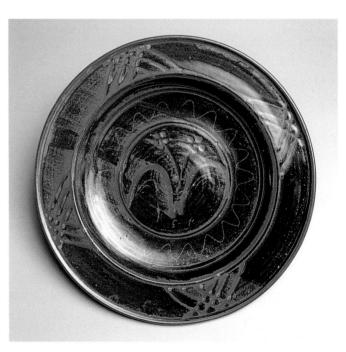

*Plate 224: David Frith, stoneware, tenmoku-glaze, c.1990,
dia: 42cm.*

Fritsch, Elizabeth b. 1940, Shropshire
Training: Royal Academy of Music, 1958–64
Royal College of Art, ceramics, 1968–71

Coiled stoneware pots of thin form painted with coloured slips often with geometric and optical designs; early pots thinly stained.

Studio: Bing and Grondahl porcelain factory, Copenhagen, Denmark, employed as artist, 1972–3
Gestingthorpe, Suffolk, 1973–6
Digswell, Herts, 1976–85
E. London, 1985–
Collections: 1, 2, 6, 7, 9, 11, 15, 18, 24, 25, 27, 28, 29, 32, 33, 35, 41, 43, 55, 60, 61, 62, 65

Does not mark work

Fry, Roger Eliot b. 1866, Highgate, London; d. 1934
Training: Cambridge University, natural science
Camberwell School of Arts and Crafts, *c.*1912–13.

Art critic and painter. Founded Omega Workshops in 1913. Tin-glazed functional wares usually undecorated and white.

Studio: Omega Workshops, Fitzroy Square, London, 1913–19
Poole Pottery, 1914–15, researching for a less porous white body
Collections: 9, 11, 29, 65

Impressed or incised mark

Fuller, Geoffrey b. 1936, Chesterfield, Derby
Training: Chesterfield College of Technology and Arts, 1965–6
West Surrey College of Art and Design, Farnham, ceramics, 1966–9; Technical Assistant, 1969–71

Thrown slipware domestic pots; handbuilt slipware figure models.

Studio: Pilsley, Chesterfield, Derby, 1972–88
Tideswell, Buxton, Derby, 1988–
Collections: 28, 29, 33, 37, 49, 56, 60

Does not mark pots;
sometimes signs figures 'G Fuller'

Garland, David b. 1941, Kettering, Northants
Lived in New Zealand, 1946–61
Training: London College of Printing, 1961–4
Ceramics self-taught

Domestic and individual earthenware vessels coated in slip and brush-decorated with oxides.

Studio: Oxford, 1971–5
Chedworth, Glos, 1975–
Collections: 8, 28, 29, 33, 56, 62

Painted signature *Garland*

Godfrey, Ian b. 1942, Islington, London; d. 1992
Training: Camberwell School of Art and Crafts, painting and then ceramics, 1957–62
Royal College of Art, fellowship, 1967–8

Handbuilt and thrown stoneware forms usually with carved or modelled animals or perforated designs.

Studio: City Road, London, 1962–67
Goswell Road, Islington, London, 1968–76
Copenhagen, Denmark, 1976–80
Highgate, London, 1980–92
Collections: 1, 2, 8, 11, 14, 15, 25, 28, 29, 33, 36, 42, 43, 49, 56, 60, 61, 62

Did not sign work.

Gordon, William b. *c.*1906
Animals and vessels in salt-glazed cast porcelain (some stoneware), 1946–56; architectural ceramics after 1956.

Studio: Chesterfield, Derbyshire, 1946–?
Collections: 29

Mark incised or in black enamel

Sometimes with year or 'Made in England'

Gorry, Colin b. 1952, Staffordshire
Training: Sunderland School of Art, 1978–9
Camberwell School of Art and Crafts, London, ceramics, 1979–82

Thrown and altered tall asymmetrical pots and jugs in raw-glazed stoneware using multiple slips and rough textures.

Studio: West Kensington, London, 1982–5
Arlingford Studios, Brixton, London, 1985–7
Clockwork Studios, Brixton, London, 1987–92
Walton-on-Thames, Surrey, 1993–
Collections: 28, 29, 56, 57

Painted or impressed mark

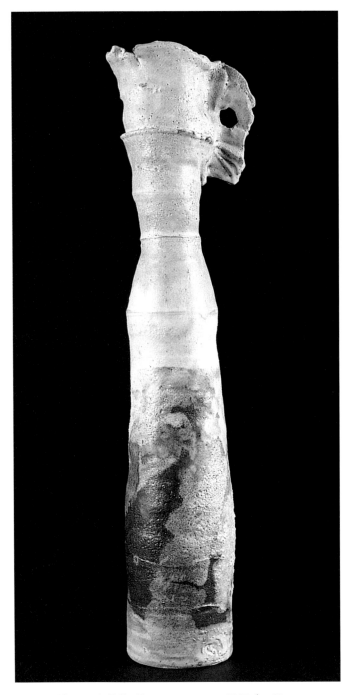

Plate 225: Colin Gorry, stoneware, c.1990, ht: 52cm.

Green, Alan Spencer
Training: South Essex College of Art, painting, 1950s

Thrown vessels in stoneware and porcelain. Studied ceramic chemistry and researched early Oriental glazes. Probably ceased potting *c*.1978.

Studio: Wimbush, Saffron Walden, Essex, *c*.1958–
Collections: 11, 18, 42, 62

Incised or painted marks

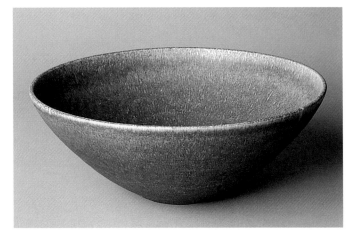

Plate 226: Alan Spencer Green, porcelain, c.1970, dia: 34cm.

Gunn-Russell, Linda b. 1953, London
Training: Camberwell School of Art and Craft, ceramics, 1972–5

Early work slip-cast or press-moulded; some raku; then slab-built earthenware with slip, painted or sponged; flattened forms in the shape of jugs, teapots and other vessel forms.

Studio: 401½ Workshops, Lambeth, London, 1975–8
Various London studios, 1978–
Collections: 18, 28, 29, 33, 61

Incised 'Linda GR' with year

Haile, Thomas Samuel 'Sam' b. 1909, London; d. 1948.
Training: Clapham School of Art, evening classes, *c*.1930
Royal College of Art, painting, then ceramics under W.S. Murray 1931–4

Slipware and stoneware with painted decoration often related to contemporary painting, 1930s; slipware after 1945; some tin-glaze, 1947–8. Also Surrealist paintings and drawings. Married Marianne de Trey, 1938.

Teaching: Leicester College of Art, 1935
New York State College of Ceramics, Alfred University, 1941
College of Architecture, University of Michigan, 1942–3
Studio: Raynes Park, London, with Margaret Rey, 1936–9
USA, 1940–3.
Bulmer Brickyard, Sudbury, Suffolk, shared with de Trey, 1945–7
Shinner's Bridge, Dartington, Devon, shared with de Trey, 1947–8
Collections: 8, 9, 16, 17, 24, 25, 27, 29, 32, 43, 48, 49, 54, 55, 62

Impressed or incised mark

Hamada, Shoji b. 1894, Tokyo, Japan; d. 1978
Training: Tokyo Technical College, 1913–16

Thrown or moulded stoneware with ash-glazes and often painted or trailed decoration; some slipware, raku, and porcelain.

Studio: Abiko, Japan, with Bernard Leach, 1919
Leach Pottery, St Ives, 1920–3 and 1929–30
Okinawa, Japan, *c.*1924
Mashiko, Japan, 1925–78
Collections: 11, 16, 17, 18, 25, 26, 27, 29, 31, 33, 35, 36, 38, 44, 48, 49, 53, 55, 56, 58, 60, 61, 62, 64, 65

Did not mark work except 1920–3 impressed mark (with Leach pottery mark)

Hamlyn, Jane b. 1940, London
Training: Harrow School of Art, ceramics, 1972–4

Functional and decorative salt-glazed stoneware and porcelain with coloured slips, roulette decoration and modelled handles.

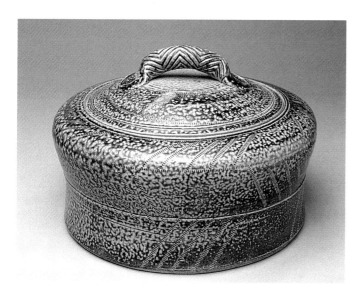

Plate 227: Jane Hamlyn, stoneware, salt-glaze, c.1990, dia: 24cm.

Studio: Millfield Pottery, Eveston, Doncaster, Yorks, 1975–
Collections: 7, 15, 18, 24, 27, 28, 29, 33, 37, 41, 49, 56, 57, 64, 66

Impressed mark

Hammond, Henry b. 1914, Croydon, Surrey; d. 1989.
Training: Croydon School of Art, 1929–34
Royal College of Art, painting, design and ceramics under W.S. Murray, 1934–8

Thrown individual stoneware pots usually with ash-glazes and brush decoration; slipware only, 1946–51; some porcelain from 1970s on. MBE, 1980.

Teaching: West Surrey College of Art and Design, Farnham, Head of Ceramics Dept, 1946–80
Studio: Runnick House, Hants, 1946–8
Bentley, Hants, shared with Paul Barron, 1948–89
Collections: 1, 2, 11, 15, 17, 18, 25, 28, 29, 32, 33, 41, 43, 49, 56, 58, 60, 62, 65

Incised mark

Impressed mark

Hanssen, Gwyn (later Hanssen Pigott) b. 1935, Ballarat, Victoria, Australia
Came to England, 1958
Training: Melbourne University, fine arts

Thrown stoneware and some porcelain, primarily wood-fired; tableware and individual pots in stoneware, 1960–; 'still lifes' groups of pots, 1980–.

Studio: Mittagong, New South Wales, apprentice to Ivan McMeekin, 1954–8
England, worked with Ray Finch, Bernard Leach and Michael Cardew, 1958–9
Portobello Road, London, shared with husband Louis, 1960–3
La Borne, France, 1963–4
Wenford Bridge Pottery, Cornwall, as Manager, 1964–5
Achères, France, 1967–73
Tasmania, 1974–80
Queensland, 1980–
Collections: 15, 17, 28, 29, 31, 32, 42, 56, 58, 62

Impressed marks

Hanssen, Louis b. 1934, Canada; d. 1968
Came to England, 1950s
Training: Ceramics learnt from his wife, Gwyn, *c.*1958

Handbuilt asymmetrical stoneware vessel forms; some work in the style of his wife, 1960–3.

Studio: Portobello Road, London, 1960–3
Hampstead, London, 1963–8
Collections: 1, 14, 22, 29, 56, 65

Impressed mark

Hasagawa, Keiko b. 1941, Yamagata, Japan
Came to England, 1977
Training: Women's Art University, Tokyo, design, 1959–63

Raku in heavy clay often with metallic glazes; bone china, 1986–91; stoneware and porcelain tableware, 1991–6.

Studio: Mashiko, Japan, 1972
Yelland Pottery, Devon, with Michael Leach, 1977–8
Norway, 1978–9
Crediton, Devon, 1980–
Collections: 29

Impressed marks: raku

 stoneware

Hayes, Peter b. 1946
Training: Moseley School of Art and Craft, *c.*1960–4
Birmingham College of Art, *c.*1964–7

Sculptural handbuilt vessel forms especially in raku-fired earthenware.

Studio: Bath, 1982–
Collections: 1, 2, 10, 42, 60

Impressed mark with year incised

Henderson, Ewen b. 1934, Cheddleton, Staffs; d. 2000
Training: Goldsmith's College, London, 1964–5
Camberwell School of Art and Crafts, ceramics, 1965–8

Handbuilt asymmetrical individual vessel forms with rough, dry surfaces made from a mixture of clays and coloured with oxides and stains, sometimes glazed; some thrown stoneware, early 1970s.

Studio: Camberwell, London, 1968–73
Camden Town, London, 1973–2000
Collections: 2, 6, 7, 16, 25, 27, 28, 29, 32, 33, 36, 40, 41, 42, 43, 49, 56, 57, 60, 61, 62, 64

Did not mark work

Hepburn, Anthony b. 1942, Stockport
Training: Camberwell School of Art, London, 1959–63
University of London, teacher training, 1963–5

Cast sculptural representational forms, 1960s; abstract sculptural forms from *c.*1970.

Teaching: Alfred University, New York, Professor of Ceramic Art, 1976–
Studio: London, 1965–*c.*1966
Hertfordshire, *c.*1966–7

Leamington Spa, 1968
USA, 1969–
Collections: 22, 28, 29

Hine, Margaret b. 1927; d. 1986
Married William Newland, 1950
Training: Derby College of Art, late 1940s
Central School of Art, London, ceramics with Dora Billington, *c.*1949
London University Institute of Education, ceramics with Newland, *c.*1949

Painted tin-glaze animals, dishes and murals.

Studio: Bayswater, London, shared with Newland and Nicholas Vergette, 1948–54
Prestwood, Bucks, shared with Newland, 1955–86
Collections: 14, 25, 29, 37, 62, 65

Painted signature, 'MARGARET HINE' or 'Margi Hine'

Homoky, Nicholas b. 1950, Hungary
Came to England, 1956
Training: Bristol Polytechnic, 1970–3
Royal College of Art, 1973–6

Thrown porcelain vessel forms with designs inlaid with black lines; thrown or slabbed vessel forms in red clay with inlaid white lines; burnished and raw-fired.

Studio: Cardiff, 1976–9
Bristol, 1979–
Towson State University, USA, 1988–9
Collections: 2, 6, 11, 25, 28, 29, 33, 35, 43, 57, 60, 62, 65, 66

Impressed mark

Hopkins, Alfred G. dates not known
Plates and vases with underglaze decoration *c.*1910–20; some modelled animals and figures. Salt-glazed stoneware and some porcelain, 1920s and 1930s.

Teaching: Camberwell School of Art, pre-1915–1940
Studio: Lambeth, London, *c.*1916–*c.*1932
Collections: 19, 29, 34, 38, 64

Incised mark 'A. G. Hopkins' often with 'Lambeth' and year.

Hoy, Anita (Agnete) b. 1914, Southall, of Danish parents; d. 2000
Training: Copenhagen College of Art and Crafts, art and design, 1933–6

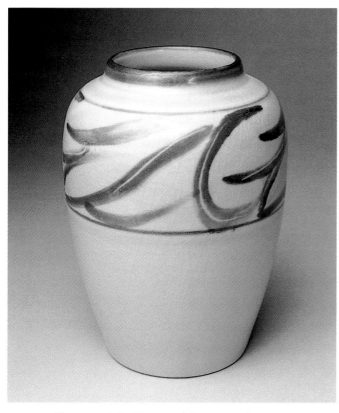

Plate 228: Anita Hoy, porcelain, c.1945, ht: 18cm.

Designed and decorated porcelain with incised or painted decoration for Bullers and salt-glazed stoneware for Doulton's; some individual pots in stoneware, raku and porcelain from 1952.

Teaching: West Surrey College of Art and Design, Farnham, 1952–c.1995
Studio: Denmark, at Holbaek with Gerhard Neilson, 1937–8
Denmark, at Saxbo with Nathalie Krebs, 1938–9
Stoke-on-Trent, at Bullers Ltd, as Head of Studio Department, 1940–52
Lambeth, London, at Royal Doulton, as Head of Studio Department, 1952–6
Acton, London, 1952–2000
Collections: 18, 25, 29, 33, 41, 49, 55, 56

Impressed or incised mark
with 'Made in England by Bullers'
Similar mark incised at Doulton's

Incised, impressed or painted mark at Acton

Hughes, Edward b. 1953, Wallasey
Training: Bath Academy of Art, 1973–6
Kyoto City Art University, Japan, 1977–9

Thrown reduction-fired stoneware and porcelain in the Oriental tradition.

Studio: Shiga, Japan, 1979–84
Renwick, Cumbria, 1985–9
Isel, Cumbria, 1989–
Collections: 11, 27, 29, 49, 56

Impressed mark

Ichino, Shigeyoshi b. 1942, Tamba, Japan
14th generation of family of traditional Japanese potters
Training: Kansai University, Japan

Stoneware and porcelain in the Leach tradition, 1970–3.

Studio: Tamba, Japan, 1964–9, 1973–
Leach Pottery, St Ives, 1969–73
Collections: 56, 59

Impressed marks

Jones, Christine b. 1955, South Wales
Training: West Surrey College of Art and Design, Farnham, 1980–3

Coiled vessels – often deep bowls – in coloured earthenware clays.

Studio: Swansea, 1985–
Collections: 11, 36, 55, 65

Incised signature with year

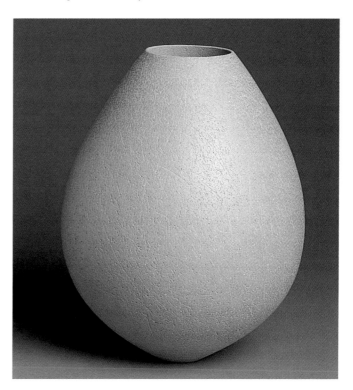

Plate 229: Christine Jones, coiled earthenware, c.1999, ht: 28cm.

Jones, David Lloyd b. 1928, Wimbledon; d. 1994
Training: Guildford School of Art, 1951–2
Ceramics largely self-taught

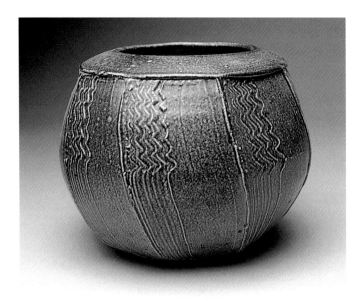

Plate 230: David Lloyd Jones, stoneware, salt-glaze, c.1990, ht: 18cm.

Thrown reduction-fired stoneware and porcelain individual pieces with a wide range of decoration; some domestic ware; salt-glaze from 1986.

Studio: Fulford, York, 1962–94
Collections: 7, 10, 11, 15, 18, 27, 28, 29, 33, 49, 54, 55, 56, 57, 60, 62, 64

Impressed mark on early work

on later work

Jupp, Mo b. 1938, Clapham, London
Training: Camberwell School of Art, ceramics, 1960–4
Royal College of Art, ceramics, 1964–7

Individual pieces in reduced stoneware, porcelain, terracotta and other media. Helmet forms, *c.*1972; miniature temples in porcelain, *c.*1973; erotic female torsos with bag or bird heads, *c.*1984; thin, spindle figures from *c.*1988; porcelain cylinders, late 1990s. Most work since 1978 based on female form. Little work made 1973–8.

Studio: Brands Hatch, Kent, 1967–72
Soilwell Manor, Lydney, Glos, 1977–82
Symonds Yat, Herefordshire, 1982–7
Bermondsey, London, 1987–94
Archway Ceramics, Mile End, London, 1995–
Collections: 6, 28, 29, 43, 56

Impressed mark, 1967–72

Painted in slip, gold lustre or sgraffito, 1978–.
Bottom right initial changes with studio

Keeler, Walter b. 1942, Edgware, Middx
Training: Harrow School of Art, pottery and lithography, 1958–63
Hornsey School of Art, teacher training, 1963–4

Vessels in salt-glazed stoneware, mostly thrown but some press-moulded, altered and reassembled, 1969–; decorated creamware vessels, 1996–; raku, *c.*1965–71; oxidized stoneware, 1965–70.

Studio: High Wycombe, Bucks, 1965–76
Penalt, Monmouth, Gwent, 1976–
Collections: 6, 7, 9, 11, 13, 15, 18, 24, 25, 27, 28, 29, 32, 33, 35, 37, 39, 41, 43, 49, 50, 51, 56, 57, 58, 61, 62, 64, 65, 66

Impressed mark (many sprigged after1995)

Kelly, Dan b. 1953, London
Training: Camberwell School of Art and Crafts, ceramics, 1973–7
Royal College of Art, ceramics, 1977–9

Thrown stoneware individual vessel forms, usually matt black sometimes with white slip added.

Studio: 401½ Workshops, Lambeth, 1980–1
Rotherhithe, London, 1981–5
Arlingford Studios, Brixton, London, 1985–7
Clockwork Studios, Camberwell, 1987–
Collections: 33, 56, 57

Does not mark work

Kemp, Dorothy b. 1905, Heaton Moor, Cheshire
Training: Manchester University, history

Thrown domestic stoneware (Leach Pottery and Felixstowe) and slipware (Barnhouse Pottery and Felixstowe); ceased potting 1960s.

Publication: English Slipware and How To Make It, 1954
Studio: Leach Pottery, St Ives, Cornwall, 1939–45
Barnhouse Pottery, Brockweir, Monmouth, 1946–51, with Margaret Leach
Felixstowe, Suffolk, 1952–
Collections: 29

Incised or impressed marks

King, Ruth b. 1955, Enfield, Middx
Training: Camberwell School of Art, London, 1974–7

Pinched and coiled pots in oxidized stoneware, 1978–86;
slab-built from 1982; salt-glazed with applied coils, sprigs,
incised lines, and coloured slips, 1986–.

Studio: Brixton, London, 1978–9
Charlton, London, 1979–81
Fulford, York, 1981–7
Shipton-by-Beningbrough, York, 1987–
Collections: 29, 37, 49, 55, 56, 57, 60

Applied 'R K'

Koch, Gabrielle b. 1948, Lorrach, Germany
Came to England in 1973
Training: University of Heidelberg, Germany, English,
history, political science, 1967–73
King's College, University of London, 1977–8
Goldsmith's College, University of London, ceramics,
1979–81

Individual coiled earthenware vessels, often large,
decorated with coloured slips, burnishing, smoke-firing
in sawdust.

Studio: Highgate, London, shared, 1978–81; own studio,
1981–
Collections: 2, 6, 10, 11, 18, 24, 27, 33, 36, 45, 49, 54, 56,
58, 64

Incised signature

Leach, Bernard Howell b. 1887, Hong Kong; d. 1979
Came to England in 1897. CBE, 1962; CH, 1973
Training: Slade School of Fine Art, London, drawing, 1903–4
London School of Art, etching, 1908–9

Slipware until 1937, raku until *c.*1930, porcelain and
stoneware; most work thrown with painted, incised, cut or
wax-resist decoration. Promoted Anglo-Oriental style.
Designed domestic stoneware for production at St Ives.

Publications: A Potter's Outlook, 1928; *A Potter's Book,* 1940;
A Potter's Portfolio, 1951; *A Potter in Japan,* 1960; *Kenzan and
his Tradition,* 1966; *A Potter's Work,* 1967; *Drawing, Verse and
Belief,* 1973; *Hamada: Potter,* 1975; *A Potter's Challenge,*
1976; *Beyond East and West,* 1978.
Studio: Apprentice to Ogata Kenzan, Japan, 1911–13
Japan, 1913–20
Leach Pottery, St Ives, Cornwall, 1920–72, ceased potting
in 1972
Collections: 1, 2, 4, 6, 7, 9, 11, 12, 13, 14, 15, 16, 17, 18,
21 22, 23, 24, 25, 26, 27, 28, 29, 31, 32, 33, 35, 36, 37,
38, 40, 41, 42, 43, 44, 45, 48, 49, 53, 54, 55, 56, 57, 58,
60, 61, 62, 64, 65

Personal painted mark, 1920–40

Personal impressed mark, 1920–40

Personal painted mark, 1940–72

Personal impressed mark, 1940–72

Leach Pottery impressed marks

Leach, David Andrew b. 1911, Tokyo, Japan
Eldest son of Bernard Leach; came to England, 1920
Training: Leach Pottery, St Ives, 1930–4
North Staffordshire Technical College, Stoke-on-Trent,
1934–7

Slipware until 1937 and 1956–61; thrown domestic and
individual stoneware and porcelain vessels, 1937–56 and
1961–.

Studio: Leach Pottery, St Ives, Cornwall, 1937–56
Loughborough College of Art, 1953
Aylesford, Kent, starts pottery for Carmelite Friars, 1954
Lowerdown Pottery, Bovey Tracey, Devon, 1956–
Collections: 1, 2, 11, 13, 14, 15, 16, 17, 21, 22, 24, 25, 27,
28, 29, 32, 33, 35, 37, 38, 40, 41, 44, 49, 50, 53, 55, 56,
57, 58, 60, 61, 62, 64, 66

At Leach Pottery, few individual pieces
incised 'D' or 'DAL' with impressed

At Lowerdown Pottery,
impressed personal mark

Lowerdown Pottery impressed mark

Leach, Janet (née Darnell) b. 1918, Texas, USA; d. 1997
Came to England and married Bernard Leach, 1956
Training: Art school in Dallas, painting, *c.*1937
Art school in New York, sculpture, 1938
Inwood Pottery and Alfred University, ceramics,
1947–8

Thrown, individual, reduction-fired stoneware, often with
ash-glazes; some salt-glaze; moulded or slabbed porcelain
pots with celadon-glaze and trailed decoration.

Studio: Spring Valley, New York, 1949–54
Mashiko, Japan, with Shoji Hamada and Tamba, Japan, with Ichino family, 1954–6
Leach Pottery, St Ives, Cornwall, 1956–97
Collections: 1, 2, 6, 8, 9, 11, 15, 17, 18, 22, 24, 25, 27, 28, 29, 32, 33, 36, 38, 40, 41, 43, 44, 49, 56, 60, 61, 62, 64, 65

Impressed personal and pottery marks

Leach, John Henry b. 1939, St Ives, Cornwall
Son of David Leach
Training: Leach Pottery, St Ives, apprentice, 1957–63

Thrown domestic stoneware in the Leach tradition; smoke-fired individual pots, 1983–.

Studio: California, USA, established pottery with Harold Guilland, 1963–4
Muchelney Pottery, Langport, Somerset, 1964–
Collections: 9, 11, 15, 16, 18, 27, 28, 29, 33, 35, 47, 49, 51, 53, 56, 57, 60, 61, 62, 64, 66

Impressed mark

Leach, Margaret b. 1918, Cheshire
Training: Liverpool School of Art, 1936–*c*.1940

Domestic slipware; ceased potting in 1956.

Studio: Leach Pottery, St Ives, Cornwall, *c*.1942–5
Barnhouse Pottery, Brockweir, Monmouth, 1946–51
Taena Community, Aylburton, Glos, with partner Lewis Groves, 1951–6
Collections: 13, 29

Impressed or incised mark (Wye Valley) 1946–51

Impressed mark (Taena) 1951–56

Leach, Michael b. 1913, St Ives, Cornwall; d. 1985
Son of Bernard Leach
Training: Downing College, Cambridge, biology, 1930–3

Thrown slipware and stoneware in the Leach tradition.

Studio: Leach Pottery, Cornwall, 1939 and 1948–55
Africa, set up two potteries making tableware for the army, 1940–6
Wrecclesham Pottery, Farnham and Bullers with Anita Hoy, 1946–8
Yellend Pottery, Fremington, North Devon, 1955–84
Collections: 16, 29, 56

Impressed marks 1955–84

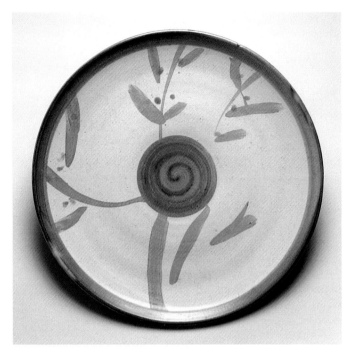

Plate 231: Michael Leach, stoneware, c.1970, dia: 27cm.

Lee, Jennifer b. 1956, Haddo, Scotland
Training: Edinburgh College of Art, ceramics and tapestry, 1975–9
Royal College of Art, ceramics, 1980–3

Handbuilt stoneware pots – usually deep bowls; bases pinched then coiled, clays coloured by oxides added to the body before building.

Studio: Robin Welch Pottery, Suffolk, assistant, 1975 and 1979
401½ Workshops, Lambeth, London, 1983–7
Peckham, London, 1987–
Collections: 2, 11, 21, 24, 28, 29, 33, 35, 36, 50, 58, 60, 61, 62

Did not mark work before 1988; different mark every year since 1988 – usually an abstracted 'jl'.

Lewenstein, Eileen b. 1925, London
Training: West of England College of Art, Bristol, drawing and painting, 1941–3
Beckenham School of Art, Kent, painting, 1943–4
University of London Institute of Education, pottery, 1944–5
Derby School of Art, pottery evening classes under R.J. Washington, 1945–6

Individual wide-ranging pieces including thrown porcelain, press-moulded dishes and modular sculptures in stoneware, 1959–; thrown domestic pots, primarily in red earthenware, 1946–58. Prolific writer and co-editor of *Ceramic Review.*

Studio: Donald Mills Pottery, Southwark, London, working partner, 1946–8
Briglin Pottery, London, co-founder, 1948–58
Park Village West, London, 1959–63
Hampstead, London, 1963–75
Hove, Sussex, 1976–97
Collections: 1, 15, 21, 29, 35, 37, 49, 56, 60, 61, 62, 64

Impressed or painted mark

Locke, Donald b. 1930, Stewartville, Guyana
Training: Bath Acadamy of Art, Corsham, painting, sculpture and ceramics under James Tower, 1954–7
University of Edinburgh and Edinburgh College of Art, 1959–64

Sculptural vessels often in reduced stoneware and sometimes resembling leather flasks, 1969–80; continues to work in painting and sculpture.

Studio: Guyana, 1964–9 and 1980–90
Edinburgh, 1969–70
London, 1970–9
Arizona State University, Guggenheim Fellowship, 1979–80
Atlanta, Georgia, USA, 1990–
Collections: 29

Painted 'ITE' or sometimes 'II', with year, 1969–79
Signed 'LOCKE' or 'DONALD LOCKE', with year, 1979–80

Lord, Andrew b. 1950, Rochdale, Lancs
Training: Rochdale School of Art, 1967
Central School of Art, 1968–71

Slab-built vegetable forms or tin-glazed earthenware vessels until 1975; then flat pieces with incised and coloured or sprigged decoration.

Studio: London, 1970–3
Holland, 1975–80
New York, USA, 1980–
Collections: 24, 29, 33, 41

Signed 'Andrew Lord' with year

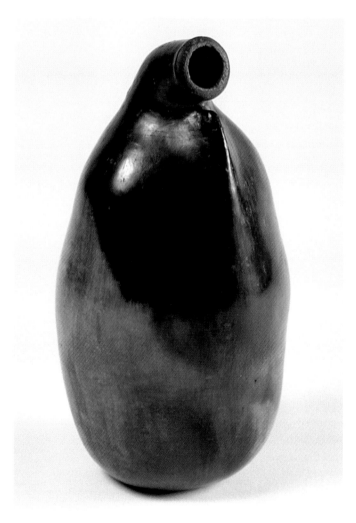

Plate 232: Donald Locke, 'Magic Bottle', earthenware, c.1978, ht: 24cm.

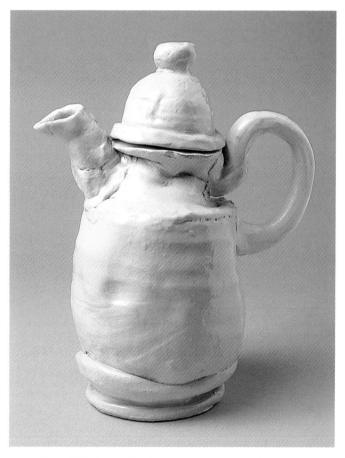

Plate 233: Andrew Lord, earthenware, c.1972, ht: 20cm.

Lowe, Jean b. 1926, Hatton, Ceylon
Training: Goldsmiths' College, London University, 1990–1

Large, coiled sculptural 'rock' forms in stoneware with oxides brushed and sponged under a lithium glaze.

Studio: Lower Halstow, Sittingbourne, Kent, 1991–
Balls Pond Studios, N. London, 1991–*c*.1999

Mark, incised 1991–3, impressed 1993–

Lowndes, Gillian b. 1936, Cheshire
Training: Central School of Art and Design, sculpture then ceramics, 1955–8

Coiled, slab-built or thrown vessels and sculptural pots in oxidized stoneware, 1960s; slabbed, press-moulded or slip-cast forms, 1970s; increasingly sculptural work incorporating non-clay materials starting in late 1970s.

Studio: Paris, 1959–60
Bloomsbury, London, shared with Robin Welch and Kate Watts, 1960–6
Chippenham, Wilts, shared with Ian Auld, 1966–87
Nigeria, 1970–2
Halstead, Essex, shared with Ian Auld, 1988–
Collections: 2, 11, 28, 29, 33, 56, 57, 62

Does not mark work

Lunn, Dora b. 1881, Sheffield; d. 1955
Training: Royal College of Art, London, *c*.1908

Domestic and individual thrown stoneware and earthenware.

Publication: Pottery in the Making, 1931
Studio: Ravenscourt Pottery, London, 1916–28
Dora Lunn Pottery, Chiswick, London, 1933–*c*.1943
Goldhawk Road, Shepherds Bush, London, *c*.1943–55
Collections: 29

Incised or impressed, 'RAVENSCOURT', 1916–28

Incised or impressed marks

Malone, Jim b. 1946, Sheffield
Training: Teacher Training College, Bangor, Wales, 1966–9
Camberwell School of Art and Crafts, ceramics, 1972–6

Domestic and individual stoneware and porcelain vessels, 1976–82; mostly individual stoneware pots in the Leach tradition since 1984; work is thrown, with brushed or incised decoration, ash-glazes and sometimes hakeme.

Studio: Llandegla, Wrexham, Clwyd, 1976–82
Carlisle, using facilities when teaching, 1982–4
Ainstable, Cumbria, 1984–
Collections: 6, 7, 27, 28, 29, 32, 33, 49, 55, 56, 57, 62

Impressed mark

With impressed mark, 1984–

Malone, Kate b. 1959, London
Training: Bristol Polytechnic, ceramics, 1979–82
Royal College of Art, ceramics, 1983–6

Handbuilt and moulded earthenware and stoneware vessels with coloured or crystalline glazes; sprigged, sponged and painted decoration. Large public commissions.

Studio: South Bank Crafts Centre, London, 1986–8
Balls Pond Studios, N. London, 1989–
Collections: 9, 11, 18, 21, 24, 28, 29, 32, 33, 49, 50, 57, 62, 64

Incised signature; sometimes small pieces with incised, painted or impressed initials.

Small moulded production pieces usually unsigned

Maltby, John b. 1936, Cleethorpes, Lincs
Training: Leicester College of Art, sculpture, 1956–9

Domestic and some individual pieces in oxidized stoneware, 1965–76; individual stoneware pots, usually oxidized with painted decoration, 1976–96; ceramic sculptural pieces, 1996–.

Studio: Lowerdown Pottery, Devon, with David Leach, 1962–3
Stoneshill Pottery, Crediton, Devon, 1965–
Collections: 1, 2, 10, 14, 15, 16, 17, 25, 27, 28, 29, 31, 32, 33, 37, 40, 42, 49, 50, 56, 57, 61, 62, 64, 66

Impressed personal and
Stoneshill Pottery marks

Incised or painted marks

Marlow, Reginald dates not known
Training: Lowestoft and Norwich Schools of Art, 1920s
Royal College of Art, ceramics under W.S. Murray, 1927–30

Thrown stoneware pots usually with brush decoration.

Teaching: Croydon School of Art, 1935–50
Stoke-on-Trent College of Art, Principal, 1950s

Collections: 17, 25, 29, 32

Incised or painted initials 'MR'
Impressed mark

Marshall, Ray b. 1913, Alberta, Canada; d. 1986
Came to England, 1940
Training: Royal College of Art, ceramics under Helen
Pincombe, 1946

Mainly thrown oxidized stoneware vessels often with
incised decoration.

Studio: Winchcombe Pottery, Glos, with Ray Finch, *c.*1946
Milland Pottery, Hants, 1948–57
Stedham, Sussex, 1952–86
Collections: 21, 29, 41, 56, 62

Incised signature sometimes with year

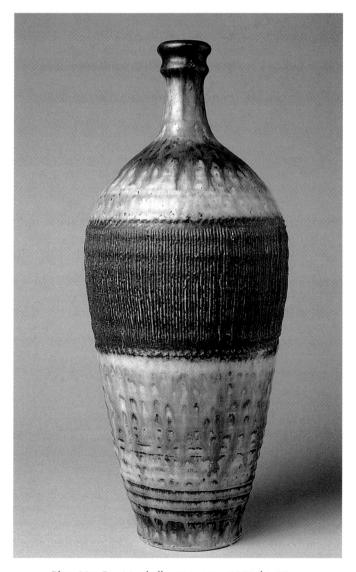

Plate 234: Ray Marshall, stoneware, c.1970, ht: 35cm.

Marshall, William b. 1923, St Ives, Cornwall
Individual and domestic pots in stoneware and porcelain
in the Leach tradition.

Studio: Leach Pottery, St Ives, apprentice and later foreman,
1938–77
Lelant, St Ives, 1977–
Collections: 2, 9, 14, 15, 25, 29, 33, 44, 49, 56, 62

Incised mark, 1954–6

Impressed marks 1956–

Impressed Leach Pottery mark

Martin Brothers Robert Wallace (1843–1924), Charles
Douglas (1846–1910), Walter Fraser (1857–1912), Edwin
Bruce (1860–1915)
Training: Wallace and Walter, evening classes, Lambeth
School of Art, *c.*1860

Salt-glazed stoneware; Walter threw and Wallace designed
1873–77. Wallace created grotesques and bird jars,
*c.*1885–1900; Edwin produced 'gourds', *c.*1897–1912.

Studio: Pomona House, Fulham, London with pottery fired
at Baileys, 1873–7.
Southall, London, 1877–*c.*1914.
Collections: 1, 3, 4, 5, 6, 9, 11, 13, 16, 17, 21, 23, 25, 26, 27,
29, 30, 31, 32, 33, 34, 35, 37, 38, 40, 41, 42, 43, 45, 46, 47,
49, 51, 53, 55, 60, 61, 62, 63, 64, 65

Work after 1882 incised mark with
variations

Mathews, Heber b. 1907, Cambridge; d. 1959
Training: Royal College of Art, painting and ceramics under
W.S. Murray, 1927–31

Thrown stoneware and some porcelain pots; early work
influenced by Murray; later domestic ware with painted
decoration and large bowls with oatmeal or yellow glazes.

Teaching: Woolwich Polytechnic, Head of Art School,
1932–59
Studio: Lee, Kent, 1932–59
Collections: 2, 11, 17, 25, 29, 32, 33, 56, 62

Incised or occasionally painted initials 'HM'

McNicoll, Carol b. 1943, Birmingham
Training: Solihull College of Technology, 1966–7
Leeds Polytechnic, fine art, 1967–70
Royal College of Art, ceramics, 1970–3

Slip-cast and assembled vessels with often colourful painted decoration; early work took its form from other materials; eccentric domestic ware, individual pieces and some more sculptural work; designs for factory production.

Studio: 401½ Workshops, Lambeth, London, shared with Alison Britton, 1973–7
Kensington, London, 1976–83
Kentish Town, London, 1983–
Collections: 2, 6, 7, 8, 11, 18, 21, 28, 29, 33, 35, 38, 43, 49, 50, 57, 61, 62

Painted signature

Mehornay, William b. 1945, Kansas City, USA
Training: Hammersmith College, London, 1971
Primarily self-taught ceramics

Thrown 'oriental' pots, mostly porcelain with bright glazes, 1974–81; decorative work for designers.

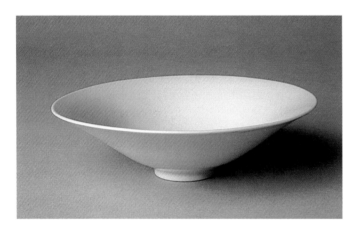

Plate 235: William Mehornay, porcelain, c.1979, dia: 15cm.

Studio: Aldermaston Pottery, Berks, with Caiger-Smith, 1972–3
Fen Ditton, Cambridge, 1974
Richmond, Surrey, 1975–
Collections: 29, 35

Impressed initials 'WNM' in oval, later incised signature

Mellon, Eric James b. 1925, Watford, Herts
Training: Watford School of Art, painting and drawing, 1939–43
Harrow School of Art, part-time pottery, 1941–3
Central School of Art and Design, drawing, painting and etching, 1944–50

Thrown stoneware vessels with ash-glazes and figurative painted decoration often based on classical myths,

c.1958–; similar porcelain, 1980s and 1990s; some raku from 1983; slip-painted earthenware, 1951–7; coiled stoneware figures, 1958–c.1960.

Studio: Hillesden, Bucks, established artistic community, 1951–7
Bognor Regis, Sussex, 1958–
Collections: 2, 15, 22, 29, 33, 37, 41, 43, 56, 57

Painted or sometimes incised marks.
Adds year, title, glaze, and work number to foot rim

Mills, Donald b. 1922
Training: Croydon School of Art, c.1938

Production wares and individual pots in stoneware and earthenware, 1946–55; individual pieces in stoneware and porcelain with painted decoration, 1974–. Did not pot 1955–74.

Studio: Fulham Pottery, London, as thrower, 1945
Donald Mills Pottery, London, with Eileen Lewenstein, 1946–8
Briglin Pottery, London, with Lewenstein and Brigitta Appleby, 1948–52
Itchenor, W. Sussex, 1974–
Collections: 29

Painted initials or signature, often with year

Mommens, Ursula (née Darwin) b. 1908, Cambridge
Training: Central School of Art and Crafts, London, 1926–9
Royal College of Art, ceramics under W.S. Murray, 1930–2

Thrown stoneware often with tenmoku or ash-glazes. Married Julian Trevelyan, 1935; married Norman Mommens, 1955.

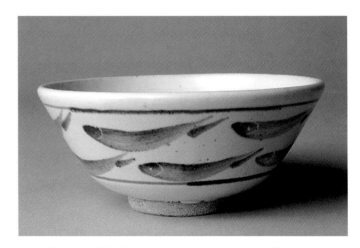

Plate 236: Ursula Mommens, stoneware, 1994, dia: 14cm.

Studio: Gorringes Down, Kent, 1932–4
Hammersmith Terrace, London, 1935–50
Wenford Bridge Pottery, Cornwall, several brief periods
with Cardew, *c.*1939 and *c.*1942.
South Heighton Pottery, Newhaven, Sussex, 1955–
Collections: 16, 21, 33, 49

Impressed, incised or painted mark

Moore, Bernard b. 1850, Stone, Staffs; d. 1935
A ceramic chemist. Developed flambé and lustre glazes by
1902 and, later, crystalline glazes. Consultant to various
firms, starting with Doulton's in 1904. Pots after 1905 are
decorated but not made by Moore.

Studio: Inherited St Mary's Works, Stoke-on-Trent, 1867.
Sold in 1905.
Wolfe Street, Stoke-on-Trent, 1905–*c.*1915.
Collections: 3, 4, 5, 6, 11, 13, 25, 27, 29, 31, 32, 40, 41, 45,
47, 49, 60, 61, 62

Painted initials in several forms

Painted or printed mark, sometimes with year

Moriuchi, Aki b. 1947, Tokyo, Japan
Training: Harrow College, ceramics, 1988–90
Middlesex University, 3-D ceramics, 1990–2

Stoneware vessels with textured surfaces from layers of
slips and glazes, often volcanic or sandblasted; tableware
in stoneware and porcelain in the Japanese tradition.

Studio: Barnet, Herts, 1991–4
Edgware, Middlesex, 1994–
Collections: 49

Impressed mark

Incised mark

Morley-Price, Ursula b. 1936, Islington, London
Training: Camberwell School of Art and Crafts, painting,
1951–7
Slade School of Fine Art, painting, 1957–9

Handbuilt stoneware and porcelain forms often with
elaborate ruffles and flanges.

Studio: Letchmore Heath, Herts, 1966–73
Vaux, France, 1973–80, 1982–6 and 1992–3
Great Oakley, Essex, 1980–1
Auckland, New Zealand, 1986–8

Brighton, Sussex, 1988–92
Lewes, Sussex, 1992–
Collections: 11, 25

Impressed mark

Incised mark

Mosley, Ivo b. 1951, London
Training: ceramics self-taught

Individual stoneware vessels with bright-coloured glazes.

Studio: London, 1972–82
Crediton, Devon, 1986–

Signature 'Ivo Mosley', with year and letter to give making
sequence

Murray, William Staite b. 1881, Deptford, London;
d. 1962
Training: Studied painting and drawing with his cousins,
William Fisher and Hettie Staite, 1893–5
Camberwell School of Art and Crafts, *c.*1909–12

Stoneware pots initially in the Chinese tradition; later
work heavily potted with pronounced feet and potting
rings; tenmoku, chun and ash-glazes often with painted
and incised decoration; some porcelain, late 1920s. Went
to Rhodesia in 1939 and ceased potting.

Teaching: Royal College of Art, Head of Pottery Dept,
1926–39
Studio: Yeoman Pottery, Kensington, London, with
Cuthbert Hamilton, *c.*1915–19
Rotherhithe, London, 1919–24
Brockley, Kent, 1924–9
Bray, Berks, 1929–39
Collections: 2, 4, 6, 11, 12, 13, 16, 17, 19, 23, 25, 27, 29, 32,
33, 38, 41, 43, 48, 49, 53, 55, 56, 58, 60, 61, 62, 64

Incised signature 'WS Murray' with year and sometimes
'London', 1919–24

Impressed mark, 1924–39

Newland, William b. 1919, Masterton, New Zealand;
d. 1998
Came to England, 1945. Married Margaret Hine, 1950
Training: Chelsea School of Art, painting, 1945–7
London University Institute of Education and Central
School of Art (evenings), ceramics with Dora Billington,
1947–8

Thrown slipware dishes; thrown and moulded tin-glaze pots, murals, animals and figures. Very little work produced between early 1960s and 1982.

Teaching: Central School of Art, *c.*1965
London University Institute of Education, 1948–82

Studio: Bayswater, London, shared with Hine and Nicholas Vergette, 1948–54
Prestwood, Bucks, shared with Hine, 1955–98
Collections: 6, 15, 25, 29, 37, 56, 57, 62

Painted or incised, 'WN', 'W Newland' or 'Newland', usually with year

Painted or incised mark

Newman, Bryan b. 1935
Training: Camberwell School of Art and Crafts, London, 1950–6

Handbuilt sculptures, especially cityscapes and bridges, and thrown domestic pottery in reduced stoneware.

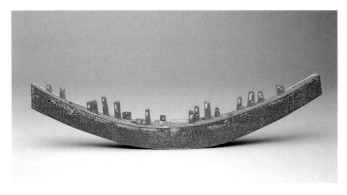

Plate 237: Bryan Newman, stoneware, c.1970, w: 40cm.

Studio: Eos Pottery, Dulwich, London, 1962–6
Aller Pottery, Langport, Somerset, 1966–
Collections: 11, 14, 28, 29, 32, 33, 41, 49, 50, 56, 60, 61, 66

Mark, 1962–6 'EOS'

Impressed marks, Aller Pottery

Nisbit, Eileen b. 1929, London; d. 1990
Training: Hornsey School of Art, 1950–3
Central School of Art and Design, ceramics, 1960–3

Handbuilt sculptural forms made from thin porcelain sheets with pierced, incised, inlayed and painted decoration; early work is press-moulded earthenware dishes with linear decoration and tiles and murals in stoneware and porcelain.

Studio: Holborn, London, 1963–90
Collections: 6, 18, 28, 29, 41, 56, 57, 60, 61, 62

Incised or painted mark

Did not mark porcelain

Odundo, Magdalene Anyango N. b. 1950, Nairobi, Kenya
Came to England, 1971
Training: Kenya, graphic art, 1969–71
Cambridge College of Art, graphics, 1971–3
West Surrey College of Art and Design, ceramics, 1973–6
Royal College of Art, ceramics, 1979–82

Coiled pots with clay slips, burnished and reduced.

Studio: Ripley, Surrey, 1982–5
Bentley, Hants, 1985–93
Farnham, Surrey, 1993–
Collections: 2, 6, 11, 28, 29, 32, 33, 37, 56, 65

Incised or written mark with year *Odundo*

Owen, Elspeth b. 1938, Stony Stratford, Bucks
Training: Oxford University, history, 1957–60
Pottery at evening classes but, primarily, self-taught, early 1970s

Small pinched stoneware, 1975–82; low-fired, burnished or smoked pots made from coloured bodies and slips, 1982–.

Studio: Grantchester, Cambridge, 1976–
Collections: 2, 7, 11, 19, 24, 25, 29, 33, 35, 49, 56, 58, 62, 64

Does not mark work

Oyekan, Lawson b. 1961, England
Brought up in Nigeria and returned to England, 1984
Training: Royal College of Art, London, 1988–90

Thrown, altered and handbuilt large forms in stoneware and porcelain.

Studio: West Norwood, 1990–3
Islington, London, 1993–
Collections: 18

Various incised signatures

Pearson, Colin b. 1923, Friern Barnet, Herts
Training: Goldsmith's College, painting, 1947–52

Thrown individual vessel forms in stoneware and porcelain, often with ragged rims and moulded 'wings' attached, *c*.1970–; domestic pottery in stoneware and some earthenware, 1955–*c*.1970.

Studio: Winchcombe Pottery, Glos, with Ray Finch, 1953–4
Royal Doulton Pottery, Lambeth, London, 1954–5
Aylesford Pottery, Kent, 1955–61
Quay Pottery, Aylesford, 1961–80
Islington, London, 1980
Collections: 1, 2, 5, 6, 7, 8, 9, 11, 14, 15, 19, 21, 25, 28, 29, 31, 32, 33, 35, 43, 55, 56, 57, 60, 61, 62, 64

Impressed marks, 1955–61

1962–

Pepper, Malcolm b. 1937; d. 1980
Training: Poole School of Art under Philip Wadsworth, early 1960s

Thrown stoneware and porcelain in the Chinese tradition often with brush decoration, hakeme or crackle glazes.

Studio: Brighton, 1970s
Collections: 25, 32, 33, 41, 48, 49, 56, 62

Impressed mark, late 1970s
(early work unsigned)

Perkins, Roger b. 1952, London
Training: Camberwell School of Art and Crafts, 1970–4

Raku bowls and dishes, 1976–*c*.1983; sawdust-fired figurative ceramic sculpture, *c*.1983–*c*.1987; ceased working in clay, *c*.1987.

Studio: Codicote, Herts, 1976–7
Little Kinghill, Bucks, 1977–80
Oxfordshire, 1980–
Collections: 15, 25, 57, 62

Did not mark work

Perry, Grayson b. 1960
Training: Portsmouth College of Art, painting and sculpture, –1982

Coiled earthenware pots with wide variety of decorative techniques; press-moulded dishes in 1980s.

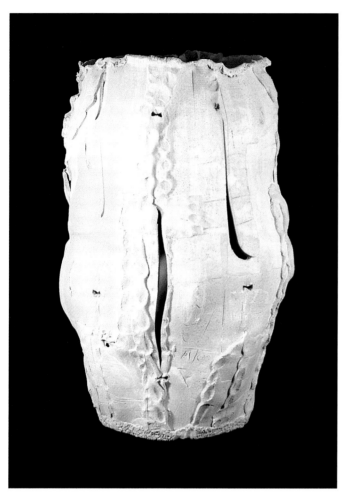
Plate 238: Lawson Oyekan, from 'Trial and Light Series', 1999, ht: 67cm.

Parkinson, Richard and Sue
Richard: b. 1927; d. 1985
Training: Guildford School of Art under Helen Pincombe, *c*.1949
Crowan Pottery, Cornwall, apprentice, 1950
Woolwich School of Art under Heber Mathews, *c*.1951
Sue: b. 1925
Training: Royal College of Art, sculpture under Frank Dobson, 1945–9

Vessels and figurines in slip-cast porcelain, 1951–63;
Richard: decorations on industrial whitewares, 1966–71; cast and decorated mugs and boxes, 1971–82.
Sue: portrait sculpture and design, 1966–.

Studio: Ashford, Kent, 1951–63
Richard: Cambridgeshire, 1966–8
London, 1968–71
Cardigan, Wales, 1971–82
Sue: Kent, 1965–
Collections: 29

Mark

Studio: Battersea Arts Centre, London, 1984–7
Leytonstone, London, 1987–94
Stratford, London, 1994–
Collections: 28

Numerous impressed marks, 1983–92

Impressed or inlaid mark, 1992–

Pim, Henry b. 1947, Heathfield, Sussex
Training: Brighton College of Education, 1965–9
Camberwell School of Art and Crafts, ceramics, 1975–9
Gerrit Rietveld Acadamie, Amsterdam, ceramics, 1988–90

Slab-built stoneware pots, often large, decorated with slips and glazes, brush-painted, trailed or poured, 1979–88; sculptures in clay, 1988–

Teaching: National College of Art and Design, Dublin, Head of Ceramics, 1990–
Studio: 401½ Workshops, Lambeth, London, 1979–81
Herne Hill, London, 1982–8
Dublin, 1990–
Collections: 6, 7, 8, 18, 28, 29, 33, 57, 62, 64

Painted signature with year, 1979–88

Impressed mark usually with year and place, 1988–

Pincombe, Helen Edith b. 1908, India
Educated in Australia; came to England in 1925
Training: Camberwell and Central Schools of Art, 1931–6
Royal College of Art, 1937–40

Thrown, coiled and slabbed stoneware, 1950s; thrown stoneware with brush or wax-resist decoration, c.1960–72.

Teaching: Royal College of Art, evacuated to Cumbria, c.1940–8
Studio: Oxshott, Surrey, 1949–72
Collections: 1, 2, 8, 15, 18, 25, 29, 31, 33, 41, 42, 49, 55, 56, 62, 64, 65

Impressed mark

Pleydell-Bouverie, Katharine b. 1895, Colehill, Berks; d. 1985.
Training: Central School of Arts and Crafts, under Dora Billington, 1921–3

Thrown stoneware pots in the Chinese tradition using wood ash-glazes; some unglazed and combed pots, c.1930s–1940s. Wood-fired at Coleshill; oil-fired, 1946–1960; electric kiln; 1960–85.

Studio: Leach Pottery, as apprentice, 1924–5
Cole Pottery, Coleshill, Berks, 1925–40; with Ada Mason, 1925–7; with Norah Braden, 1928–36
Collections: 1, 2, 4, 6, 9, 11, 12, 13, 15, 16, 17, 18, 19, 22, 27, 29, 31, 32, 33, 35, 38, 41, 43, 44, 45, 48, 49, 50, 53, 55, 56, 58, 60, 61, 62, 64, 65

Incised or impressed marks, 1925–8

Impressed marks, 1928–85

Pots often have incised numbers relating to clay bodies and painted roman numerals relating to glazes.

Poncelet, Jacqueline b. 1947, Liège, Belgium
Came to England, 1951
Training: Wolverhampton College of Art, ceramics, 1965–9
Royal College of Art, ceramics, 1969–72

Cast thin bone china, carved, pierced or stained, c.1972–6; slab-built forms with inlaid clay, painted slips or enamels, c.1977–85; sculpture, not in clay, 1986–

Studio: King's Cross, London, 1972–7
Brixton, London, 1977–82
USA, 1978–9
East Dulwich, London, 1982–
Bing and Grondahl, Copenhagen, 1985–6
Collections: 1, 2, 6, 7, 15, 21, 22, 25, 28, 29, 32, 33, 41, 48, 56, 57, 60, 61, 62, 64

Did not mark ceramics

Quick, Kenneth b. 1931, St Ives, Cornwall; d. 1963
Thrown stoneware in the Leach tradition; mostly standard-ware until 1960.

Studio: Leach Pottery, St Ives, Cornwall, 1945–55 and 1960–3
Tregenna Hill Pottery, Cornwall, 1955–60
Collections: 2, 9, 29, 33, 56

Impressed marks at Leach Pottery

Impressed mark at Tregenna Hill Pottery

Radstone, Sara b. 1955, London
Training: Herefordshire College of Art, 1975–6
Camberwell School of Art and Crafts, ceramics, 1976–9

Handbuilt individual stoneware pieces with rough, stony surfaces; vessel forms, 1980s; larger-scale, wall-hanging sculptural forms, 1990s.

Studio: 401½ Workshops, Lambeth, London, 1979–84
Arlingford Studios, Brixton, London, 1985–95
Blackheath, London, 1995–
Collections: 2, 6, 28, 29, 33, 36, 50, 57, 62

Did not mark before 1986, then incised 'SR' with year

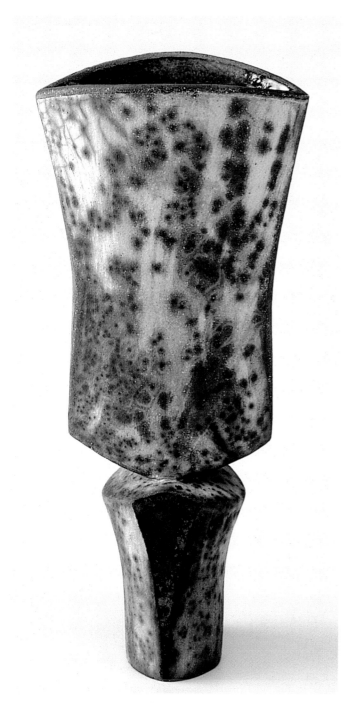

Plate 239: Elizabeth Raeburn, raku, 1992, ht: 20cm.

Raeburn, Elizabeth b. 1943, Surrey
Training: Harrow School of Art, pottery, 1973–5

Handbuilt sculptural vessel forms, raku-fired, painted with slips and finished with transparent or coloured glazes; tiles and murals.

Studio: West Pennard, Somerset, shared with Rodney Lawrence, 1975–
Collections: 9, 25, 27, 29, 41, 49, 56

Impressed marks

Rainer, George b. 1923

Handbuilt stoneware sculptural and vessel forms. Some thrown and press-moulded functional ware.

Studio: Bristol, *c.*1970s
Collections: 9, 27

Impressed mark

Reeve, John b. 1929, Vancouver, Canada
Thrown stoneware and porcelain in the Leach tradition.

Studio: Leach Pottery, Cornwall, 1958–61 and 1966
Hennock, Devon, *c.*1964–7
Canada, 1970s–
Collections: 56, 62

Impressed mark with others

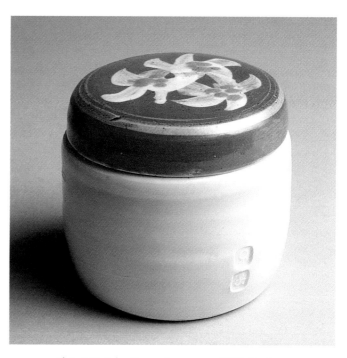

Plate 240: John Reeve, stoneware, c.1960, ht: 9cm.

Reeves, Ann Wynn b. 1929, London
Training: Willesden School of Art, London, 1948–51
Central School of Art, London, 1951–4

Tin-glazed earthenware vessels, 1950s, later work
primarily tiles.
Married Kenneth Clark, 1954.

Studio: Kenneth Clark Pottery, West London, 1954–80
Kenneth Clark Ceramics, Lewes, Sussex, 1980–
Collections: 29, 41

Painted initials 'AWR' or 'AC'

Rey, Margaret b. 1911, Dinas Powys, Cardiff, Wales
Training: Royal College of Art, ceramics under W.S. Murray,
1932–5

Reduced stoneware, largely in the Murray tradition,
ash-glazes often with brush decoration; some
earthenware, late 1930s; little work after 1939, no
pottery after 1960; now works in sculpture.

Studio: Raynes Park, London, 1935–60, shared with
Sam Haile, 1936–9
Forest Green, Surrey, 1960–
Collections: 2, 9, 27, 29, 33, 38, 45, 49, 55, 58, 62

Impressed mark

Rich, Mary b. 1940, Helston, Cornwall
Training: Bournemouth College of Art, painting and
ceramics, 1956–60.

Salt-glaze, 1962–83; porcelain decorated with gold and
lustres, 1983–.

Studio: Crowan Pottery, Cornwall, workshop experience
with Harry Davis, 1960
Lowerdown Pottery, Devon, workshop experience with
David Leach, 1961
Falmouth, 1962–70
Penwerris Pottery, Truro, Cornwall, 1970–
Collections: 14, 15, 25, 27, 49, 56, 58

Impressed mark

Richards, Christine-Ann b. 1944, Fulmer Chase, Bucks
Training: Harrow School of Art, ceramics under Michael
Casson, 1971–3
Worked for Bryan Newman, 1973; and David Leach,
1974

Thrown porcelain with crackle and monochrome glazes;
some large high-fired earthenware since 1989.

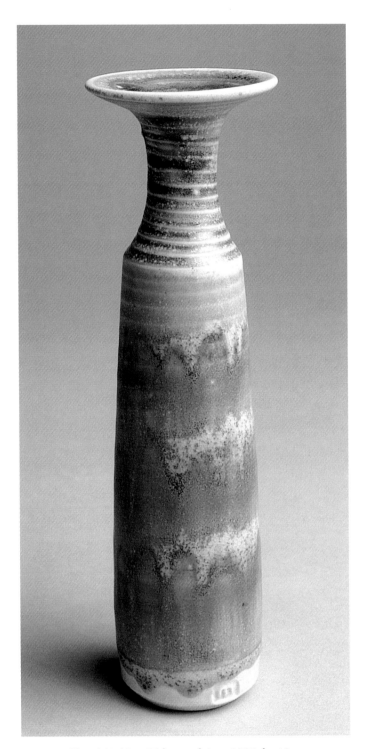

Plate 241: Mary Rich, porcelain, c.1985, ht: 19cm

Studio: Barbican Arts Group, London, 1975–81
Percy Circus, London, 1981–92
Wanstrow, Shepton Mallet, Somerset, 1992–
Collections: 27, 29, 56

Impressed 'car' on porcelain

Incised or impressed on earthenware

Richards, Frances Emma b. *c*.1869; d. 1931
Training: probably self-taught

Earthenware and stoneware in a variety of decorative styles.

Studio: 39 Claremont Road, Highgate, London, 1898–1900
33 Archway Road, Highgate, London, 1901–31
Collections: 29, 48, 55, 64

Incised or painted marks with year

Rie, Lucie (née Gomperz) b. 1902, Vienna, Austria;
d. 1995.
Came to England, 1938; OBE, 1968; CBE, 1981; DBE, 1991
Training: Kunstgewerbeschule, Vienna, 1922–26

Thrown earthenware 1926–*c*.1948; ceramic and glass buttons and some jewellery, 1945–7; domestic stoneware with manganese and tin-glazes, *c*..1948–*c*.1960; individual stoneware and porcelain, *c*.1950–; coloured, pitted, volcanic glazes sometimes with sgraffito, incised or fluted decoration.

Studio: Vienna, Austria, 1925–37
Albion Mews, Bayswater, London, 1939–95
*Collections:*1, 2, 5, 6, 8, 9, 11, 12, 14, 15, 17, 18, 21, 22, 24, 25, 27, 28, 29, 32, 33, 35, 36, 37, 41, 42, 43, 49, 50, 51, 54, 56, 57, 58, 60, 61, 62, 64, 65, 66

Painted mark, Vienna

Incised, brushed or
impressed marks early 1940s

Impressed mark with variations

Roberts, David b. 1947, Sheffield
Training: Bretton Hall College, Yorks, 1966–70

Raku, 1976–; early work slab-built, some thrown; then work coiled, often large pots with lustre and crackle glazes; more recent work glazed surfaces have been replaced with textural smoke markings and deep carbonization.

Studio: Holmfirth, Huddersfield, Yorks, 1975–
Collections: 6, 7, 10, 11, 18, 19, 24, 27, 29, 33, 35, 49, 54, 56, 57, 60, 64

Impressed mark

Rogers, Mary Elizabeth b. 1929, Belper, Derbyshire
Training: Watford School of Art, graphic design, 1945–7
St Martin's School of Art, London, graphic design, 1947–9
Loughborough College of Art, ceramics, 1960–4

Pinched and coiled porcelain and stoneware vessels based on organic forms. Porcelain, mostly bowls, sometimes carved or pierced, often painted to resemble agateware; stoneware, decorated with glazes and oxides. Changed from ceramics to painting *c*..1992.

Studio: Loughborough, Leics, 1960–87
Roskrow, Falmouth, Cornwall, 1987–92
Helston, Cornwall, 1992–
Collections: 2, 8, 11, 14, 15, 16, 18, 25, 27, 28, 29, 32, 33, 35, 37, 40, 41, 42, 43, 48, 49, 50, 56, 57, 62, 64, 66

Impressed or incised marks

Rogers, Phil b. 1951, Newport, South Wales
Training: Ceramics essentially self-taught
Newport College of Art, 1969–70
Swansea College of Art, 1970–2

Oxidized stoneware, 1978–80; reduced stoneware since 1980; ash-glazes essentially in the Leach tradition; salt-glaze since 1986.

Studio: Bridge St, Rhayader, Powys, 1978–84
Lower Cefn Farm, Rhayader, Powys, 1984–
Collections: 2, 37, 49, 56, 64, 65, 66

Impressed mark

Rooke, Bernard b. 1938
Training: Ipswich School of Art, painting and lithography, 1955–8
Goldsmith's College, ceramics under Gordon Baldwin, 1958–9

Handbuilt individual stoneware and moulded commercial vases, lamp-bases, murals. Has done less individual work after the early 1970s and returned to painting.

Studio: Greenwich, London, 1960–7
Swilland, Ipwich, Suffolk, 1967–
Collections: 2, 14, 25, 27, 29, 33, 41, 56, 62, 66

Most work before 1964 unsigned
Commercial pieces up to 1974 stamped, 'ROOKE' or 'BR'
Individual work and later commercial work incised 'BR' or sometimes painted signature

Ross, Duncan b. 1943
Training: West Surrey College of Art and Design, Farnham, 1961–5
Sussex University, 1965–6

Thrown, burnished terra-sigillata forms with inlay and resist decoration, smoke-fired, 1988–; thrown and handbuilt dishes and bowls in stoneware and porcelain, 1970–88

Studio: Farnham, Surrey, 1988–
Collections: 10, 11, 21, 24, 29, 56, 58, 59, 61

Impressed marks 1970–88

1988–

Salazar, Fiona b. 1949, Athens, Greece, of English parents
Educated in England
Training: Hammersmith College of Art, 1975–6
Central School of Art and Design, 1976–8
Royal College of Art, ceramics, 1979–82

Coiled earthenware pots, burnished and decorated with coloured slips and painted images often with Greek or Central American sources.

Studio: Wapping, London, 1982–84
Kingsgate Workshops, Kilburn, London, 1984–95
Redston Road, N. London, 1995–c.2000
Collections: 8, 24, 28, 29, 33, 50, 57, 64

Painted signature

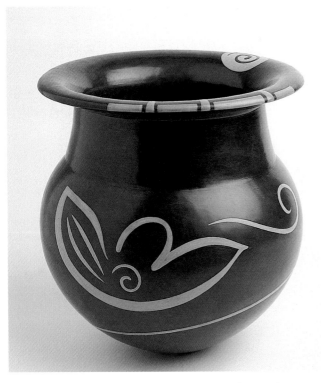

Plate 242: Fiona Salazar, earthenware, painted, 1995, ht: 25cm.

Silverman, Ray b. 1943, Hitchin, Herts
Training: Camberwell School of Art and Crafts, 1959–64

Individual, mostly thrown, vessel forms in porcelain and stoneware, 1973–; domestic stoneware before 1973. Did not pot c.1992–5.

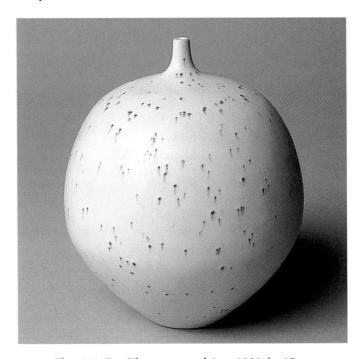

Plate 243: Ray Silverman, porcelain, c.1990, ht: 15cm.

Studio: East Chinnock, Somerset, 1964–7
Lapid Ceramic Works, Israel, designer, 1967–71
England, various studios, 1971–3
Hornchurch, Essex, 1973–
Collections: 33, 49, 56

Impressed mark

Simpson, Peter b. 1943, Hillingdon, Middx
Training: Bournemouth and Poole College of Art, sculpture with ceramics, 1959–64

Thrown, coiled and cast porcelain forms based on seed pods and fungi, some stoneware and raku, 1970s; larger porcelain 'bone' forms, late 1970s; large stoneware sculptural pieces, c.1979–93; ceased working in clay, 1993.

Studio: Bournemouth, facilities while teaching, 1965–70
Sway, Lymington, Hants, 1970–7
Brockenhurst, Hants, 1977–90
S.E. London, 1990–3
Collections: 8, 15, 18, 25, 29, 32, 33, 41, 48, 50, 56, 57, 60

Impressed mark on early work

Incised or painted signature

Slee, Richard b. 1946, Carlisle
Training: Carlisle College of Art and Design, 1964–5
Central School of Art and Design, 1965–70
Royal College of Art, design, 1986–8

Individual coiled and slabbed earthenware pieces with colourful glazes and slips; strong references to ceramic history and 'funk' ceramics.

Studio: Parsons Green and Hackney, London, 1973–80
Brighton, 1980–
Collections: 2, 8, 18, 21, 25, 28, 29, 33, 35, 49, 62, 64

Incised signature

Smith, Jane Osborn b. 1952
Training: Royal College of Art, 1975–7

Bone china forms with detailed narrative painting; designed work for Rosenthal, 1977; designs for glass in N. America.

Studio: Brighton, Sussex, *c.*1978–80
USA and Canada, 1980–
Collections: 25, 28, 62

Incised mark

Smith, Martin b. 1950, Braintree, Essex
Training: Ipswich School of Art, 1970–1
Bristol Polytechnic, ceramics, 1971–4
Royal College of Art, ceramics, 1975–7

Individual moulded and altered vessel forms in red or white earthenware from 1978; often with additions of metal leaf, 1990–; some work in small editions; coiled raku bowls with geometric decoration, 1975–8.

Studio: Stowmarket, Suffolk, 1974–8
Rotherhithe, London, 1978–84
St John's Wood, London, 1984–
Collections: 2, 6, 7, 18, 21, 24, 25, 28, 29, 33, 49, 54, 57, 60, 62

Does not mark work

Spira, Rupert b. 1960, London
Training: West Surrey College of Art and Design, Farnham, ceramics under Henry Hammond, 1978–80, 1983
Wenford Bridge Pottery, Cornwall, apprenticeship with Michael Cardew, 1980–2

Thrown stoneware vessels; mainly monochrome celadon, chun, and copper red glazes; early 1980s work often with painted decoration influenced by Cardew; tiles.

Studio: Lower Froyle, Hants, 1984–96
More, Shropshire, 1996–
Collections: 2, 36, 56

Impressed mark

Stair, Julian b. 1955
Training: Camberwell School of Art and Crafts, ceramics, 1974–5 and 1976–8
Royal College of Art, ceramics, 1978–81

Thrown porcelain vessels, initially with inlaid decoration, then with cut or altered forms. Similar forms in red earthenware. Porcelain decorated by the painter, Eileen Cooper, late 1990s.

Studio: St Just, Cornwall, assistant to Scott Marshall, 1975–6
401½ Workshops, Lambeth, London, 1981–5
Arlingford Studios, Brixton, London, 1985–95
Peckham Road, London, 1996–
Collections: 21, 28, 29, 33, 36, 49, 56, 57

Impressed or sometimes incised

Standige, Gary b. 1946, Blackpool, Lancs
Training: Stoke-on-Trent College of Art, 1964–7
Royal College of Art, London, 1967–70

Thrown vessels in stoneware and porcelain, 1975–88; moulded forms in mixed clays, 1995–; no work 1988–95.

Studio: Westliffe, Kent, 1975–80
Aylesford, Kent, 1981–8
Lindale, Cumbria, 1995–
Collections: 11, 28, 29, 56, 57

Impressed mark

Suttie, Angus Macdonald b. 1946, Tealing, Scotland; d. 1993
Training: Camberwell School of Art, ceramics, 1976–9
Whitelands College, Putney, London, teacher training, 1979–80

Handbuilt vessel forms cut and shaped and decorated with glazes and enamels; earthenware, 1981–4 and 1986–92; stoneware, 1984–6.

Studio: 401½ Workshops, London, shared with Sara Radstone, 1981–4
Clerkenwell, London, 1984–92
Collections: 6, 7, 28, 29, 33, 37, 43, 49, 51, 57, 62, 64, 66
Inscribed 'ANGUS MADE ME' or 'ANGUS', 1981–4

Incised or painted mark, 1985–92

Swindell, Geoffrey b. 1945, Stoke-on-Trent
Training: Stoke-on-Trent College of Art, painting and
ceramics, 1960–7
Royal College of Art, ceramics, 1967–70

Porcelain and some stoneware, press-moulded, coiled and
pinched until *c.*1975; thrown and turned porcelain forms
with equal emphasis on the surface, which is sometimes
sandblasted or lustred, *c.*1975–88 and from 1995.

Studio: York, 1970–5
Cardiff, 1975–
Teaching: York School of Art, 1970–5
University of Wales, Cardiff, 1975–
Collections: 6, 8, 15, 22, 25, 28, 29, 32, 35, 41, 42, 50, 56,
57, 60, 64, 65, 66

Incised mark

———————————

Sykes, Stephen b. 1914, Formby, Lancs; d. 1999
Training: Royal College of Art, stained glass and mosaics,
1933–6

Earthenware dishes, tiles and figures, relief decoration and
tin-glaze, 1947–*c.*1959; also mosaics and architectural
pieces, notably mural for Coventry Cathedral. Work in
other media.

Teaching: Chelsea School of Art, London, 1947–79
Studio: Kew, Surrey, 1947–60
Fulham, London, sculpture, 1960–8
Bepton, Midhurst, Sussex, 1960–79
Collections: 29

Incised 'Stephen Sykes' with date

———————————

Taylor, Sutton b. 1943, Keighley, Yorks
Training: self-taught

Complex lustre decoration primarily on large bowls and
chargers from mid-1970s; bottle forms in 1990s; wall
pieces and architectural panels; early work largely
handbuilt stoneware and porcelain.

Studio: Temple Newsam House, Leeds, 1971–5
Aberford, Yorks, 1975–80
Lotherton Hall, Leeds, 1980–90
Fylingthorpe, Whitby, 1990–6
St Buryan, Penzance, Cornwall, 1996–
Collections: 2, 6, 9, 10, 11, 18, 24, 25, 27, 28, 29, 33, 35, 41,
43, 45, 48, 49, 54, 61

Impressed mark, 1980–

Impressed Lotherton Hall mark, 1980–90–

Taylor, William Howson (Ruskin Pottery) b. 1876;
d. 1935
Training: Birmingham School of Art, where his father was
headmaster

Experimented with high-temperature glazes, particularly
flambé and lustre glazes. Also produced pots of eggshell
thinness with matt or crystal glazes.

Studio: Edgbaston, Birmingham, –1898
The Ruskin Pottery, West Smethwick, Birmingham,
1898–1933
Collections: 1, 6, 13, 22, 27, 29, 32, 34, 35, 37, 38, 41, 43,
47, 49, 60, 61, 62, 64, 65

Early impressed mark

Painted or incised marks *c.*1898 onwards

Impressed mark with year *c.*1904–15

Various impressed marks from *c.*1904 with 'Ruskin' or
'Ruskin Pottery'
Impressed 'Made in England' *c.*1920 onwards

———————————

Tchalenko, Janice b. 1942, Rugby, Warks
Training: Putney School of Art, 1965–7
Harrow School of Art, ceramics, 1969–71

Thrown or press-moulded stoneware with colourful slip-
trailed or painted decoration, 1979–; thrown domestic
ware in reduced stoneware in the Leach tradition, 1971–9;
numerous designs for production, most notably for Dart
Pottery, Devon, since 1984.

Teaching: Camberwell School of Art and Crafts, 1972–87
Royal College of Art, 1981–96
Studio: E. Dulwich, London, 1971–88
Camberwell, London, 1988–
Collections: 7, 8, 11, 15, 18, 27, 28, 29, 32, 33, 35, 41, 42,
48, 49, 50, 56, 57, 58, 60, 61, 62, 64, 66

Impressed mark

Work of 1970s and 1980s is usually unsigned

———————————

Thomas, Gwilym b. 1914, Swansea; d. 1995
Training: Swansea School of Art, *c.*1931–3
Royal College of Art, ceramics under W.S. Murray, 1935–8

Stoneware at RCA; earthenware, 1950s; reduced stoneware
from 1950s; some porcelain from *c.*1975.

Publication: Step by Step Guide to Pottery, Hamlyn, London,
1973

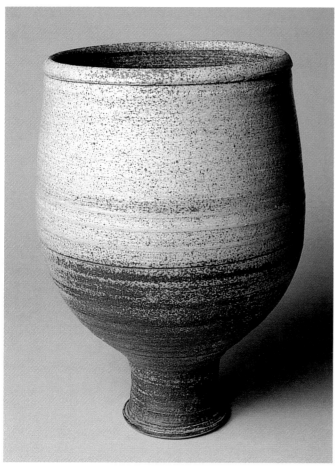

Plate 244: Gwilym Thomas, stoneware, 1970, ht: 31cm.

Studio: Bromley, Kent, *c.*1946–56
Orpington, Kent, 1956–95
Collections: 6, 25, 29, 33, 49, 62, 64, 65

Incised mark with year

Tollow, Vera b. 1931
Training: Croydon College of Art, studio pottery and textile design, 1948–52

Thrown reduced stoneware vessels, wood ash-glazes with brushwork in iron oxide, *c.*1958–*c.*1991; slipware, 1954–7.

Studio: Wallington, Surrey, 1954–88
Goudhurst, Kent, 1988–91
Hawkhurst, Kent, 1991–
Collections: 56

Painted signature

Tower, James b. 1919, Sheerness, Kent; d. 1988
Training: Royal Academy Schools, London, painting, 1938–40

Slade School of Fine Art, London, painting, 1946–9
London University Institute of Education, ceramics, with William Newland, 1949–50
Central School of Art, ceramics, evenings with Dora Billington, 1949–50

Tin-glazed press-moulded earthenware dishes, bowls and flattened vases; decoration by sgraffito through dark glaze to reveal white glaze below; some painted decoration on very early dishes; *c.*1949–59 and 1978–88; only bronzes and terracotta for casting produced, *c.*1959–*c.*1975.

Teaching: Bath Academy of Art, 1949–60
Brighton College of Art, 1966–86
Studio: Corsham, Wilts, 1950–65
Barcombe, Lewes, Sussex, 1965–88
Collections: 6, 15, 18, 21, 25, 28, 29, 33, 36, 37, 41, 54, 62, 65

Incised or painted signature with year

Some 1950s pieces unmarked or with 'Tower' only

Trim, Judith b. 1943, Cambridge; d. 2001
Training: Bath Academy of Art, painting and pottery, 1961–4

Vessel forms in various clays fired to earthenware temperatures; early work raw-fired in sawdust kiln, burnishing, carving, cutting or spraying with coloured oxides and smoking; primarily lustres since *c.*1985.

Studio: Islington, London, 1978–84
Hammersmith, London, 1984–2000
Collections: 2, 11, 15, 18, 28, 35, 56, 62
Did not sign work before *c.*1986, then work often has incised 'JT'

Tustin, Sidney b. 1914, Winchcombe, Glos
Small functional slipware in style of Michael Cardew; stoneware after 1959.

Studio: Winchcombe Pottery, Glos, under Cardew, 1927–39; under Finch, 1946–78
Collections: 13, 15, 32, 33, 49, 60, 62

Impressed marks

Vergette, Nicholas b. 1923, Market Deeping, Lincs; d. 1974
Training: Chelsea School of Art, painting, 1946–50
London University Institute of Education, 1950–1

Tin-glazed earthenware vessels and figures; in USA primarily worked in bronze.

Teaching: Camberwell and Central Schools of Art, 1951–8
Studio: Bayswater, London, shared with William Newland
and Margaret Hine, *c.*1948–54
USA, 1958–74
Collections: 6, 25, 29, 37, 62

Painted or incised marks

Vyse, Charles b. 1882, Staffordshire; d. 1971
Training: Royal College of Art, 1905–12
Camberwell School of Arts and Crafts, *c.*1912

Stoneware in the Chinese tradition, *c.*1927–63. Also
slip-cast figures in collaboration with Nell Vyse.

Studio: Cheyne Row, Chelsea, London, 1919–63
Collections: 1, 2, 4, 6, 9, 16, 17, 18, 19, 25, 26, 27,
29, 33, 34, 35, 37, 38, 41, 43, 48, 49, 53, 55, 56, 58,
60, 61, 64, 65

Incised, impressed or painted mark
often with year, late 1920s
Most incised or impressed, 'CV', 'C VYSE',
'CHARLES VYSE', sometimes with 'CHELSEA' or year

Wadsworth, Philip b. 1910, Cheshire; d. 1991
Training: Malvern College, late 1920s
Chelsea College of Art, painting and drawing, 1929–31
Royal College of Art, ceramics under W.S. Murray, 1931–6

Heavily potted thrown stoneware often with brush
decoration; most work 1936–40 and 1946–9.

Teaching: Leeds School of Art, 1946–9
Poole School of Art, 1949–66
Studio: Leeds, 1946–9
Poole, Dorset, 1949–66
Malvern, 1970–91
Collections: 9, 24, 29, 49, 55, 58

Incised 'PSW' sometimes with year, later work sometimes
with 'L', 'P' or 'M' indicating studio

Walford, James b. 1913
Training: The Slade and Royal College of Art, painting,
1930s

Thrown stoneware and porcelain, mostly in the Chinese
tradition, 1948–59, and some work after 1977.

Studio: South Nutfield, Surrey, 1948–59
Crowbourough, Sussex, 1959–
Collections: 11, 29, 56

Impressed mark

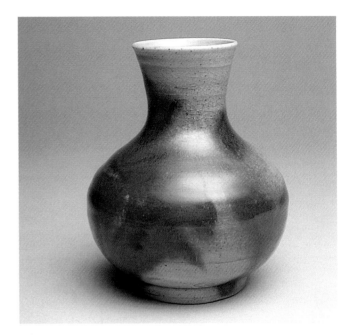

Plate 245: James Walford, porcelain, c.1978, ht: 14cm.

Wallwork, Alan b. 1931, Watford, Herts
Training: Watford School of Art, *c.*1952–4
Goldsmith's College, London, 1955–6

Wide variety of handbuilt stoneware pots sometimes with
thrown and altered sections, tall pots, pebble and organic
forms; earthenware tile production by assistants, 1957–84;
production wares including lamp-bases; some thrown tin-
glazed earthenware, 1957–62.

Studio: Alan Gallery, Forest Hill, London, 1957–*c.*1962
Greenwich Studios, Deptford, London, *c.*1962–*c.*1966
Marnhull, Dorset, *c.*1966–84
Lyme Regis, Dorset, 1984–
Collections: 14, 15, 27, 29, 41, 46, 49, 56

Earthenware impressed or incised 'W.', 1957–*c.*1962
Impressed or incised 'W' on repetition pieces
Incised 'AW' on individual pieces

Walton, Sarah b. 1945, London
Training: Chelsea School of Art, painting, 1960–4
Middlesex Hospital, London, trained as a nurse, 1966–71
Harrow School of Art, ceramics, 1971–3
Apprenticeships with David Leach and Zelda Mowat, 1973–4

Thrown salt-glazed stoneware, functional pots and
sculptural birdbaths.

Studio: Selmeston, Sussex, 1975–
Collections: 21, 24, 28, 29, 33, 35, 36, 37, 49, 56, 61,
62, 64, 66

Impressed mark

Ward, John Douglas b. 1938, Islington, London
Training: East Ham Technical College, London, 1965–6
Camberwell School of Art and Crafts, London, ceramics, 1966–70

Individual handbuilt stoneware pots, coiled and sometimes altered by cutting and rejoining; matt glazes or once-fired slip glazes.

Studio: Anerley, S.E. London, 1971–6
Charlton, London, 1976–9
Cilgwyn, Newport, Dyfed, 1979–
Collections: 2, 7, 15, 21, 24, 25, 27, 29, 33, 36, 37, 49, 56, 57, 60, 62, 64, 65, 66

Impressed mark

Washington, Robert Johnson b. 1913, London; d. 1997
Training: Goldsmith's College, London, painting, 1930–3
Royal College of Art, London, painting, 1933–6
Central School of Art, ceramics under Dora Billington, 1937–8
Royal College of Art, ceramics under W.S. Murray, 1937–8

Heavily potted stoneware, mostly tall bottle forms with semi-abstract female nudes painted in oxides, 1938–40, 1959–c.1965, c.1980–4; wall platters, late 1980s; paintings and sculpture in ceramic fibre and clay pulp, early 1990s; low-fired bowls 1995–7; some early 1980s pots decorated c.1996. Was Inspector for Art Education in Essex for thirty years after the war.

Studio: Shenstone Pipe Works and Joseph Bourne, Derby, 1938–40
Little Baddow, Essex, 1954–97
Collections: 2, 6, 11, 25, 27, 29, 33, 38, 41, 43, 56, 62

Incised or painted 'RJW' often with year

Wason, Jason b. 1946, Liverpool
Training: self-taught

Thrown or handbuilt individual vessel forms; primarily raku with black matt surfaces, studded, ridged and incised, 1980s; also white stoneware clay with incised decoration, 1990s.

Studio: Leach Pottery, St Ives, Cornwall, 1976–81
St Just, Penwith, Cornwall, 1981–
Collections: 27, 56

Impressed mark

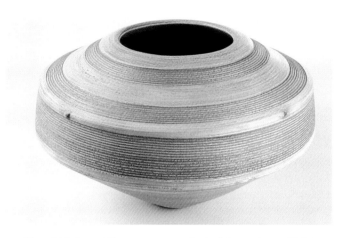

Plate 246: Jason Wason, stoneware, incised decoration, c.1997, dia: 20cm.

Welch, Robin b. 1936, Nuneaton, Warks
Training: Nuneaton School of Art, 1952–3
Penzance School of Art, sculpture and ceramics, 1953–6
Central School of Art and Design, ceramics, 1959–60
Technician at Central School, 1960–2

Domestic stoneware, 1960–2; domestic ware using jigger and jolley technique and larger thrown pieces in 1960s and 1970s; raku from 1980; then individual stoneware – thrown, coiled or slabbed.

Studio: Leach Pottery, St Ives, 1953
London, 1960–2
Melbourne, Australia, sets up workshop with Ian Sprague, 1962–5
Stradbroke, Suffolk, 1965–
Collections: 1, 2, 8, 9, 11, 12, 14, 16, 18, 27, 29, 32, 33, 35, 42, 43, 49, 50, 53, 56, 57, 59, 60, 61, 62

Painted mark, sometimes with date

Impressed marks, 1965–

Wells, Reginald b. 1877; d. 1951
Training: Royal College of Art, sculpture, c.1895
Camberwell School of Art, pottery under W.B. Dalton

Slipware until 1910. Coldrum ware 1910–19 were earthenware with experimental monochrome glazes in Chinese style. Stoneware in Chinese style often with copper or cobalt glazes. Some figures and bronzes.

Studio: Coldrum, near Wrotham, Kent, c.1900–10
Coldrum Pottery, Chelsea, London, 1910–25
Storrington, Sussex, 1925–51
Collections: 1, 4, 15, 17, 23, 27, 29, 31, 32, 53, 55, 64

Slipware marked 'Coldrum' or 'Coldrum, Wrotham'
Impressed or incised, 1910–24, 'Coldrum' or 'Coldrum, Chelsea'

Impressed or painted, 1910–14

Impressed or incised, *c.*1919 onwards

White, Mary b. 1926, Croesyceliog, Newport, Wales
Training: Hammersmith College of Art, London, design, 1946–8
Goldsmith's College of Art, London, 1949–50

Some sculptural stoneware before 1973; stoneware domestic ware, 1973–*c.*1980; porcelain, thrown bowls often with calligraphy, 1975–80; primarily thin handbuilt porcelain organic forms, 1980–; reintroduced calligraphy, 1990–.

Teaching: Art teacher in grammar schools and art college, 1950–61
United World College of the Atlantic, Wales, 1961–73

Studio: Glamorgan, Wales, 1973–5
Malmesbury, Wilts, 1975–80
Wonsheim, Germany, 1980–
Collections: 1, 9, 11, 17, 26, 29, 35, 41, 46, 50, 56, 64, 66

Impressed, incised or painted mark

Whiting, Geoffrey b. 1919, Stocksfield, Northumberland; d. 1988
Training: Birmingham School of Architecture, 1937–40

Thrown individual pieces in stoneware and porcelain in the Leach tradition, incised, combed, or painted decoration; some handbuilt work; range of domestic slipware but soon changed to stoneware, 1949–72.

Studio: Avoncroft Pottery, Bromsgrove, Worcs, 1949–55
Stoke House Pottery, Bletchley, Bucks, 1950–2
Avoncroft Pottery, Hampton Lovett, Worcs, 1955–72
St Augustines Pottery, Canterbury, 1972–88
Collections: 1, 6, 8, 14, 15, 17, 27, 29, 31, 32, 33, 37, 49, 50, 56, 57, 64, 66

Impressed marks at Avoncroft Pottery

Impressed marks at St Augustines Pottery

Impressed mark Stoke House Pottery

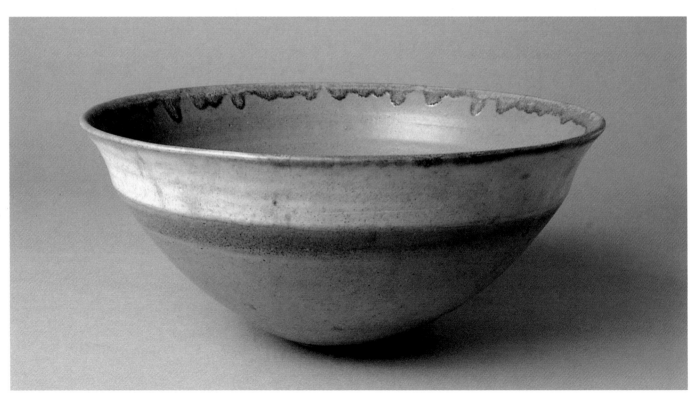

Plate 247: Mary White, porcelain, c.1978, dia: 21cm.

Whittall, Eleanor b. 1900; d. *c.*1970
Training: Central School of Art, *c.*1942

Reduced stoneware, often ash-glazed, *c.*1944–63, porcelain, *c.*1958–63.

Studio: North London and, later, Kensington, London
Collections: 29, 56

Impressed mark

Wren, Denise b. 1891, Western Australia; d. 1979
Came to England, 1900
Training: Kingston College of Art, design, 1907–12
Learnt throwing from a flowerpot maker

Established with others the Knox Guild of Design and Crafts, Kingston upon Thames, 1912. Handbuilt earthenware until 1920. Then stoneware and earthenware. Salt-glaze from *c.*1950–1967.

Studio: Oxshott Pottery, Surrey, 1920–79.
Collections: 2, 15, 17, 27, 29, 33, 41, 49, 56, 61, 62, 64

Incised marks in many variations

Yasuda, Takeshi b. 1943, Tokyo, Japan
Came to England, 1973
Training: apprentice at Daisei Pottery, Mashiko, Japan, 1963–6

Wood-fired earthenware, 1973–5; ash-glazed reduction-fired stoneware, 1975–85; thrown functional oxidized stoneware with sancai glaze and impressed, relief-moulded or slip-trailed decoration, 1984–; creamware, 1996–2000; oxidized porcelain, 1999–.

Teaching: West Surrey College of Art and Design, Farnham, 1978–85
Studio: Mashiko, Japan, own workshop, 1966–73
Monk Sherborne, Hants, shared with Sandy Brown, 1973–5
Meshaw, Devon, shared with Brown, 1975–81
Bergenkunsthandverksskole, Norway, residency, 1978
South Molton, Devon, shared with Brown, 1982–93
Cleveland Crafts Centre, Middlesbrough, residency, 1984–6
Bath, 1992–
Collections: 7, 15, 16, 18, 21, 28, 29, 32, 33, 35, 39, 41, 49, 55, 56, 57, 60, 62, 64, 65, 66

Impressed marks after *c.*1983

Did not mark early work

Yeap, Poh Chap b. 1927, Kota Bharu, Kelantan, Malaysia.
Came to England in 1948 and studied law
Training: Putney Evening Institute, ceramics, 1962–3
Hammersmith College of Art, 1963–7
Royal College of Art, research student, ceramics, 1967–8

Thrown stoneware and porcelain in the Chinese tradition, 1970–85.

Studio: Aarhus, Denmark, 1961
Ewhurst, Surrey, 1969–86
Collections: 2, 15, 25, 33, 42, 57, 64

Incised or painted signature

Glossary of Ceramic Terms

Agate ware – Made from different coloured clays that are not mixed and give a striated effect.

Ash glaze – A glaze for stone, where wood or plant ash is used as a flux.

Biscuit – Clay that has been fired once prior to glazing.

Body – The clay or mixture of clay and other materials of which a pot is made.

Burnishing – Polishing leather-hard clay with a smooth tool.

Celadon glaze – a grey-green or blue-green glaze of Chinese origin used on stoneware or porcelain.

Ceramic – A material made of clay that has been fired.

Chun glaze – A pale blue opalescent glaze of Chinese origin used on stoneware.

Clay – Decomposed feldspathic rock.

Coiling – Handbuilding a pot using ropes of clay.

Combing – Decorating a surface with a toothed tool.

Crackle – Crazing when intentionally used as a decorative effect.

Crawling – Movement of the glaze during firing leaving unglazed areas.

Crazing – Cracks in the glaze caused by uneven expansion of glaze and body.

Earthenware – Ware fired usually below 1200°C, that is porous.

Engobes – Slips containing other material as well as clay usually used to change the colour.

Feathering – A decoration process where two layers of different coloured slips have a feather drawn across at right angles to partially mix them.

Firing – Bringing a pot to high temperature to change clay to pottery or to fuse glazes.

Flambé glazes – Iridescent glazes of Chinese origin in which reduced copper is used to produce mainly red or purple hues.

Fluting – Cutting repeated decorative grooves into the clay surface.

Flux – Oxides that cause a body or glaze to fuse.

Glaze – A vitreous substance applied to the surface of a pot and fired for decorative effect and to prevent leaking of porous vessels.

Hakeme – A white slip that is thickly and roughly applied by brush to the surface of a pot.

Handbuilding – Making a pot without using a wheel or a mould, usually by coiling, pinching or slabbing.

Incised decoration – A design made by cutting into the clay surface with a pointed tool.

Inlay – Clay or slip, different in colour from the body, that is inserted into a design cut in the clay surface and then smoothed level.

Impressed decoration – Motifs pressed into the clay using a stamp.

Jiggering and jolleying – A process of mechanical throwing.

Kiln – A furnace or oven in which pottery is fired.

Laminated – Made of separate layers of different clays.

Lead glaze – An earthenware glaze with lead as a fluxing agent.

Leather hard – Partly dried clay that has lost most of its plasticity.

Lustre – A metallic skin applied to the surface of a glaze and fired in a reducing atmosphere to produce a metallic sheen.

Marks – The ways that potters sign their work.

Modelling – Building up of parts of the surface of a pot with clay or removing clay with a tool.

Once-fired – pottery which is raw glazed and finished in a single firing.

Overglaze – Decorating with colour applied on top of a fired, glazed surface.

Oxidation – Firing a kiln with an ample supply of oxygen so that combustion is complete and the metals in the clay and glaze can form their coloured oxides.

Painting – The decoration of the surface of a pot by brush painting.

Pinching – Forming a pot by shaping the clay with fingers and thumb.

Porcelain – A particular type of high-fired pottery that is fine, white and translucent.

Porosity – The ability of a fired body to absorb water.

Pottery – Articles made of clay fired to above 600°C.

Press-moulding – Making forms by pressing slabs of clay into moulds.

Raku – A particular kind of low-fired pottery with greater resistance to thermal shock.

Raw glaze – A glaze that can be applied to pottery that has not been biscuit-fired.

Reduction – Firing a kiln with a limited supply of oxygen so that combustion is incomplete and carbon reduces any metal oxides to their metallic state.

Relief decoration – Decoration produced by portions of the body being raised.

Salt-glaze – A thin glaze produced by throwing salt in the kiln when it is at stoneware temperature. The salt vaporizes and combines with silica in the clay.

Sang-de-boeuf glaze – A rich red glaze coloured by reduced copper.

Sawdust firing – Firing of pots in a container of sawdust, normally to produce areas of colour by reduction.

Sgraffito – Decoration produced by a slip or glaze to reveal what lies beneath.

Slab-building – Handbuilding a pot by joining slabs of clay.

Slip – Clay in a liquid state.

Slip-casting – Making pottery by pouring slip into plaster moulds.

Slipware – Earthenware decorated with slips under a lead (galena) glaze.

Standard-ware – A range of domestic pottery produced over a period of time with the same body, glaze and design.

Stoneware – Pottery fired to a temperature usually over 1200°C, when the body vitrifies and becomes impermeable.

Tenmoku glaze – An iron glaze of Chinese origin, usually black to brown or rust where thinner.

Terracotta – Low-fired earthenware usually red in colour and unglazed.

Throwing – Shaping clay by hand on a potter's wheel.

Tin-glaze – A white and opaque glaze containing tin or zirconium oxide.

Trailing – Decorating pots with lines of thick slip.

Turning – Shaving and trimming the walls of a pot and cutting the foot when it is leather hard.

Underglaze – Decoration applied under a transparent glaze.

Vitrification – The process by which a substance becomes glassy by fusion or clay becomes impermeable in firing.

Wax-resist – Decoration applied in wax so that the glaze or slip will not adhere to those areas of the surface.

Wheel – The potter's wheel is a horizontal revolving disc on which clay is thrown or shaped.

Index